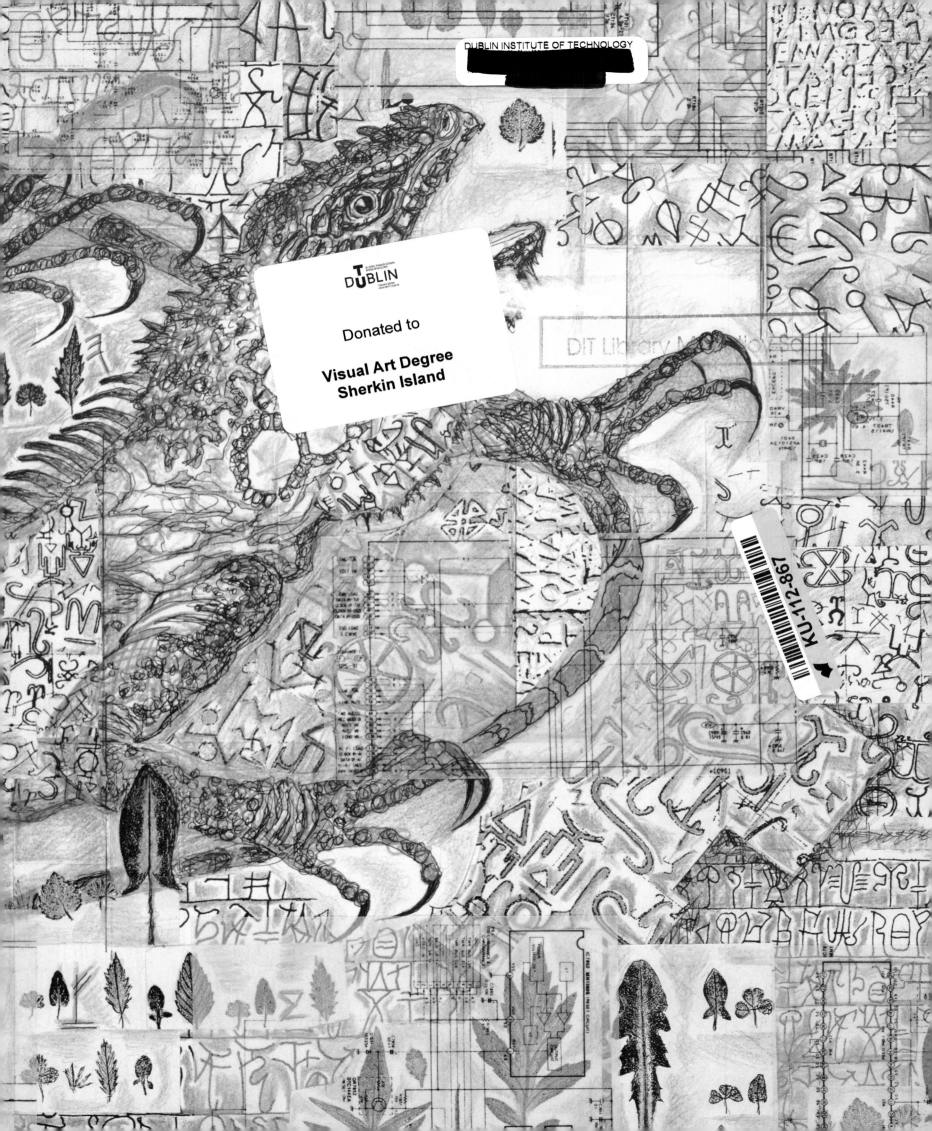

DMITRI PLAVINSKY

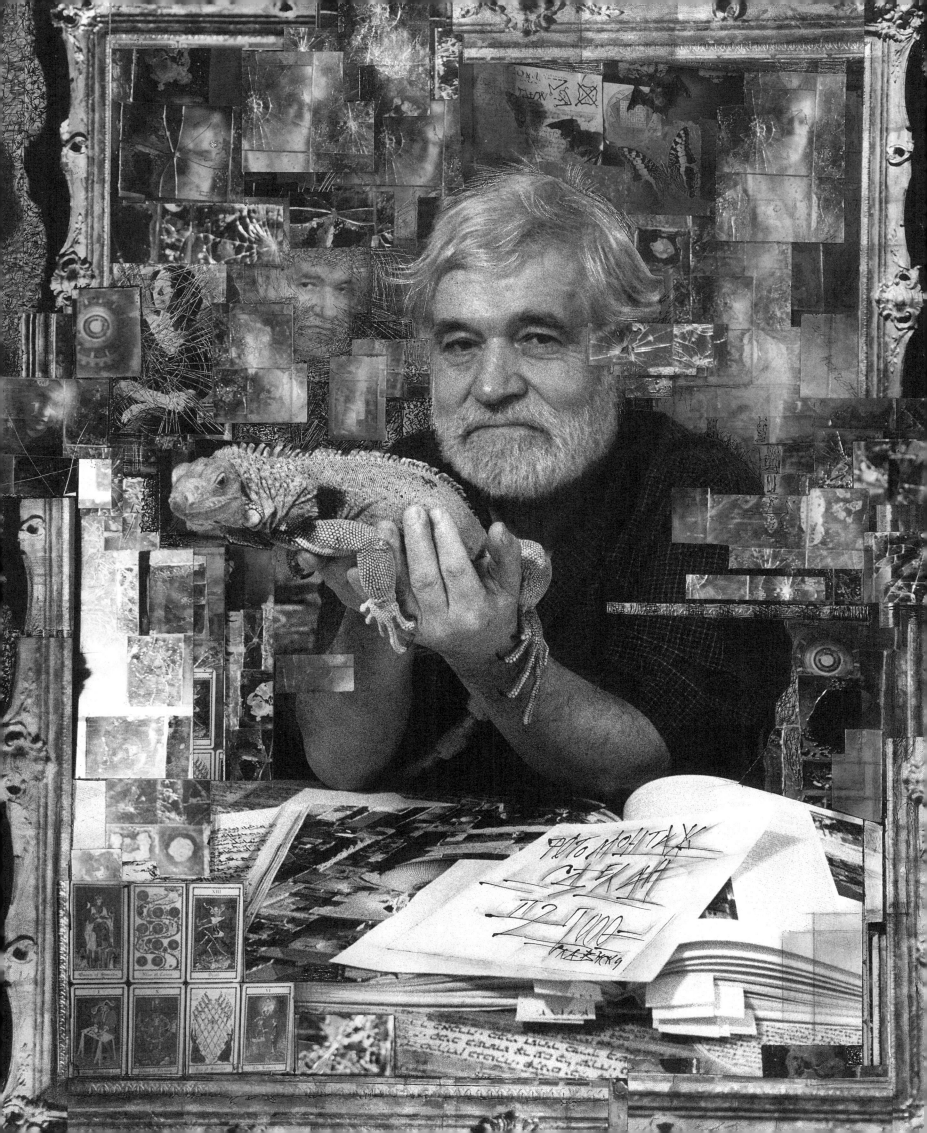

DMITRI PLAVINSKY

RIZZOLI
NEW YORK

First published in the United States of America in 2000 by
Rizzoli International Publications, Inc.
300 Park Avenue South
New York, NY 10010

Copyright ©2000 Rizzoli International Publications, Inc.

Text copyright © John E. Bowlt
Alexander Jakimovich
Elizaveta Plavinskaya-Mikhailova
Dmitri Plavinsky

Translation: Irina Barskova

Concept et design: Paola Gribaudo

ISBN 0-8478-2315-6

Color separation: Fotomec, Turin, Italy
Printing: Pozzo Gros Monti, Moncalieri, Italy

End and front papers:
Iguana, 1999, Ink, colored pencil, collage on paper
18$^{7/8}$ x 31$^{3/4}$ in. 47.8 x 80.8 cm.

CONTENTS

THE VOICE OF SILENCE

The pictorial images of Dmitri Plavinsky are semaphores along the dark and uneasy passage of time, a passage that is familiar and haunting in its eternal recurrence and yet enigmatic and hostile in the fleeting shadows of its crepuscular glow. For Plavinsky, time is like the dog racing in the circle of gloom that we see in *Running in the Darkness* (1972), but it is also a condition that he evokes in the proud and mighty symbols hallowed by time, such as the Parthenon and Knossos. Plavinsky simultaneously distinguishes between two times — a local, calendar time epitomized by a cathedral or a shed, and a timelessness, where an inchoate mesh of fish, lizards, turtles, butterflies, and bats are the inheritors of the earth, far more resilient and enduring than the fragile artifacts of the human hand.

The essence of Plavinsky's art, then, lies in the abrasive confrontation between two levels of perception — that of the natural time of prehistory and that of the false time of history — a confrontation that the artist expresses in his synthetic appreciation of the pagan swastika and the Christian cross, "the idea of movement stopped and the beginning of the new," as he affirms in his Notebooks of 1994. Some of Plavinsky's most powerful compositions, such as the *Vikings Ship* (1976) and the *Abandoned Church* (1975), therefore register the pathetic traces of our brittle material culture within the shifting sand of eternity. These stark exercises in black and white remind us that all is ephemeral, that all will be engulfed in the primeval dust of time, and that, as in the forest at night, we will always go forward only to come back to our point of departure.

Plavinsky continues his inquiry into the timelessness of time in his Italian series of 1997-98, his alluring evocations of Florence, Rome, and Venice. But the pastel tones and aerial perspectives of these reminiscences conceal an ambiguity and a disjunction that, once again, have to do with the forward march of calendar time within the ubiquitous mass of cosmic time — except that these impressions now seem to deal with aftermath and subsequence, and not just with the tension between the moment and eternity. In spite of their gentle harmonies, pictures such as *Venetian Secrets* (1997) and *Evening in Venice* (1997) evoke both a pregnant stillness and a calm after the storm. In turn, their apocalyptic mood elicits the sensation that the real center of attention is outside the frame, and that these silent edifices bereft of human emotion are the surviving monuments to a pestilence or deluge that has already come to pass. The eerie, neutronic *Gondolier's House* (1997) is without gondoliers; the remote and phantasmal *Arno Bridges* (1997) cross over to an eschatological vision. *Vivaldi's Music upon the Grand Canal* (1997) plays to no human audience, and the bleak ruins of the *Coliseum* (1998) stand untempered by ancient gladiator or modern tourist. Here are celebrations of the human talent for cultural construction — and for mass destruction.

Plavinsky is also concerned with communication or, rather, with the fallacy of everyday language, for his other concentration is on the Word in the biblical sense of primal utterance, when sound, meaning, and image were the same and the Word (logos) was a perceptual mechanism that incorporated all the senses. With its introduction of dissent and divorce, the Fall ruined that totality and split the Word into label and object.

Plavinsky tries desperately to restore that wholeness through parables and rebuses, suggesting, for example, a proximity of the ancient manuscripts to botanical organicity, as in *Eastern Manuscripts with Butterflies* (1989), or of music notations and the Venetian cityscape to cosmogonies.

What solutions does Plavinsky offer for the vast problems of time and space? What salvation does he glimpse in what he calls an "inanimate, electronic world"? How can he build a bridge between the incompatibilities that he elicits, between "here" and "there"? One response seems to lie simply in the act of creating — the paint-brush touching the surface of the canvas, the incision of the etching tool, and the burning of the acid of the metal plate. In the busy textures of his compositions, especially the recent reminiscences such as *Butterfly of Crete* (1995), Plavinsky emphasizes the visceral, spontaneous gesture of the artist's hand, which, ultimately, has no need of a recognizable image, a conventional scale of colors, or an imposition of perspective and propor-tion. Just as unkempt nature will reclaim an abandoned city (*Machu Picchu*, 1978) or the ocean inundate a prodigal vessel (*Lost Ship*, 1995), so Plavinsky at once describes a human artifact such as the temples of Delphi or the Bridge of Sighs and then undermines their solidity by the seismic force of his factures, grids, and era-sures. The result is that appearance becomes apparition — as in *Mirage in Aegean Sea* (1995) or *Boat of Remembrances* (1997) — and what seemed to symbolize temporal and aesthetic permanence suddenly yields to the greater energy of the circular passage of time. The word surrenders to the Word, presence to absence, loud-ness to softness. In this sense, Plavinsky's disturbing imagery is actually reassuring, for he compels us to heed a higher harmony and the resonant voice of silence.

John E. Bowlt

DMITRI PLAVINSKY'S MYTHS ON CULTURE AND NATURE

The very first glance on Dmitri Plavinsky's paintings, graphic works, objects, and installations betrays that this artist deals with civilizations, or "cultures," if this Spenglerian distinction makes sense to the viewer. Before 1990, living in the former Soviet Union, Plavinsky immersed himself in old Slavonic, Oriental, and Medieval Christian symbols, inscriptions, tools, and other relics of extinct civilizations incorporated them into his "archaeological" fantasies. He built up an imaginary museum of the cultural genealogy of East and West. Traveling across the vast spaces of the former Soviet Union, he introduced into his wood and clay models, etchings, and oil paintings the everyday things as well as cult objects of nations that no longer exist, religions that have been dismissed, and societies that have been extinguished. What did he want to say: that cultural values are immortal, or, on the contrary, that they are doomed to decomposition?

In any case, viewers and critics always read in Plavinsky's works some kind of cultural optimism, or, conversely, a tragic feeling of the hopelessness and senselessness of human efforts. In a sense, Plavinsky provoked such a reading himself. As long as he existed as a nonofficial artist in the frame of the totalitarian system of the former Soviet Union, he appeared in a certain light.

Of course, this artistic gesture was highly ambivalent, if not suspect, within the context of the battle being waged between so-called nonofficial art and a political system that insisted it was both eternal and immortal. Plavinsky was something of a black sheep even in his own community of alternative nonconformist artists, who in the sixties gave their hearts to classical modernism and its deities – Sartre, Picasso, and Hemingway, along with other giants of charismatic creation – who thought of art as a magic act.

Plavinsky's colleagues and friends had been inspired by abstract art and Surrealism since the fifties, and enjoyed the sense of liberation they found in anarchistic revolutionary self-expression as opposed to social conformism of the Soviet citizen. Conceptualism was introduced in the seventies. This is to say, the principle of artistic value was rejected. Artist, museum, meaning, message, value and artwork were declared false slogans and instruments of power and domination in the new radical art. Western artists were quicker and more effective in introducing again this old dream of the Dadaists, ridding themselves of power, culture, and ideology. There were influential intellectual circles in Paris and New York that channeled their leftist energies into the aesthetic torrents of the day. In the Communist world, artists embraced a similar activity several years later, mainly after the shock and disillusion of 1968. After the violence of the Prague reform, the cold war began, and no one could predict how long it would last. Not surprisingly, the new negativist strategies were realized in Moscow and Leningrad with biting social and political sarcasm.

Viewed in this context, Plavinsky looked someway eccentric. He practiced some sort of cultural archaeology, and was a staunch adept of prehistoric art, medieval spirituality, Renaissance painting, and the musical

endeavors of Johann Sebastian Bach. Plavinsky could easily be mistaken for a partisan of conservative Eurasian philosophy, or some other ideology that was clearly inimical to modernism and modernization. The dust of centuries and the pathos of a museum or cultural archive of past cultures were hardly compatible with the pathos of the modernist revival. Still, the apostles and martyrs of the Russian underground readily tolerated in their own ranks such things as a commercial Surrealism served with a good deal of necrophilia — not to mention mystical visions of Orthodox saints, and scandalous anecdotal paintings, and an eroticism that had degenerated into pornography. So the "cultural historian" Dmitri Plavinsky was equally acceptable in this heterogeneous company. He aroused suspicion and antipathy in official powers, and this was the decisive factor.

Of course, official institutions had no doubts about his being an "alien." Plavinsky's genealogical studies in cultural history were dramatically incompatible with totalitarian ideology: what men believe to be the absolute truth and the only right order of things inevitably becomes the dust of centuries and the province of museums. The ideology of the Soviet State Communism, having positioned itself as the summit of cultural development, claimed the right to dispose of and to dominate the heritage of world culture — probably the most acute symptom of debility in this ideology. Imagine a rather dumb and obtuse patriotic regime that claims it commands the spiritual reserves of humanity! Its reaction to a philosophically questioning art whose subject is the life and death of cultures (without trying to dominate them) could hardly have been other than negative. Plavinsky has had to feel this on his own skin. In his work, the artist made it quite clear that if somebody or something is a master of values, symbols and languages of culture, this is not any power system of any given state.

Plavinsky dealt with such powers as nature and history, creation and destruction, man and chaos. States, religions, ideologies, epochs were but small coin in this play of titanic forces. How could such an artist be welcomed by the capricious, intolerant political power of the Soviets? This system was attuned only to new fairy tales of its presumed immortality. What could it make of an impertinent artist like Plavinsky, who demonstrated that there were systems in the past, and epochs in history, that were probably richer and more productive — and yet nothing is left of them except a few relics and residual tracks in the sand of time?

An air of stoicism was always assumed in this peculiar art, or projected onto it. Plavinsky's paintings and graphic works clearly stood against the museum-oriented, retrospective, and ideological "Socialist Realism" of the Soviet Academy of Fine Arts. The artist displayed his own version of archaeologism and retrospectivism — a militant version that contrasted sharply with the archness and obsequiousness of the official state art. In a sense, Plavinsky used the strategy of Soviet Communism to undermine the mythology of its own claims of historical legitimation. His work excluded ideology, but it encompassed the issue of the disappearance, death, and decay of cultural matter through time.

Needless to say, Plavinsky sought confirmation or legitimation in the distant past for any supervalue of the present, whether it is called reason, logic, justice, or morals. His early work dealt with the indisputable fact that civilizations, like people come and go. As William James indicated, truth is always plural. All human organizations and claims to a "higher sense" are therefore problematic. The truths of civilizations appear again and again; they wither, dissociate, and fall time and again. The endless spiral of this "come and go" is Plavinsky's favorite theme. This begs the question, should we, then, ascribe to his art some sort of pathos of the human and cultural endeavor?

After the Communist giant of the East decayed and fell, and proved to be yet one more "cultural archaeology" of the past, Plavinsky moved to New York, joining the heterogeneous community of Russian-born artists and critics there. His vision then gained new ground, and received additional impulses, without losing its magistral line or its impetus. Immigration has not led the former Moscow underground artist to create repetitions of some formula he has already found. Rather he continues to expand his investigations of the cultural roots and mythical beginnings of Europeans, Asians, and Americans. He has traveled to Greece to experience the enigma of the early Cretan and Mycenaen symbols and myths, and painted in 1994-95 several canvases representing the temple of Aphaia on the isle of Aegina — the archaic monument of religious architecture that belongs to the most revered relics of Western cultural genealogy. He, has also embarked, on new topics — for example, the cultural roots of the biblical Jewish tradition and that of the American Indian. In 1997-98 his works dealt with images and meanings found in, the historical cities of Italy, the Venetian series being at the center of his neoclassical studies.

The discourse of cultural genealogy, which was Plavinsky's shield and credo in Soviet imperial surroundings, is further being transformed on American soil. One can easily predict that his seemingly "civilizationist" vision and "multicultural" orientation will be integrated into the quasi-official ideology of American society, which cultivates political correctness toward ethnic, racial, sexual, and cultural minorities. Artists who immigrated to the West from the former Communist bloc often play the role of living arguments in favor of the pluralism and openness of Western civilization (which sanctions political correctness toward other cultures as long as they are ready to play their role in subordinating their interests to the dominant power institutions). An artist like Plavinsky would seem to be a good candidate for a place in this somewhat dubious category of a privileged second class. He is so enthusiastic about the genealogy of different symbols, myths, and cultures that journalists should be flocking to his door. Why not present the Muscovite artist to the rest of the world as a new Walt Whitman or, better still, as a Soros of cultures, who sings the vigor and energy of his

beloved new homeland, which has opened its doors to such ethnic minorities as Minoan Greeks, Scandinavian Vikings, Slavonic pagans, biblical Jews, early Christians, and the ancient shamans of Machu Picchu, or Mannahatta, now called Manhattan? Do they not all come together at last in New York to feast on the final potlatch of the long and martyr-like history of mankind? For more than a century, enthusiasts of so-called Americanism have been pointing out that Providence itself chose the New World in order to overcome the deadlock that faced previous civilizations. America has never had a dictator or, properly speaking, privileged social classes although its history of slavery and racial discrimination cannot be denied. Here, millionaires come from the ranks of the poor, and everybody has his chance. What better place, then, to create a new synthesis of world cultures encompassing all languages and religions, all colors and worldviews?

Perhaps we should take a closer look at what Plavinsky's art really means. Works of art have a life of their own, and they can convey messages that the artist himself may not have envisaged. What is the artist trying to say when he displays, again and again, signs and writings, relics and wrecks of cultural meanings? Is he trying to tell that we should be more reverential toward the cultural substrata of civilizations? Or is he saying that everything on earth inevitably dies and turns to ashes? Or is there another, deeper message?

In Plavinsky's etching from his Moscow period, *Viking Ship* (1976), we see a carpet of wildly blossoming flora (the kind of orgiastically vital landscape that often appears in his work), which make a framing for a strange configuration in the middle of the composition, reminding us of the decayed remains of a very primitive ship, but equally having some vague geological or biomorphic implications. This uncanny ghost figure may be a vision of a primordial beast, a rock, or a ship. This multivalence is a typical feature of Plavinsky's visions of ancient cultures. As a rule, his work evokes not only cultural meaning but also feelings and intuitions concerning the universe and what Emerson called "the domicile of Mother Nature."

The artist may appear to be more explicit about what he means in his later variations on this naval theme made in New York. Both *Lost Ship* (1995) and *Mirage in Aegean Sea* (1995) revive what we already know from the ghostly image of the earlier Moscow etching. Both later works seem to be "clearer" and more readable, and not only because they are executed in a more monumental format, as well as using a mixed media technique. Plavinsky obviously wanted to define more precisely what he had to say in his New York canvases; the biomorphic and mineral implications fall away, and we observe the unmistakable body of an ancient ship.

The "archaeological" object, or fantasy, is clearly different from natural phenomena (sea, landscape, flora). But the ghost sent or left by a sunken civilization is on the verge of waning: it seems not to be substantial, as if it were going to dissolve into thin air before our eyes. This time the characteristic impression of instability

and transience (non-eternity) of the cultural substance stems not so much from universal elements and forces as from the language of culture itself. The surface of Plavinsky's paintings carries inscriptions and/or musical notes that obviously belong to later chronological strata. (Several inscriptions seem themselves to have been semi-effaced by time and history, and musical notes equally seem to melt into thin air). In this way, the movement of time itself leaves traces in the layered structure of these paintings.

Writings and "texts" executed in hermetic "letters of high culture", especially musical notations, are given a rich and fruitful perspective in Plavinsky's work. This is something of an obsession of his — evoking natural phenomena through a cultural tissue, or, vice versa, signs, or scriptures made transparent across the surface of mineral, floral, or animal form. His American paintings of the nineties (before he traveled to Greece in 1994 to be overwhelmed by the crystalline Pythagorean magic of the Mediterranean) evolved such a theme. Further, he makes us hesitate about what we really see. Are these objects products of cultural activity or the results of natural forces? This is seen in *Sheep Skin with Khlebnikov's Poetry* (1991), which shows a seemingly ancient cultural object, the skin of a domesticated animal, with the half-effaced letters of a deliberately primitive Greek or Slavic alphabet. The allusion to Velimir Khlebnikov, who created most of his magic verses and "incantations" between 1910 and 1920, is highly meaningful. Khlebnikov's conception of a "universal language" for all living beings, using the sounds and syllables of nature to convey the "planetary" message of the coming unity of culture and nature, served as a starting point for the early American phase of Plavinsky's work.

Is Plavinsky a believer in human culture and its supremacy? Or is he a skeptical observer of the heroic and hopeless repetition of the same cultural efforts that lead nowhere? In fact, an interpretation depends on the viewer, as is true of many postmodern artworks, which can be seen as cynical as well as idealistic.

After Plavinsky's arrival in New York he produced, in 1991-92, exclusively "magic" objects and paintings on natural forms and cultural signs. The *Golden Disc* (1991) is a spiral composition in which the lower forms of life as well as galactic configurations are reproduced, along with musical notes — i.e., conventional writing of organized, harmonious sounds. *Golden Tortoise* (1991) is an object of nature, but its geometry implies that humans have mathematical imperative that they, in turn, have projected upon the universe.

Decades ago, the Surrealist movement praised the "paranoidal" ability of artists to unite discordant things, not to see the "real" thing or to recognize two or more images in a single visual figure. This idea that something is not only what it is but can be seen as something entirely different is one of the cherished notions of the intellectualist conceptual trend present in Western art since the sixties, and supported by several influential Western thinkers of the twentieth century.

Plavinsky experimented with this kind of seeing in two large paintings completed in 1992 and 1994, *Manhattan Fish* and *Manhattan Ghost*. Both compositions result from superimposing the map of Manhattan onto the figure of a primeval living being — the dragonlike coelacanth fish. One can read the painting as the imprint civilization has made on the surface of the globe — the huge body of a megapolis; but equally compelling is the presence of the primitive beast, living in the depths of the ocean long before the unruly biped anthropoids dared to transform the face of the planet by the sheer force of their logocentric ratio. Tracks left by the progression of prehuman Nature, on the one hand, coincide with those left by a highly developed civilization. This is the philosophical keystone of Plavinsky's work, and it continues to have an exceptional importance for him.

One can only guess at what the artist had in mind when he produced this image of the bilateral superimposition of the two rivals and protagonists, Culture and Nature. But the fact that an artist deals with this kind of philosophical binomial in a painting is hardly surprising. Looking at the artistic developments of East and West, one cannot help noting the constant interest this complex interplay of natural and cultural attributes sparks. Such is the core topic of the modern mentality. Philosophy and literature devote an enormous amount of attention to the problem of a developed civilization devolves into chaos again, or perhaps into an essentially sublimated form of precultural powers.

A twofold reading of such artworks is unavoidable, independently of whether we want to associate them with a relativist (deconstructivist) philosophy or with more positive thinking. Of course, this also tells us something about the ethos of preserving cultural signals from a distant past. However, as explicit and insistent as this conservative ideology may be, we can at the same time experience the *impossibility* of a *preservation* of firm values (things, monuments, messages, writings, symbols) in the flow of time, in the pulsations of life, under the impact of such universal corrosive agents as water, air, geological forces, biological energies, forgetfulness, dissipation, and, in the final analysis, **entropy**. This is a key word indeed.

I think that Plavinsky's art addresses entropy both as a problem that must be dealt with and as an observation — devoid of any illusions — of destruction, destabilization, and chaos. Can organized, harmonious, human, cultural structures and constellations (architecture, tools, texts, sacral symbols, etc.) survive at all in the Heraclitean flow of time and transformation? There is no affirmative answer to this question, but, on the other hand, no pessimistic resignation is present in what we see, either.

We should laugh when we read critical phrases about how Plavinsky rescues the cultural memory from oblivion — phrases that smack of a governmental report on the elevation of an artist to an honorable order.

Equally senseless, however, are traditional banalities about how the philosophical artist demonstrates the futility of human existence. This is the stock response of civilized people to a philosophically intense work of art; they ascribe to the art their own one-dimensionality.

A philosophically predisposed art has little interest in telling us how strong and triumphant the human spirit is, or how imperishable a culture may be. There are no imperishable cultures, and the human spirit has its own destructive potential. Though, a thinker is not he who reminds us of the debility and frailty of man and culture in the quicksand of time, in the abyss of Being. Philosophical minds have very little truck with the platitudes of mass culture and the stereotypes of religion and ideology.

The philosophy of modern times first of all cares for the idea about the ambiguity of thinking and the hidden rear plan of culture. The central problem of thinking since Marx, Freud, and Nietzsche is the shocking discovery that human values (ideas, norms, language, conscience, mind) are built of material that is too alien for humans to be reconciled with. *Our* values are spun out of the raw material of the *other* – what we used to call delirium, subconsciousness, absurd, ideology, or the will to power. Be it good or bad, thinking is now suspect, and to formulate the supposition that behind our thinking itself is something *other* – that is something we humans can neither call nor describe; we have no adequate words for this, and no way to overcome taboos and barriers. This is why Paul Ricoeur has given modern thinkers the title of "masters of supposition".

Cultural heroes (politicians, artists, thinkers) erect the edifice of culture using building material that was extracted from the "great delirium of the Universe," beyond any reason, morality, or memory. *Our* values defend us against the aggression of the *other*, but the instrument of self-identification is borrowed from the *other* side.

A cultural hero – the key figure of civilization – is an agent who produces new realities of culture with the help of the unknown and the unknowable, practicing insight, trance, naïveté (down to deliberate idiocy), and the breaking of taboos. Making unpermitted things, and erasing the frames given by culture, an artistic individual (as well as a political champion or a giant of scientific thought), in fact, effectuates a vindication of the narcissistic postulate of the given culture – the principle of active selfadoring. I break and refuse; I forget and get out of what is normal because I dare to do so. Here, the extrahuman "great delirium of the Universe" (the realities of a being totally incommensurable with the measures and notions of people) meets the humanist syndrome of civilization, or the pride of Apelles, who has found an unbelievably expressive line never before seen or thought.

Double agents work for two sides – otherwise they would not be double agents. Politicians commit a lot of

what is called "crimes against humanity" in order to achieve some hypothetically moral and reasonable goal. Artists find ideas, words, forms, sounds that should have been excluded from cultural circulation altogether. Magic, trance, the absurd, sacrilege, monstrous insights, and fantasies as well as other factors and energies of a biocosmic nature are easily discernible in the art of antiquity, the Middle Ages, and modernity. Such are the helpers and collaborators of the emerging human (and humanist) civilization. The fact is that these workers and helpers constantly assume missions that should be excluded and forbidden in the framework of civilization. Cultural heroes used to break the confines of their cultural commission.

The case in point is not only the monstrous imagery of Bosch, Goya, and de Sade. If we look at the art and literature of the greatest masters of the European humanist civilization, we will recognize that the most essential question posed by Shakespeare, Goethe, and Pushkin is probably the question of the extent to which the *other* reality (the tabooed, humanly unacceptable one) is present in human life, how it helps to build up culture, reason, morality, government, law, and collective wisdom. (Among other things, this seems to be the sense of Shakespeare's *The Tempest*, and Goethe's *Faust*.) In terms of cultural anthropology, cultural heroes are numinous figures; that is, they mediate between what is excluded from human life or cannot be accepted among people (in their language) at all, on the one hand, and what forms human values, patterns of cultural behavior, and communication, on the other hand.

Contemplating Plavinsky's paintings and objects, we should recognize some sort of drama — a mythical eternal struggle between the human order of things and words, on the one hand (the discourse of Culture incorporated in linguistic or musical notations), and the power of the *other* namely, the alldiffusing and all-effacing flow of time, on the other. This is a contest with a forever-uncertain outcome.

Plavinsky's "philosophy of history" arrived at a very clear formula in the drawings, paintings, and installations dedicated to the antiquity that came to life after his trip to Greece in 1994. Of course, these retrospective dreams and visions are not just about the survival and triumph of the fundamentals of Western civilization, as a superficial observer may deduce. Neither should we see them as apocalyptic prophecies of death and decay. They are about the problem of survival. That is to say, there are no optimistic promises or fatal prognoses. Nothing can be taken for granted, neither salvation from time and entropy nor a definite failure of culture and man. No relief, no tragedy is a case in point. **Hope never dies; entropy never stops.** This way of seeing things is sometimes called "epic." Americans know it from the "natural philosophy" of Walt Whitman; Russians get it from the novels of Leo Tolstoy, which are imbued with a fatalistic and epic historicism. (Or maybe in Russia real life obliterates any philosophy at all because the terrible entropy of life is open

to anybody, but great hopes still exist.) Plavinsky's paintings and installations of the nineties tell us that human societies and cultures try again and again to impose themselves and their measure on the universe. They cannot succeed once and for all, but they never give up.

Some of Plavinsky's works in the "antique" series resort to a famous technique, introduced years ago by Max Ernst, that verges on absence. In these works (*Sanctuary of Knossos' Palace*, 1994; *Demethra*, 1994) Plavinsky evokes some clearly recognizable structural units, largely having the pronounced characteristics of classical architecture or sculpture. But the structural order and reasonable logic of these cultural strongholds dissolve before our very eyes. In Plavinsky's vision, the order of culture is becomes amorphous, flowing, unstable. In its place, chaotic masses — rocks, stones, water, and vegetation — loom large.

The two side panels of the big *Knossos* installation (1995), significantly named *Hurricane of Time*, illustrate in the most consequential manner this idea of an irrational and chaotic nature, overpowering the perfect order of human culture. The central panel, though, reinstates the balance of forces. The human *Culture*, on the one hand, and the uncontrollable, destructive, and vital *Nature*, on the other, are locked in eternal competition.

Allusions to primordial shamanistic rites and objects dealing with intuitions of chaos and magic participation in the domicile of Mother Nature was anything but news in the nineties. Some kind of a "Re--Enchantment of Art" (Suzy Gablik) aiming at a revival of extra-human impulses periodically makes its reappearance in the history of modern and contemporary art. Artists are tempted to display the seductive Utopia of natural forces (the biological, cosmic, psychic ones), which are seemingly alien to any form of ratio or morality, but are dependent on refined intellectual strategies, such as Freudian libido, the "nomadic" theory of meaning, or "rhizomatic" ideas of life and societal forms as well as cognition. Deleuze's "rhizom", Derrida's "difference" and "indecidables", together with other formulae of postmodernism, are just ways of organizing cultural systems (texts) to bring the latter as close as possible to fallibility and disorder, to Emerson's "endeavor to change and to flow." No language or notion could be more suitable as a description of Plavinsky's images.

In 1997-98, Plavinsky devoted his efforts to the Italian cycle, first to paintings, watercolors, and objects dedicated to the popular theme of Venice — the miraculous city on the Adriatic Sea, the original mixture of East and West, of the ancient cultural memory and the careless everyday life so typical of Italy.

Studying the middle-size, such as *Venetian Secrets* (1997), *Bridge of Sighs* (1998) and, in particular, the cycle of cityscapes inspired by *The Four Seasons* of Antonio Vivaldi, the viewer may be surprised to find that the usual agents and forces of natural entropy are entirely absent from these works. The city, which since its birth has been confronted with the presence of water, seems to be fully purged of all natural elements. Here,

water and air, light and stone do not promise any uncontrollable whims or ploys that can take man by surprise. Channels and palaces are encompassed by nets and crystallic structures of precise correctness. No plants, sands, clouds, or crumbling stones remind the viewer of the universal power of the all-devouring time. Man, culture, and society hold life in complete control. That is to say, they love the idea of having that much power.

As if this alleged victory over destruction, time, and nature weren't enough, the artist fills all possible surfaces and facets with musical notes from Vivaldi's work, as well as blueprints of electronic devices — some sort of endlessly reproduced symbol of computer chips. Symbols concerning the old Vivaldi epoch and the scripture of the new virtual culture grow through or cover anything that will support them — bridges, palaces, riversides; the all-pervading *ecriture* even shows through reflections of sunlight and the mirror effects of water. The odd Venice of Plavinsky seems to consist not of material substances (stone and water) but, rather, of musical notes and computer symbols.

Actually, these signs of the ancient and newest culture (the humanist culture of Vivaldi and posthumanist high-tech surroundings) take over the role of the absurd, unbelievable, and uncontrollable factors and forces that once belonged to nature — biological life, aerial elements, water, and minerals. Now, at last, natural forces have abdicated. Moving across channels, bridges, porticos, the sites of Venice, the artist sees exclusively the essence of cultural substance grown thick and all-pervading. All other substances have seemingly been driven away by human signs and symbols, writings and notes. Nothing else is left. We see neither marine horizons nor dirty and chaotic corners nor the luxurious beaches of Lido nor the parks and lawns two stations down from San Marco, where the charmingly odd pavilions of the artistic Biennale are situated. All the contingency and chaos of material reality have disappeared. The magic delirium of the universe is gone. All that is left is the strict order of the signs and symbols of culture — the traditional as well as the new.

The paradoxical fact is that these scriptural fixations of both musical phrases and electronic chains and processes have thickened so much, and become so pervasive, that they have actually replaced the magical irrationality of living life, expanding matter, restless energy, and all devouring time. Signs and letters are on the offensive, like grass and bush in the old etching of 1976, like sand and rocks, like old timber and decaying leather, like the smells of the God-forgotten corners of Venice, Moscow, or New York.

So, a second nature has completely replaced the first one. Both humanists and engineers have occupied our reality with their productions. The ancient cultural Venice has finally lost its water and stone altogether. As depicted by Plavinsky, the city consists of a concentrated energy that has been compressed into letters, writings, signs, and supersigns. Students of cultural anthropology would probably apply the term "cultural overload" to this effect. It means that beneath the layers and swells of ideas, meanings, and values embodied

in signs and letters, there is no memory of immediate, direct feelings; of real things and material realities.

How, exactly, does a sun-beaten old stone smell? What is the feeling of an old wet bar on a Venetian boat station if one lies back against it? Looking at paintings of old Venetian cityscape painters, we could guess about this — but not before Plavinsky's Venetian visions. In his paintings, the old stones of palaces and the old timber of boat stations are probably spun from a transformed mental energy and spiritual waves, symbolized by musical notes and the geometric ornaments of computer schemes. In fact, we are dealing with a transformed reality. A new magic of the universe has taken the place of the old one. Before, in the former epoch, we were moved and excited with strange and mysterious consonances and analogies of light and sound, life and death, I and non-I. People of the natural past have construed their arts and their philosophies on these primary lines of experience. Now we have different experiences, and people are absorbed by other transformations and magic tricks.

They ask why their electronic chips are so similar to Vivaldi's musical notes, what makes palace constructions and church facades so analogous to electric chains and graphically fixed electromagnetic signals. Electronic details acquire a mythical similarity to old timber half-eaten by seawater, and to the marble facades, winds, and solar rays of a Mediterranean city.

The eye and the mind of civilized bipeds are lost in cultural archives and the labyrinths of technology. More than a hundred years ago, Baudelaire and Nietzsche devined that culture would turn itself into a simile of tropical forest, ocean depth, or geological processes; that culture would at last substitute the life energy of living organisms, and events inside the cultural substance would come closer and closer to the overloading, irrational, immoral processes found in nature.

When the process of cultural saturation reaches its full fruition, the culturally transformed surroundings, full of communications and services (including modern museums, touristically adjusted historical cities, etc.), loses its formerly anthropean character. Contacts take place not as human-to-human relations but as impersonal global forces, organizing masses of impersonal beings to travel from Asia to Europe, from Europe to Asia, and from North America everywhere. Culture, including technology, turns out a kind of cosmic energy, like the energy that gives life to seas, forests, mountains, and prairies. We can see in culture a degree of repetition and predictability that is comparable to what we observe in seasonal changes; a degree of wonder, as in a rainbow; and a degree of madness, nightmare, and unpredictability, as in an epidemic, a forest fire, or an earthquake.

The Second Nature eventually grew as unlimited and as complicated as all the things that people incorporated in to it, inevitably embracing again the old magic and shamanistic relation to the outer world. We learn

that things like airplanes, telephones, missiles, and TV transmitters, as well as museums, concert halls, newspapers, the Internet, governments, big stores, police stations, and other cultural constructs are made or organized by reasonable and moral beings for a reasonable and moral organization of real existence. But this abstract knowledge finds no immediate confirmation on the level of life and experience. Actually, one cannot soberly and reasonably deal with something that is more than 99 percent unknown and hidden from understanding.

People simply believe or have trust in the fact that ideas, symphonies, architectural buildings, constitutions, lavatories, airports, and the rest of what they live in are made logically, technologically, and reasonably, and that everything serves justice and humanness. But only rare individuals really know from stem to stern how a car works, what the word *cantabile* means, what exactly somebody named Giotto painted, in which direction signals travel from a satellite to an antenna, or the nature of the mechanism of municipal or parliamentary vote. The rest just believe or have to trust. They can never verify what they believe in. In fact, their relation to the Second Nature hardly differs from the relation of their ancestors to spirits, animal totems, or the dead souls of their forefathers.

At this point, we can gather that we have something to add to the legacies of Marx, Nietzsche, and Freud. Obviously, it is alluded to by declaring that the substance of culture (the rational and moral fabric of thinking, language, and the plastic creations of humans) consists of fibers borrowed from an extra-human and noncultural dimension. Furthermore, than that: even if we decide to put an end to our fashionable deconstruction methods and critique of culture, and return to a state of militant humanism and technological pathos, we will one day see that our thinking, speech, and art are indebted to myth, magic incantation, and other primitive practices. In the crucial points of concentration, all kinds of culture (both the humanist version and the rational supertechnology) tend to become transformed into a new chaos, a spectacle of contingent plays, a redundant flow of uncontrollable universe.

The weird finale of cultural saturation is the theme of the last works by Dmitri Plavinsky. They sum up four dramatic and fruitful decades of his artistic trajectory. In the context of the Big History, they mark the end of the second millennium of the Christian calendar. The themes and problems of the Russian-born artist cannot be called unique. One should, instead, call them characteristic and symptomatic. The second half of the twentieth century has produced several remarkable artistic proposals in Europe and America, which have dramatically widened the horizons of art viewer. Cultural history and technology belong to the crucial points in artworks by Joseph Beuys, Sigmar Polke, and Bruce Naumann. As for Plavinsky, his treatment is marked by a specific purity of experimental means, as well as by a fanatic tenacity in working on this theme from the

time of his etchings of the sixties and the seventies to his pictures and installations of the nineties.

An essential result of his philosophically artistic efforts materialized in 1998 as the three meter-high installation called *Cathedral*. Not only does this composition subsume the preceding course of Plavinsky's archaeological studies but the artist tries to bring together, in one material object, at least four levels of anthropean culture: the idea of a religious cult, architectural construction, the metaphorical rendering of music, and modern technology. At this crossroads of cultural meanings, several typical motives again make their appearance: a church facade, a musical organ with its tubes, and an altar composition provided with two ancient symbols of morals and aesthetics, as well as knowledge and irony — a skull and a mask. The surface of the architectural construction is made of a synthetic material that corresponds to the geometric order of vertical tubes.

Here, as in his other late works, Plavinsky demonstrates a surplus of the cultural productions of mankind in the course of his historic development, from the primordial sacrificial table to the high-tech inventions of the second millennium. The notorious cultural overload becomes some kind of obsession, and grows to a disturbing scale. Here we have not a painting but a big spatial composition of a symmetrical structure, built of allegedly hard and eternal materials. (*Cathedral* is built mainly of wood, cardboard, and other temporary materials, but Plavinsky aims at the effect of precision and technological perfection.) The summa of religion, art, and technology is mirrored in the special reflecting plinth at the foot of the composition, and so the entire body is visually repeated below. The Second Nature presented in this concentrated form is cool, perfect, correct, and inexorable.

As is well known, any surplus can result in its opposition. We face a sanctuary of superculture, the temple of mind, work, ingenuity, technology. As is also well known, this is a virtual haven of burgeoning psychoses, uncontrollable events, technogenic catastrophes, nonsense, and the absurd. The formerly free Heraclitean universe of chance and play has been captured and disciplined by mathematics and music, by engineering and humanization. But, as a result of this process of civilization, symptoms of entropy appear at the summit of cultural organization.

And so the viewer can contemplate the strange *Cathedral*, which shows a stupefying similarity to an old sacrificial hut, a construction of poles, skins, skulls and masks. Such were the prime installations of prehumans, who believed in the First Nature, and followed it in their magical and shamanistic practices, and slowly, almost imperceptibly prepared themselves to erect the Second Nature, which, as they hoped for so long, will be the creation of man, and never betray him.

Alexander Jakimovich

THEME AND TECHNIQUES IN THE GRAPHIC ART
OF DMITRI PLAVINSKY

The graphic heritage of Dmitri Plavinsky has a history of more than four decades. It consists of a few hundred meticulously complex drawings in all techniques known to the history of art; more than sixty etchings in which, on the basis of classic achievements, he found a new expressiveness in this technique; as well as studies in the realm of collage and text. In this, he discovered the possibility of graphically transforming a text into a rhythm. This story started at the time of rampaging abstraction, went through pop and conceptual art, passed Postmodernism, and has now acquired an entirely new and unanticipated perspective. His themes have been the life of nature and that of lost civilizations, the scrutiny of prehistoric fishes, and the rhythms of the notes in music. The ancient nature of the stones of Israel will constitute his next major step.

In 1963, at the peak of fashionable abstractionism, when the country's entire artistic force was preoccupied with this trend, Plavinsky (who had also paid homage to it in his paintings) went to village, where he produced a series of drawings and monotypes that called *Book of Grass*. Leaf by leaf, he made imprints of ferns, burdocks, and herbs with even and jagged contours – the ones that resemble a solid black stain and, by contrast, those that recall a network of the finest filaments on white sheets of watercolor paper. Simultaneously, he produced the "descriptions." With the finest pen and diluted, barely visible ink, he rendered clusters of leaves and entire portions of a meadow in bloom. Instead of pressure application and chiaroscuro, what we see here is the tension of prolonged lines, the density of small jagged areas, and the balance between this density of depiction and an untouched background. Every detail has been captured: each blade of grass and each thorn. Thus the copied text of nature represents the distinct and living unified whole: infinitely small, yet exceedingly great. This phenomenon, strictly speaking, constitutes something totally incomprehensible from the point of view of the new art. Indeed, Plavinsky's artist friends (those who were captivated by abstractionism) came to the unanimous conclusion that he must have lost his mind. In reality, however, it was the impressions and drawings of *Book of Grass* that, ultimately, shaped Dmitri Plavinsky's future as an artist. It consists of the drawing, unemotional and objective in every detail, and the unpredictable effect of spontaneous gestures (imprints, spatters, deep pickling, glazing, crackelure, etc.) In *Book of Grass*, Plavinsky defines his specific optics and his specific hearing, both of which allow him to describe, simultaneously on the micro and the macro scale, the whispers of grass and the echoes of the big bang that engendered the universe. Later, this technique resurfaced in many wonderful etchings, such as *Small Leaf* (1970) and *Crystals* (1969), where we seem to hear the very sound of growth, invisible though it is to the eye.

It was also in the sixties that the artist began to do large-scale, painstaking drawings whose dimensions often amount to a meter or more. The tonal range of these drawings is remarkably developed. Besides his natural feel for tone, density, and weight, the artist's upbringing must have played a significant role here.

Plavinsky received his initial artistic training from three volumes of art history by Gnedich, a luxury turn-of--the century edition with engraved and phototype illustrations from which he made color copies of the paintings. At that time, his eye gradually learned to judge the depth of color by the thickness of a line and the black-and-white range of a phototype.

Objects of Plavinsky's graphic works coincide, as a rule, with the ones that he explores in his paintings and models in his installations. However, curious objects find their way into his graphic art more often than into his paintings. In his Notebooks of 1960 Plavinsky wrote: "I looked through an album of drawings by Dürer. Wonder is the first stage of perceiving nature. A child's love for the exotic: a walrus, a crab, a rhinoceros." Plavinsky has many such wonders. They are extinct in their appearance: a colossal candle in a monastery church, an eerie blowtorch, a tool box on a distant railway station. In his numerous journeys through Russia, Plavinsky sketched motifs for his future large-scale paintings in sketchbooks and even on etching plates, in the manner of the old Dutch masters. These travel notes are distinguished from their kind by the incredible harshness of line. The lines are not fine, tentative experiments marked by gradual accumulation but trenches bored with a heavy pencil. Usually, it is sculptors and children who draw like this: they have to overcome the immense resistance of the material, and yet they are confident of the result.

The early sixties were marked for Plavinsky by studies of engraving technique and theory; he even composed a table of all known engraving strokes. By the mid-sixties, he had completely mastered all the variations of etching, easily combining them with collage and linoleum engraving. The techniques that he mastered are drypoint, aquatint, deep etching, and soft ground etching. For a prolonged period, etching became a predominant technique in Plavinsky's art. Virtually complete sets of these prints are now in the collections of the State Pushkin Fine Arts Museum (Moscow), the State Tretiakov Gallery (Moscow), and Jane Voorhees Zimmerli Art Museum at Rutgers University (USA); individual prints can be found at the State Russian Museum (St. Petersburg), New York Public Library, and other collections. The artist sees the essence of creation through etching as a unity of set objectives, which is accomplished by various techniques (painting, drawing, etching, and installation). In etching, "in order to achieve a painterly effect of form modeling, texture, light and shade, an artist needs to find the technique." (From the Notebooks.) Plavinsky's prints contain a conflict in the very mechanics of their creation: the resistance of metal, the violence of the chisel, and the corrosive quality of acid. The result of this conflict lies in the lightspace structure of a print. These etchings are exemplified by *Big Tree and a Moon* (1972), in which copious bites virtually squeeze light out of metal, and *Chinese Landscape* (1969), where, by contrast, a fine drawing emerges in the even and clear light that is slightly accentuated by "drops" of aquatint as if by dewdrops before dawn. In his etching, Plavinsky

employed so deep a pickling that the relief character of a print became one of the most important aspects of his work. Such etched plates as *Cosmic Leaf* (1975) look not like a drawing scratched on metal but, rather, like an organic formation: a mold or an imprint that was left in the melted metal that had been accidentally spilled on Earth.

The seventies and the early eighties were marked by the flourishing of tone drawing in the art of Dmitri Plavinsky. An example of this is the drawing *Moonlight* (1980), in which house stands in ruins amid overgrown fields, the rafters of its caved-in roof thrust into the sky like the carcass of a ship or that of a giant brontosaurus. The movement of space is created by a tornado of light in the form of needlelike hatches. It is not the house-ship but, rather, the effulgence that turns out to be the basis of this. These piercing rays — distant descendants of linear perspective — appear in many of Plavinsky's landscapes that are less luminous by far. The rays are similar to cosmic currents rendered visible; they suffuse a landscape that is earthy and frequently quite ordinary with a dynamic pulsation.

Occasionally, the function of cross-hatching has an audible nature, rather than a physical-molecular one. In the cityscape *A View from the Window on Moscow Side-Street* (1970), the divisions into sky, trees, and land are superimposed into a kind of general throbbing or fading pulse by fetters of the branches. Contours are deliberately vague. The drawing is based only on the scintillation of hatches in different directions. Here, the glimmering grisaille of a Moscow courtyard becomes the fragile vacillation of a poem or a musical theme.

Even though the artist frequently depicts the same themes in his paintings and in his graphic works, it is in the latter that we observe harsher approaches that require an absolute manifestation of all layers. Here, regardless of the technique, the principles of etching prevail: each line remains visible, in any event. Line is defined by Plavinsky as the trajectory of a point that moves in space; as an object — a material length in space, for instance, a wire, a thread, etc. This line-object can belong to any epoch or culture, depending upon what is needed. In this way, the artist had been developing, over many years, three totally different themes: the Village, the Orient, and Christianity.

Plavinsky likes to have some sort of initial material. This role could be played by a textual collage, the contour of a map, or a totally abstract imprint of crumpled cloth, which provides a cubist with something that grows, with the help of pen or a brush, the shell of a specific object. This can be seen in the drawing *Telavi* (1982), or in the etching *Abandoned City Machu Picchu* (1978). The contextual part of the work wholly corresponds to the technical principle. In one solid metaphor, Plavinsky unites a mountain mass and the archaeological plan of a city. In the root of an emerging element, he puts a reasoning structure. The cosmic creation and the human creation turn out to be the results of applying the same force, only moving in different

directions. And, in this case, it is not particularly important what gets produced first. In the drawing *Tree* (1983), the structure of branches was laid out first and then the artist unleashed, shaped, confused, and dissected the calligraphy of abstract imprints that destroyed the drawing but created the work of art. In the drawing *Paleographic Composition* (1966, Museum of Modern Art, New York), impressions of fabrics make up a text in much the same way printed letters would.

For two decades, in variously transformed series, Plavinsky used the motif of an image as if it were emerging on the pages of an ancient Arabic manuscript (this is from his Orient theme). The rhythmically beautiful background of these pages was not meant to be read, however. Quite the contrary: the body of exact meaning decayed, but the skeleton of the writing remained. By the very fact of its illegibility, it had to say more about the time that persists in transparency than any accessible and translated document. A curious incident that occurred confirms that everyone who sees a text accompanied by a picture knows, without any reading, that he is already familiar with its context. In the mid-eighties, in Moscow, a special committee was reviewing works of art that were earmarked for purchase by the collection of Deutsche Bank. The purchase was ultimately undermined, but even prior to that the committee "denied a visa" to a work by Plavinsky, which featured ancient Arabic writings on the ritual skull of a ram because it had been deemed an anti-Soviet appeal for Jews to emigrate from the USSR.

Soon after this incident, Plavinsky abandoned the ancient Orient and turned his attention to somewhat younger European civilizations. It was not the writing that turned out to be the pulse, microstructure, and code of this new focus but the sound. And now the foundations, background, and figures of the artist's paintings and drawings are made up of collages fashioned from sheet music. The theme that in the abstract sixties had sounded like the tempo of a succession of tempos in the form of spirals, and was then gradually transformed into the problem of rhythm and dynamics in the manuscripts and drawings of medieval cultures, has now approached its most manifest incarnation – music. The first work in the series is a portrait of the composer in the image of a medieval monk who is seen emerging from the scores of the composer's music *Dream of Igor Stravinsky*, 1983. The drawing is colored with pencils by way of hatching in different directions, following the same principle that was present in the artist's pen drawings of the preceding period. Color pencils provide the same transparency as watercolors, yet they are dry as pollen or the remains of old frescoes. This effect proved to be remarkably good for rendering the texture of ancient stones, beaten by wind and burned by the sun.

Drawings take up many months of work, and they are placed at the beginning of a series. They are often preceded by numerous minor sketches. In the process of their production, the artist completes the study of

an actual object — a fortress, a turtle, a skull — and the formation of a theme: whether it is the skeleton of a dead civilization, which comes to life high in the mountains in the precarious light of clouds, or a cosmic and heraldic structure suddenly perceived in the shell of a common turtle, or a mystical message from Pythagoras to infinitely remote descendants that came to us in the form of a scholarly theorem. As a result, the real object that is the basis of a drawing is transfigured into a synthetic message. Following his trip to Armenia in 1987, Plavinsky made a drawing in color pencils, *The Crosses of Armenia* (1987, Collection of Albert Rusanov). In this drawing, three crosses carved out of brownish Armenian tuff shoot off, one after another, into a distant perspective, which looks like the runway of a mountain airdrome. The artistic objective lay in the correct solution of a mindboggling foreshortening and an organic conjunction of the colors of the Fauves: a bright red in the light and a purple in the shadows. However, the events that exploded in Armenia only a year later — a gory war and an earthquake that completely destroyed several cities — brought trepidation to everyone who was familiar with those crosses.

All of these techniques — color pencils, monotype, collage, and pen drawing — were used by Plavinsky simultaneously in another famous drawing, *Manhattan Fish* (1992, Metropolitan Museum of Art, New York). Here, a map of the New York borough of Manhattan is seen as a huge submarine. The isle of Manhattan itself remains a giant fossil, however, the monstrous coelacanth fish. The fish-ship plays in rainbow colors and crumbles into whimsical details. It looks like old Russian lace. Yet, for all that, the drawing of this creature represents the web of streets and avenues of the real Manhattan. The drawing of Manhattan-fish marked the beginning of a series in which the City That Never Sleeps, a.k.a. the Big Apple, was seen in its newest and, at the same time, its most ancient hypostasis.

Plavinsky's art of the seventies also contained map drawings, but those were ancient maps of mountains and winding rivers that were colored by a knowledge of the history of a particular location. The map of New York turned out to be totally different — a mechanical web, canvas, structure-scheme. The impression of metallic firmness, rather than that of an organic softness of foundations, was authenticated and became enhanced with the passage of time. At the end of the nineties, computer schemes assumed the structural backgrounds of the artist's work. This technique soon embodied the general tendency of Plavinsky's work. From the sixties to the nineties, his art gradually acquired clarity in its themes, purity in color, and firmness in lines. An extinct object that glimmers somewhere through the thick layer of archaeological dust became an essential, concretized aspect of distant perspective. An implacable denial of the somewhat crooked Russian spirit and the "old" smokiness of glazings in Plavinsky's art marked the artist's achievement of complete artistic freedom and the acquisition of a new, monumental style. This style had been in the making dur-

ing his Moscow period at the end of the eighties, and it was introduced, in its entirety, to the international orbit in New York in the mid-nineties.

The theme of rethinking the life of European civilization that began in Moscow was continued in New York. In 1993-96, Plavinsky traveled to Greece and Italy — to the sources of European civilization. From those journeys, he made drawings that were uniquely free and exquisite in color. The Greek Cycle is done in color crayons, altogether without contours in ink or black inscriptions. The graphic nature of these pictures is based on the nerves of conelures, the settings of scripts, and the wind-beaten surface of marble. A stable sensation derived from the hatching of trajectories is transformed into the movement of the particles of primary elements. In Italy, the pulse of civilization is discovered by the artist not only in sheet music but also in graphic techniques. For all that, one is curiously amazed at the ease of Plavinsky's classical mastery of pen and brush.

In the sixties, marvelous collections of the world's graphic art were opened to the public at the Print Room of the Pushkin Museum. There, one could handle the famous Rembrandt and the far less known etching master Seghers, in addition to host of European drawings and a Japanese engraving. Plavinsky had mastered this material through meticulous copying years ago, but if he used it afterward, it was in concealed, latent forms. Now he quotes directly the dynamism of a brushstroke, the running of hatching, and the colorist richness of the drawings of old Italian masters. He draws his own Venetian cityscapes in the technique of such great artists as Canaletto and Guardi. Plavinsky actualizes with ease the arsenals that he absorbed in his youth, at the Print Room of the Pushkin Museum. Now, however, the old themes sound in an entirely different orchestration. A dark flower of decay — the thistle of the sixties — flourishes as a bright, colorful iris in the magic crystal of Florentine air.

In the system of new arts, there is a scheme that allows the viewer to see, from one distance, a certain picture and, from another, closer distance only a system of signs (hatches, dots, spots). Plavinsky used this discrepancy between the sign and the optic image a long time ago, but only recently, at the end of the nineties, did he discover an entirely new, unique rendition of it. The artist's European travels yielded such a huge photo material that the prints threatened to take over his entire living space of the artist's studio. And so, as a joke at first, but then in total earnestness, he picked up scissors, glue, and his photos. Combining them in pairs, as mirror images, then cutting and combining them again, Plavinsky created collages. The documentary photo material, arranged in this manner, works as a specific, thematically chromatic palette. A hidden symbolism of color is created by the existing reality. The history of tone is depicted in the tone itself, and there is no longer any doubt that "mountains of blue, decrepit glass"[1] originated in Venice, and that the one who

"came back, filled with time and space,"[2] is the man who grasped the essence of antiquity. The artist has already created convincing structures of gaping skies of Venice and a ship of Greek antiquity (*Paestum Vessel*, 1999). Oddly, details and entire landscapes, as well as altogether different photographs that match only in color or movement, add up an image of space as exact as it is in his paintings or large drawings. The photo- - collage *Church Organ* (1999) is composed of photographs of the bars, flues, and pipes of an old organ, of the documentary photos of assembling the installation *Cathedral (1998)*, of a view from the train in which the artist travels in New York, of textures of stones and stains of photographic umbrellas. As a result, the system of movement of color and light in the collage ascends through the structure of the organ, a musical instrument, to its music, spiritually lofty and beautiful.

Plavinsky has been making his photo-collages for less than a year, but one can already say that the advent of works fashioned from photographic modules represents an entirely natural continuation of the wonder of the year 1960, when a meticulous study of nature constituted the first stage of the artist's work.

Elizaveta Plavinskaya-Mikhailova

1 Osip Mandelshtam, *Tristia*, 1920.
2 Osip Mandelshtam, *The Eyesight of Wasps*. Translated by James Greene. Ohio: A Sandstone Book, Ohio State University Press, 1989, p. 53.

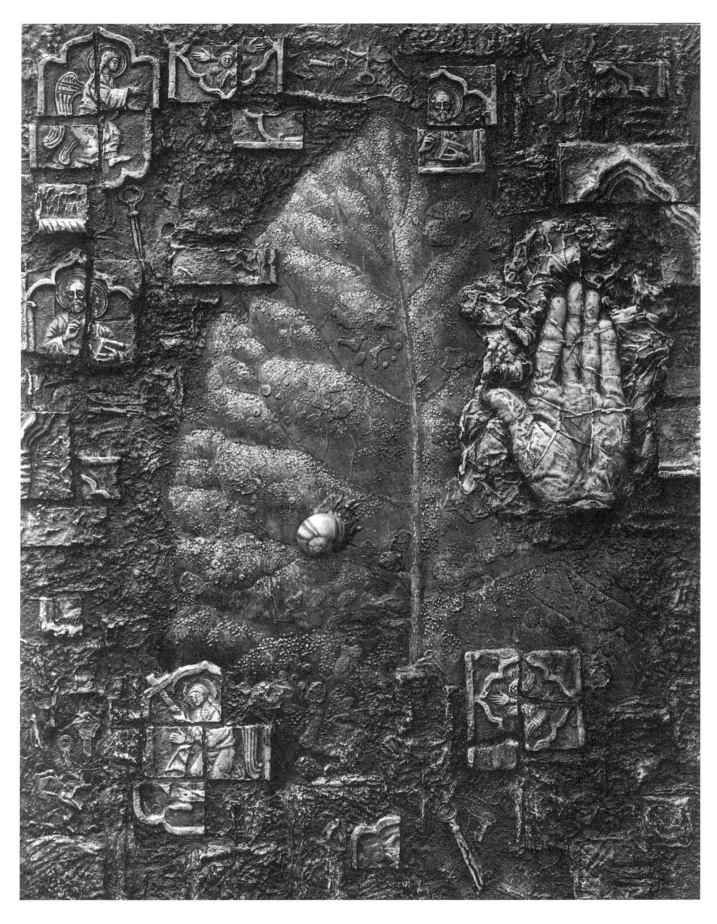

Dmitri Plavinsky, *Leaf in the Wall of Church*, 1974
Oil, polyvinylacetate tempera, collage on canvas, 39³/₈ x 31¹/₂ in. 100 x 80 cm
Private collection, Italy

PLATES

I. Canyon's Circles

There are the orbs of the worlds in space with ample room enough
& there are the orbs of souls also swimming in space
Each one composite in itself
And the spirit of God holding them together
The orbs as the suns & worlds swim in space,
But the Souls swim in the Spirit of God in greater space.

Walt Whitman, *Leaves of Grass.*

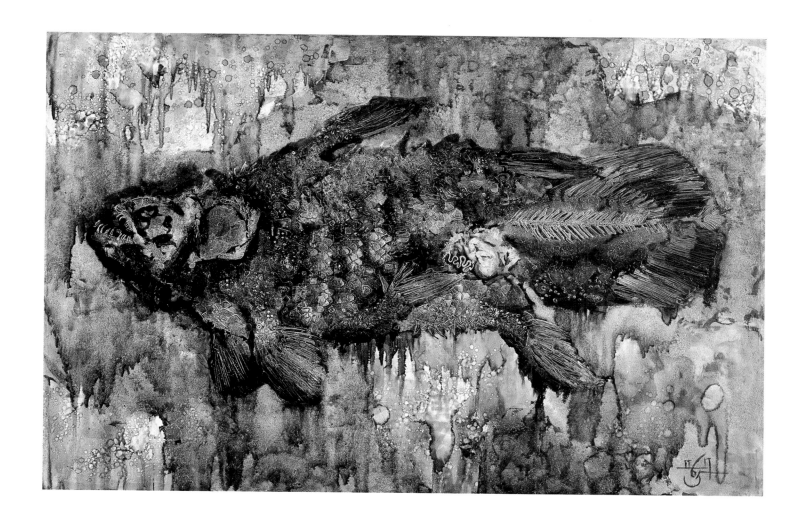

Coelacanth, 1965, Oil and synthetic polymer paint on canvas with small pieces of cardboard and wood shavings
beneath paint, 39³/₈ x 59¹/₈ in. 99.7 x 150.1 cm
The Museum of Modern Art, New York. Purchase
Photograph © 2000 The Museum of Modern Art, New York

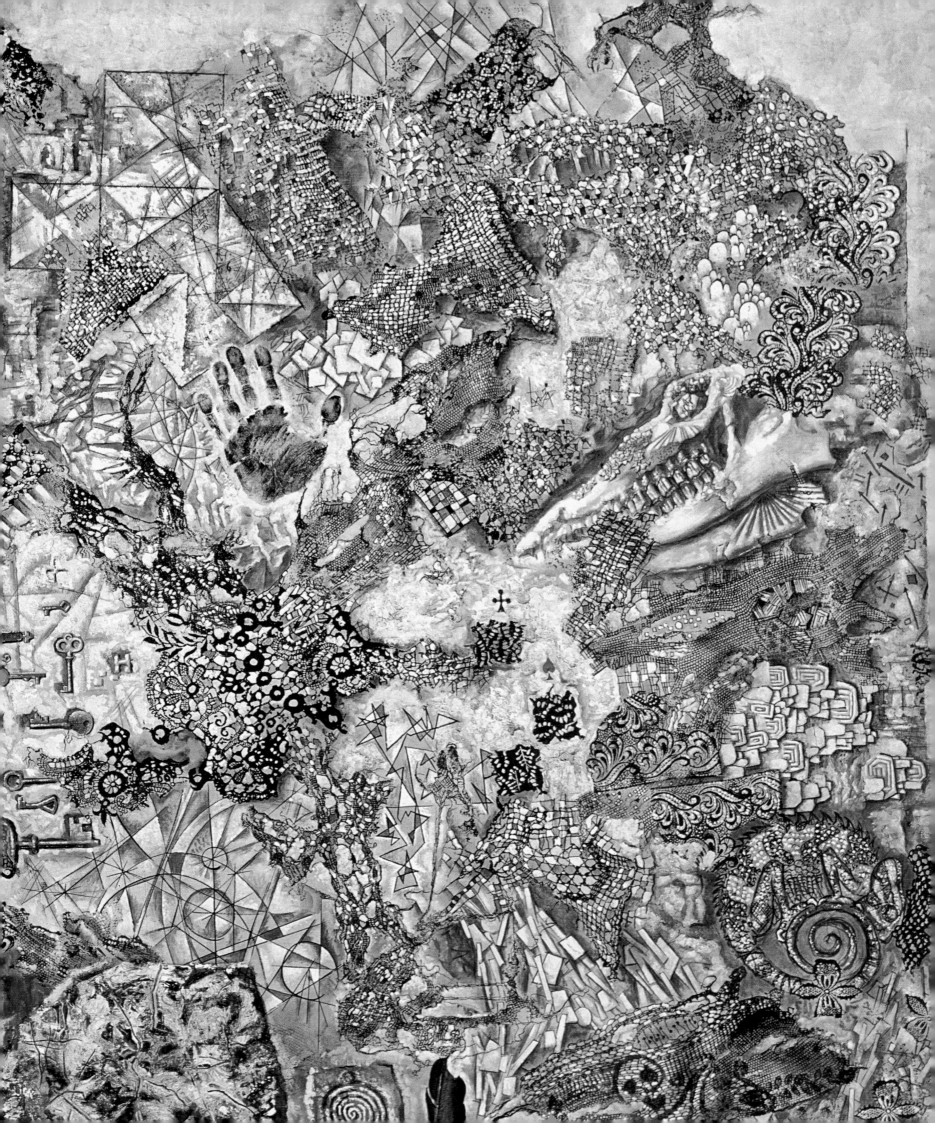

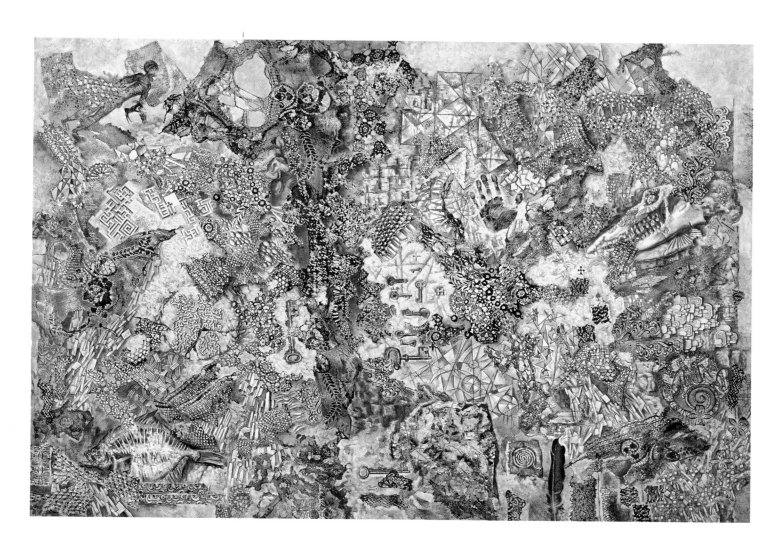

Voices of Silence, 1962. Oil on canvas, 55¼ x 67 in. 139.8 x 200.5 cm
The Museum of Modern Art, New York. Purchase
Photograph © 2000 The Museum of Modern Art, New York

Voices of Silence (detail), 1962

The Town of the Dead (4-parts detail from installation *Asia − The Wall of the Koran*), 1978
Oil, sand, polyvinylacetate tempera, cardboard on canvas, 39³/₈ x 47¹/₄ x 5 in. 100 x 120 x 12.5 cm
National Collection of Contemporary Art (in Tsaritsino Museum), Moscow

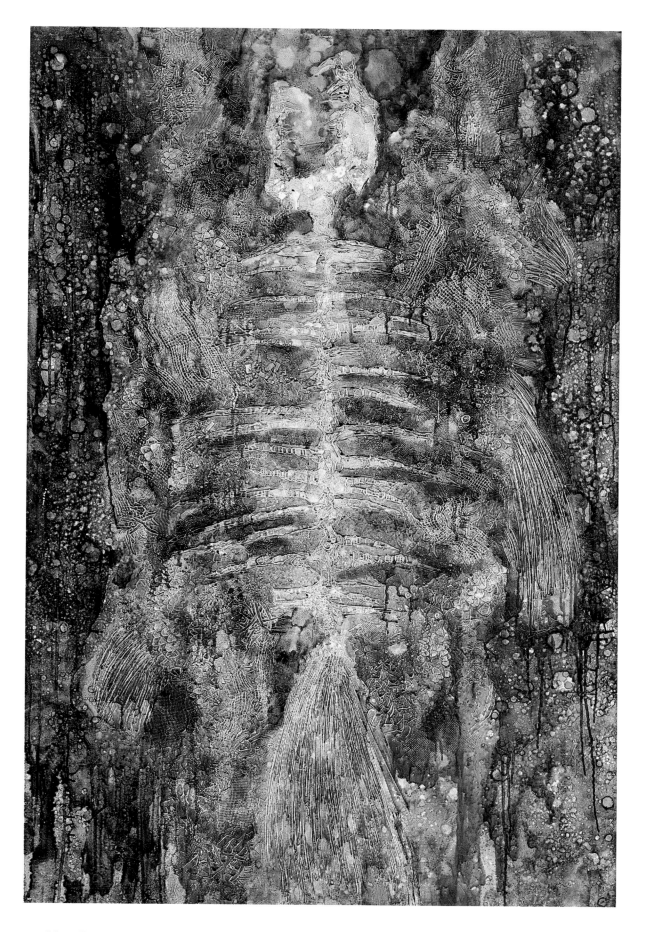

Man-Fish, 1964, Oil, polyvinylacetate tempera, fabric on canvas, 39 x 58³/⁴ in. 99 x 149 cm
Jane Voorhees Zimmerli Art Museum, Rutgers, The State University of New Jersey
The Norton and Nancy Dodge Collection of Nonconformist Art from the Soviet Union

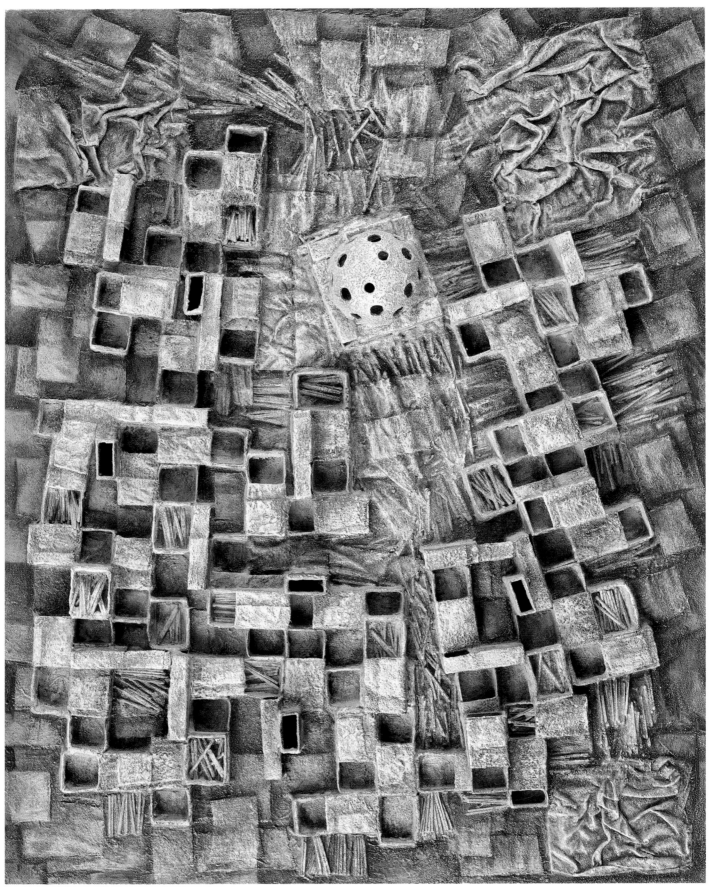

Asian Cemetery, 1977, Oil, polyvinylacetate tempera, matchboxes, matches, fabric, dried plants on canvas
27$^{1/2}$ x 35$^{1/2}$ x 4 in. 70 x 90 x 10 cm
Jane Voorhees Zimmerli Art Museum, Rutgers, The State University of New Jersey
The Norton and Nancy Dodge Collection of Nonconformist Art from the Soviet Union

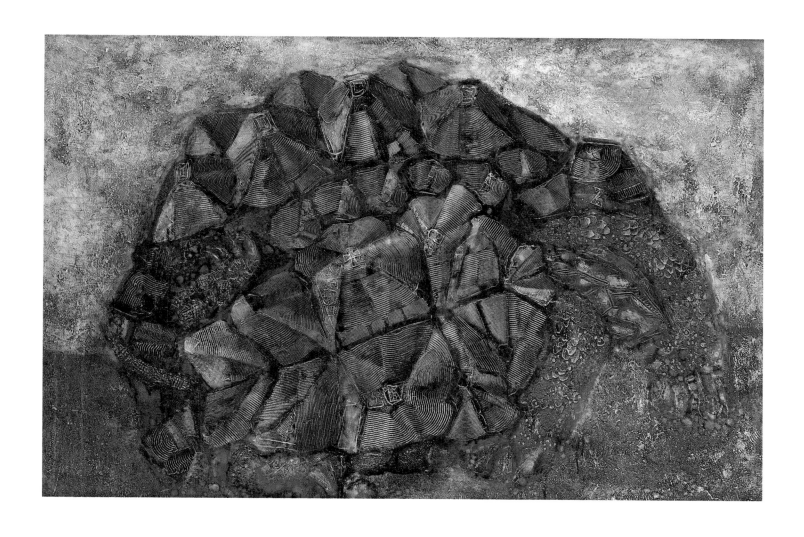

Tortoise. 1967. Oil, polyvinylacetate tempera, cardboard on canvas, 39¹/² x 59¹/⁴ in. 100.5 x 150.5 cm
Jane Voorhees Zimmerli Art Museum, Rutgers, The State University of New Jersey
The Norton and Nancy Dodge Collection of Nonconformist Art from the Soviet Union

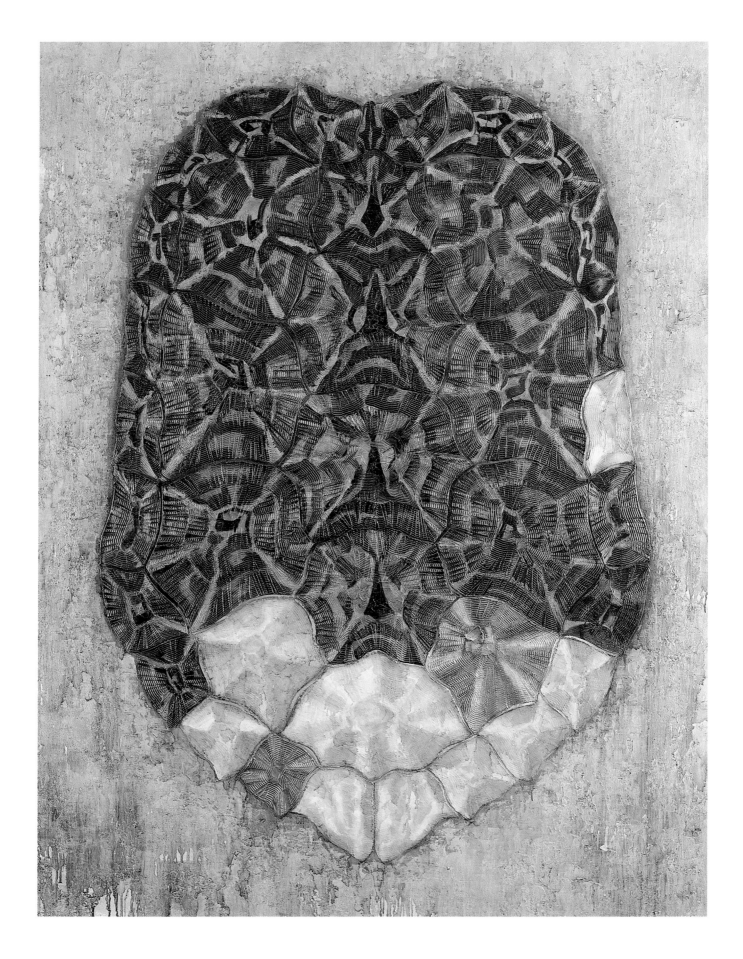

Golden Turtle, 1991, Oil, sand, acrylic on canvas, 68 x 50 in. 173 x 127 cm
Werner Schneider Collection, Neu-Ulm, Germany

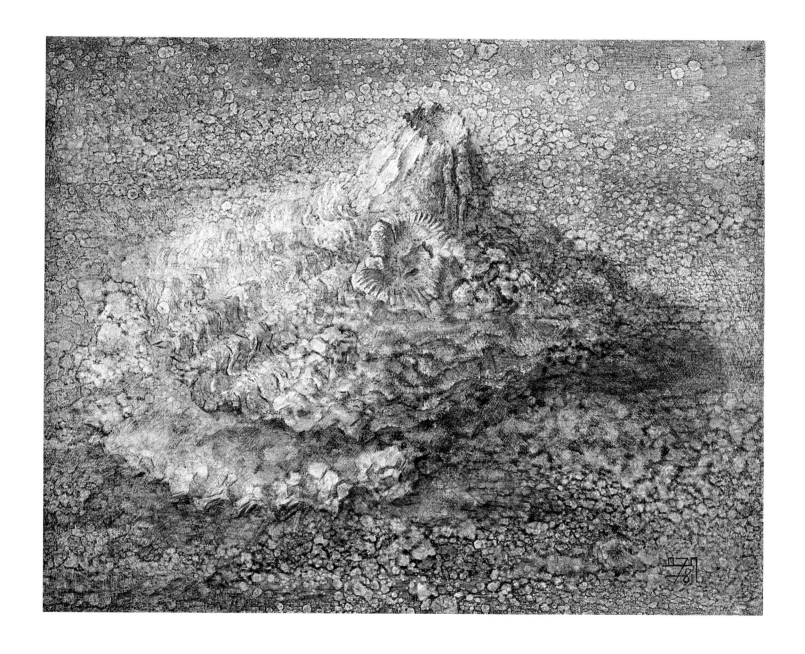

Sea Shell with Barnacle, 1978, Oil, polyvinylacetate tempera on canvas, 31$^{1/2}$ x 43$^{1/4}$ in. 80 x 110 cm
The Tabakman Collection, USA

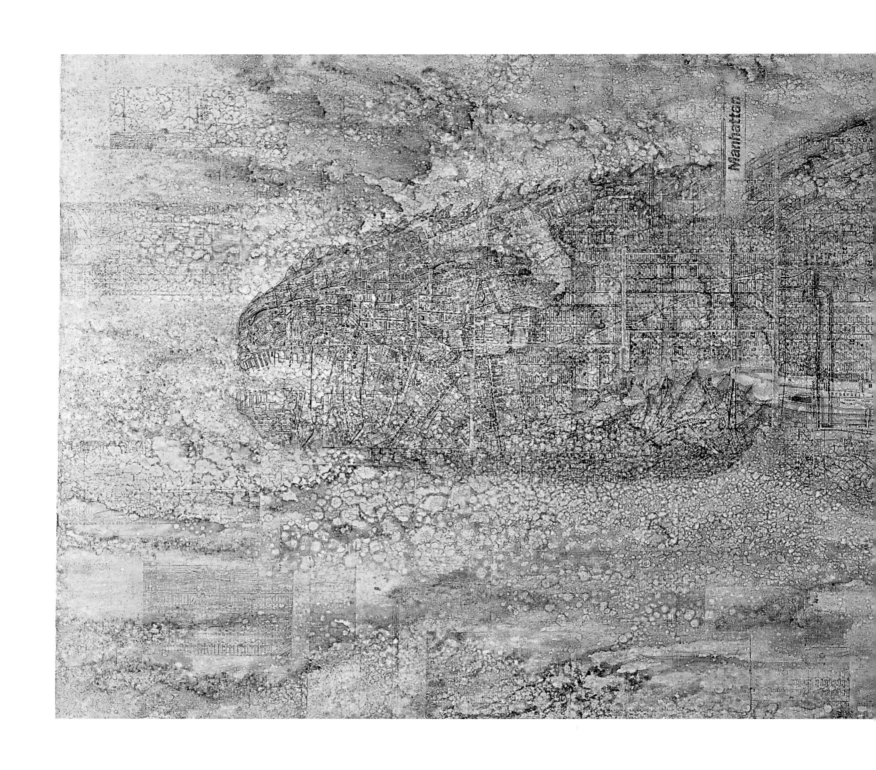

Manhattan Fish, 1992, Oil, acrylic, collage on canvas, 50 x 121 in. 127 x 307 cm
Werner Schneider Collection, Neu-Ulm, Germany

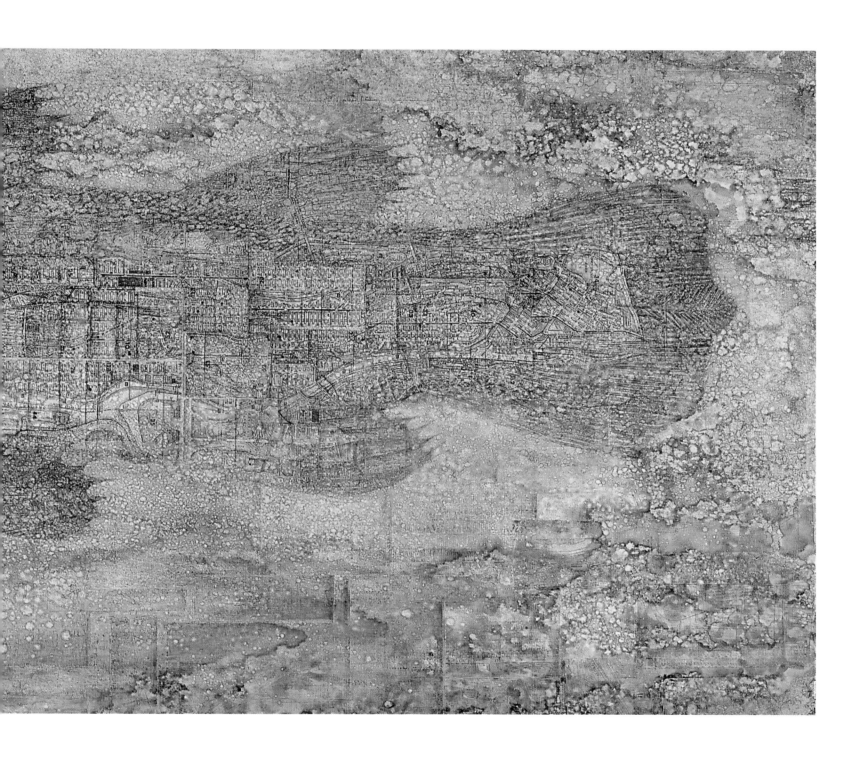

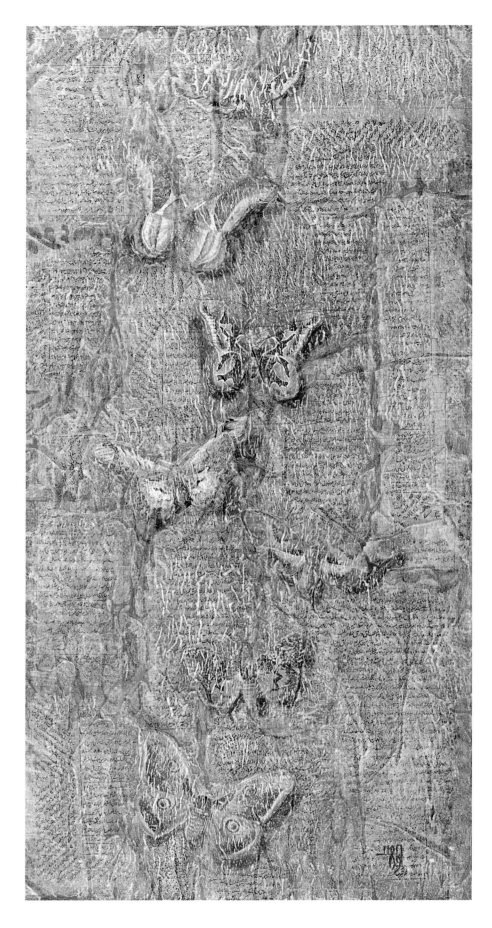

Eastern Manuscripts with Butterflies, 1989, Oil, polyvinylacetate tempera, collage on canvas
39¹ᐟ² x 19³ᐟ⁴ in. 100 x 50 cm
Private Collection, Moscow

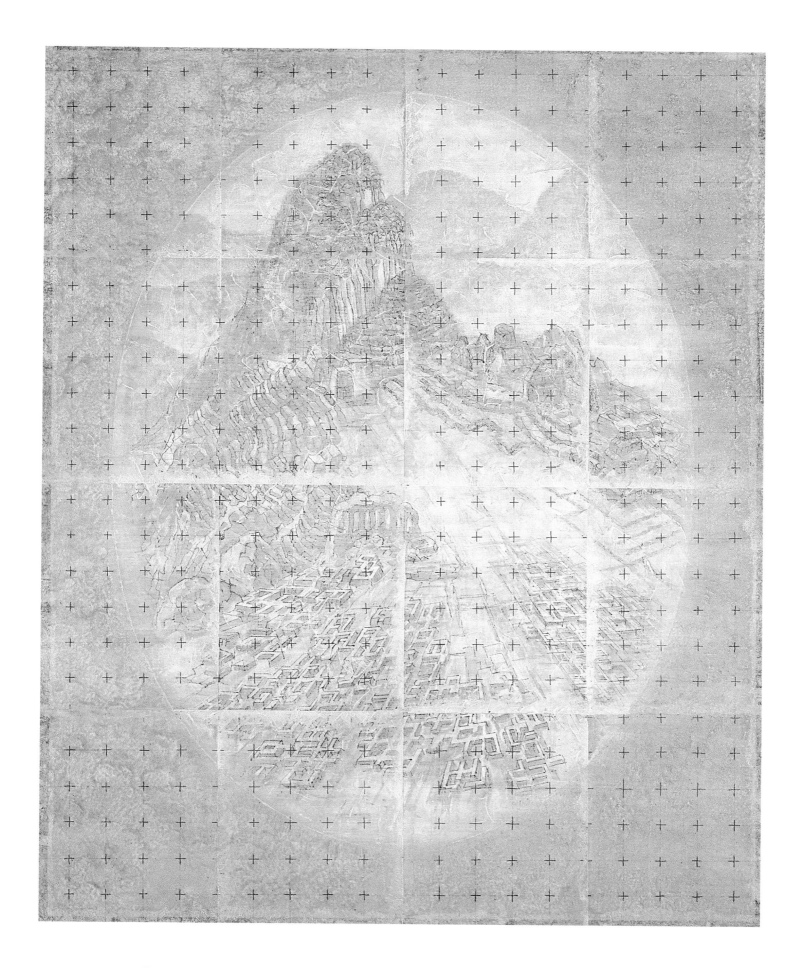

Deserted Town Machu Picchu, 1991, Oil, acrylic on canvas, 50 x 40 in. 127 x 102 cm
Ben-Zion and Inge Zelman Collection, Raamana, Israel

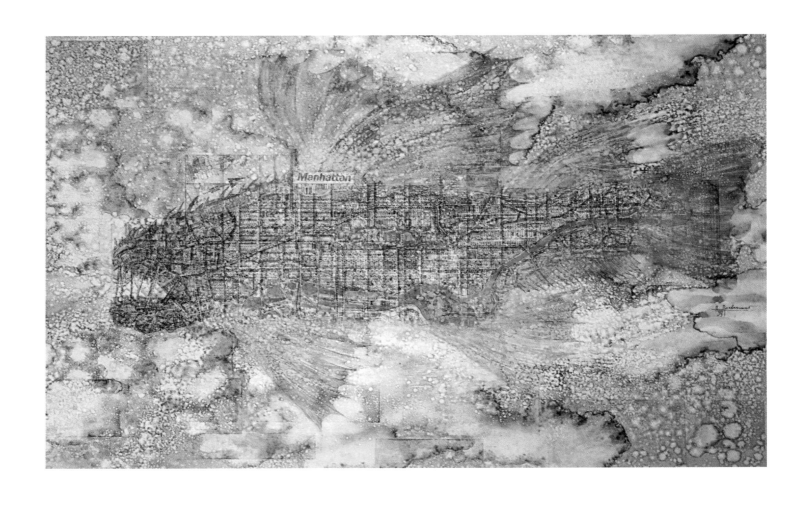

Manhattan-Ghost, 1993, Oil, acrylic, collage on canvas, 42 x 60 in. 107 x 153 cm
Jan Visser Collection, Paris

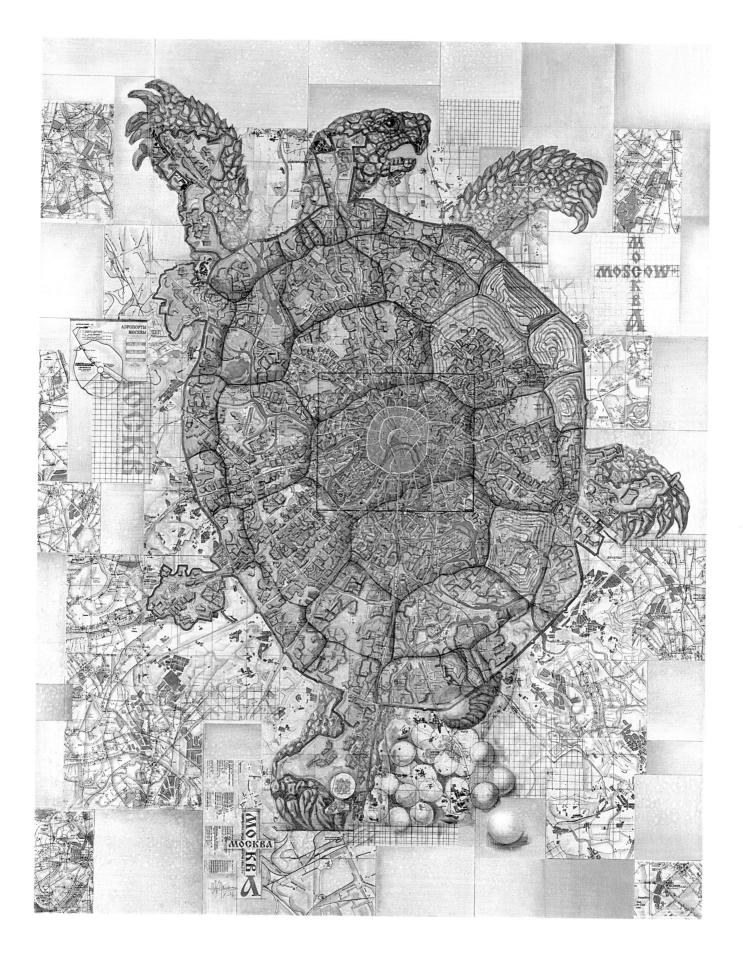

Moscow-Tortoise, 1996, Oil, acrylic, collage on canvas, 62 x 48 in. 158 x 122 cm
Artist Collection

Skate, 1981, Oil, polyvinylacetate tempera on canvas, 59 x 39$^{3/8}$in. 150 x 100 cm
Artist Collection

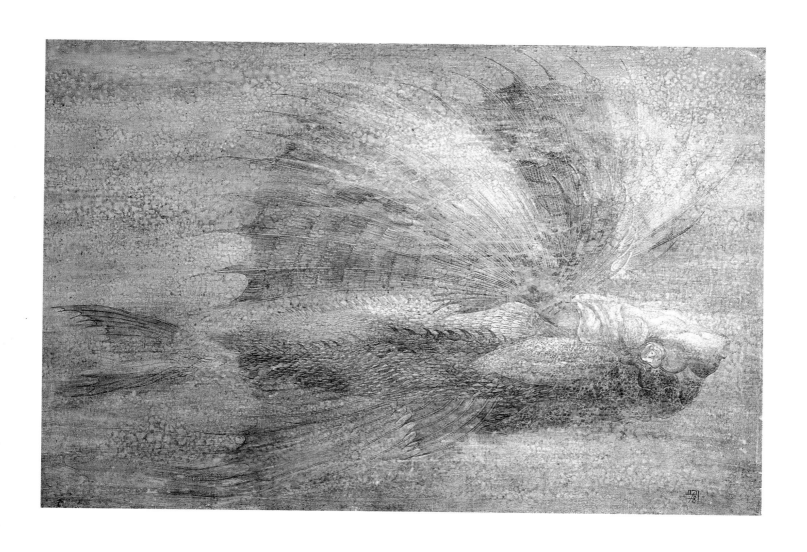

Flying Fish, 1978, Oil, polyvinylacetate tempera on canvas, 39$^{1/2}$ x 59 in. 100 x 150 cm
Museum of Modern Art, Moscow, Alina Roedel Collection

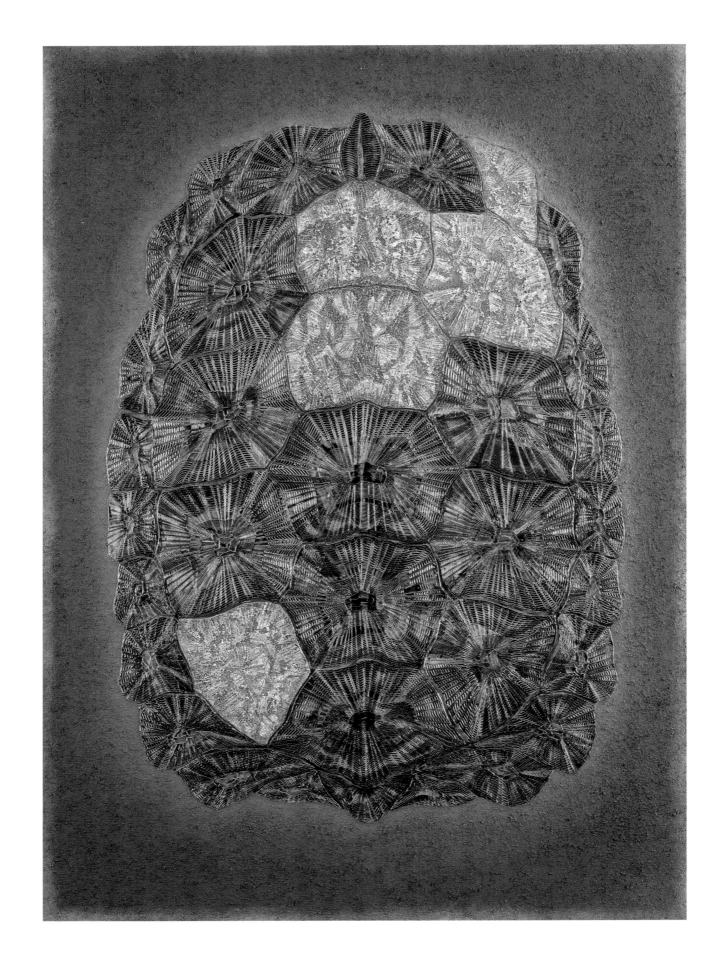

Agate Turtle Shell, 1992, Oil, sand, acrylic on canvas, 48 x 36 in. 122 x 91.5 cm
Private Collection

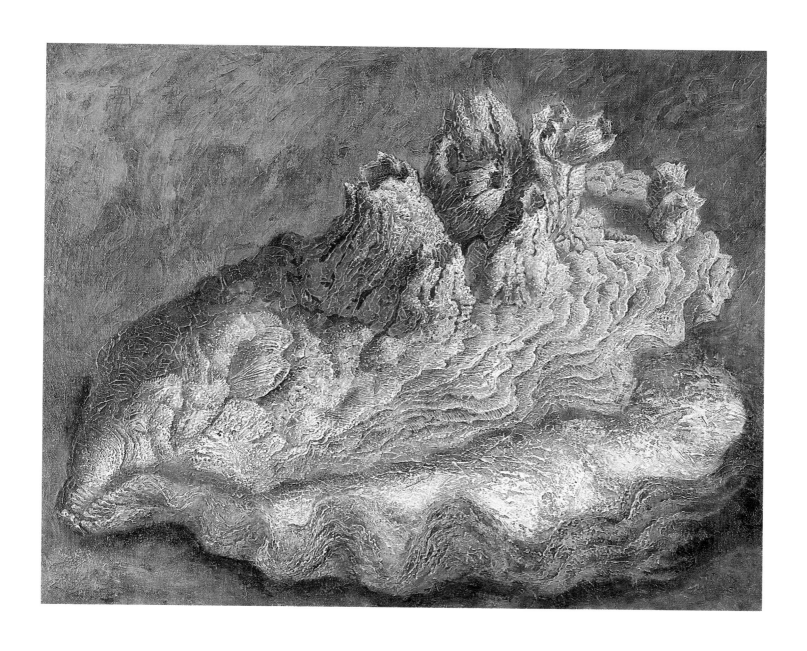

Sea Shell with Barnacles, 1977, Oil, polyvinylacetate tempera on canvas, 31¹ᐟ² x 43¹ᐟ⁴ in. 80 x 110 cm
Private Collection, Los Angeles

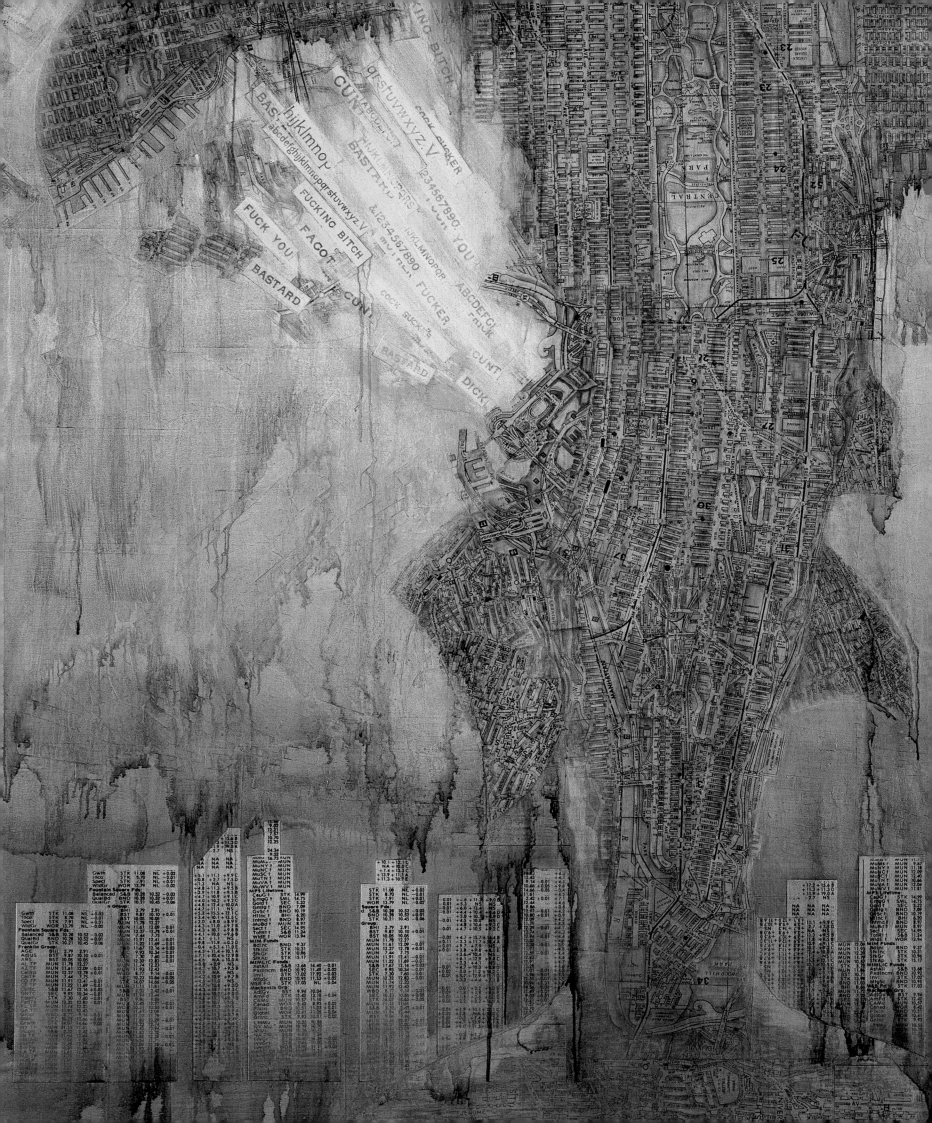

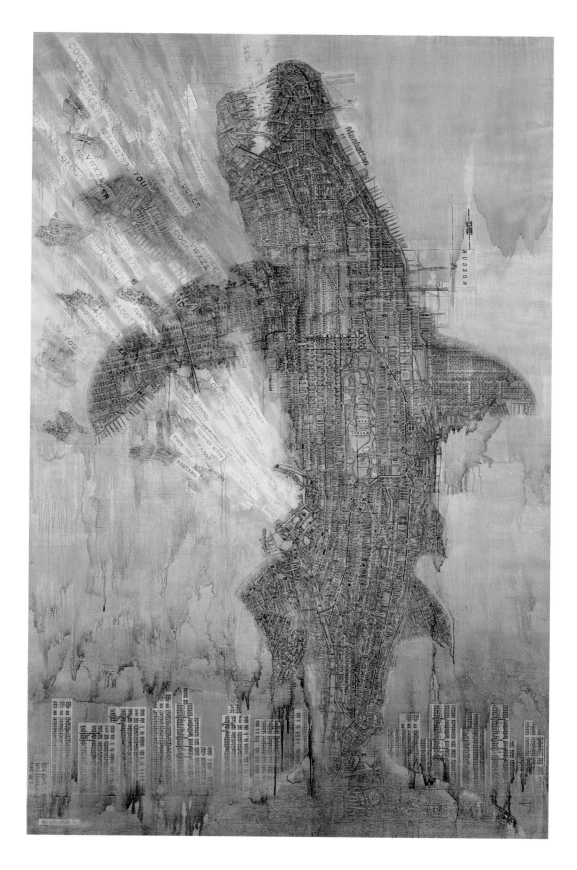

Manhattan Shark, 1997, Oil, acrylic, collage on canvas, 80 x 50 in. 203 x 127 cm
Alexandre Zouev Collection, Moscow

Manhattan Shark (detail), 1997

II. Word

1. In the beginning was the Word,
and the Word was with God, and the Word was God.
2. He was with God in the beginning.
3. Through him all things were made;
without him nothing was made that has been made.
4. In him was life, and that life was the light of men.

Holy Bible, New Testament,
John 1: 1-4.

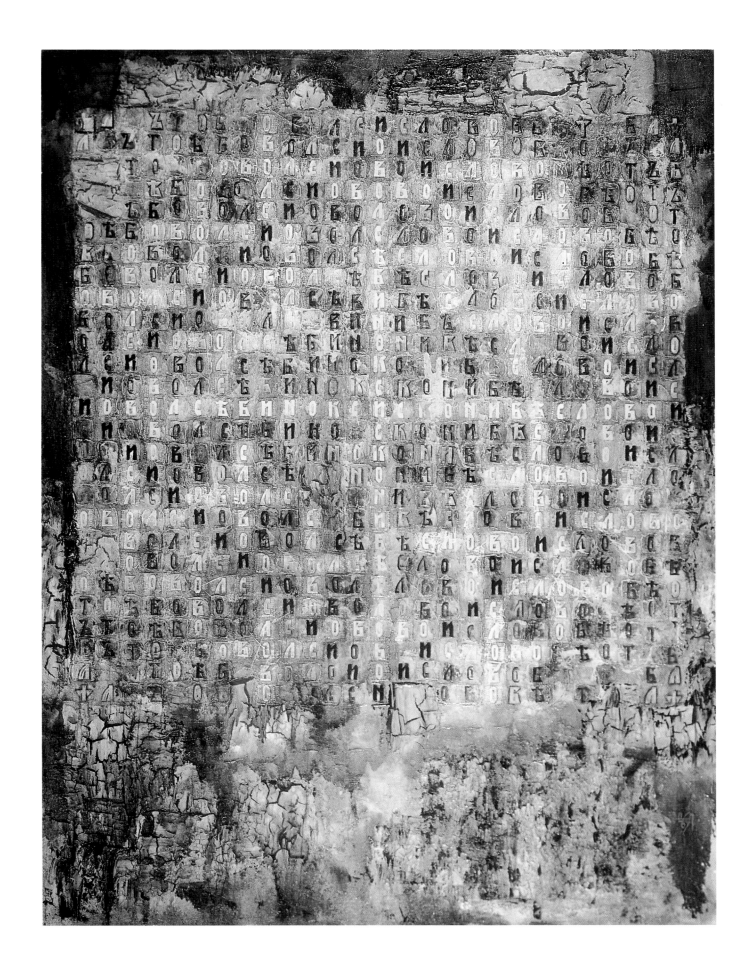

Word, 1967. Oil, plaster, polyvinylacetate tempera, cardboard on canvas, 79 x 59 in. 200 x 150 cm
The State Tretiakov Gallery, Moscow

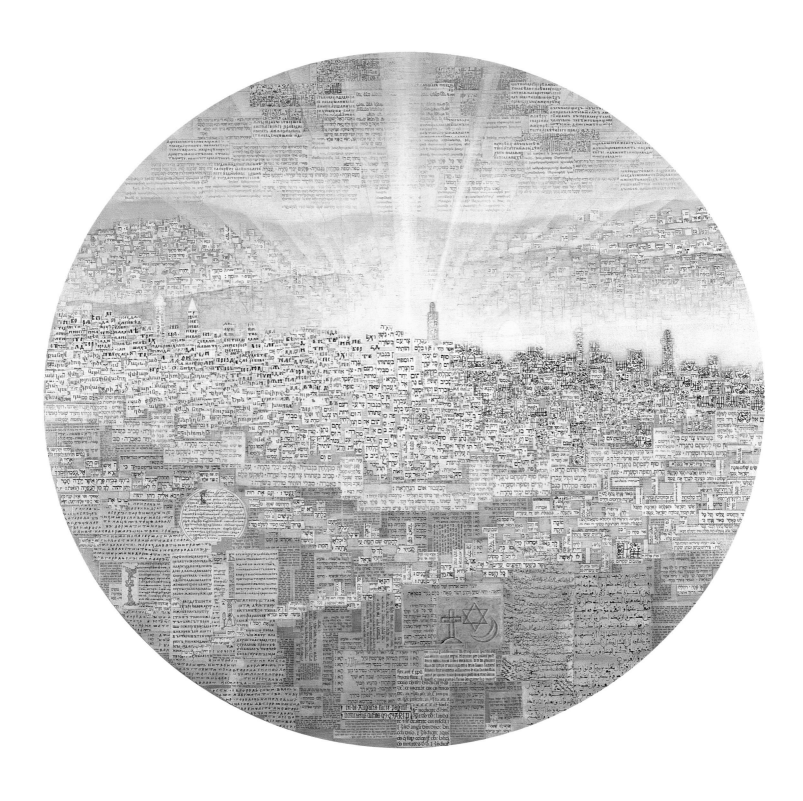

Jerusalem, 1999, Oil, collage, acrylic on board, 48 in. diameter - 122 cm diameter
Michael and Lynda Gardner Collection, New York

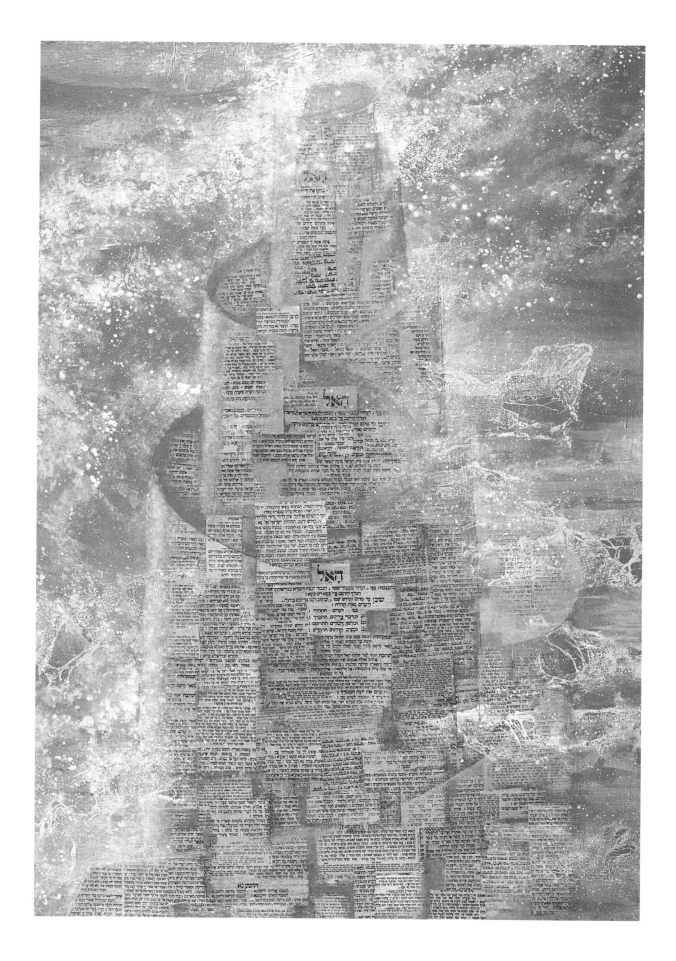

Tower of Torah, 1989. Oil, polyvinylacetate tempera, collage on canvas, 56¼ x 38¾ in. 143 x 98.5 cm
Artist Collection

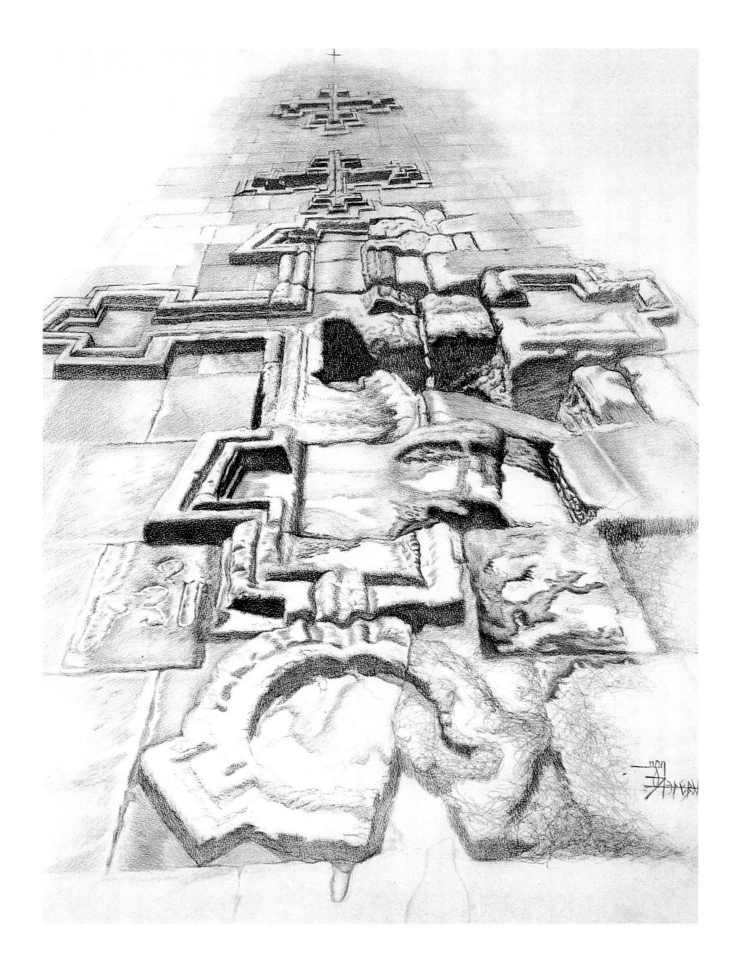

Crosses of Armenia, 1987, Colored pencil on paper, 39³/₈ x 283/4 in. 100 x 73 cm
Albert Rusanov Collection, Moscow

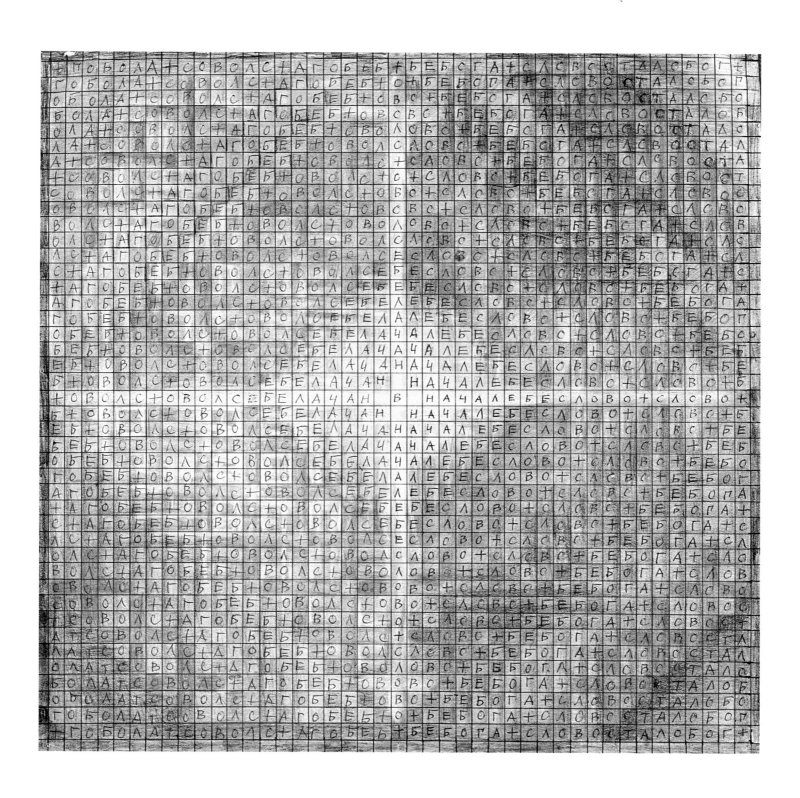

In the Beginning was the Word…, 1988, Colored pencil, pen and ink on paper - 17⁵/₈ x 17⁵/₈ in. 44.8 x 44.8 cm
Artist Collection

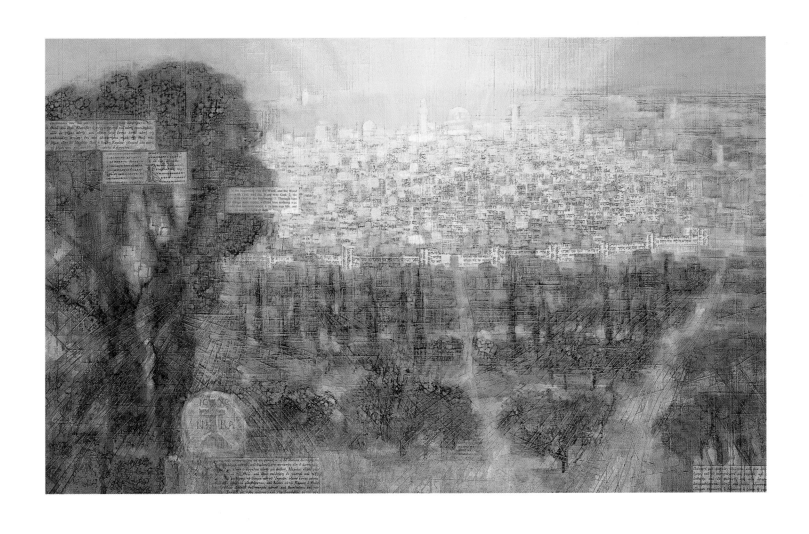

… And the Dusk Descended Upon the Gardens of Gethsemane, 1999, Oil, acrylic, collage on canvas
42¹ᐟ² x 64¹ᐟ⁴ in. 108 x 163 cm
Christopher and Christine Wetherhill Collection, Bermuda

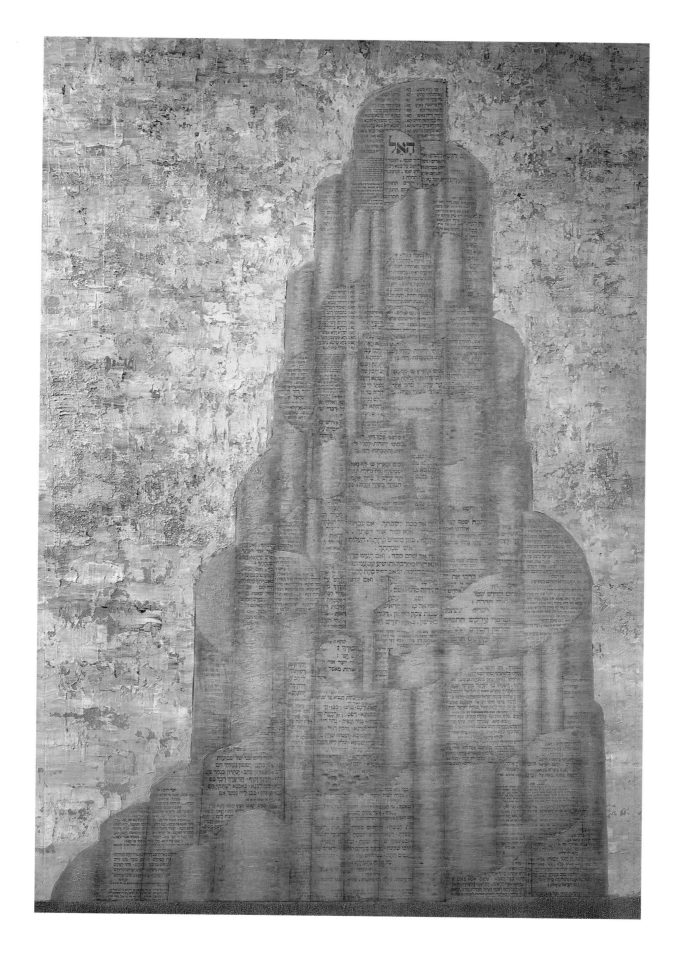

Wanderer's Vision, 1992, Oil, acrylic, collage on canvas, 72 x 50 in. 183 x 127 cm
Private Collection

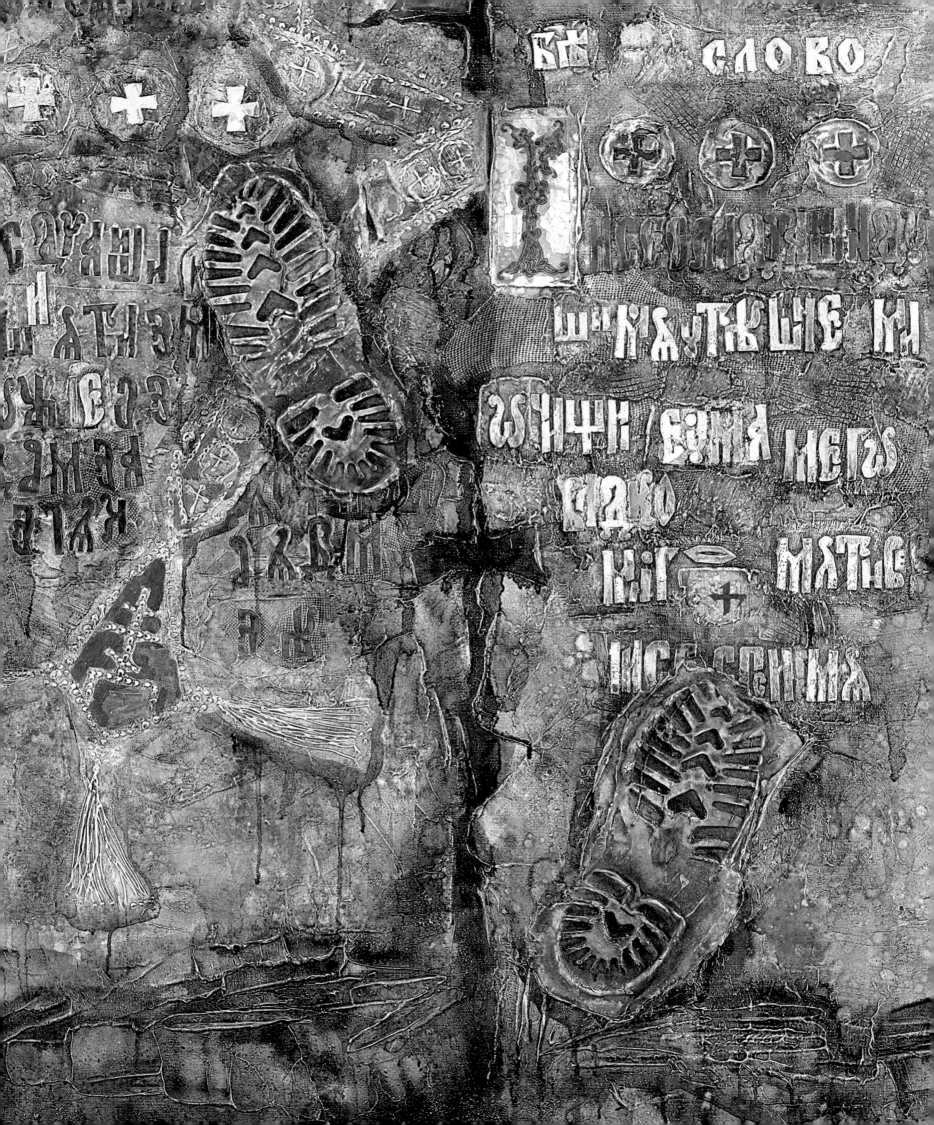

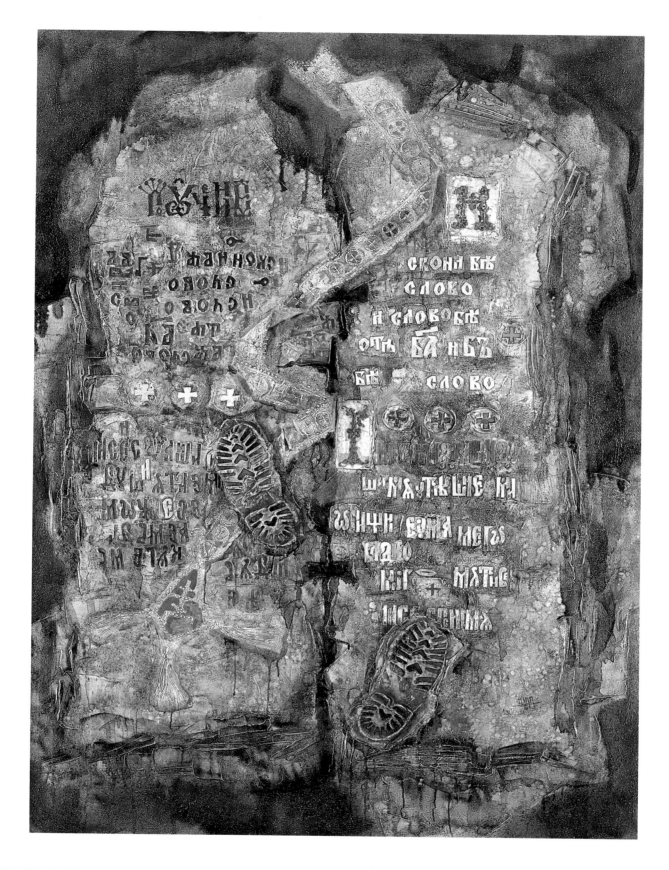

St. John's Gospel, 1967, Oil, polyvinylacetate tempera, plaster, collage on canvas, 70³/⁴ x 47¹/⁴ in. 180 x 120 cm
The Tabakman Collection, USA

St. John's Gospel (detail), 1967

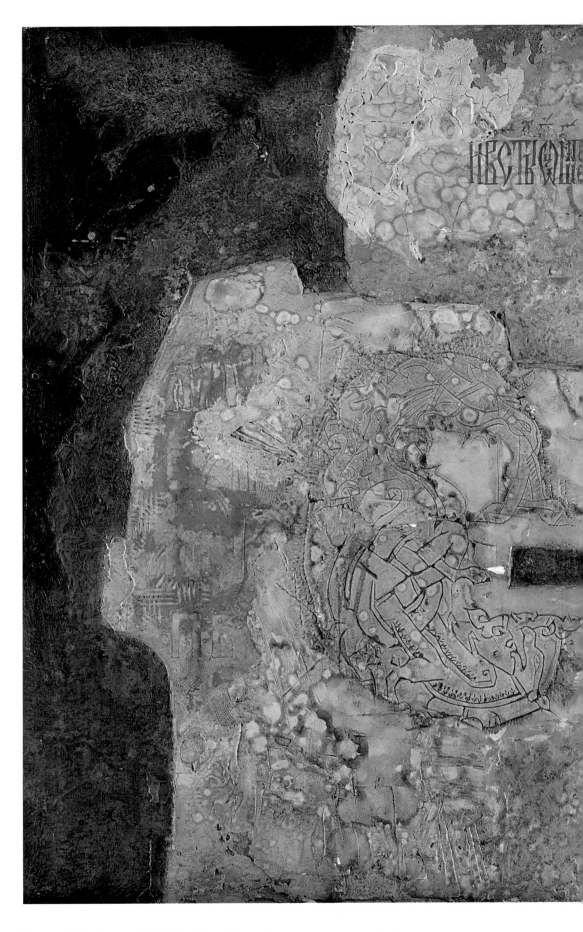

Letter "C" (2 parts), 1966. Oil, polyvinylacetate tempera, plaster,
canvas on board, 47 x 72 in. 119 x 183 cm
Jane Voorhees Zimmerli Art Museum, Rutgers,

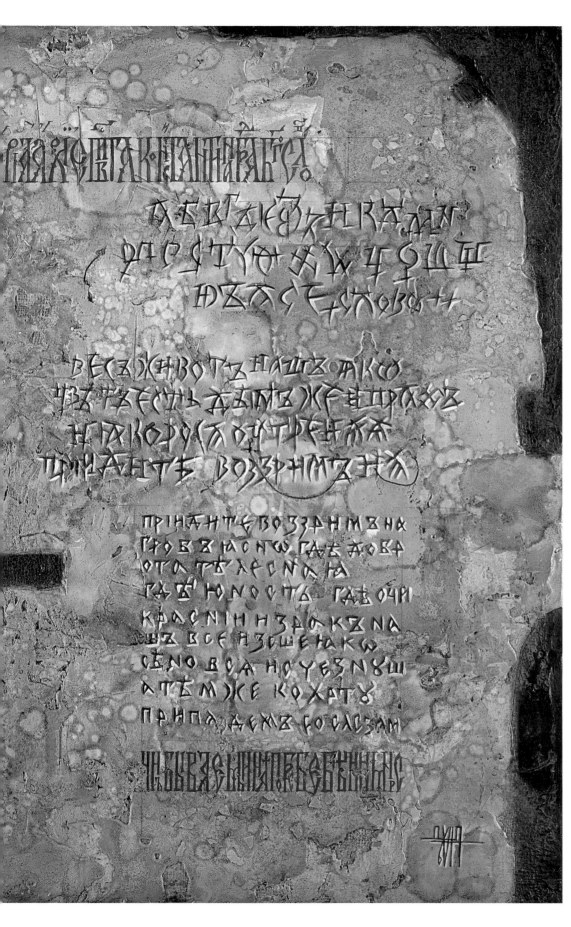

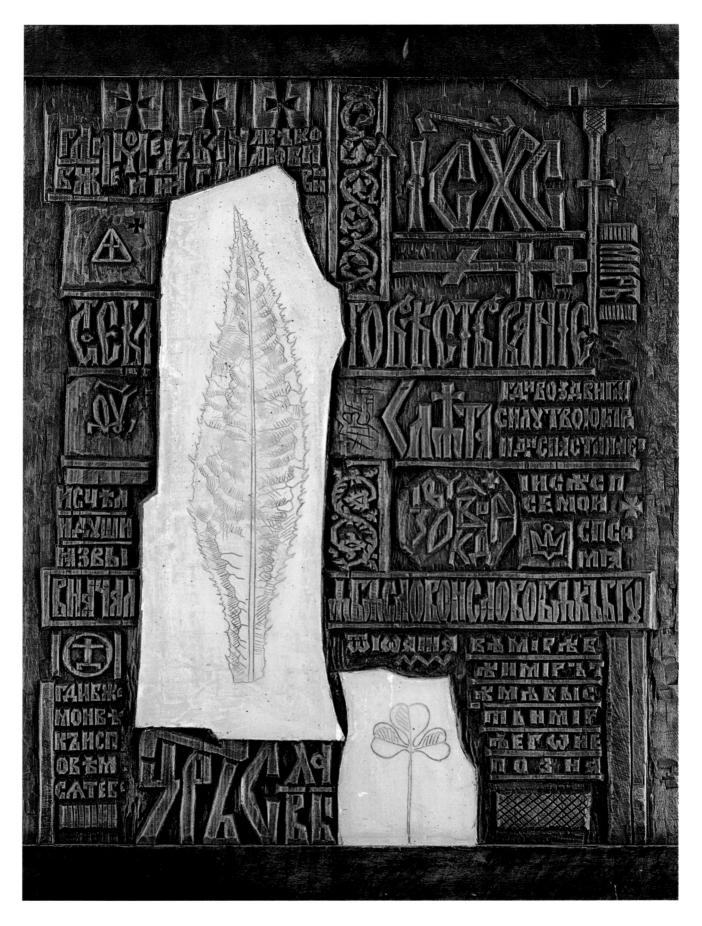

Church Wall, 1965, Oil, curved wood, engraving on plaster on wood, 29¹/₂ x 20 x 3/4 in. 75 x 50.5 x 2 cm
Jane Voorhees Zimmerli Art Museum, Rutgers, The State University of New Jersey
The George Riabov Collection of Russian Art, donated in memory of Basil and Emilia Riabov

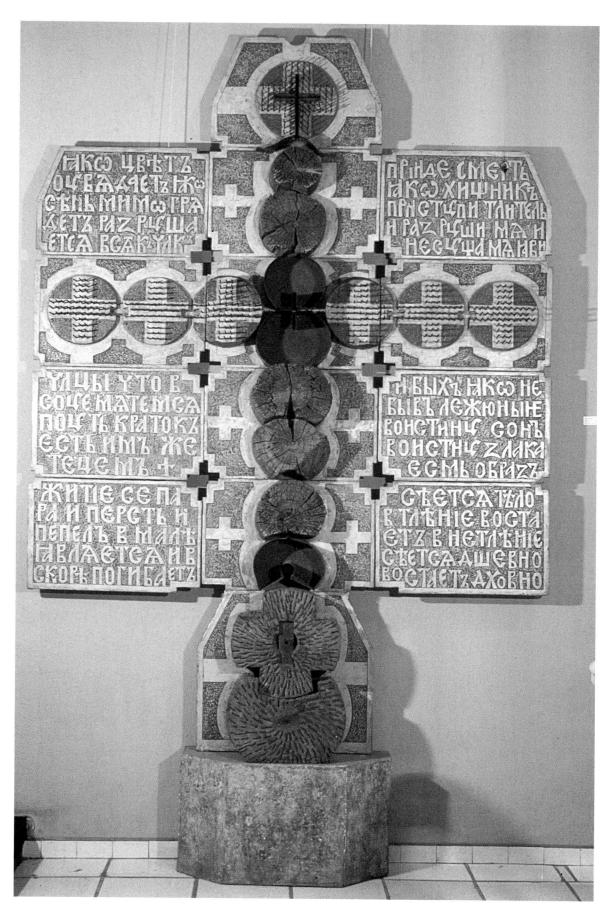

Cross, 1976, Oil, polyvinylacetate tempera, carving on plaster, nails, wood, metal on wood
118 x 71 x 13³/⁴ in. 300 x 180 x 35 cm
Artist Collection

Wall of Novgorod Church (3 parts), 1974: 1978. Oil, sand, polyvinylacetate tempera, plaster on cardboard
41¹ᐟ² x 100¹ᐟ² in. 105 x 255 cm
National Collection of Contemporary Art (in Tsaritsino Museum), Moscow

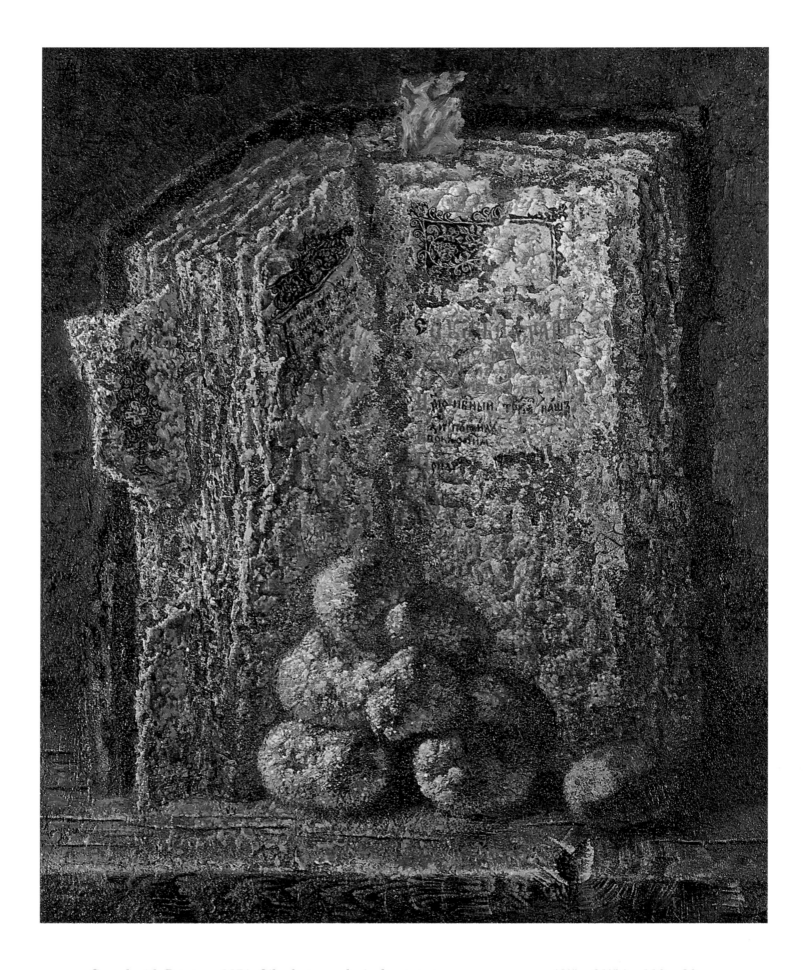

Gospel with Potatoes, 1974, Oil, plaster, polyvinylacetate tempera on canvas, 43¹/⁴ x 31¹/² in. 110 x 80 cm
Private Collection, Paris

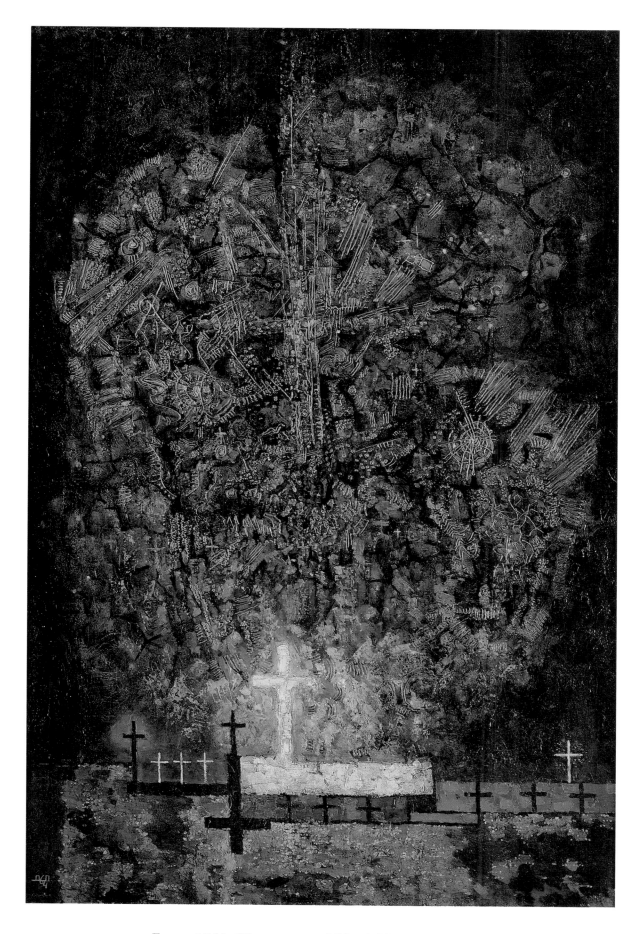

Easter, 1964, Oil on canvas, 46$^{1/2}$ x 34$^{3/4}$ in. 118 x 78 cm
Jane Voorhees Zimmerli Art Museum, Rutgers, The State University of New Jersey
The Norton and Nancy Dodge Collection of Nonconformist Art from the Soviet Union

Dog, 1965, Oil, sand, plaster, polyvinylacetate tempera on canvas
47¹/⁴ x 71 in. 120 x 180 cm
Ludwig Stiftung für Kunst und Internationale Verständigung, Cologne

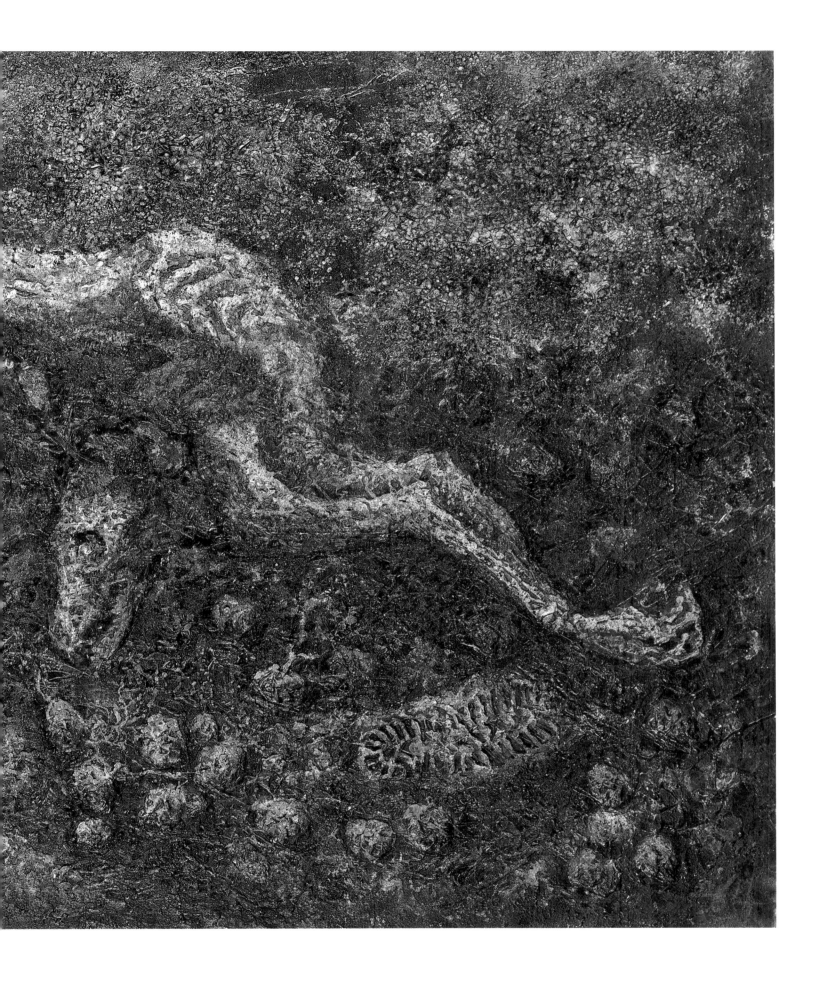

III. Measure of Universe

For the true knowledge of music is nothing other than this:
to know the ordering of all separate things and how the
Divine Reason has distributed them;
for this ordering of all separate things into one,
achieved by skilful reason, makes the sweetest and
truest harmony with the Divine Songs.

Hermes Trismegistus.

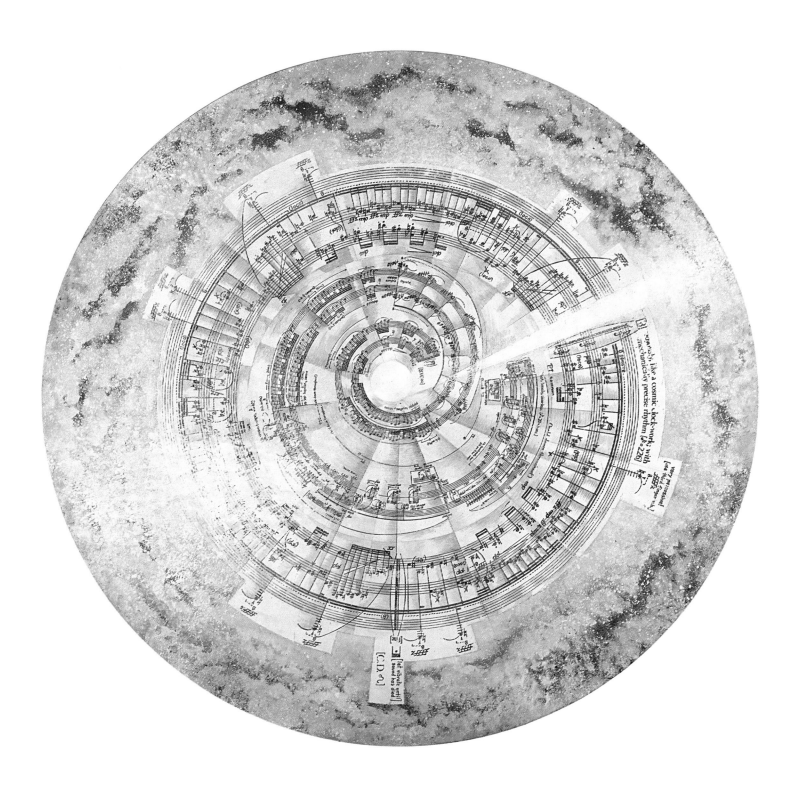

The World of Music (Cosmogony), 1993, Oil, acrylic, collage on canvas, 60 in. diameter, 153 cm diameter
The Tabakman Collection, USA

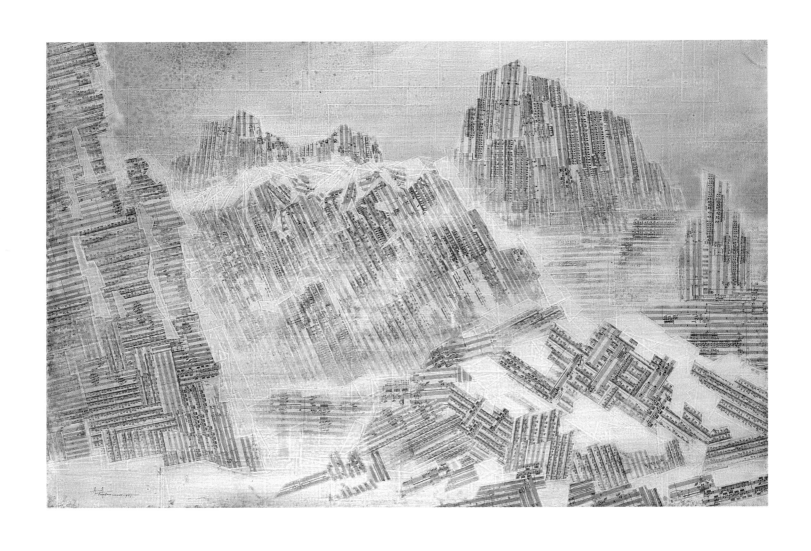

Cliffs' Voices, 1995, Oil, acrylic, collage on canvas, 40 x 59 in. 102 x 150 cm
Isabel Goldsmith Collection, London

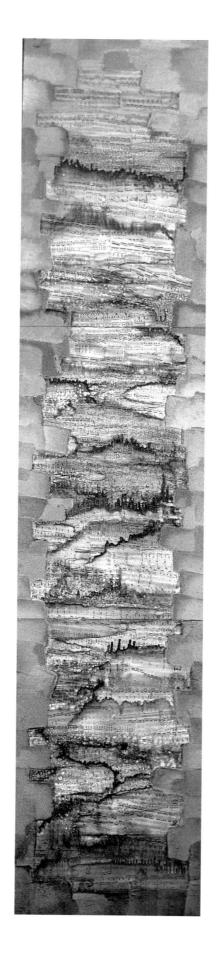

Color-Sound Vertical (3 parts), 1987, Oil, polyvinylacetate tempera, collage on canvas, 98³/⁴ x 21⁵/⁸ in. 250 x 55 cm
Private Collection

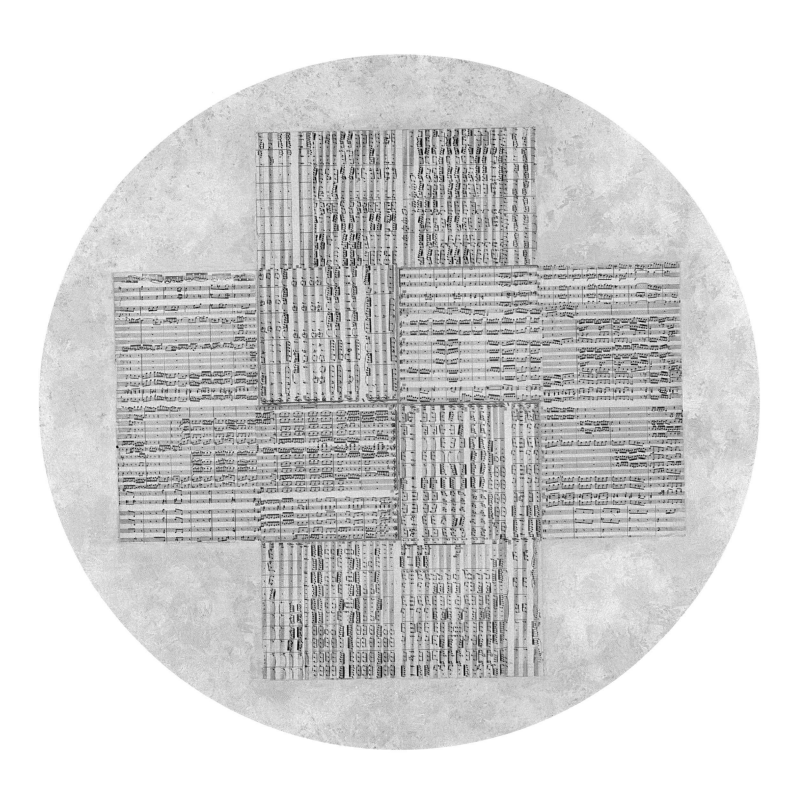

Silver Disc, 1991, Oil, acrylic, collage on canvas, 42 in. diameter, 107 cm diameter
Private Collection, Moscow

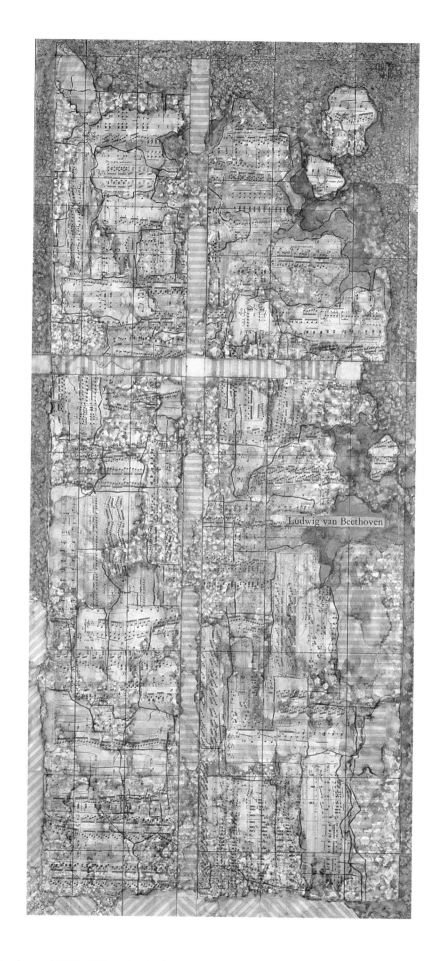

Beethoven's Archipelago. 1988. Oil, polyvinylacetate tempera, collage on wood, 45¹/₄ x 19³/₄ in. 115 x 50 cm
Private Collection

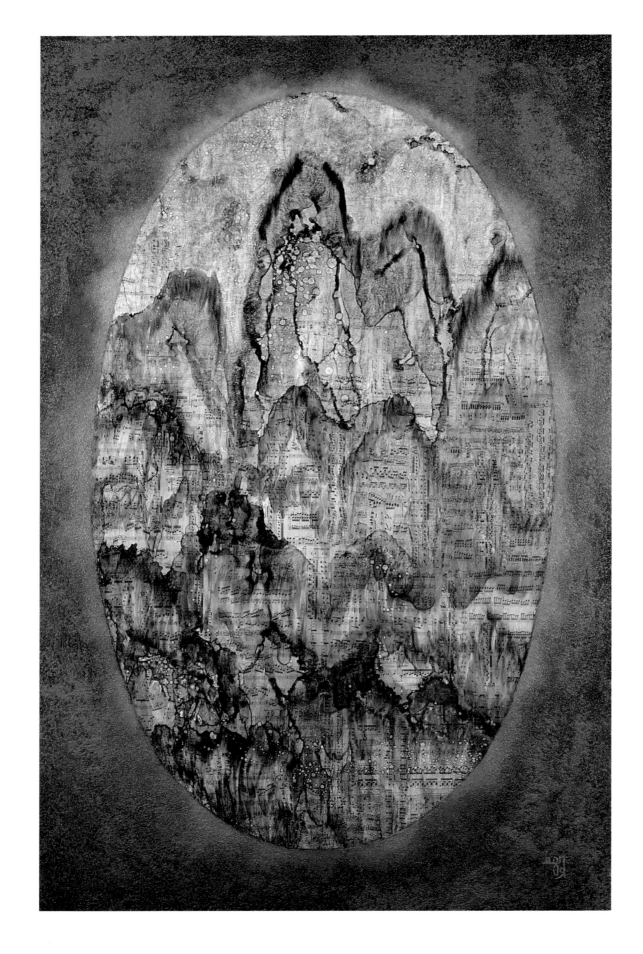

Black Mirror, 1989, Oil, polyvinylacetate tempera, collage on canvas, 55 x 35$^{1/2}$ in. 140 x 90 cm
The State Russian Museum, St. Petersburg

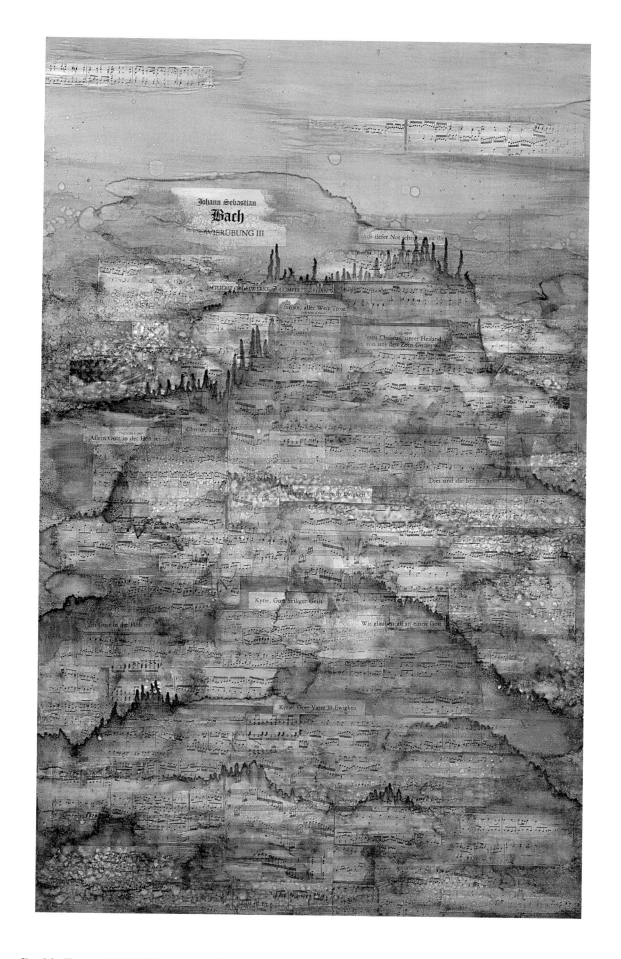

Bach's Fugue, 1987, Oil, polyvinylacetate tempera, collage on canvas, 55 x 35$^{1/2}$ in. 140 x 90 cm
Private Collection, Germany

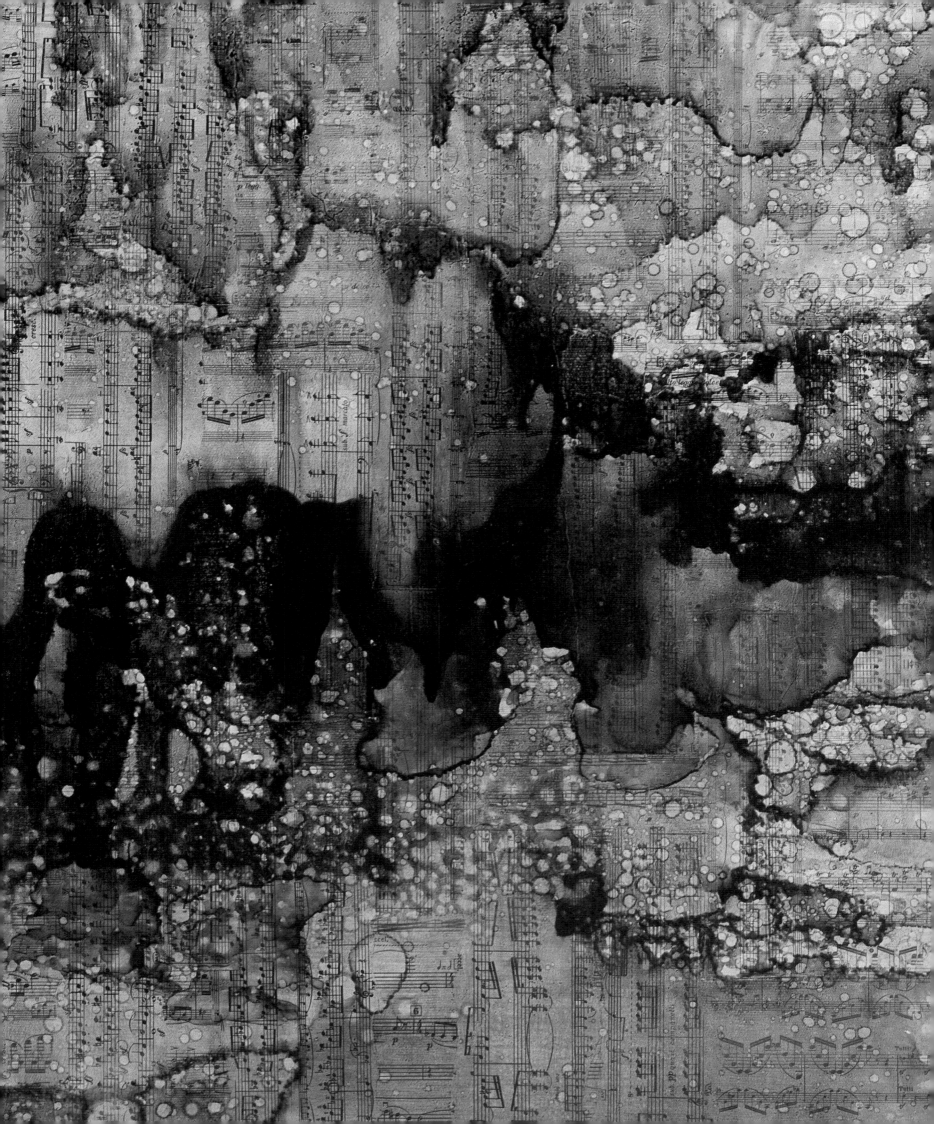

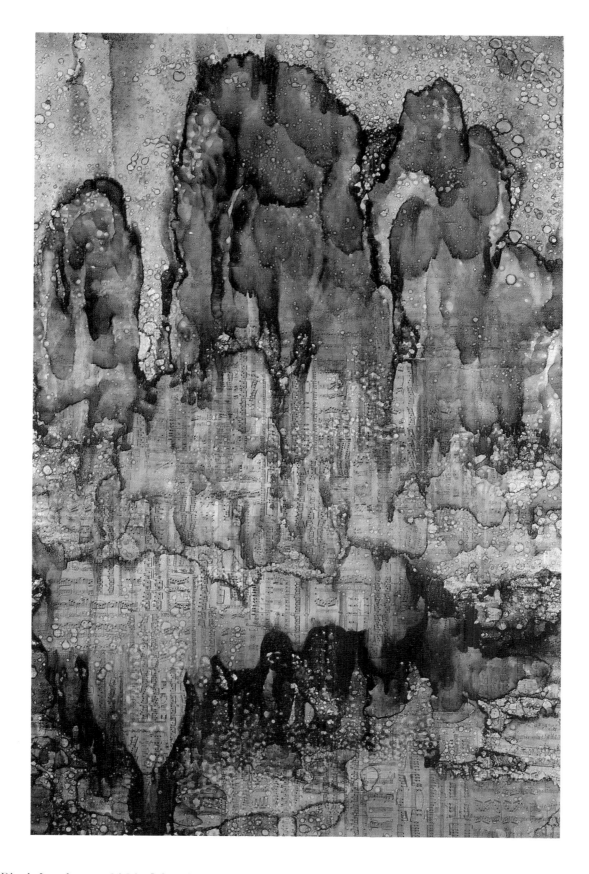

Black Landscape, 1988. Oil, polyvinylacetate tempera, collage on canvas. 55 x 35¹/² in. 140 x 90 cm
Private Collection

Black Landscape (detail), 1988

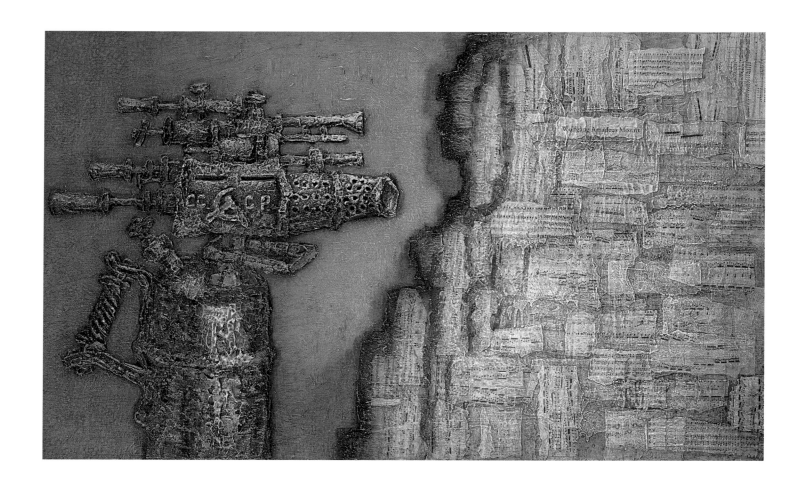

Mozart and Saljeri, 1987, Oil, sand, polyvinylacetate tempera, collage on canvas, 39³/₈ x 56³/₄ in. 100 x 144 cm
Private Collection

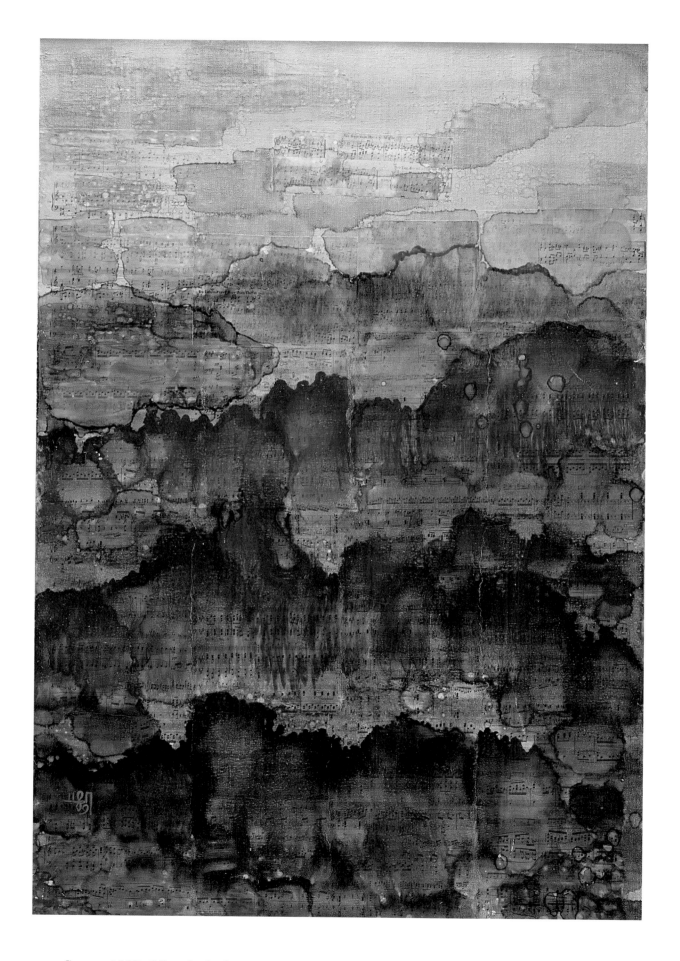

Sunset, 1989, Oil, polyvinylacetate tempera, collage on canvas, 47³/⁸ x 31¹/² in. 122 x 80 cm
Gregory Vinitsky Collection, New York

IV. Music of Myth

Lo, yonder the Sun-god is turning to earthward his splendour-blazing
Chariot of light;
And the stars from the firmament flee from the fiery arrows chasing,
To the sacred night;
And the crests of Parnassus untrodden are flaming and flushed, as with yearning
Of welcome to far-flashing wheels with the glory of daylight returning
To mortal sight.
To the roof-ridge of Phoebus the fume of the incense of Araby burning
As a bird taketh flight.
On the tripod most holy is seated the Delphian Maiden
Chanting to children of Hellas the wild cries, laden
With doom, from the lips of Apollo that ring.

Euripides, *Ion.*

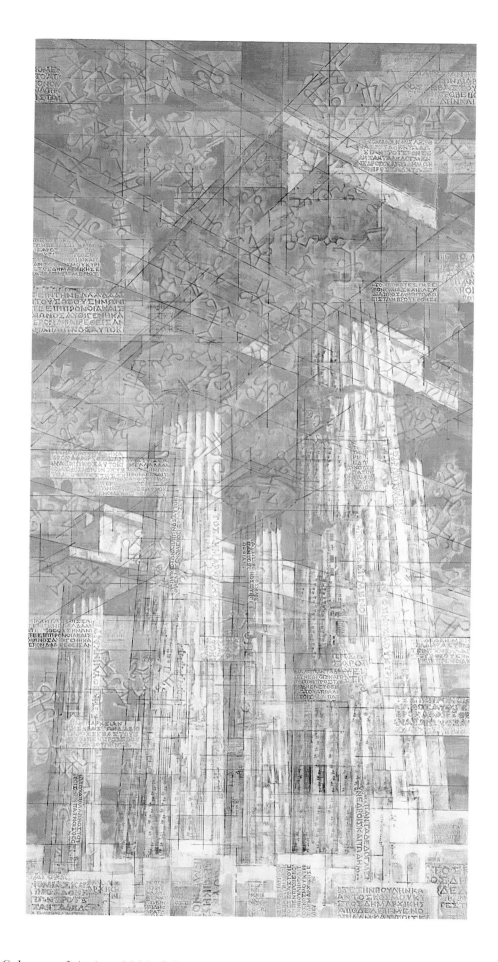

Columns of Aegina, 1995, Oil, acrylic, collage on canvas, 60 x 30 in. 153 x 76 cm
Wolfgang Schoellkopf Collection, New York

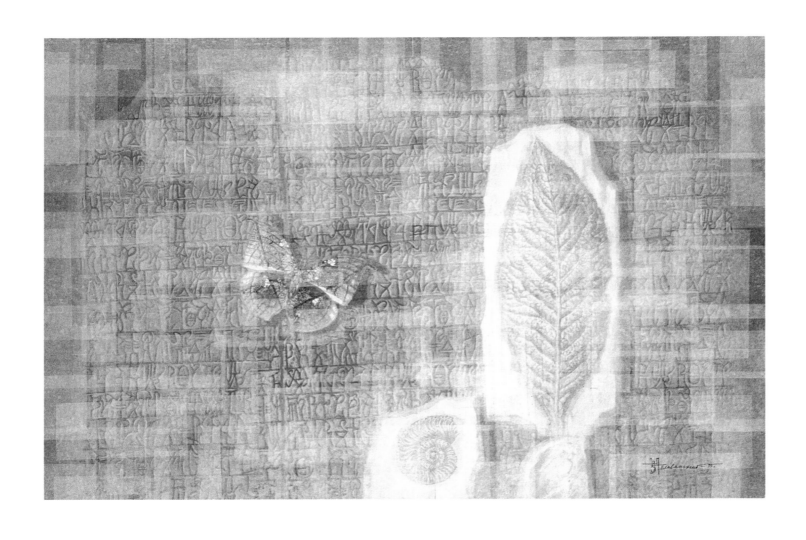

Butterfly of Crete, 1995, Oil, acrylic, collage on canvas, 26 x 40 in. 66 x 101 cm
Dorothy Schoelen Collection, Los Angeles

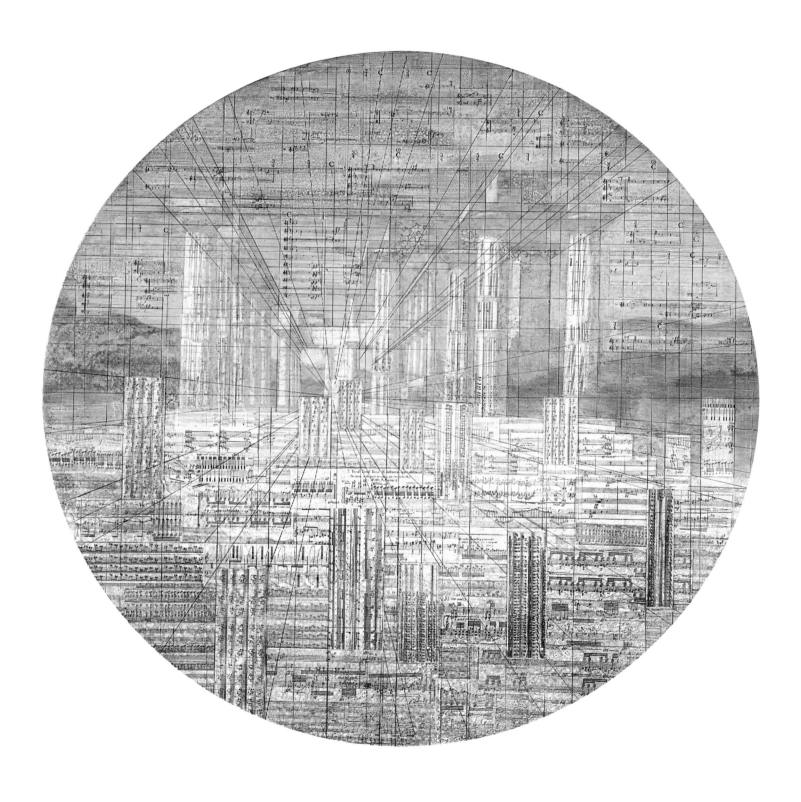

Vanishing Point, 1995, Oil, acrylic, collage on canvas, 42 in. diameter, 107 cm diameter
Peter Axilrod and Sandra Kuhach Collection, Cambridge, USA

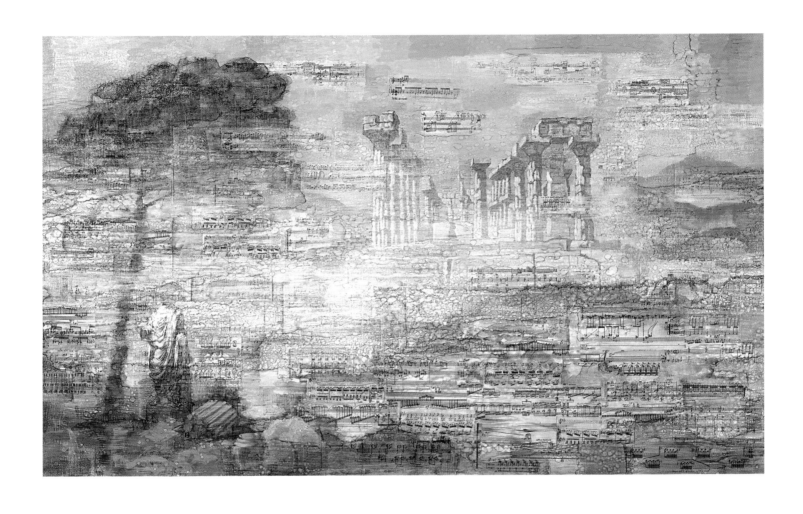

Music of Ancient Ruins, 1993, Oil, acrylic, collage on canvas, 36 x 60 in. 92 x 153 cm
Aliki Costaki Collection, Athens

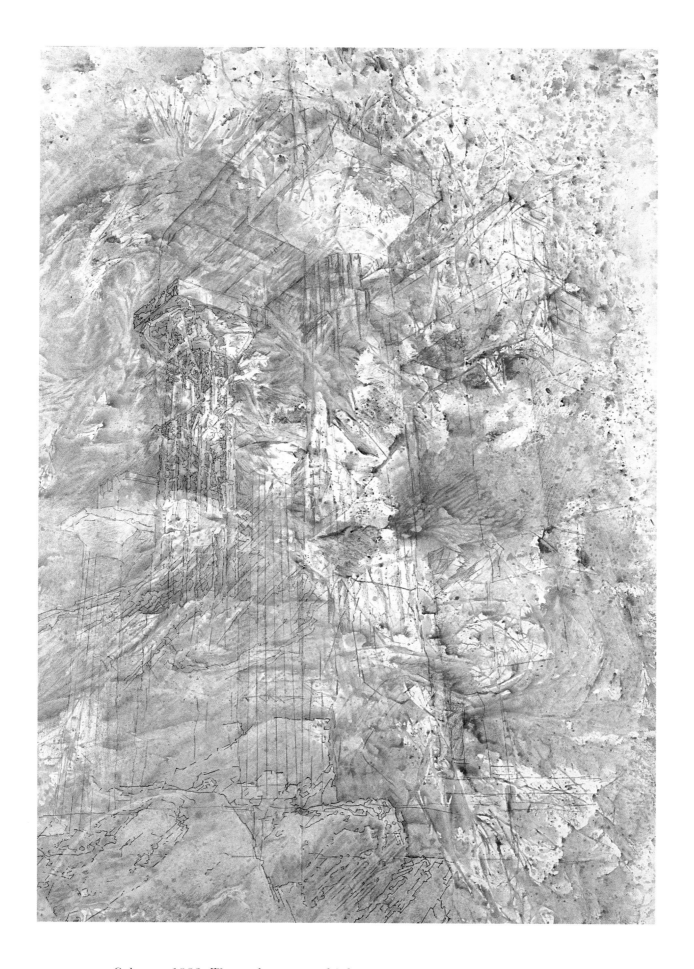

Columns, 1993, Watercolor, pen and ink on paper, 35¹⁄₂ x 24¹⁄₂ in. 90 x 62 cm
Alberto Sandretti Collection, Venice and Milan

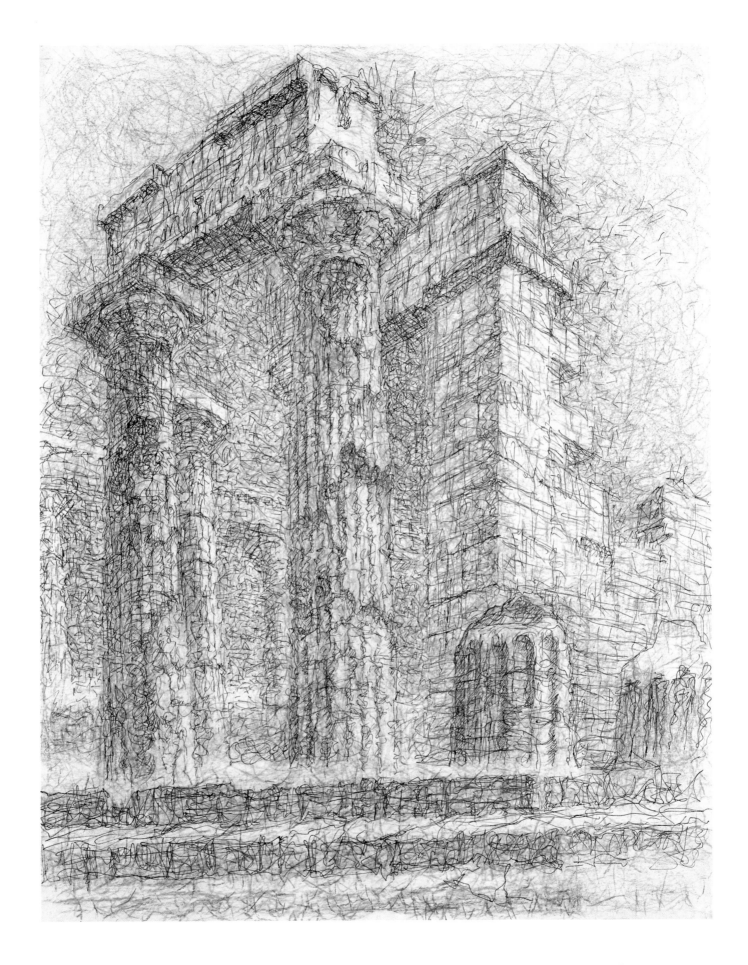

Columns of Aegina, 1993. Colored pencil, pen and ink on paper, 28¹ᐟ² x 21 in. 73 x 53 cm
Artist Collection

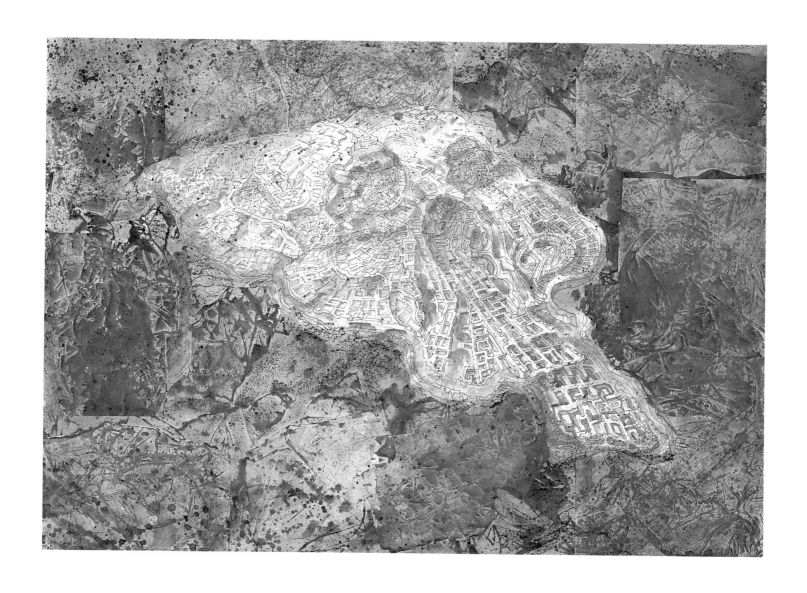

Mycenae, 1995, Watercolor, pen and ink, acrylic, collage, monotype on paper, 31 x 41¼ in. 79 x 115 cm
Peter Axilrod and Sandra Kuhach Collection, Cambridge, USA

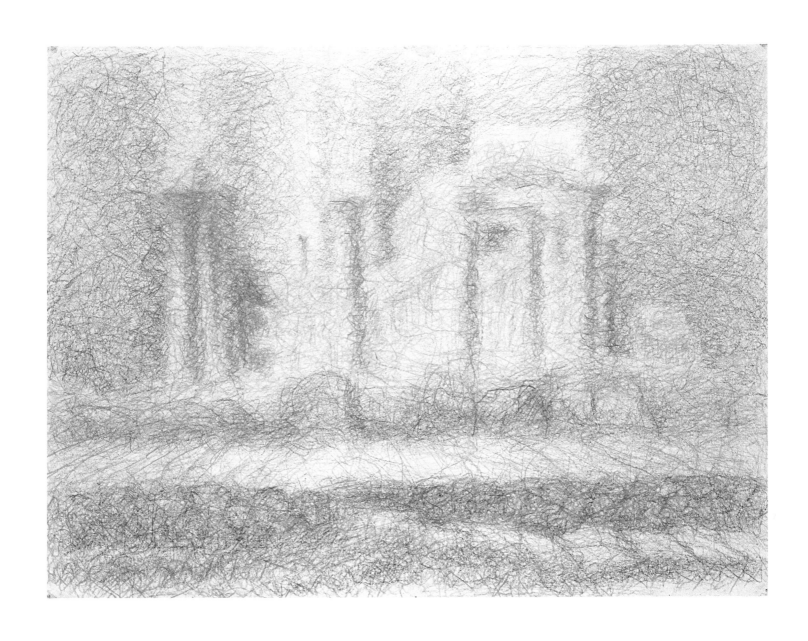

Ruins, 1994, Colored pencil on paper, 19 x 24 in. 48 x 61 cm
Alberto Sandretti Collection, Venice and Milan

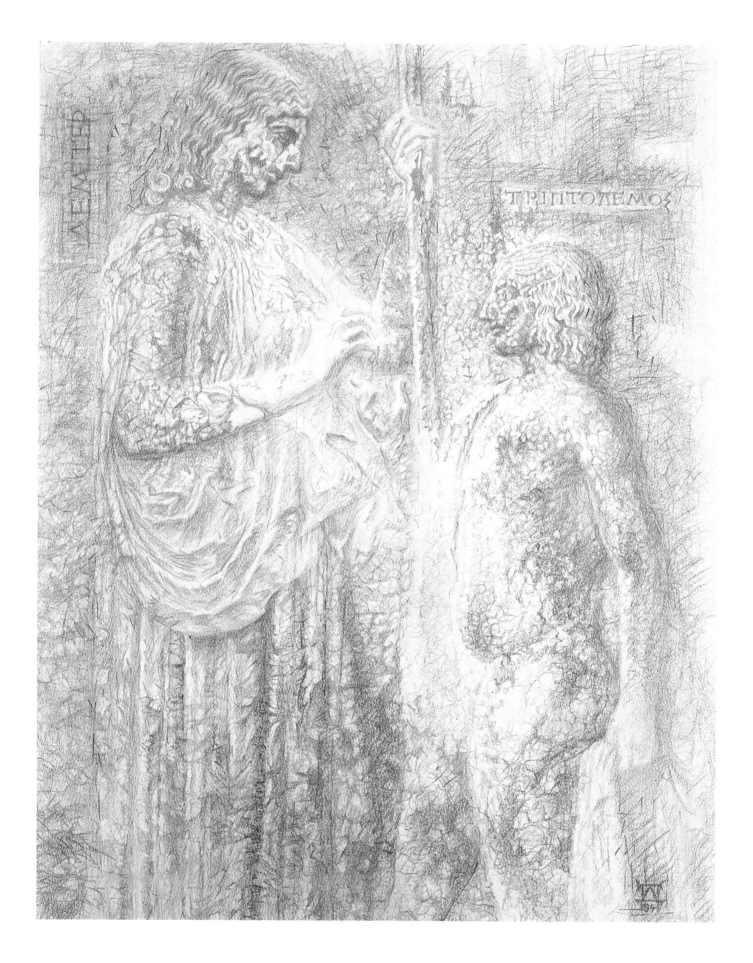

Demethra. Ancient Relief, 1994. Colored pencil on paper, 28¹ᐟ² x 21 in. 73 x 53 cm
Artist Collection

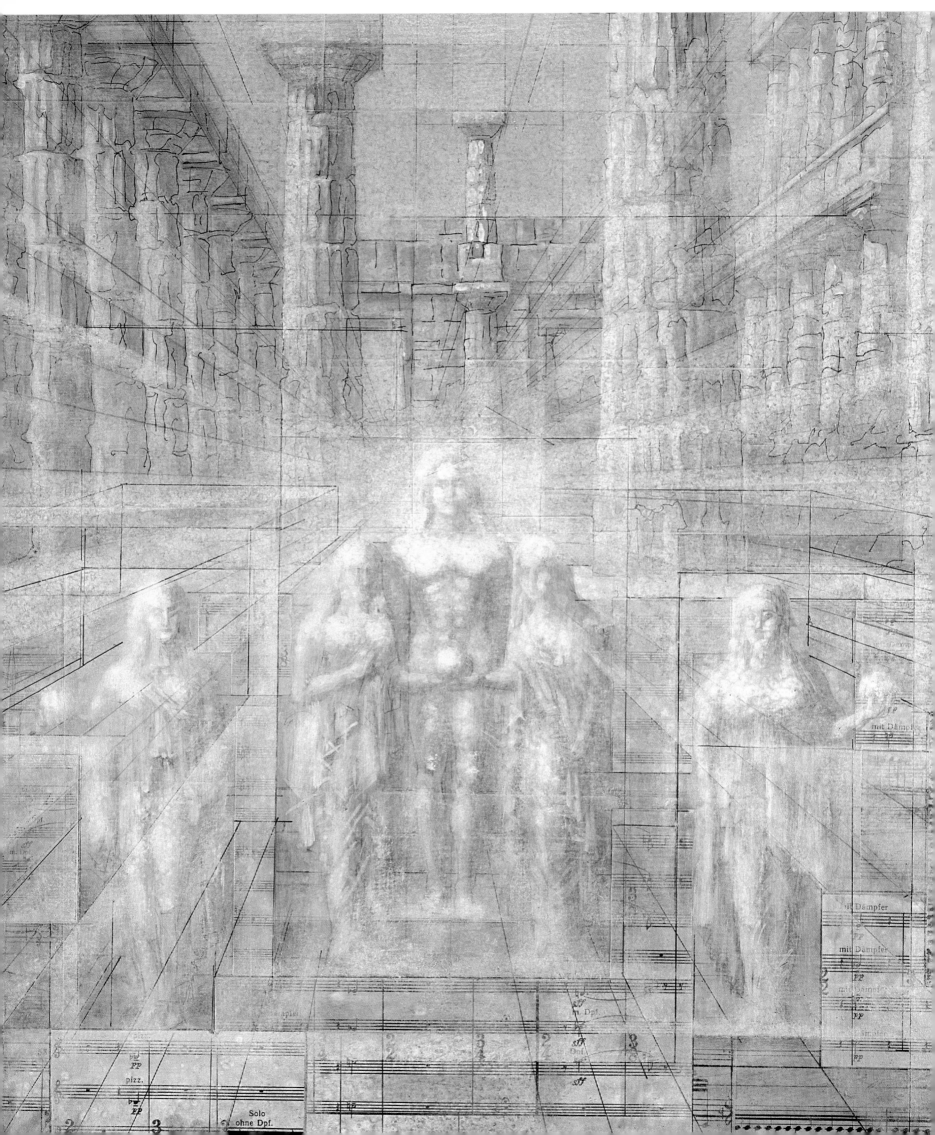

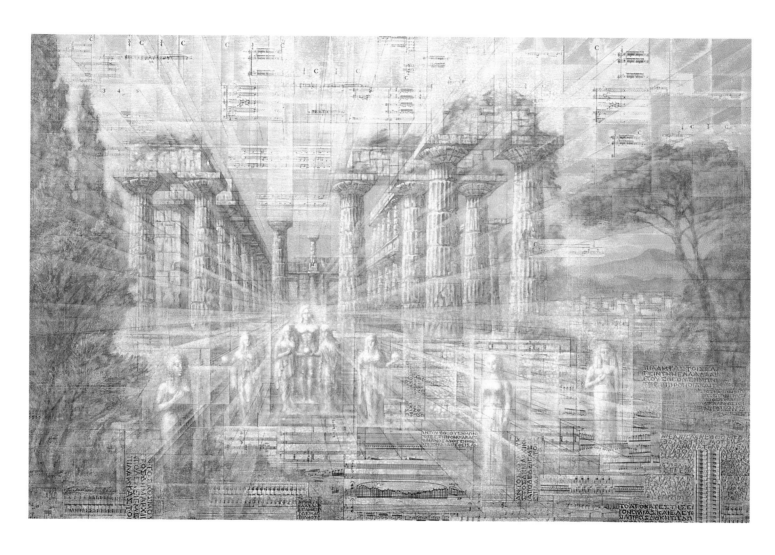

Apollo and Muses, 1995, Oil, acrylic, collage on canvas, 42 x 64 in. 107 x 163 cm
Hank and Nancy Corwin Collection, New York

Apollo and Muses (detail), 1995

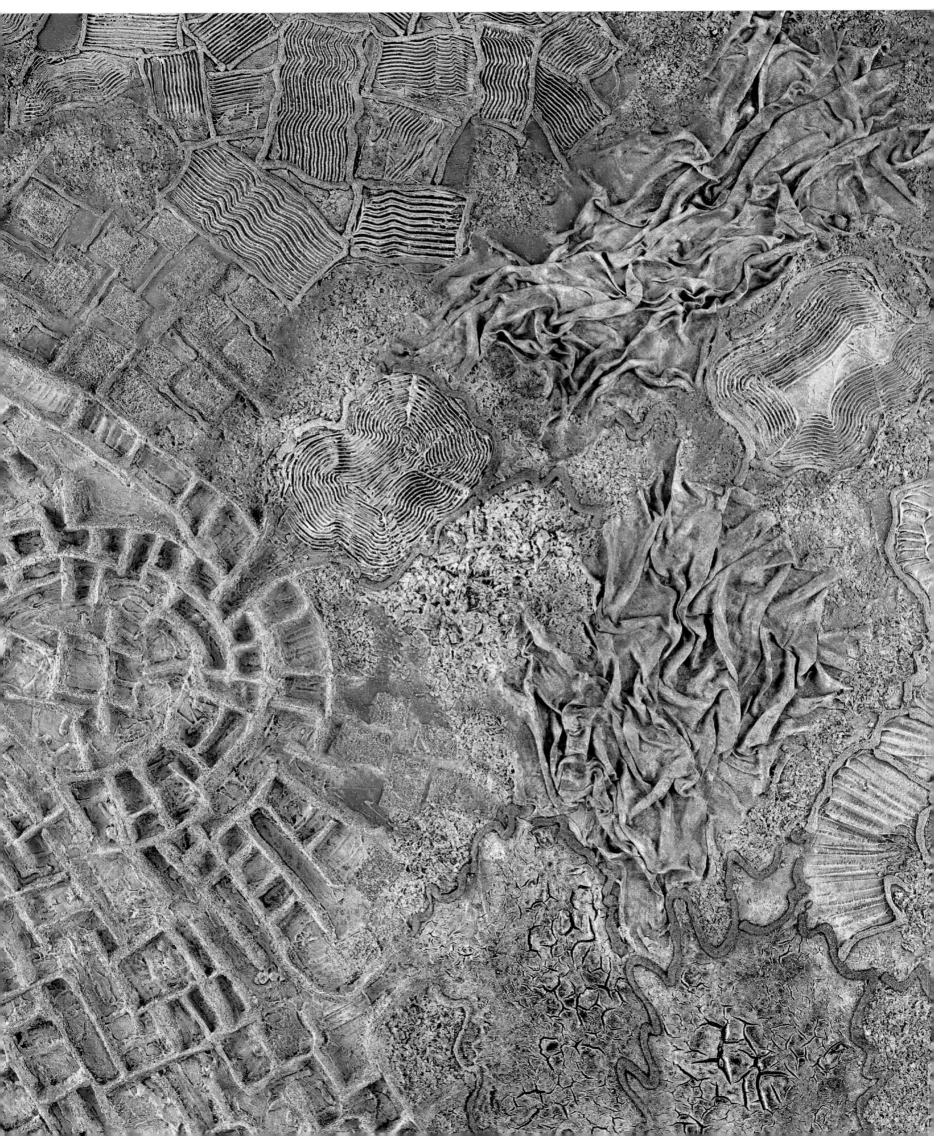

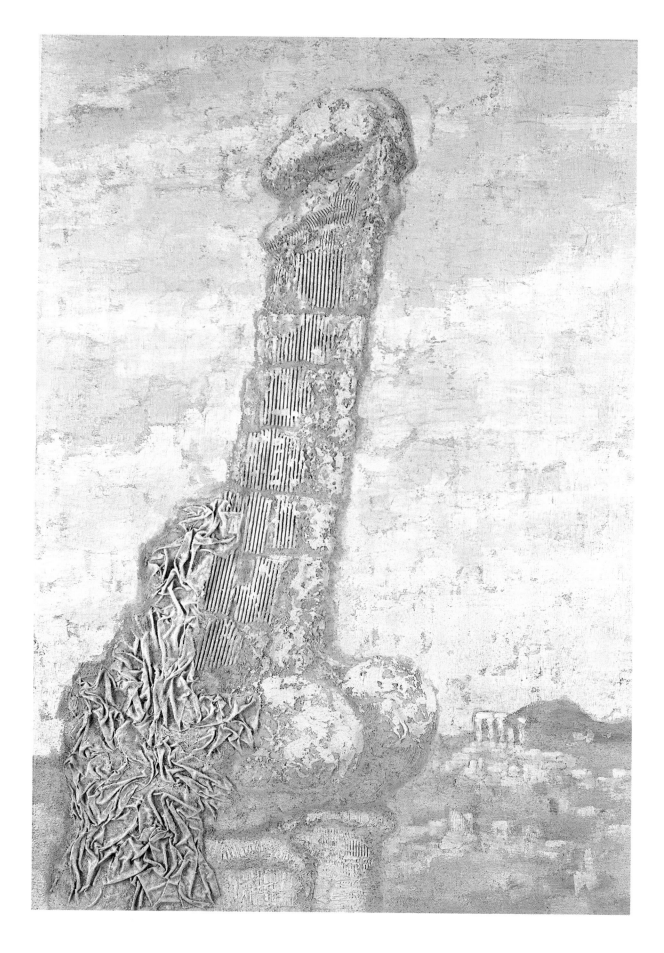

Dionysian Element, 1995, Oil, sand, acrylic, collage on canvas, 74 x 50 in. 188 x 127 cm
Aleksander Kotyolkin Collection, Moscow

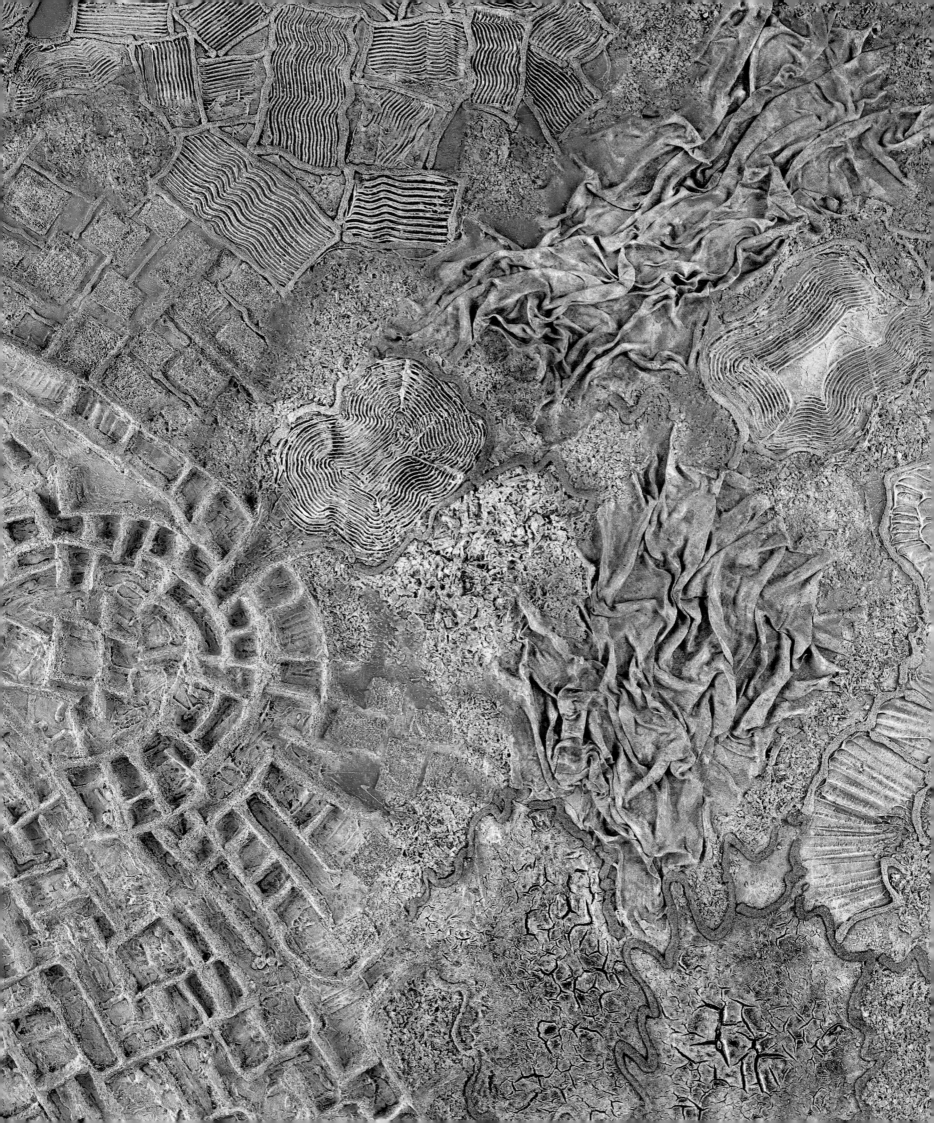

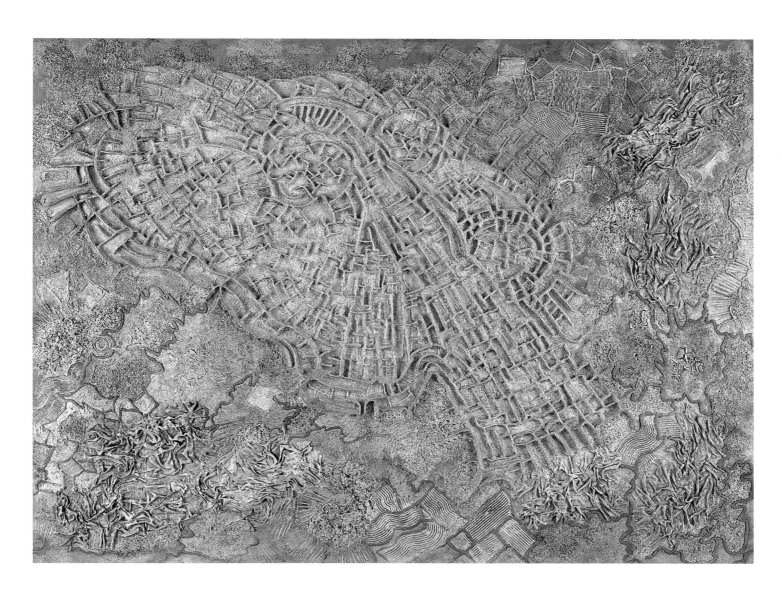

Golden Mask of Mycenae, 1995, Oil, sand, acrylic, synthetics, collage on canvas, 60 x 80 in. 153 x 203 cm
Artist Collection

Golden Mask of Mycenae (detail), 1995

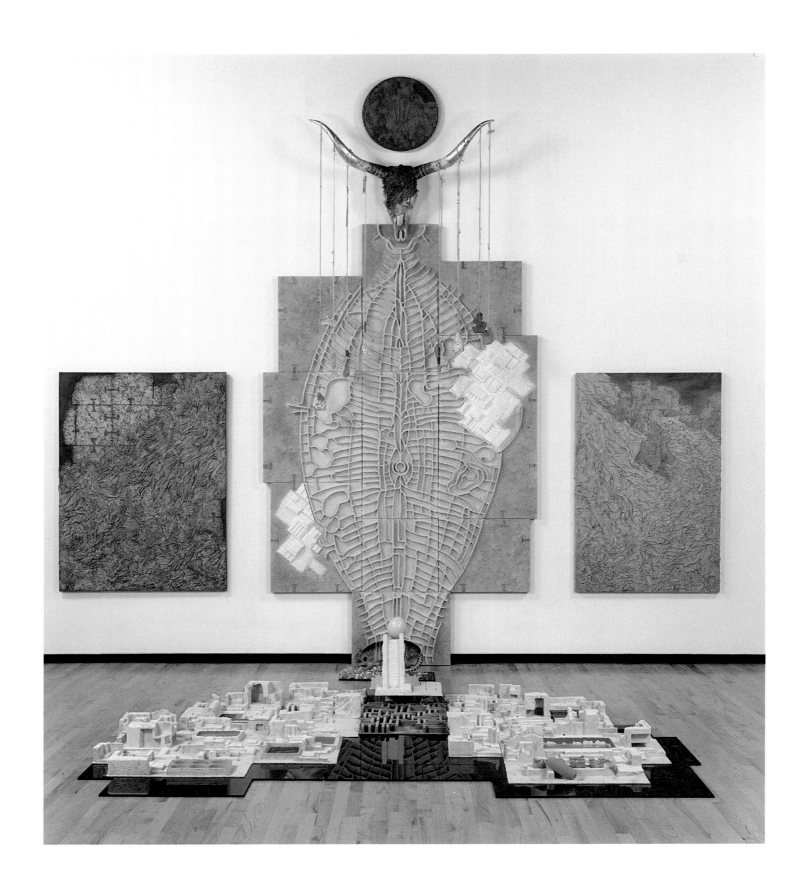

Knossos. Installation, 1995, Part I on the floor: *Knossos Palace* , Part II on the wall: *Minotaur's Labyrinth*
Oil, colored sand, acrylic, metal, synthetics, masonite on plastic and linen with ready-made objects
162 x 100 x 110 in. 411 x 254 x 280 cm
Artist Collection

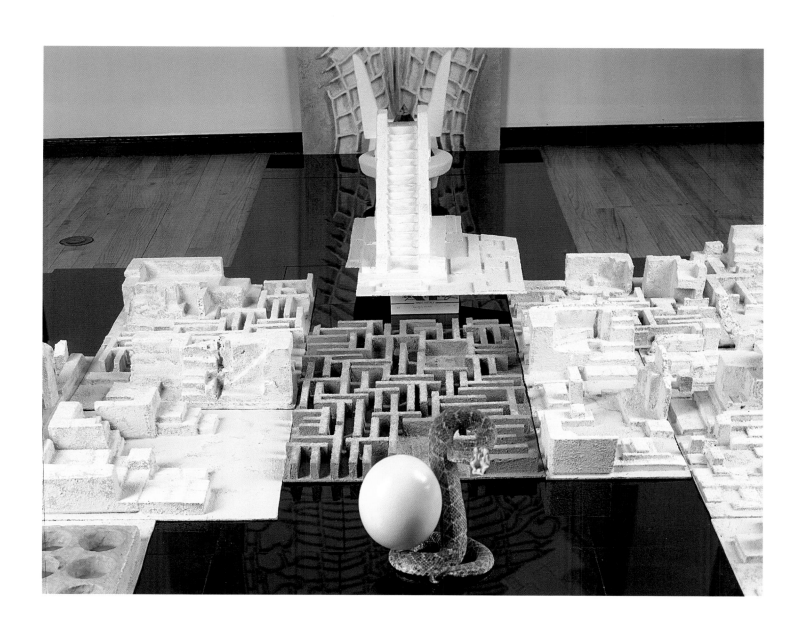

Knossos (detail of installation), 1995

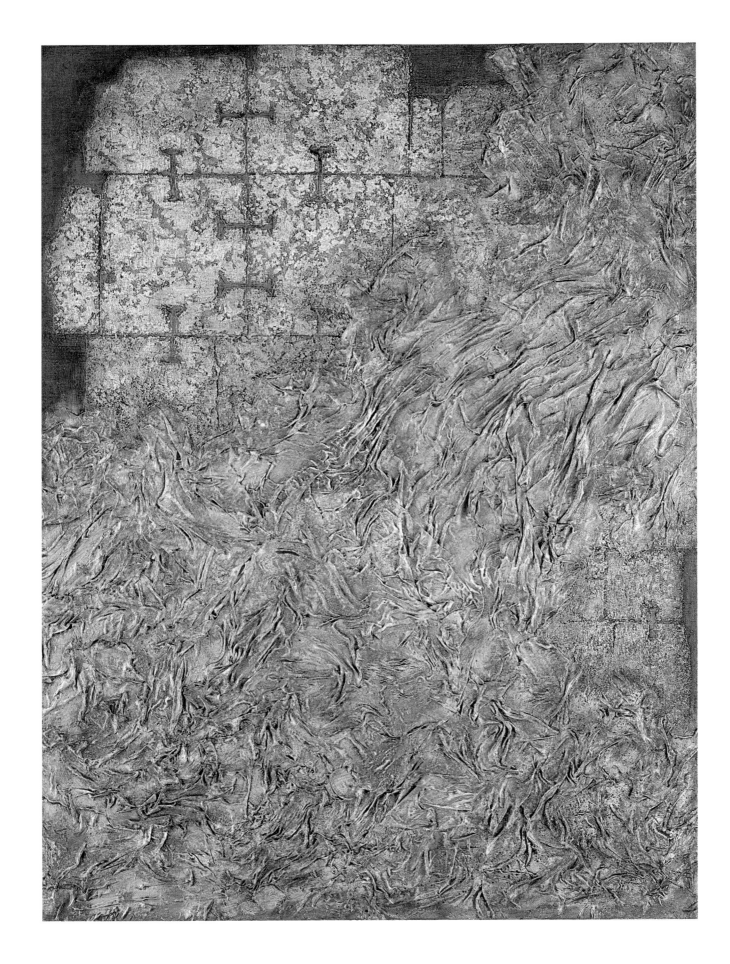

Hurricane of Time I, 1995, Oil, sand, acrylic, fabric on canvas, 60 x 42 in. 153 x 107 cm
Tatiana and Natalia Kolodzei Collection, Moscow, Russia; and Highland Park, USA

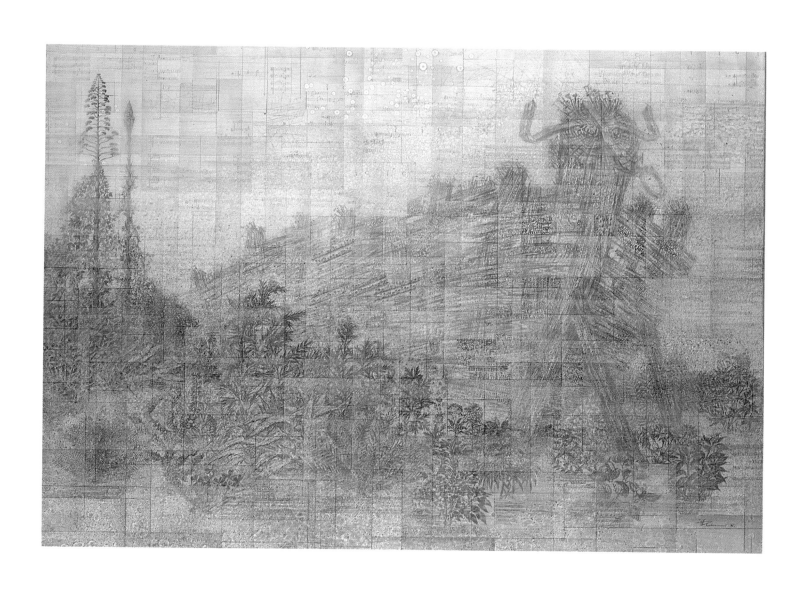

Lost Ship, 1995, Oil, acrylic, collage on canvas, 50 x 68 in. 127 x 173 cm
Joann and Charles Clayman Collection, Chicago and Bloomfield Hills, USA

V. Amalgam Tilted in Azure

Arms and the man I sing, the first who came,
Compelled by fate, an exile out of Troy,
To Italy and the Lavinian coast,
Much buffered on land and on deep
By violence of the gods, through that long rage,
That lasting hate, of Juno's. And he suffered
Much, also in war, till he should build his town
And bring his gods to Latium, whence, in time,
The Latin race, the Alban fathers, rose
And the great walls of everlasting Rome.

Virgil, *Aeneid*, Book I.

That's how orchestras fade. The city, while words are at it,
is akin to attempts to salvage notes from silent beat,
and the palazzi, like music stands, stand scattered,
hoarded and poorly lit.
Only up where Perm's citizen sleeps his lasting sleep, a falsetto
star is vibrating through telegraph wires, reaches a minor key.
But the water applauds, and the quay is hoarfrost settled
down on a do-re-mi.

Joseph Brodsky, *Venetian Stanzas I*, VII.

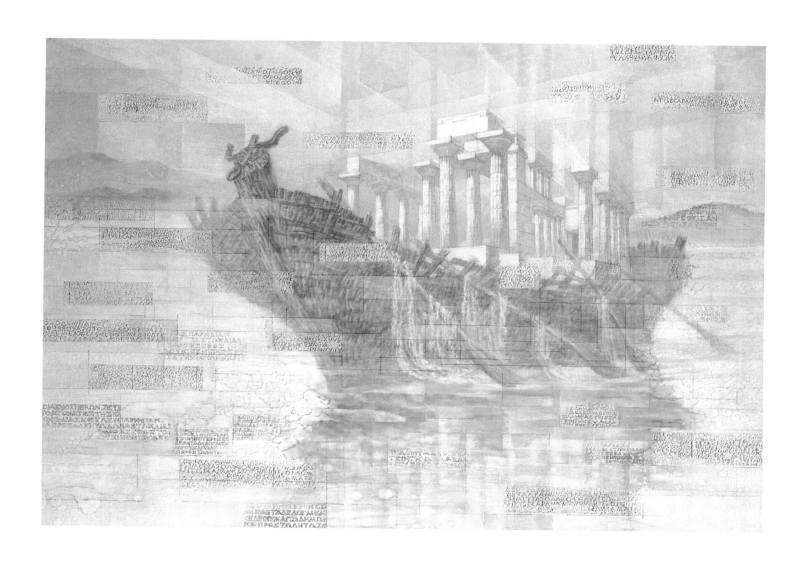

Mirage in Aegean Sea, 1995. Oil, acrylic, collage on canvas, 42 x 60 in. 107 x 153 cm
Ben-Zion and Inge Zelman Collection, Raamana, Israel

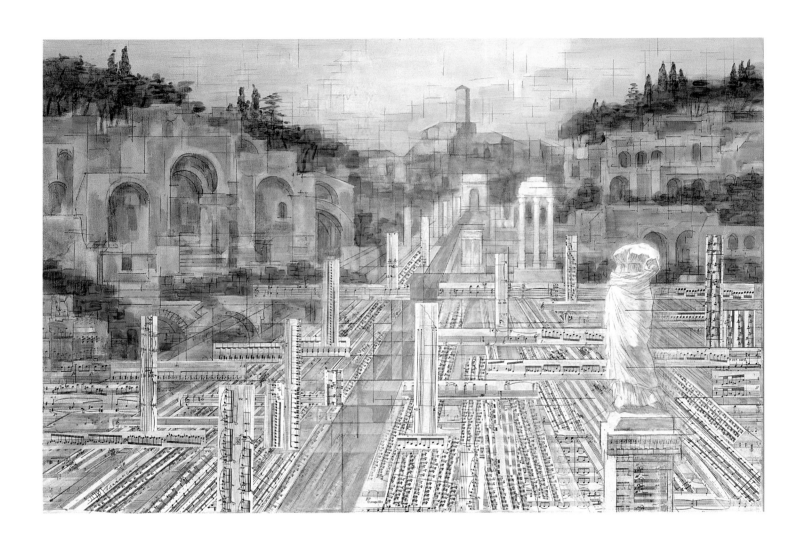

Roman Forum, 1998, Oil, acrylic, collage on canvas, 26 x 38 in. 66 x 97 cm
Ruth Anne Dreisbach Collection, New York

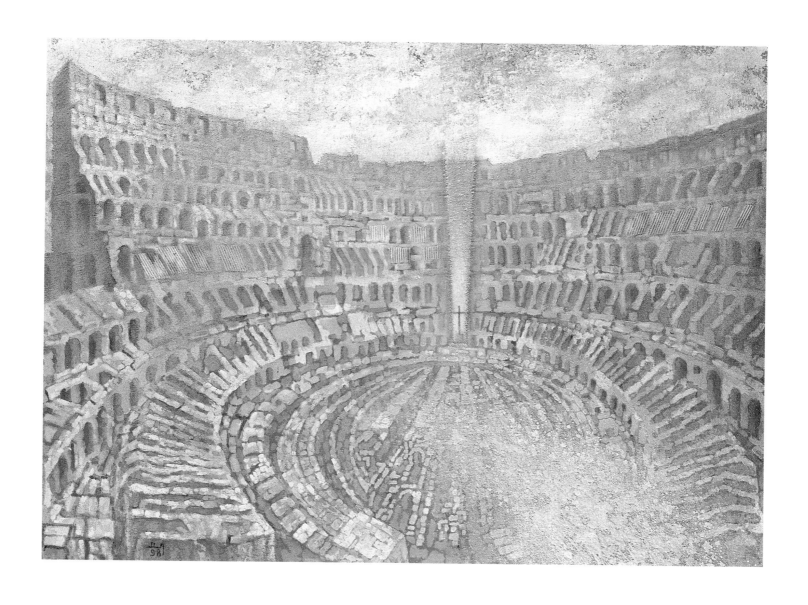

Coliseum, 1998, Oil, sand, marble dust, cardboard, acrylic on canvas, 60 x 80 in. 153 x 203 cm
Aleksander Kotyolkin Collection, Moscow

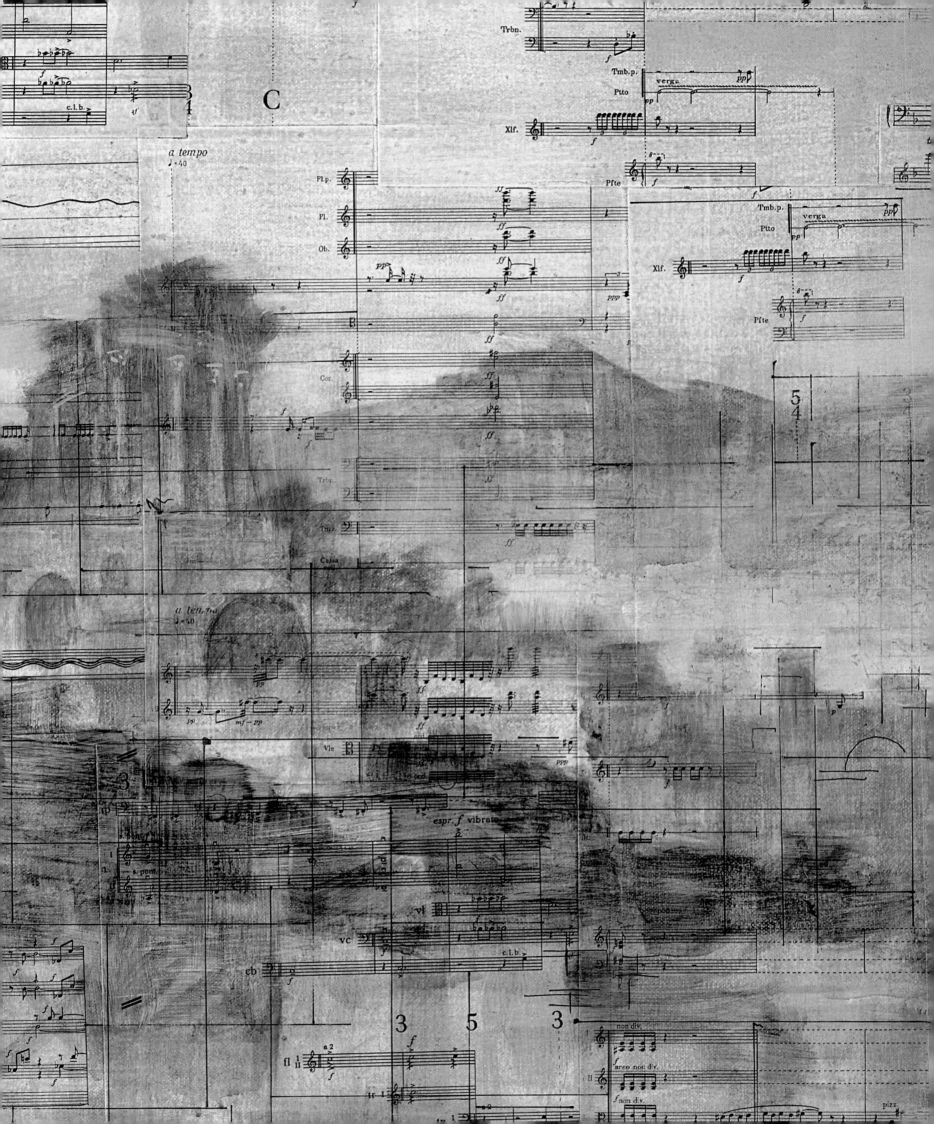

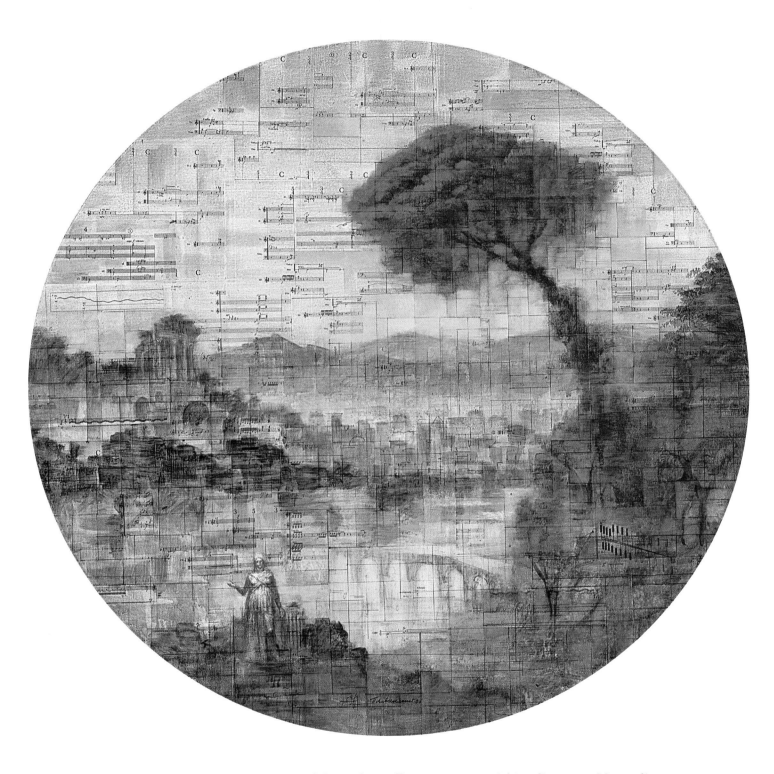

The Temple of Sybil at Tivoli, 1998, Oil, acrylic, collage on canvas, 36 in. diameter, 92 cm diameter
Ryan Collection, New York

The Temple of Sybil at Tivoli (detail), 1998

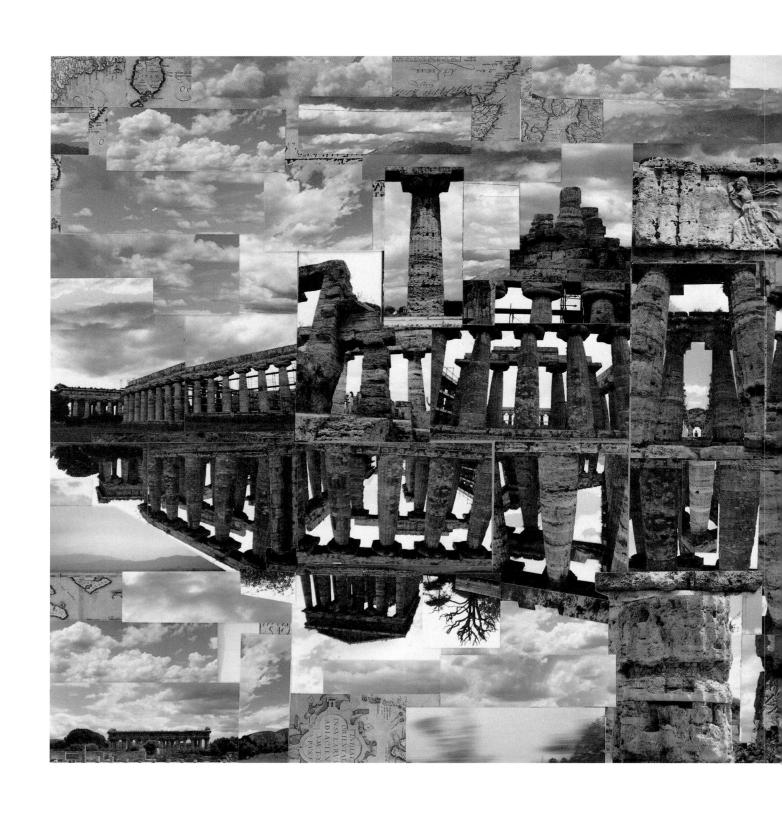

Paestum Vessel, 1999, Photo-collage, 22 x 48 in. 56 x 122 cm
Artist Collection

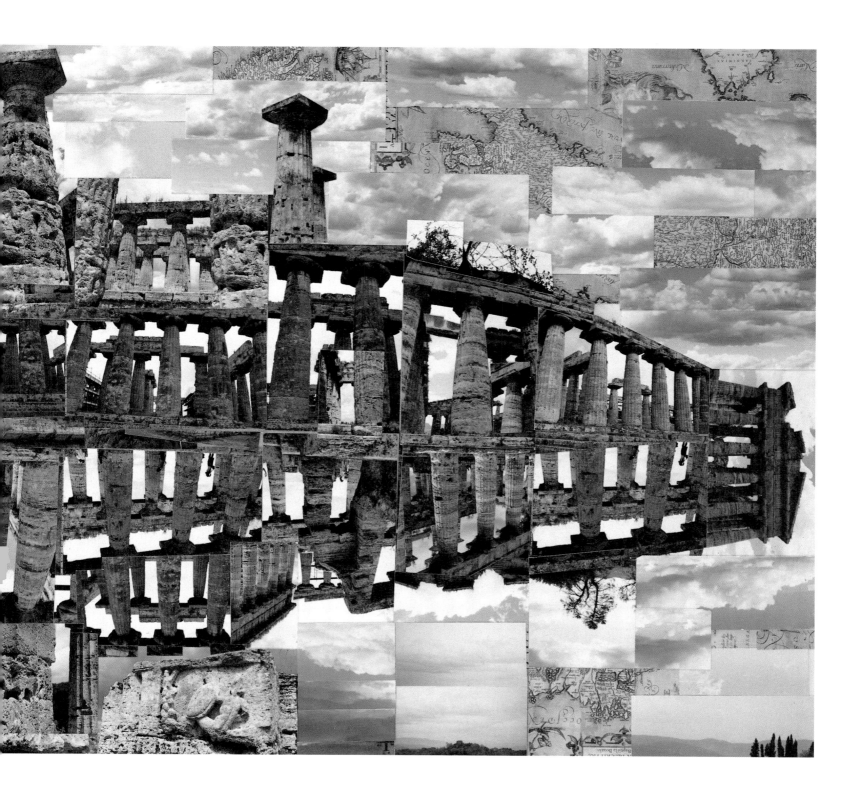

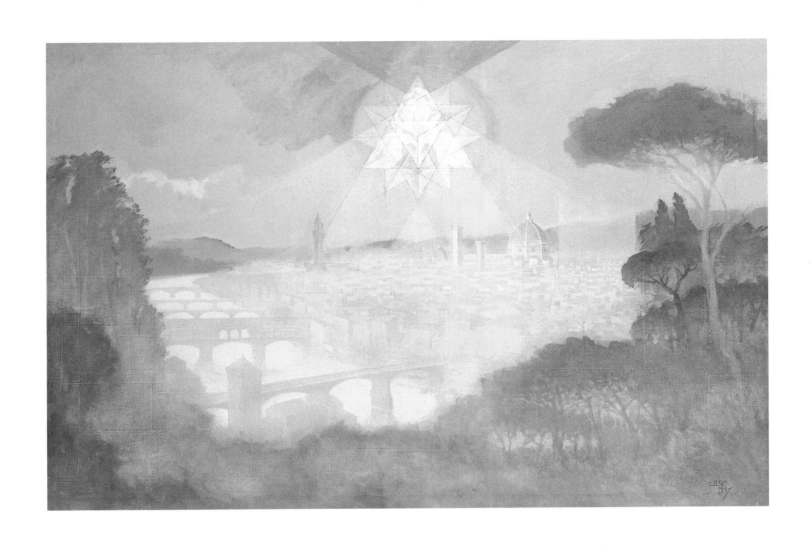

Arno Bridges, 1997, Oil, acrylic on canvas, 42 x 62 in. 107 x 158 cm
Michael and Lynda Gardner Collection, New York

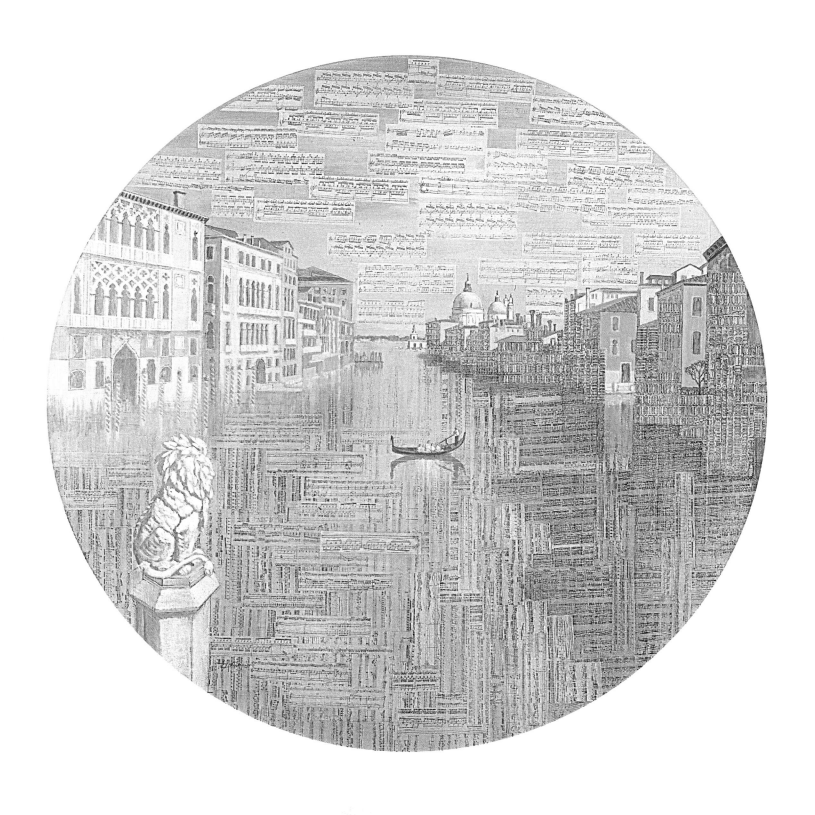

Vivaldi's Music upon Grand Canal, 1997, Oil, acrylic, collage on canvas, 60 in. diameter, 153 cm diameter
Leslie Glass Collection, New York

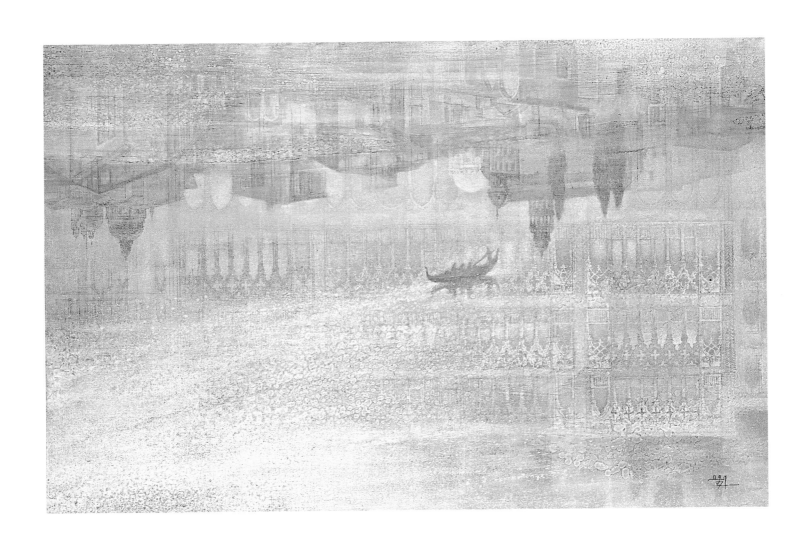

Evening in Venice, 1997, Oil, acrylic on canvas, 42 x 62 in. 107 x 158 cm
Patricia Levy Collection, New York

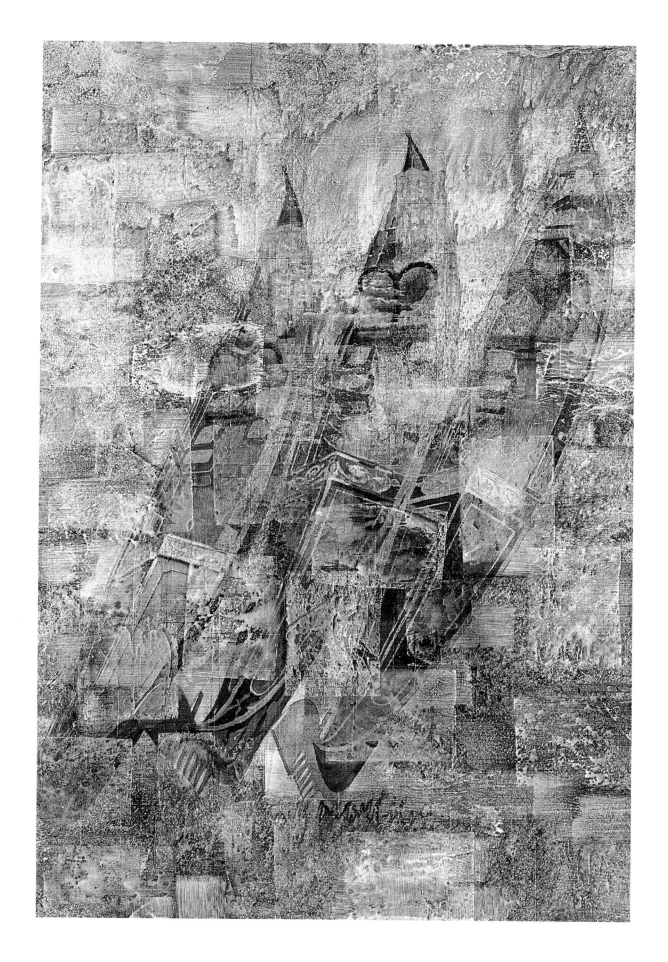

Gondolas, 1997, Oil, acrylic, collage on canvas, 64 x 42 in. 163 x 107 cm
Ivan Blinoff Collection, Geneva

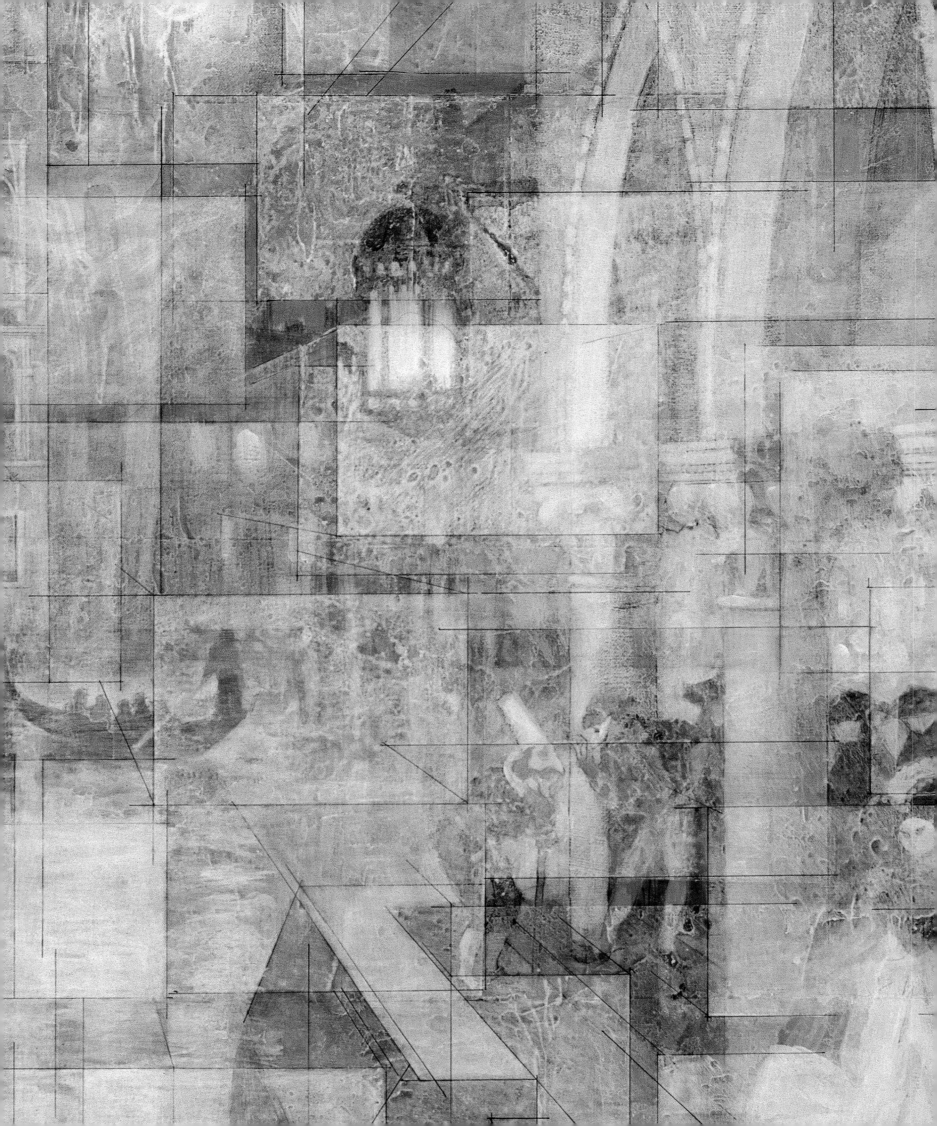

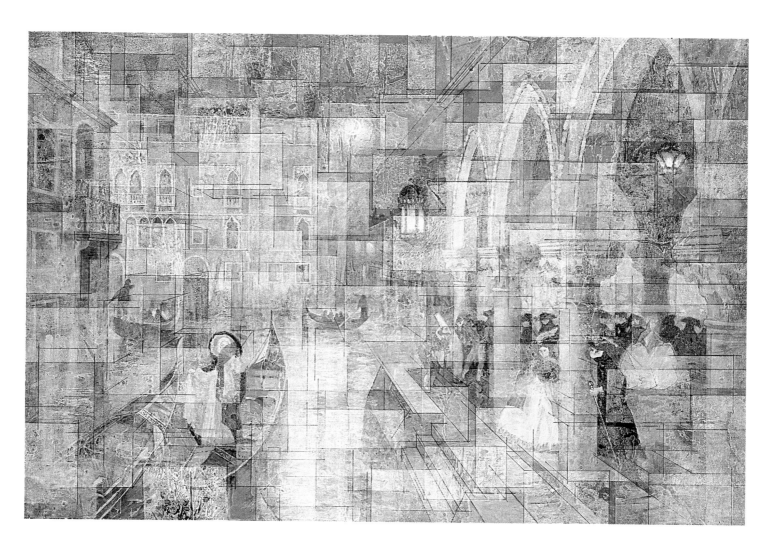

Venetian Secrets, 1997, Oil, acrylic, collage on canvas, 41 x 59 in. 104 x 150 cm
Leslie Glass Collection, New York

Venetian Secrets (detail), 1997

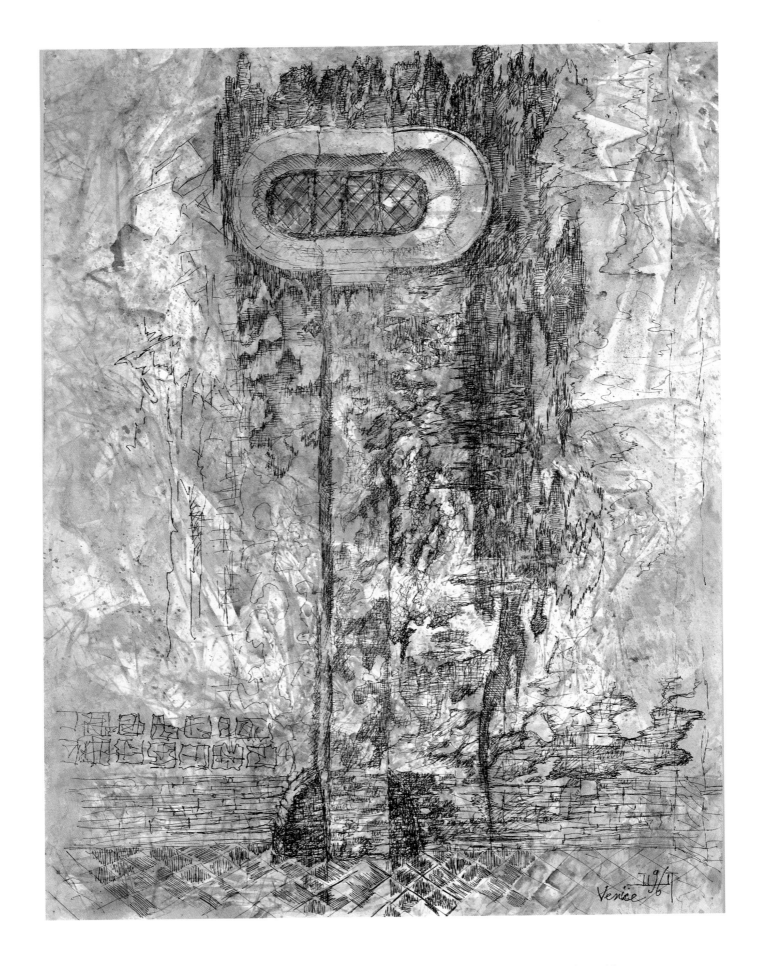

Wall of the Church, 1996, Watercolor, pen and ink on paper, 24 x 19 in. 61 x 48 cm
Michael and Lynda Gardner Collection, New York

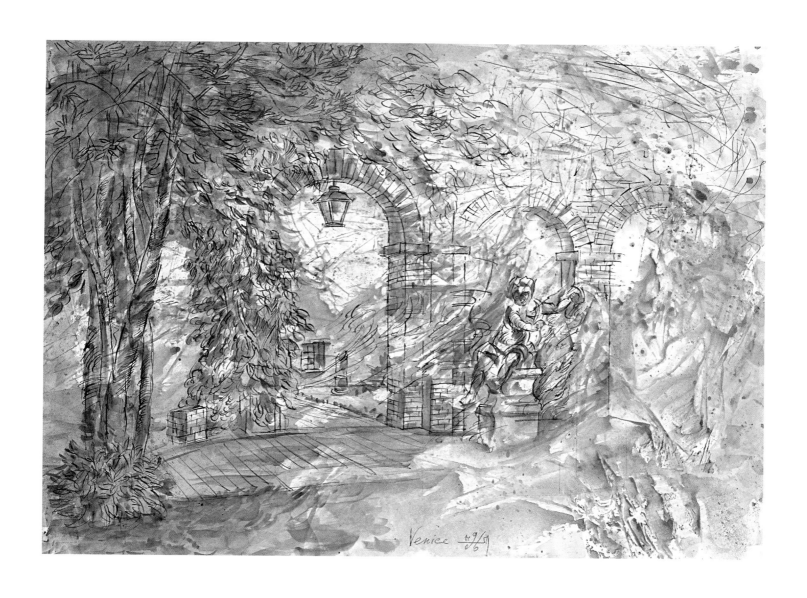

Venetian Courtyard, 1996, Watercolor, pen and ink on paper, 18 x 24 in. 45.5 x 61 cm
Artist Collection

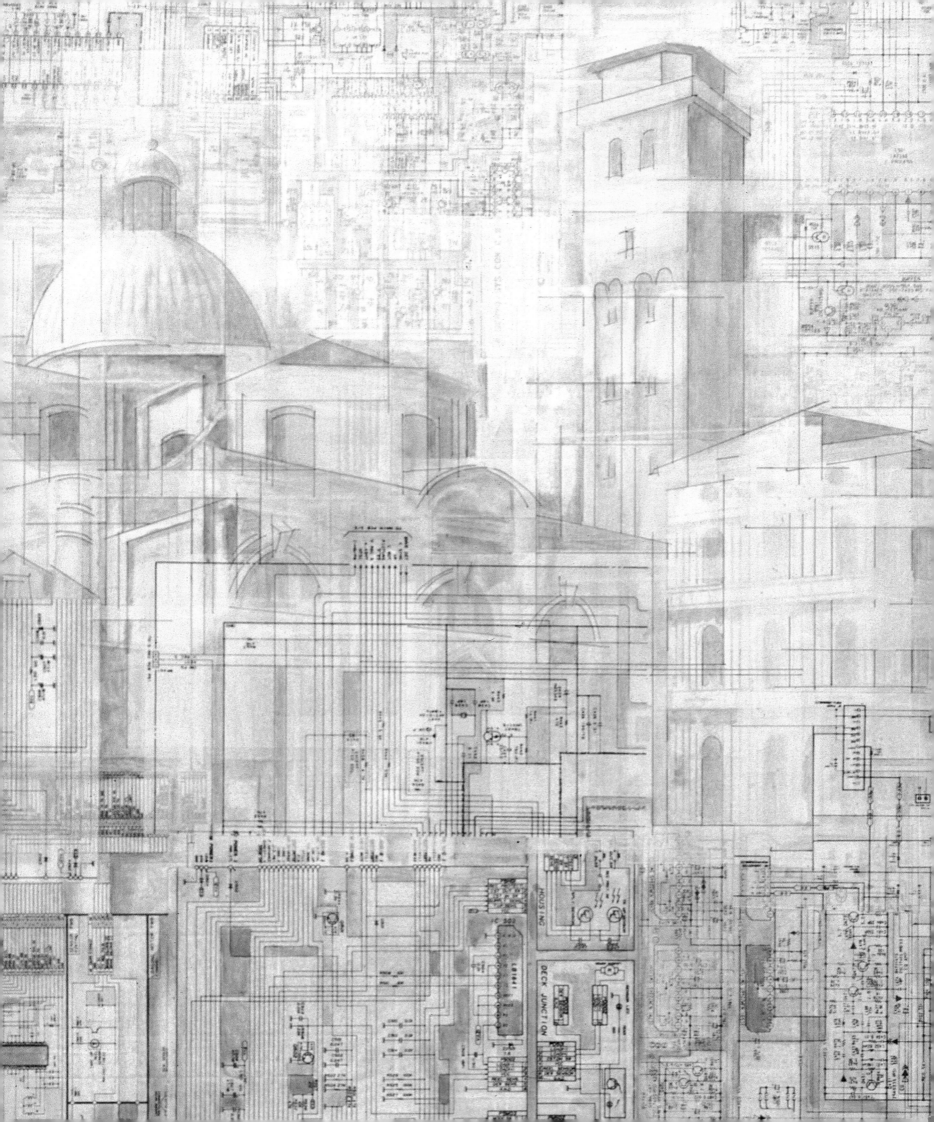

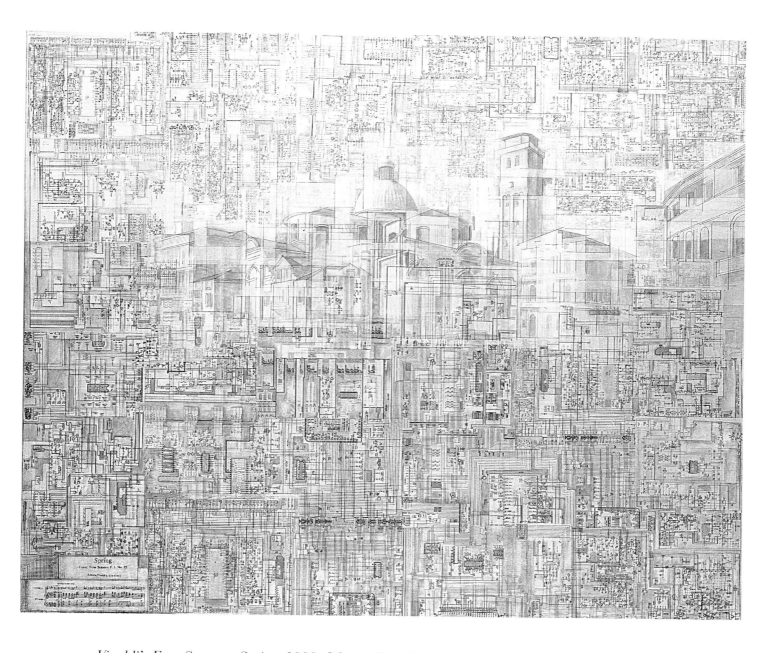

Vivaldi's Four Seasons. Spring, 1998, Oil, acrylic, collage on canvas, 42 x 50 in. 107 x 127 cm
James Tod Collection, London

Vivaldi's Four Seasons. Spring (detail), 1998

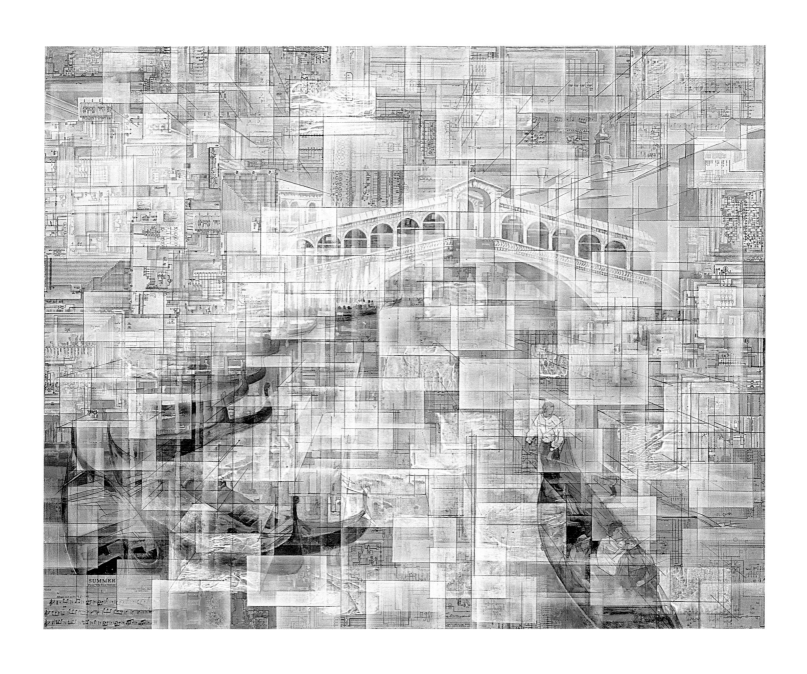

Vivaldi's Four Seasons. Summer, 1998, Oil, acrylic, collage on canvas, 42 x 50 in. 107 x 127 cm
Private Collection, New York

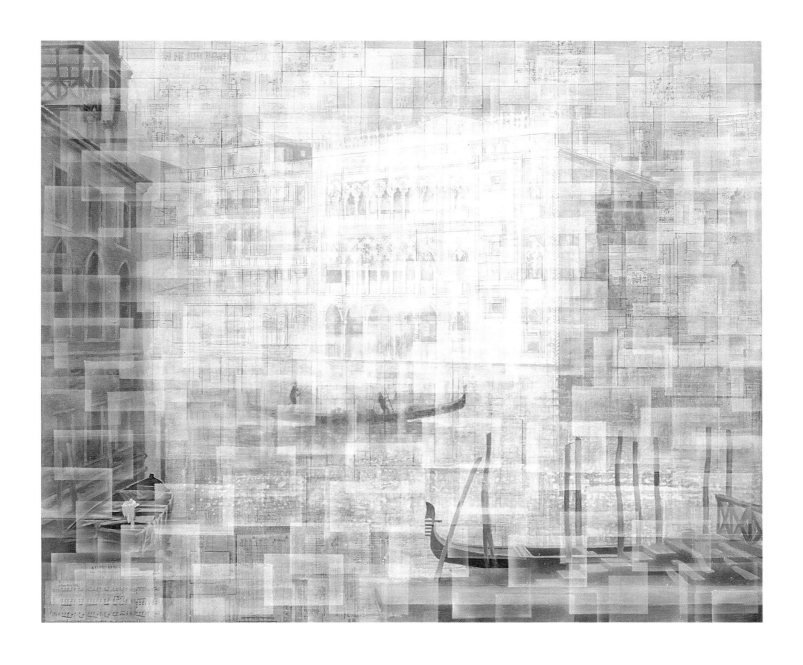

Vivaldi's Four Seasons. Autumn, 1998, Oil, acrylic, collage on canvas, 42 x 50 in. 107 x 127 cm
Jeffrey and Cathy Friedland Collection, Denver, USA

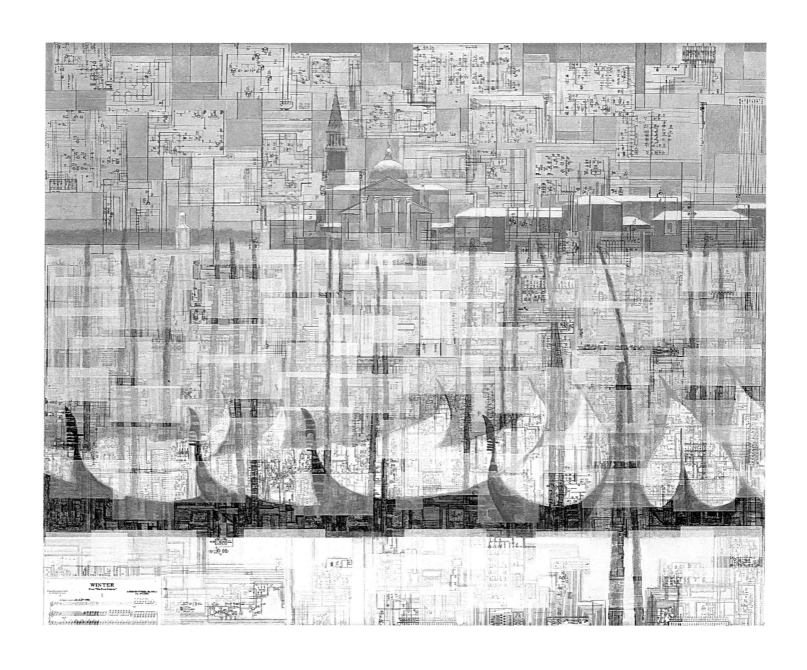

Vivaldi's Four Seasons. Winter, 1998, Oil, acrylic, collage on canvas, 42 x 50 in. 107 x 127 cm
Beumer-Vorfeli Collection, Schoten, Belgium

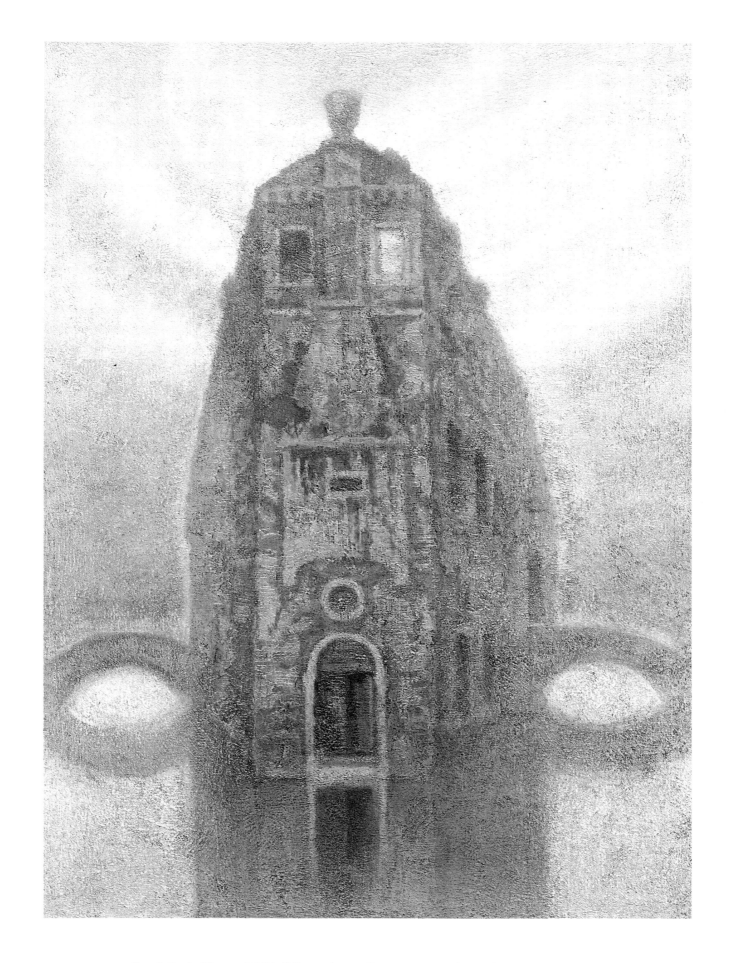

Gondolier's House, 1997, Oil, sand, acrylic on canvas, 58 x 42 in. 148 x 107 cm
Artist Collection

Venetian Spirit II, 1998. Oil, sand, acrylic on canvas, 42 x 36 in. 107 x 91.5 cm
Artist Collection

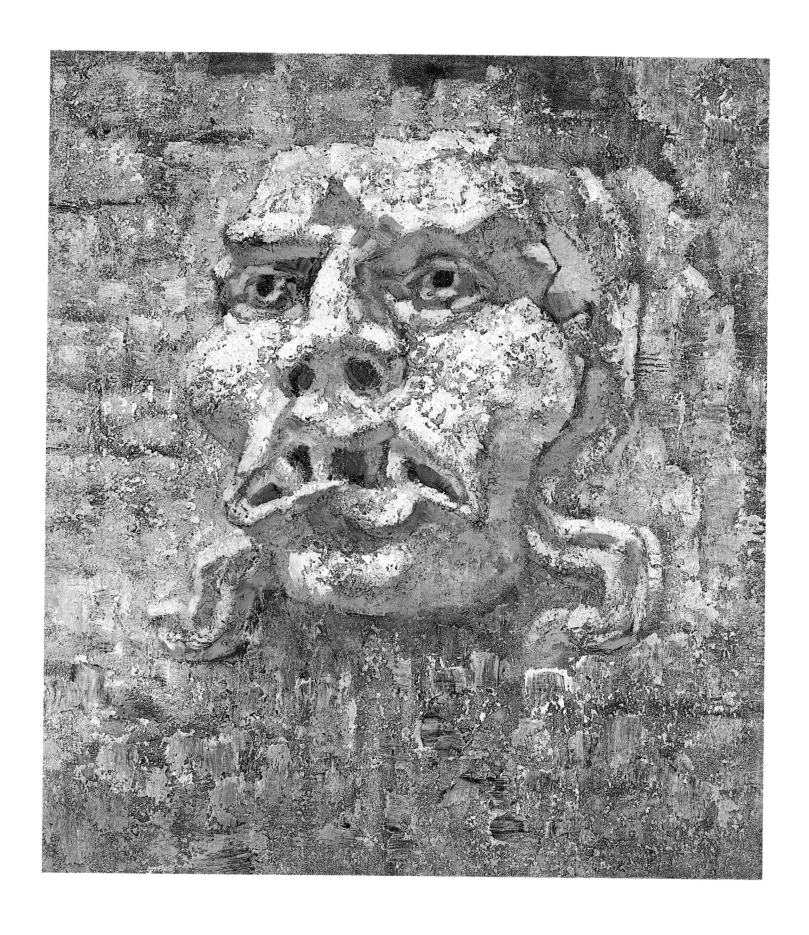

Venetian Spirit I, 1998, Oil, sand, acrylic on canvas, 42 x 36 in. 107 x 91.5 cm
Christian Homan Collection, New York and Amsterdam

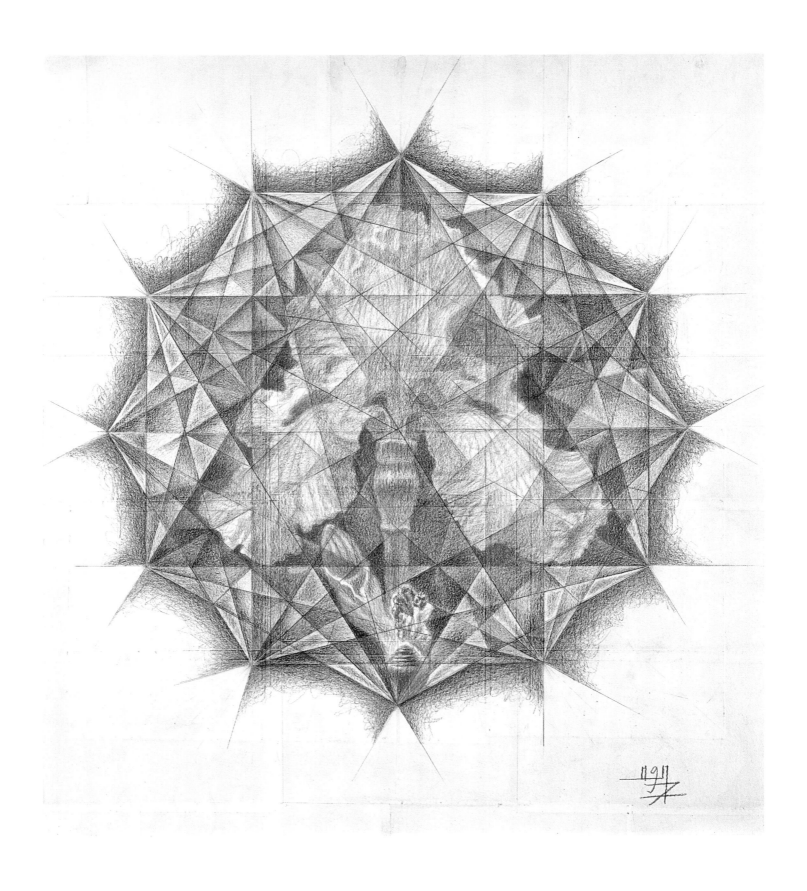

Geometry of Iris, 1997, Colored pencil, collage, paper on cardboard, 28¹/⁴ x 29³/⁴ in. 73 x 72 cm
Artist Collection

144

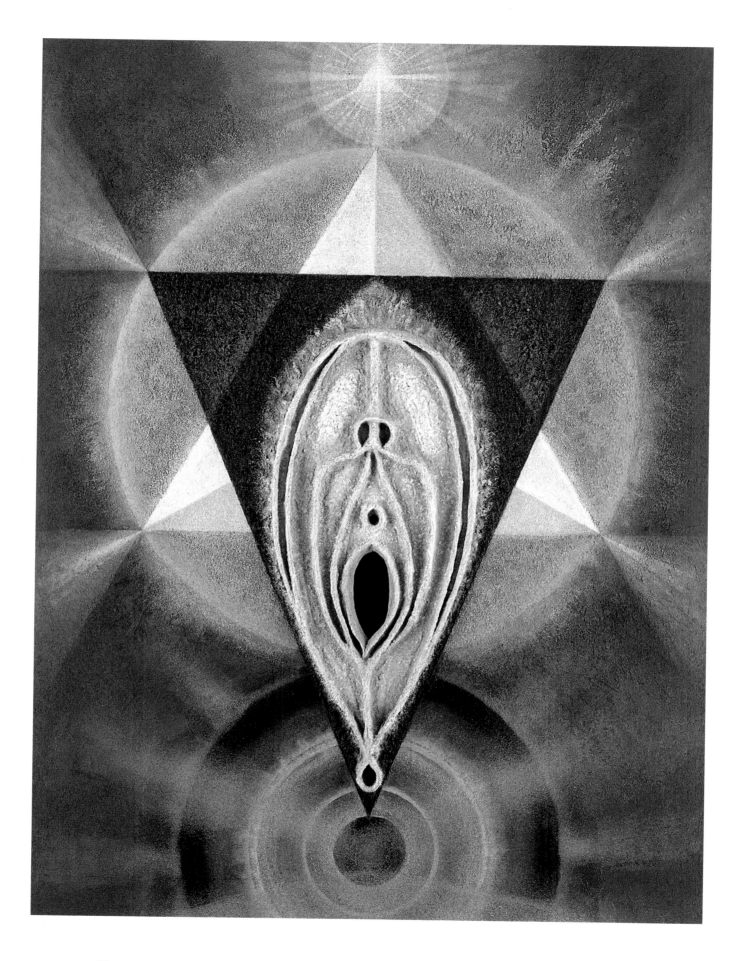

Hexagram, 1998, Acrylic, colored sand, synthetics on masonite, 65 x 48 in. 165 x 122 cm
Artist Collection

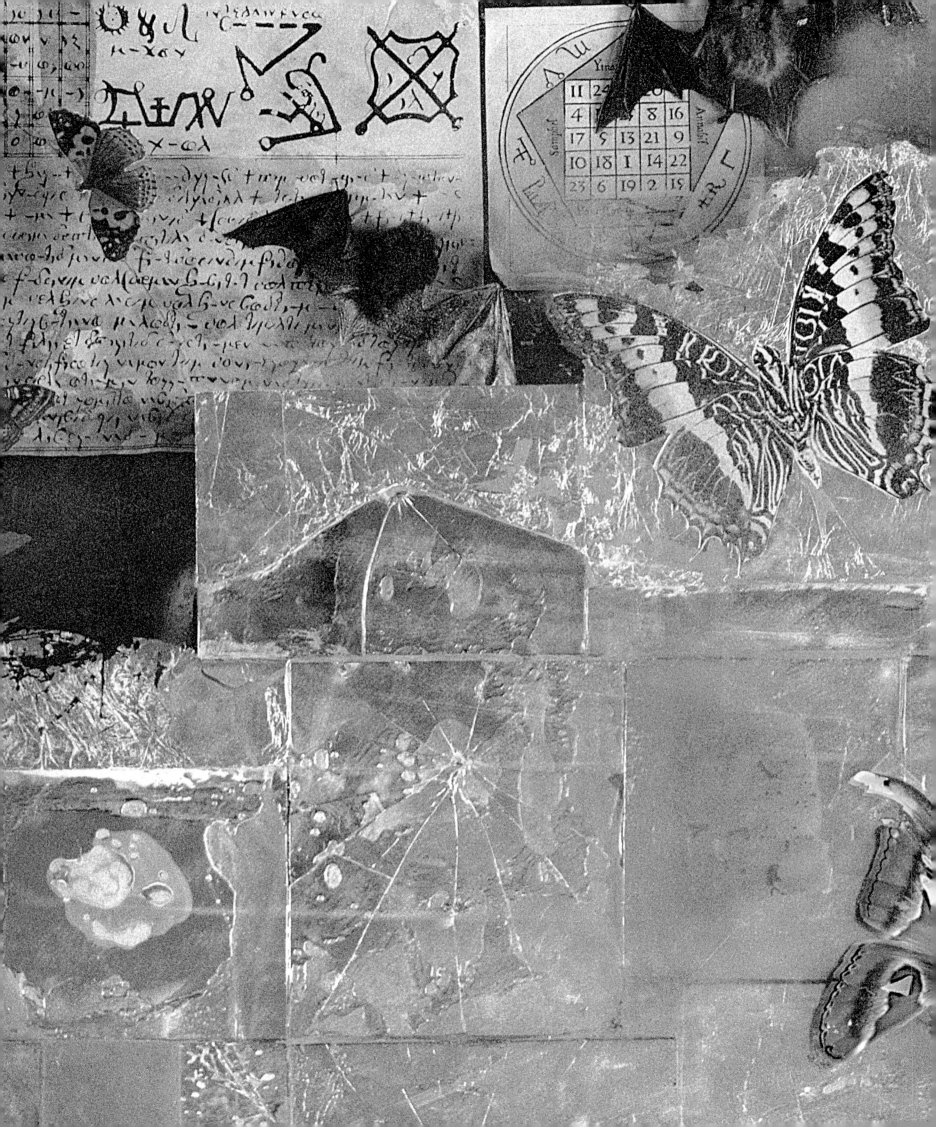

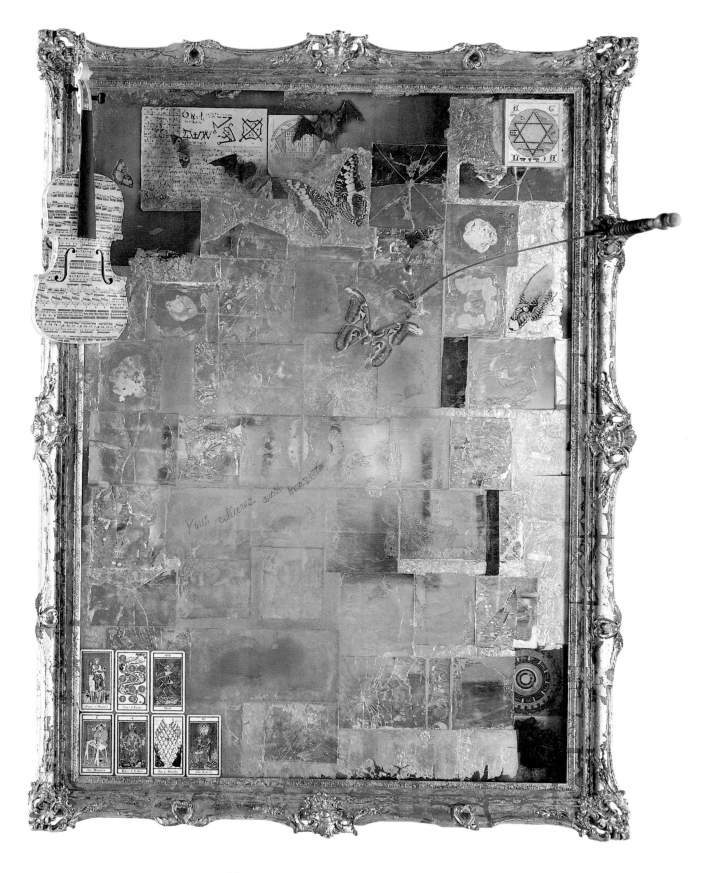

Memory of Venetian Mirror, 1997
Acrylic, golden and silver leaf, mirror, wood, plastic, collage, masonite with ready-mades
67 x 58 x 35 in. 170 x 148 x 89 cm
Artist Collection

Memory of Venetian Mirror (detail), 1997

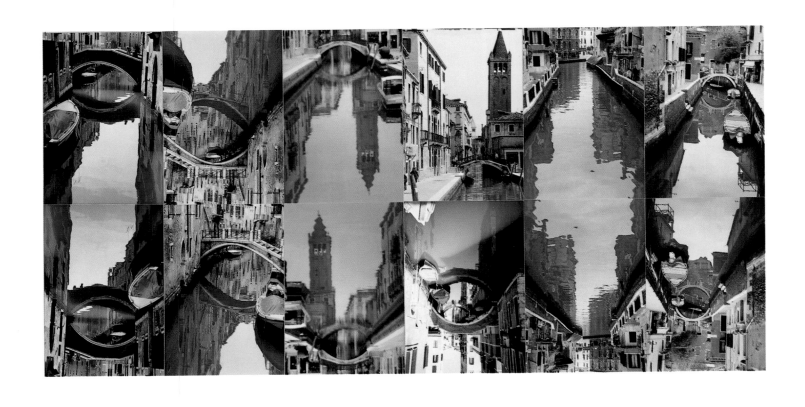

Venetian Baroque, 1998, Photo-collage, 12 x 24 in. 31 x 61 cm
Alberto Sandretti Collection, Venice and Milan

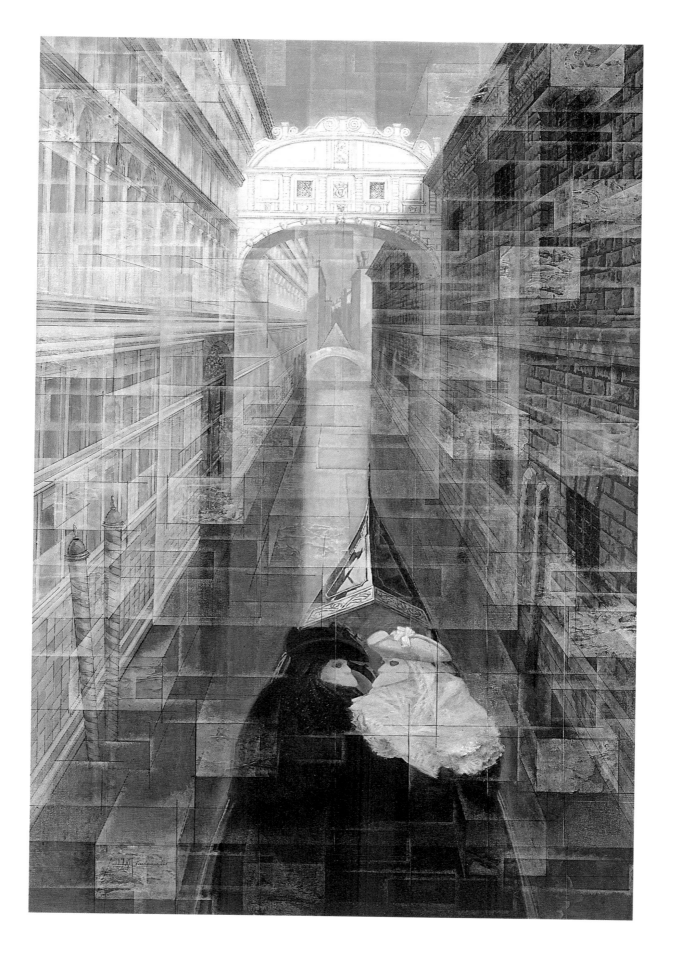

Bridge of Sighs, 1998, Oil, acrylic, collage on canvas, 62 x 42 in. 158 x 107 cm
Private Collection, London

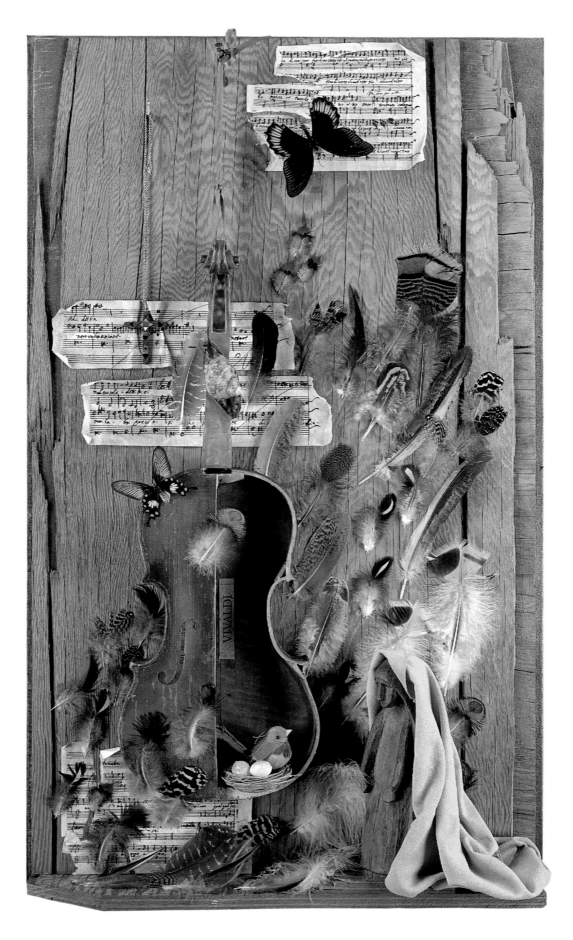

Lost Violin, 1998. Plastic, feathers, paper, shammy with ready-mades objects on plywood
38 x 22 x 5$^{1/2}$ in. 97 x 57 x 14 cm
Alexandre Zouev Collection, Moscow

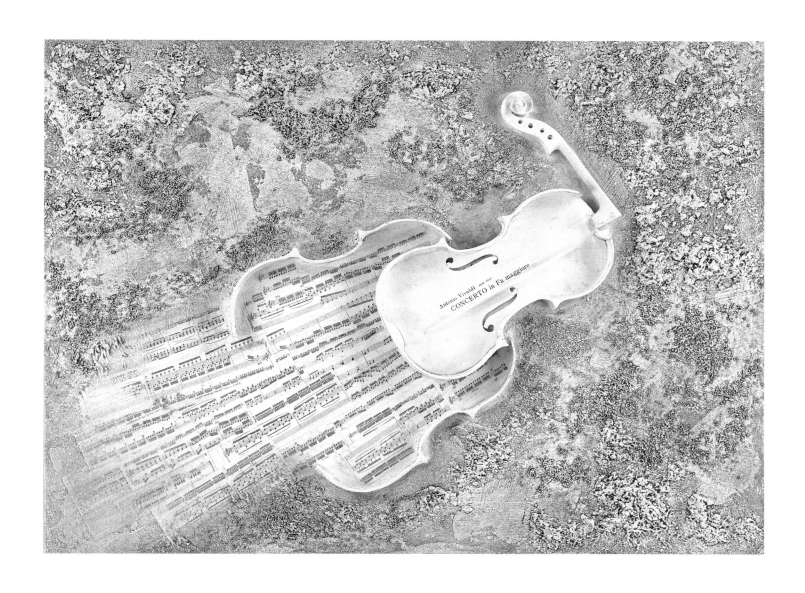

On the Water, 1998. Oil, sand, acrylic, collage, violin on board, 31 x 42 in. 79 x 107 cm
Linda G. Martin Collection, New York

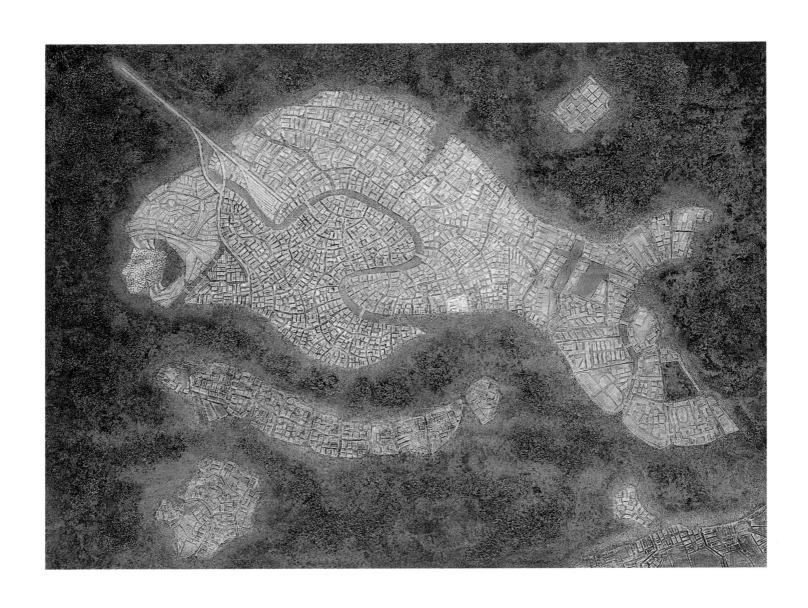

Venetian Cosmogony, 1997, Oil, cardboard, canvas, sawdust, acrylic on canvas, 60 x 80 in. 153 x 203 cm
Artist Collection

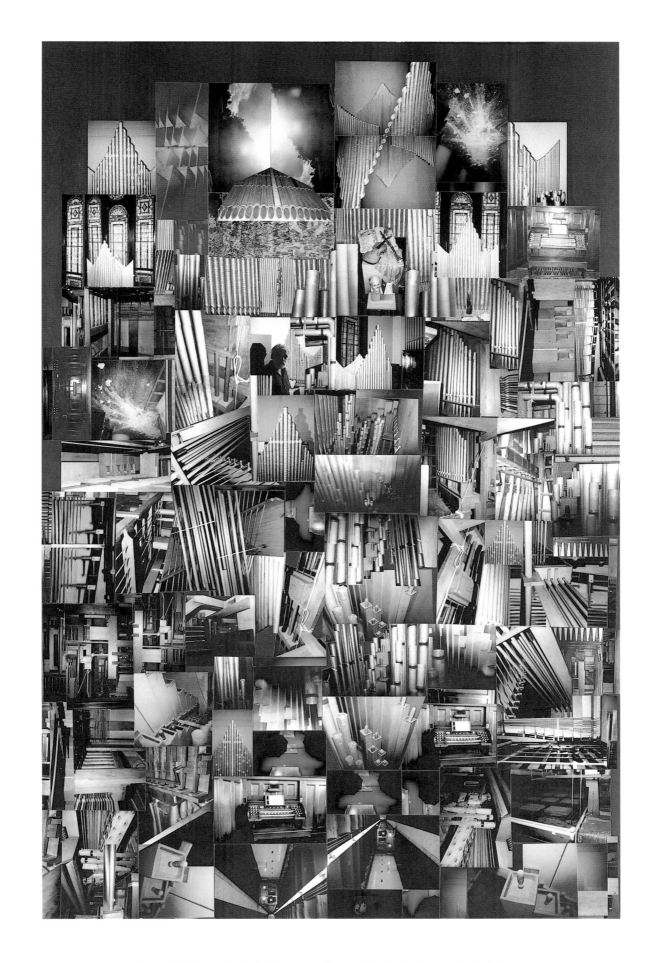

Church Organ, 1999, Photo-collage, 48 x 31¼ in. 122 x 79.5 cm
Artist Collection

153

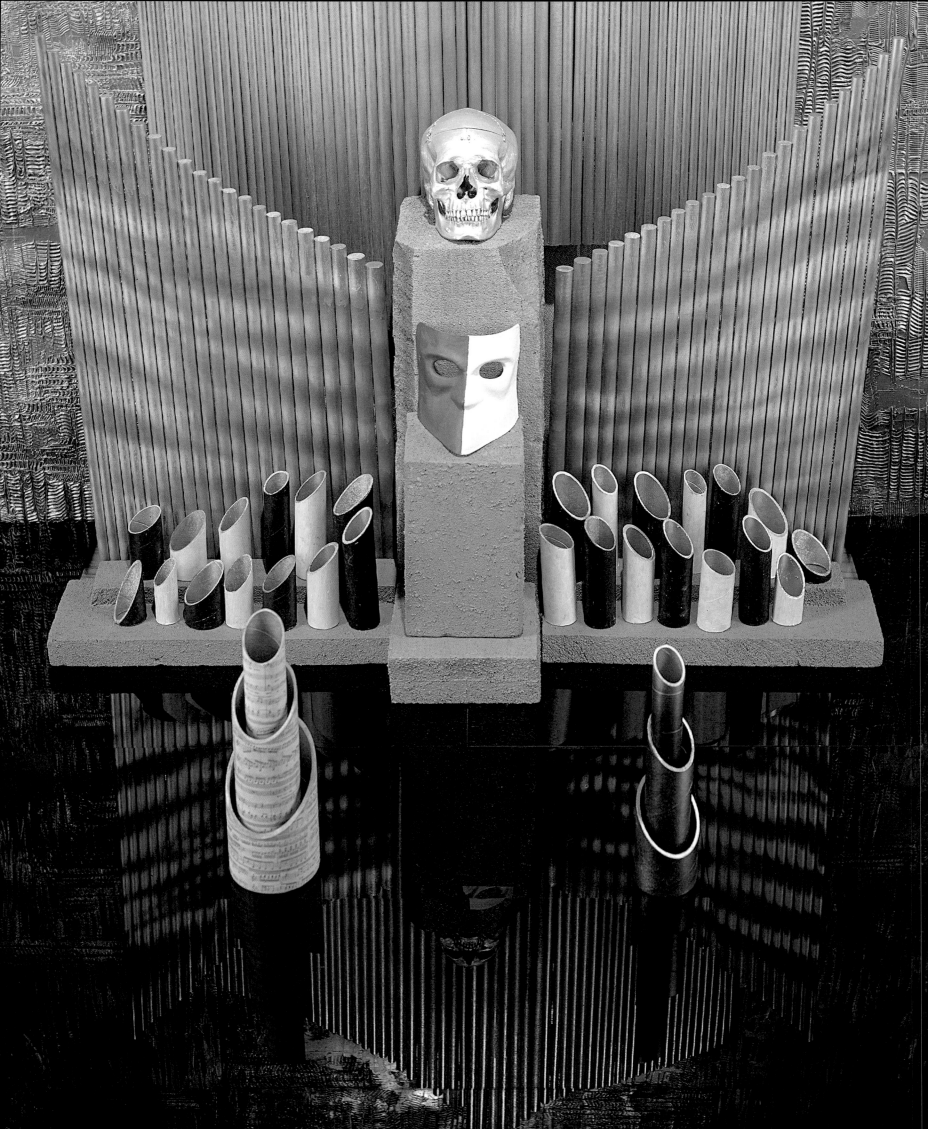

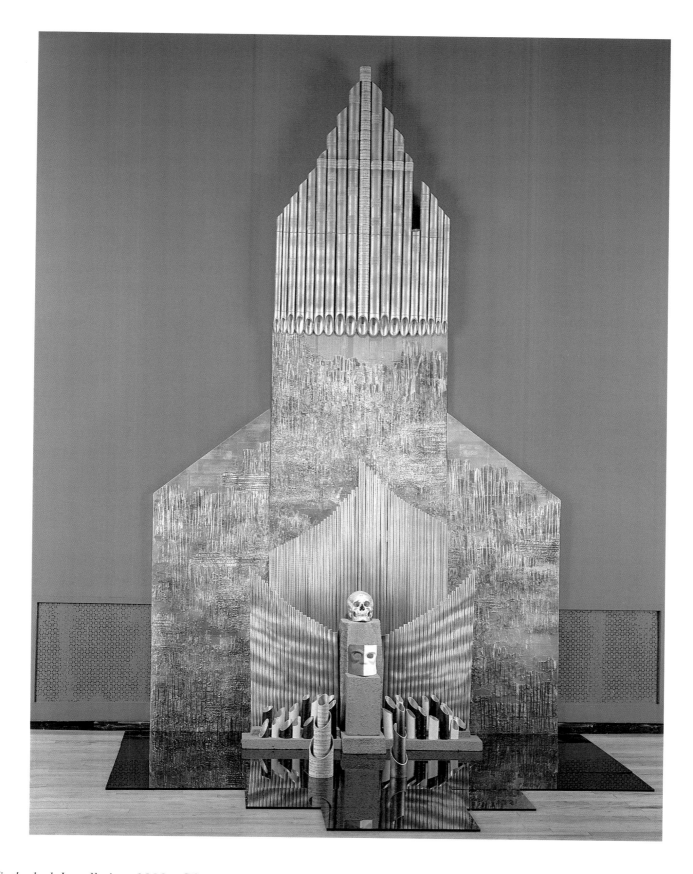

Cathedral. Installation, 1998. , Silver, enamel, acrylic, collage, paper, cardboard, wood, masonite, plastic with objects
116 x 96 x 60 in. 295 x 244 x 153 cm
Artist Collection

Cathedral (detail of installation), 1998

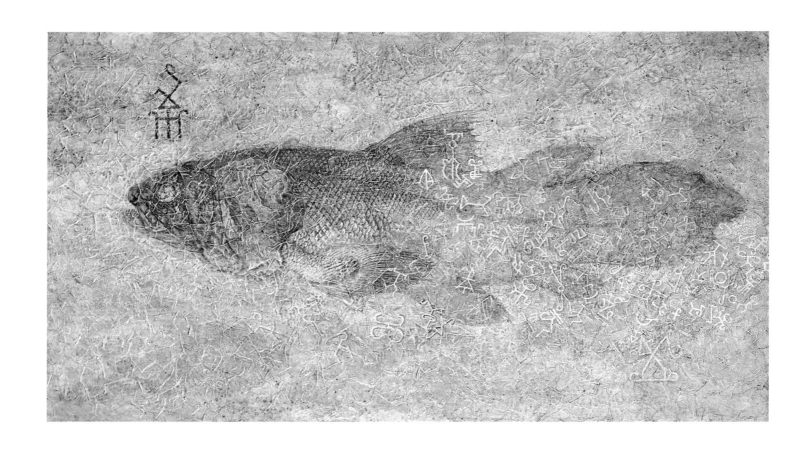

Birth of Sign, 1989, Oil, polyvinylacetate tempera, collage on canvas, 47¹ᐟ⁴ x 71 in. 120 x 180 cm
Artist Collection

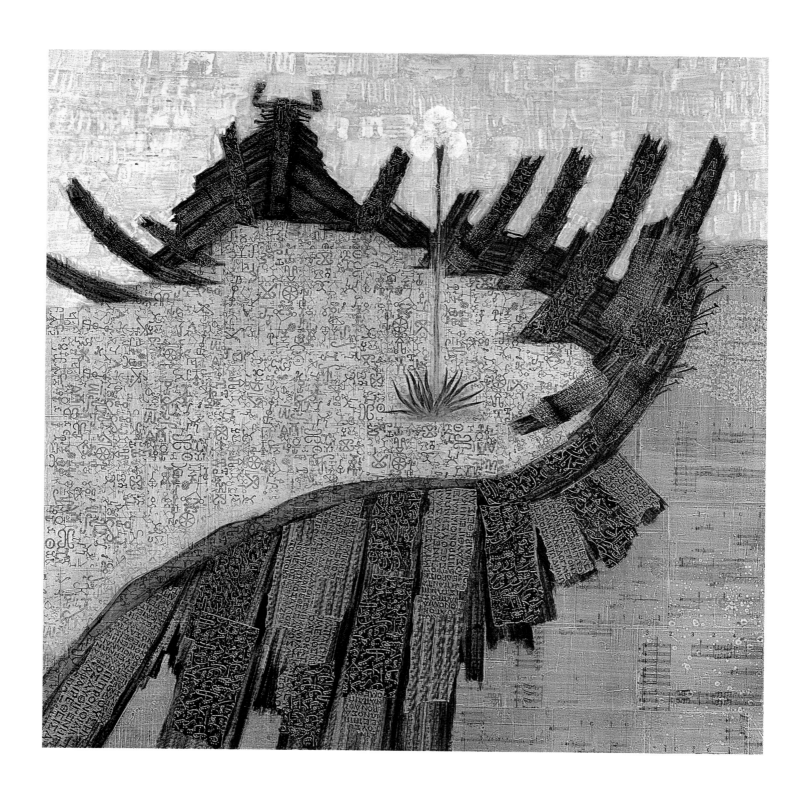

Boat of Remembrances, 1997, Oil, acrylic, collage on canvas, 60 x 60 in. 153 x 153 cm
Michael and Lynda Gardner Collection, New York

VI. TIME AND NATURE

Nothing is ever really lost, or can be lost,
No birth, identity, form—no object of the world.
Nor life, nor force, nor any visible thing;
Appearance must not foil, nor shifted sphere confuse thy brain.
Ample are time and space—ample the fields of Nature.

Walt Whitman, *Leaves of Grass.*

Rhinoceros, 1987, Etching, 19 x 25³⁄₈ in. 48.5 x 64.5 cm
Elena Lobachevskaya Collection, Moscow

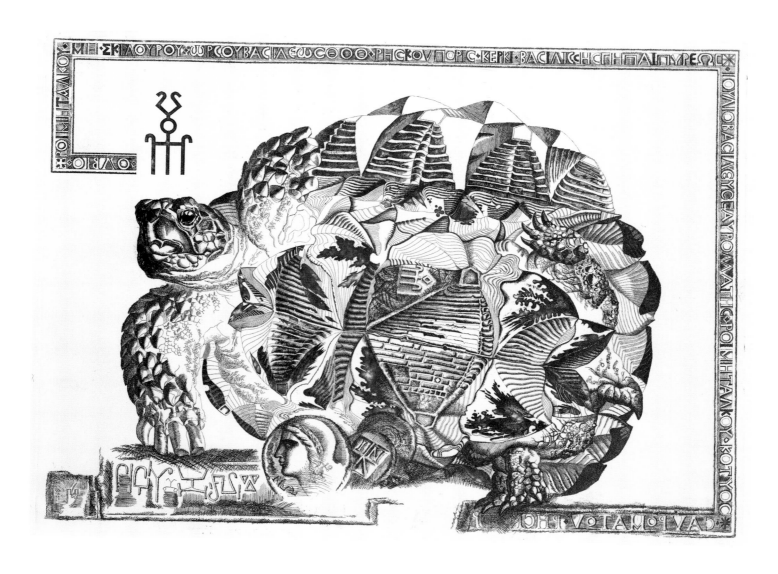

Bosporus Tortoise, 1969, Etching, 24½ x 33 in. 62 x 84 cm
Jane Voorhees Zimmerli Art Museum, Rutgers, The State University of New Jersey
The Norton and Nancy Dodge Collection of Nonconformist Art from the Soviet Union

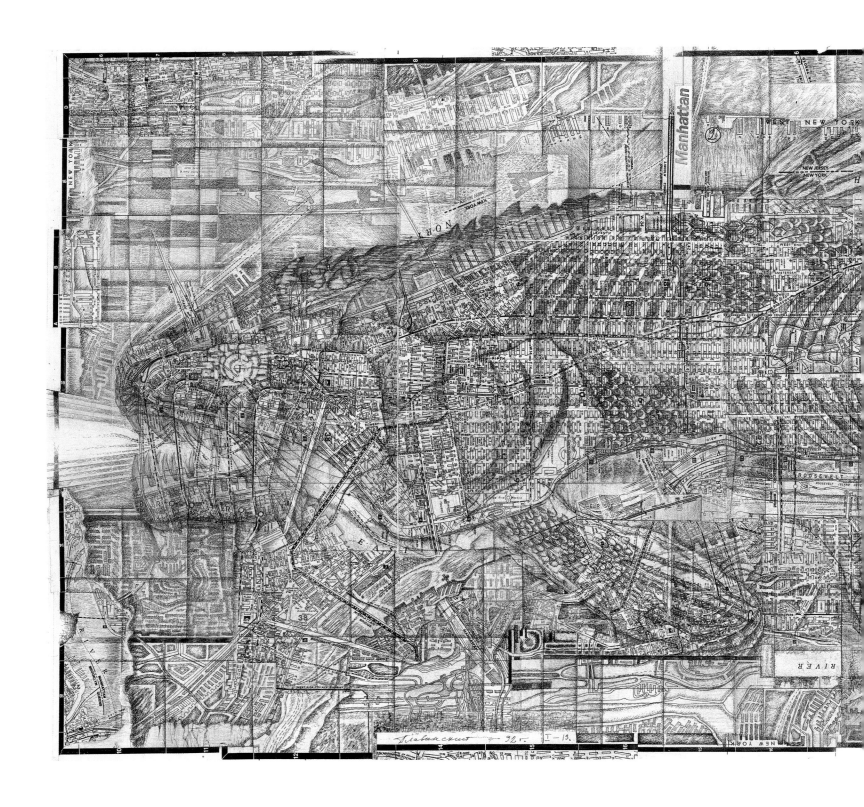

Manhattan Fish, 1992, Pen and ink, colored pencil on cut and pasted and printed paper, $32^{1/8}$ x $71^{1/2}$ in. 81.6 x 181.6 cm
Signed and dated (lower left): Plavinsky 92 I-13
The Metropolitan Museum of Art, Purchase, Mr. and Mrs Charles A. Krasne Gift, 1993. (1993.203)
Photograph © 2000 The Metropolitan Museum of Art

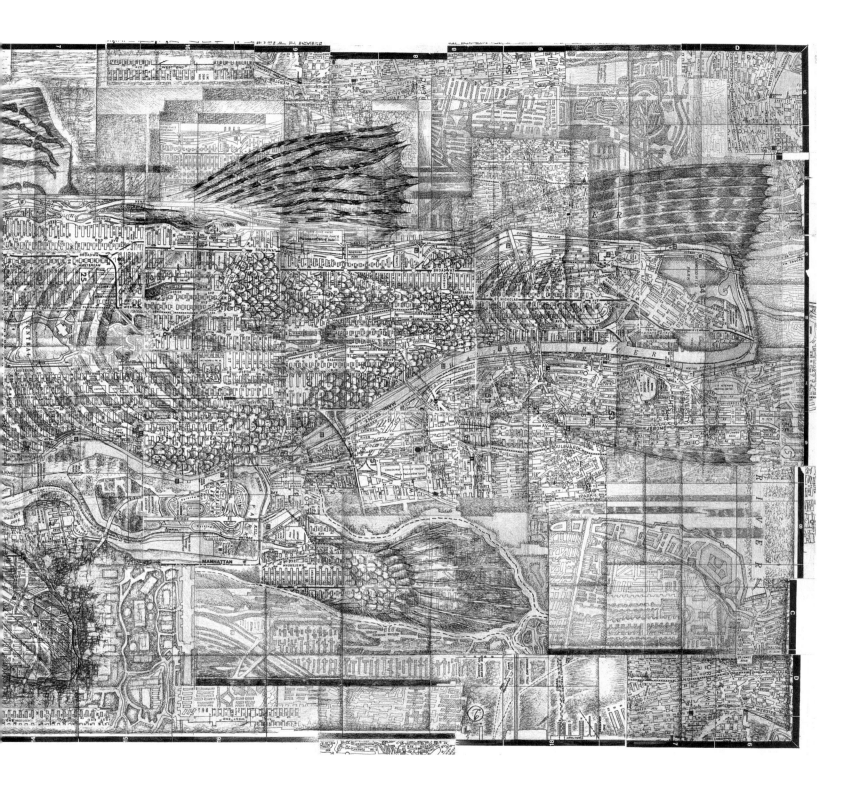

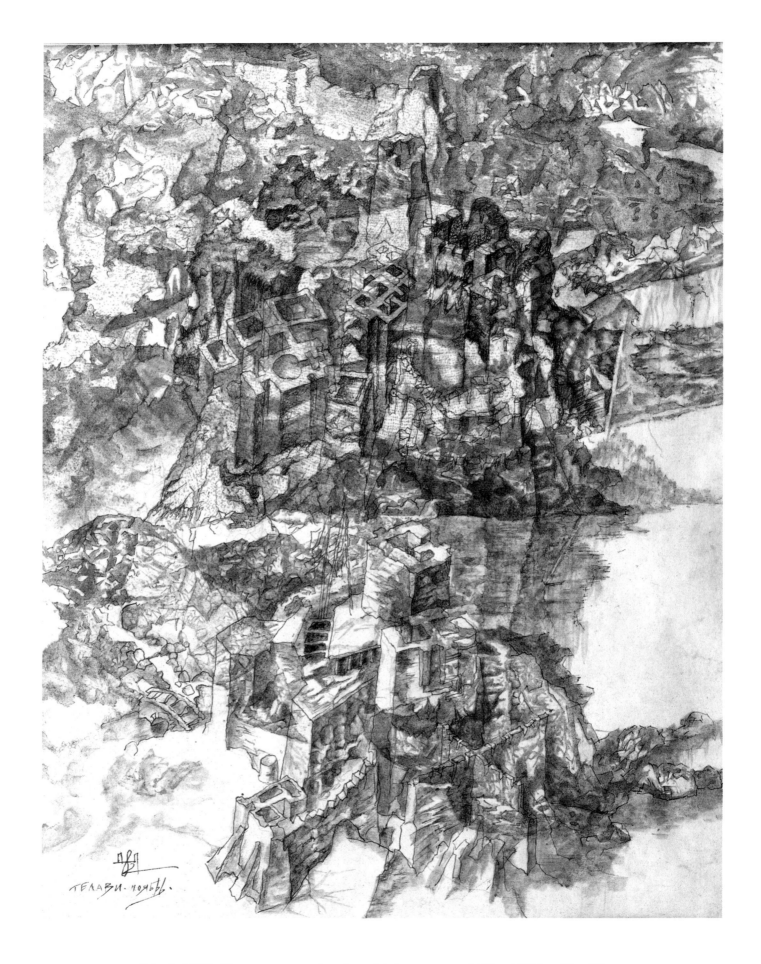

Telavi, 1982, Monotype, pen, brush and ink on paper, 15³/₄ x 12¹/₄ in. 40 x 31 cm
Artist Collection

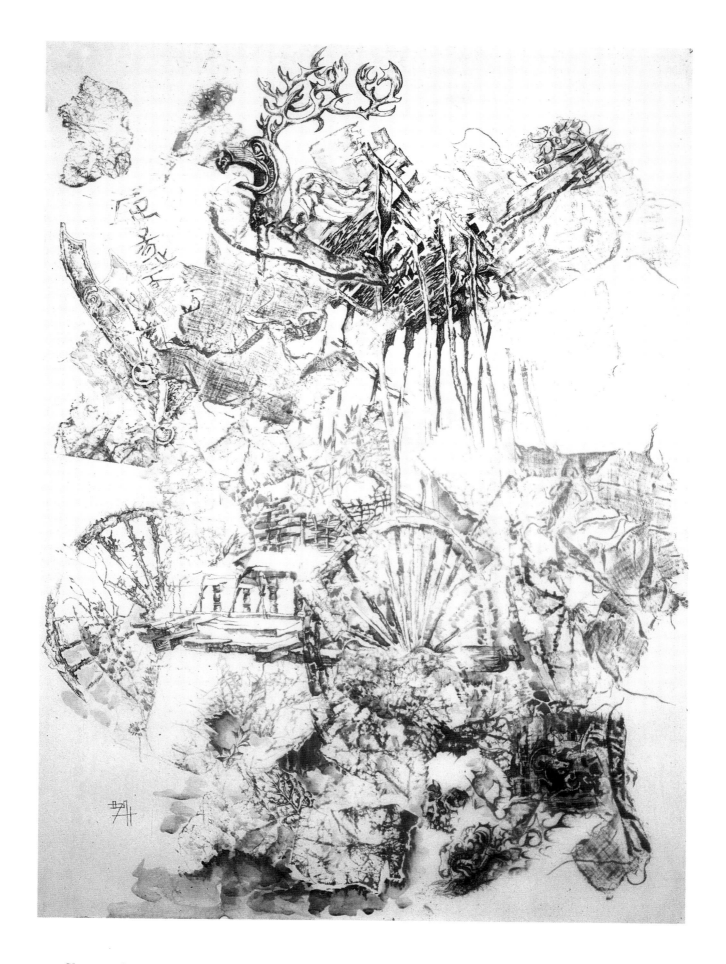

Chariot of Altaian Chief, 1971, Monotype, pen, brush and ink on paper, 35 x 25¹/₈ in. 89 x 63.8 cm
Igor Palmin Collection, Moscow

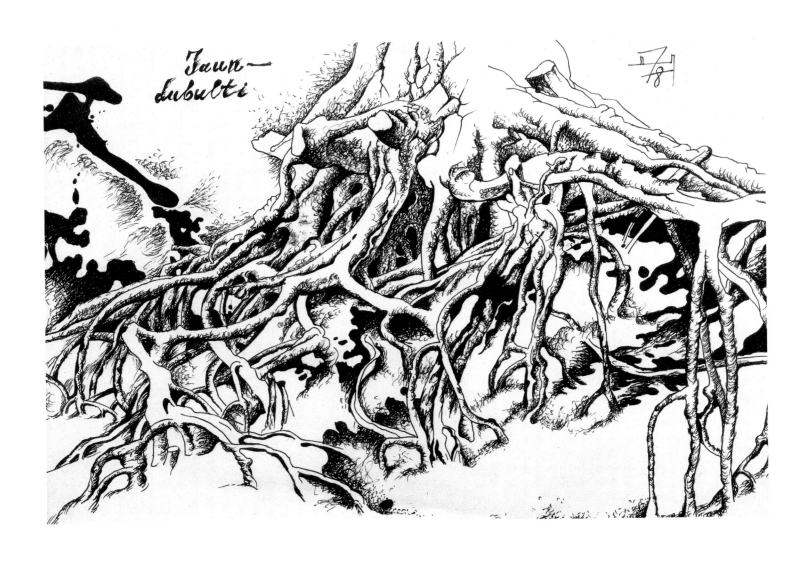

Pine Roots, 1978, Pen and ink on paper, 10$^{1/2}$ x 15 in. 27 x 38 cm
Artist Collection

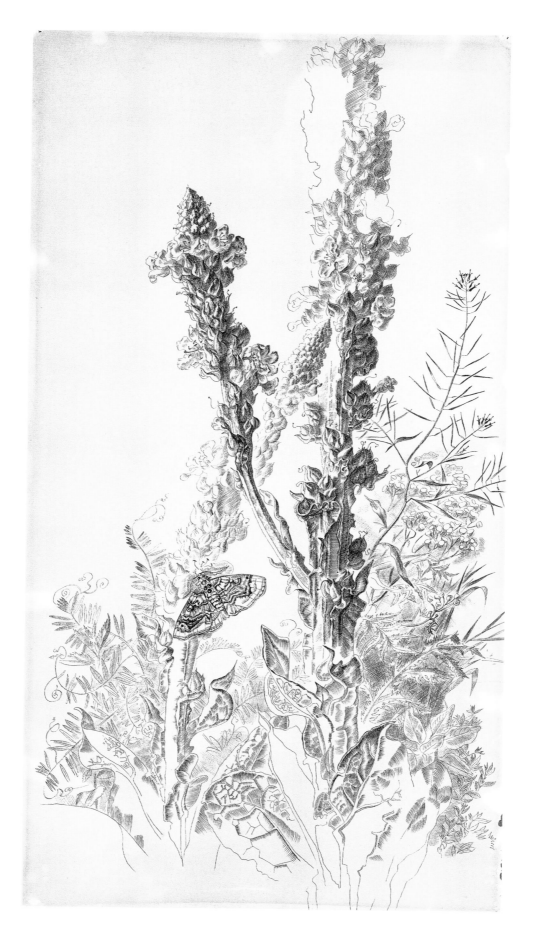

Herb Ferbascum Taspus, 1965, Pen and ink on paper, 29³/⁴ x 15³/⁴ in. 75.3 x 39.8 cm
Jane Voorhees Zimmerli Art Museum, Rutgers, The State University of New Jersey
The Norton and Nancy Dodge Collection of Nonconformist Art from the Soviet Union

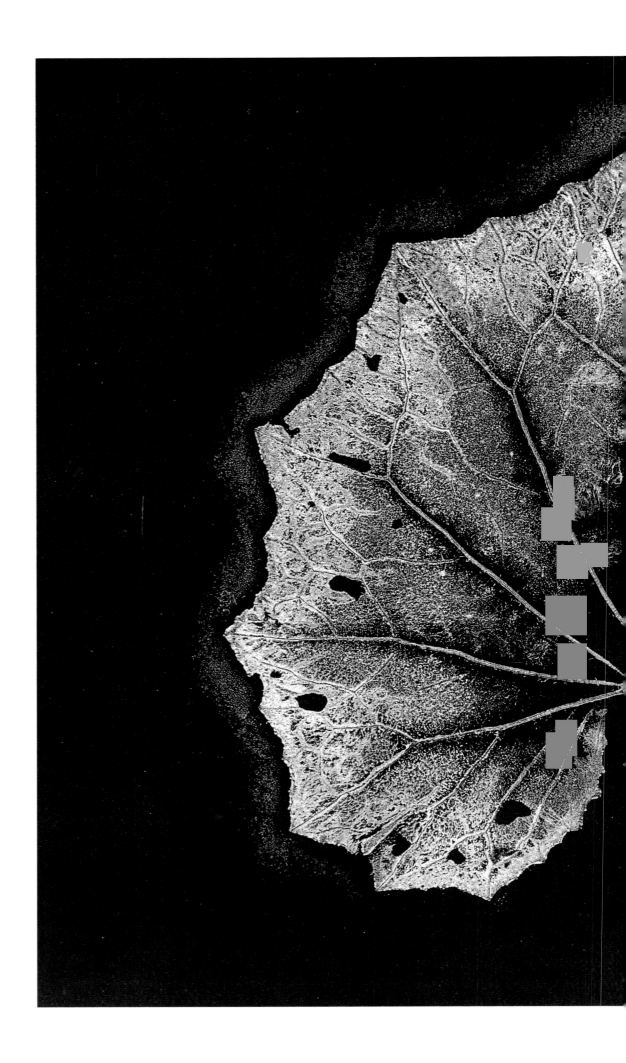

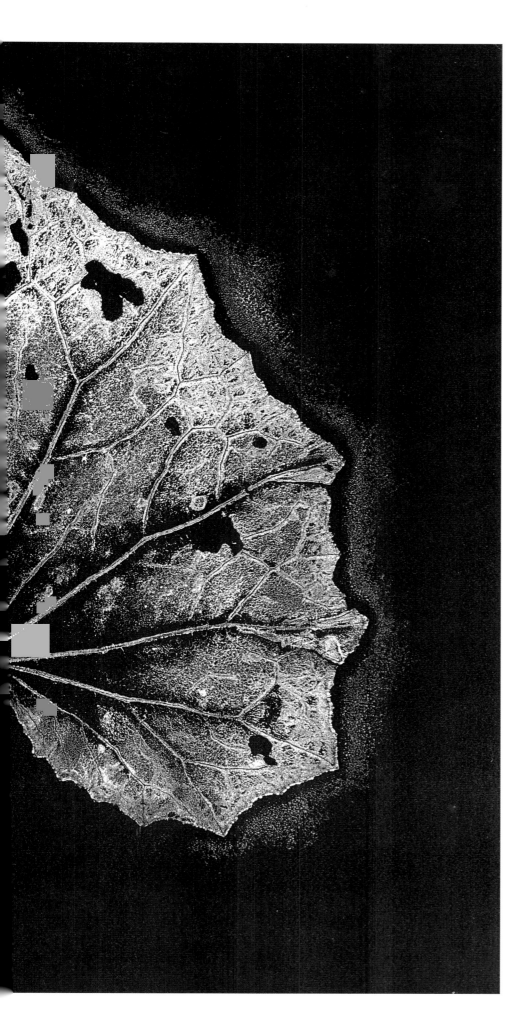

Silvery Leaf from *Book of Grass* (2 parts),
1963, Nature print
$10^{5/8}$ x $11^{7/8}$ in. 27 x 30 cm
Artist Collection

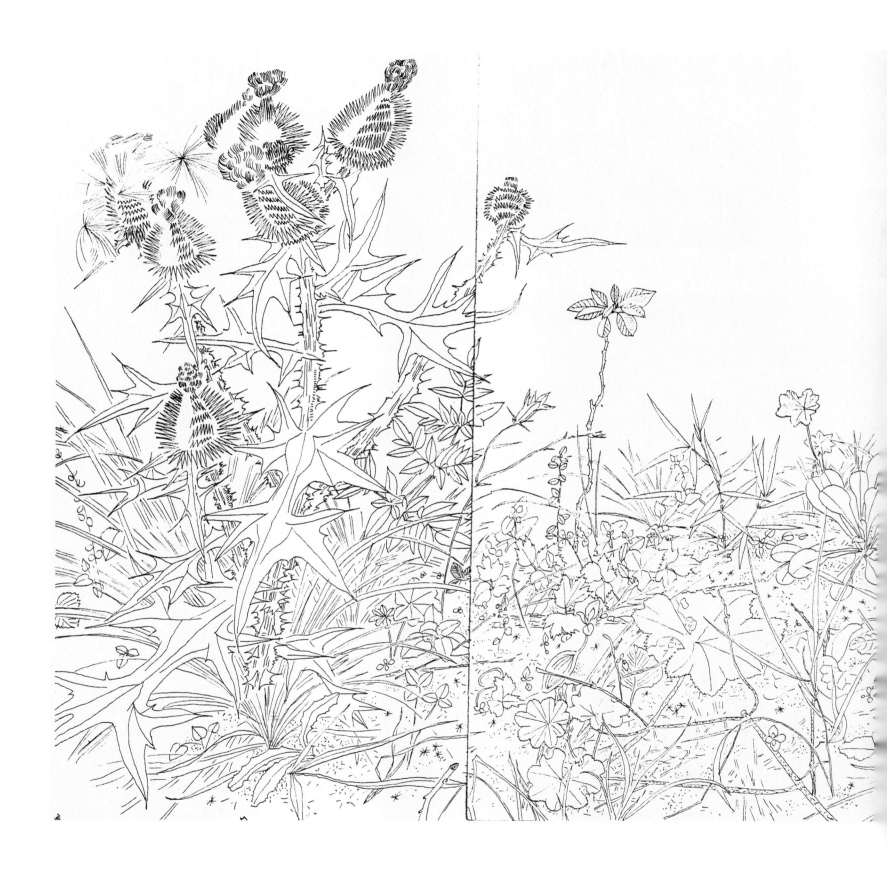

Meadow from *Book of Grass* (2 parts), 1963, Pen and ink on paper, 10⁵/⁸ x 23⁶/⁸ in. 27 x 60 cm
Artist Collection

176

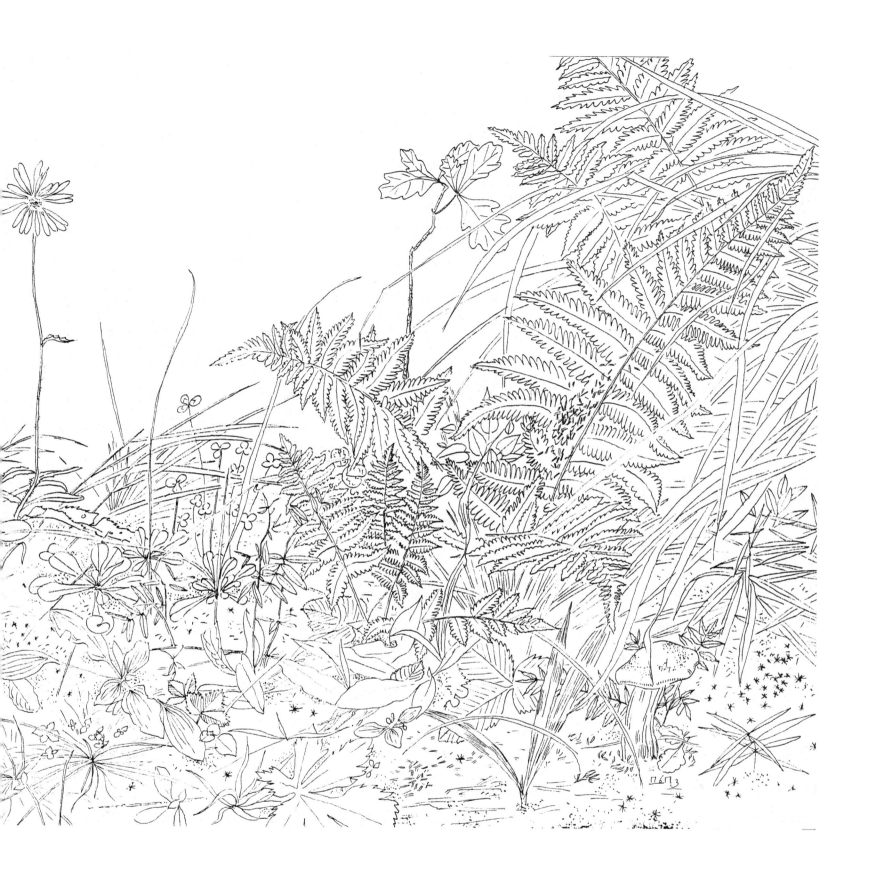

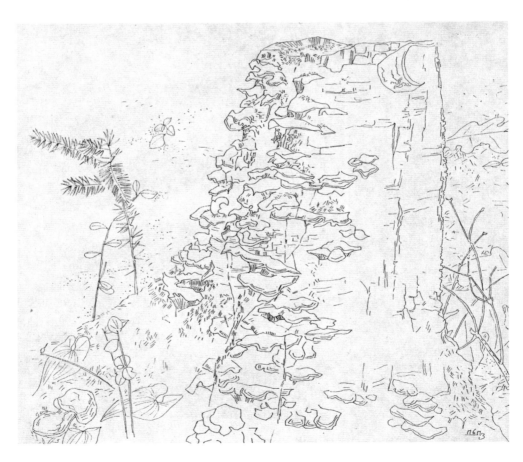

Sheets from *Book of Grass*, 1963, Pen and ink on paper, 10⁵/₈ x 11⁷/₈ in. 27 x 30 cm
Artist Collection

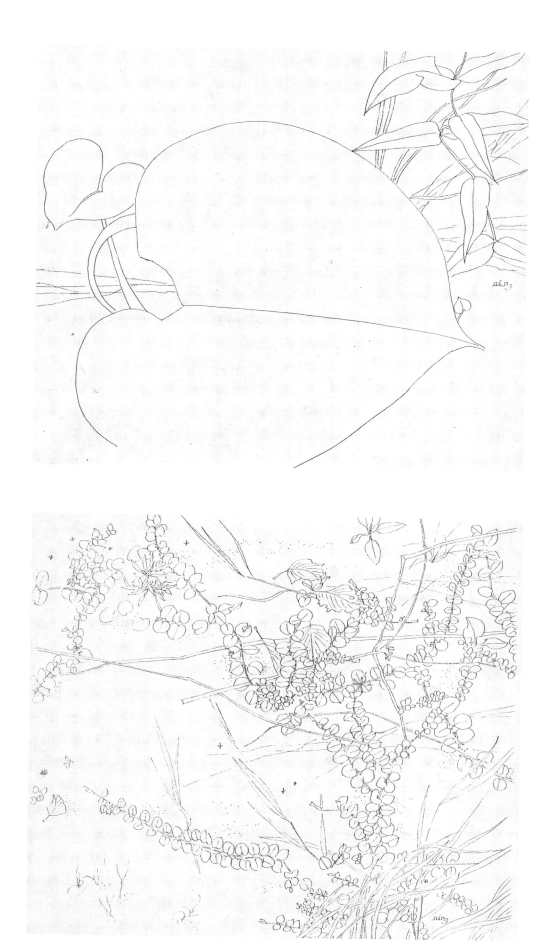

Sheets from *Book of Grass*, 1963, Pen and ink on paper, $10^{5/8}$ x $11^{7/8}$ in. 27 x 30 cm
Artist Collection

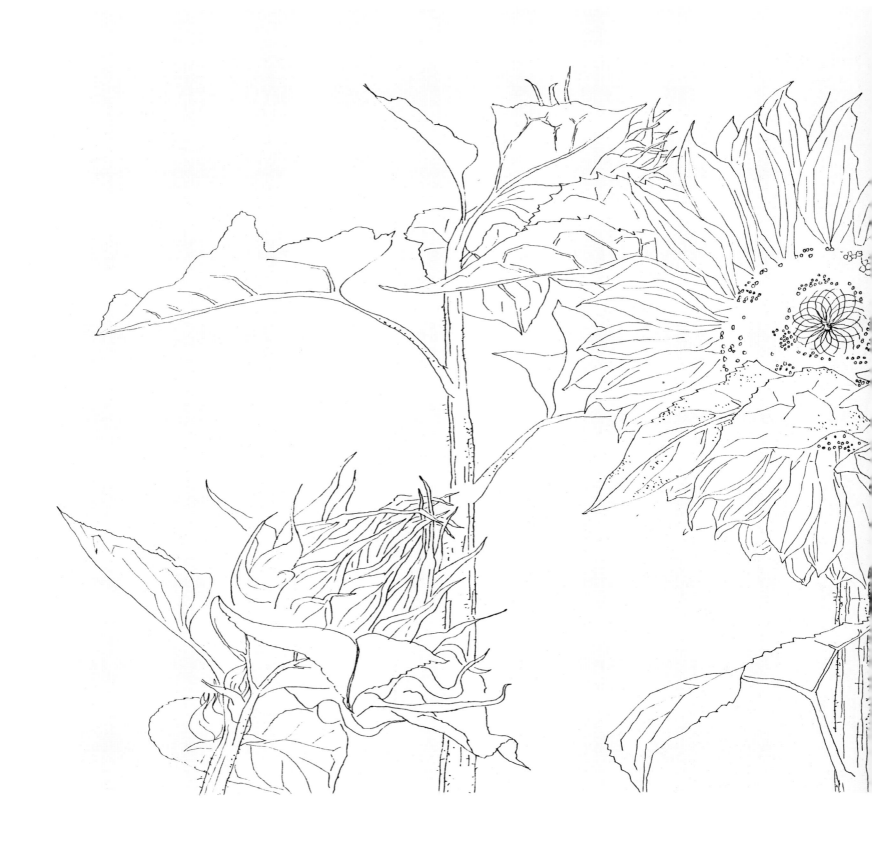

Sunflowers from *Book of Grass* (2 parts), 1963, Pen and ink on paper, 10⁵/₈ x 23⁶/₈ in. 27 x 60 cm
Artist Collection

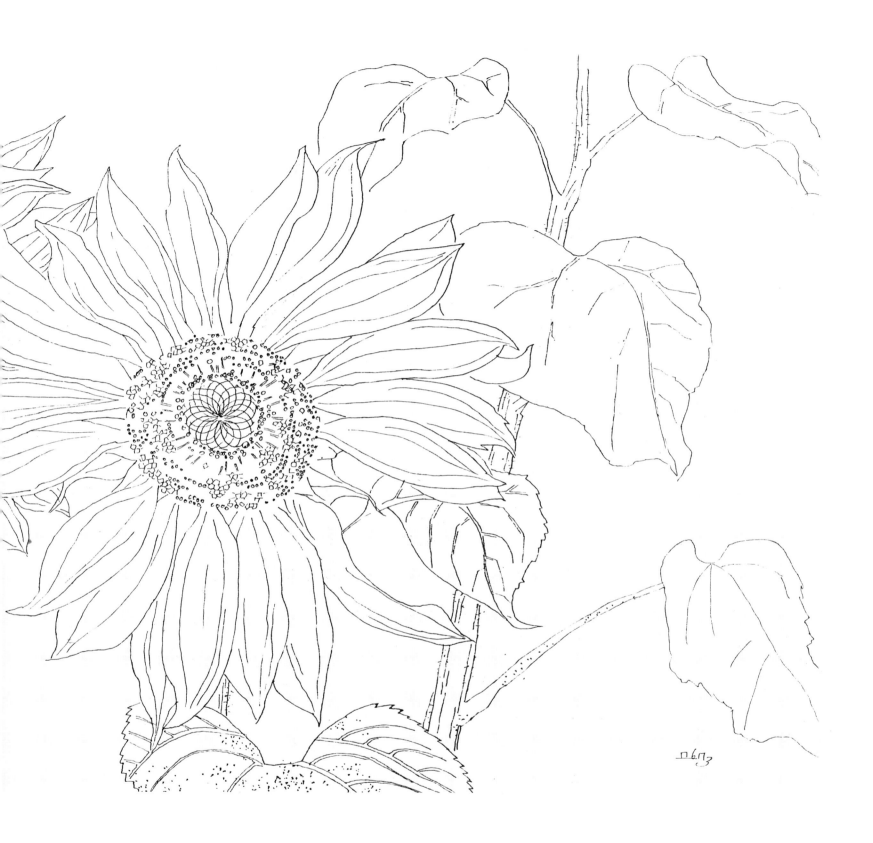

181

Moonlight Leaf from *Book of Grass* (2 parts), 1963, Nature print, $10^{5/8}$ x $23^{6/8}$ in. 27 x 60 cm
Artist Collection

Small Leaf, 1970, Drypoint, aquatint on copper plate, 17¹/⁴ x 7³/⁴ in. 44 x 19.7 cm
The State Pushkin Fine Arts Museum, Moscow

Grasshopper, 1963, Drypoint, $11^{1/2}$ x $13^{1/2}$ in. 29 x 34.3 cm
Jane Voorhees Zimmerli Art Museum, Rutgers, The State University of New Jersey
The Norton and Nancy Dodge Collection of Nonconformist Art from the Soviet Union

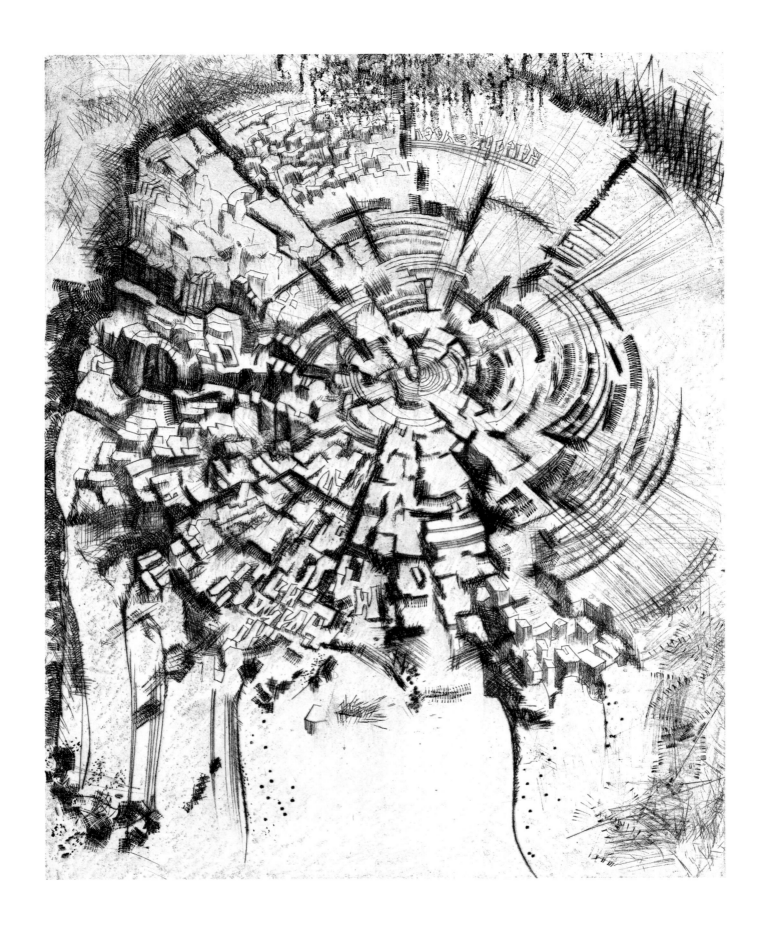

Large Tree Stamp, 1978, Drypoint, 16 x 12⁷/⁸ in. 40.5 x 32.5 cm
The State Pushkin Fine Arts Museum, Moscow

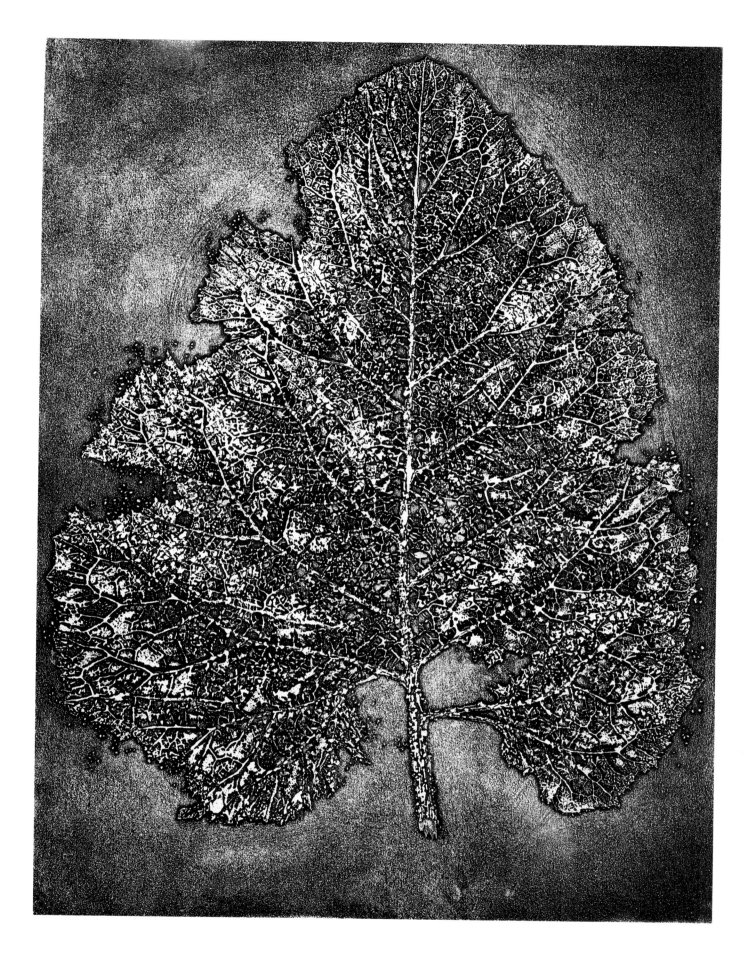

Cosmic Leaf, 1975, Etching, aquatint, 25¼ x 19⅛ in. 64.2 x 48.5 cm
The State Pushkin Fine Arts Museum, Moscow

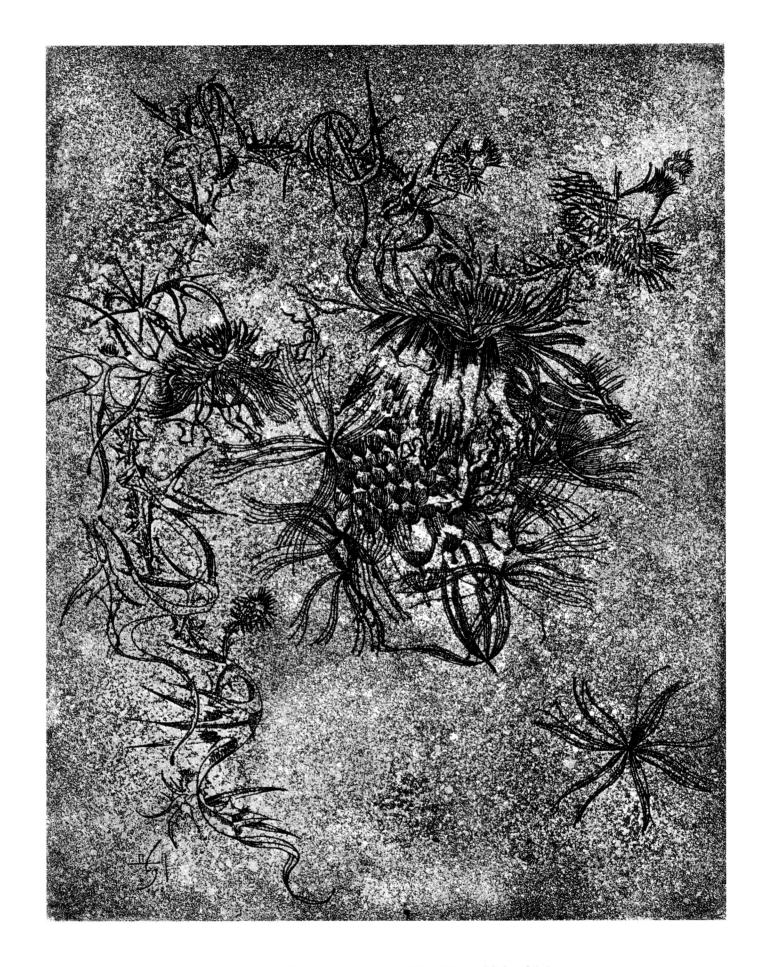

Thistle, 1969, Etching, aquatint, 12⁵/⁸ x 9⁵/⁸ in. 32.2 x 24.4 cm
The State Pushkin Fine Arts Museum, Moscow

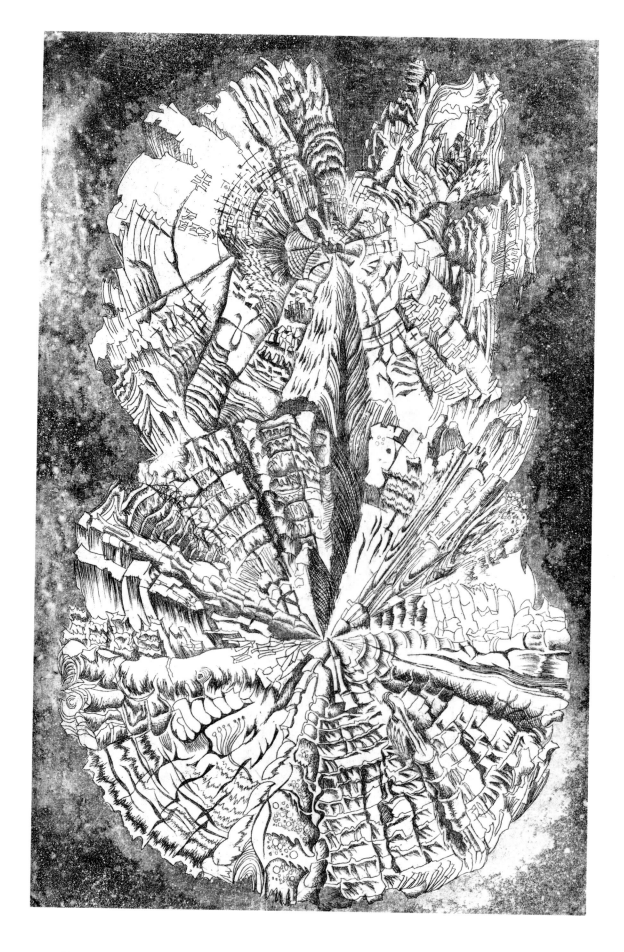

Double Cut, 1970, Etching on copper plate, aquatint, 12 x 7⁵/₈ in - 30.7 x 19.5 cm
The State Pushkin Fine Arts Museum, Moscow

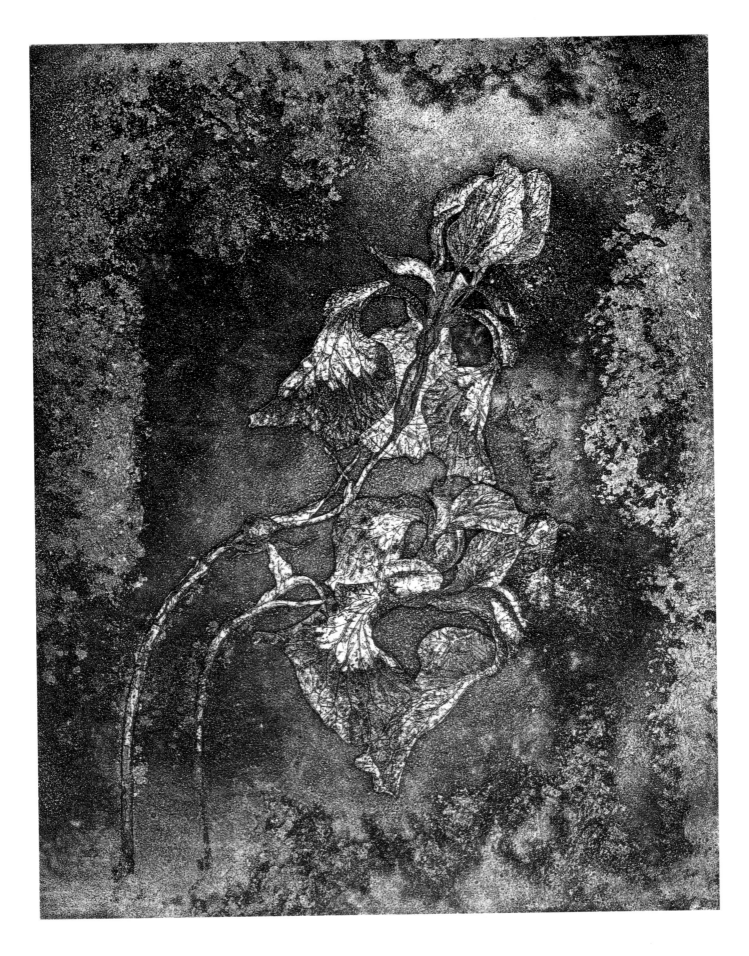

Iris, 1978, Etching, aquatint, 16³/₄ x 12³/₄ in. 42.4 x 32.4 cm
The State Pushkin Fine Arts Museum, Moscow

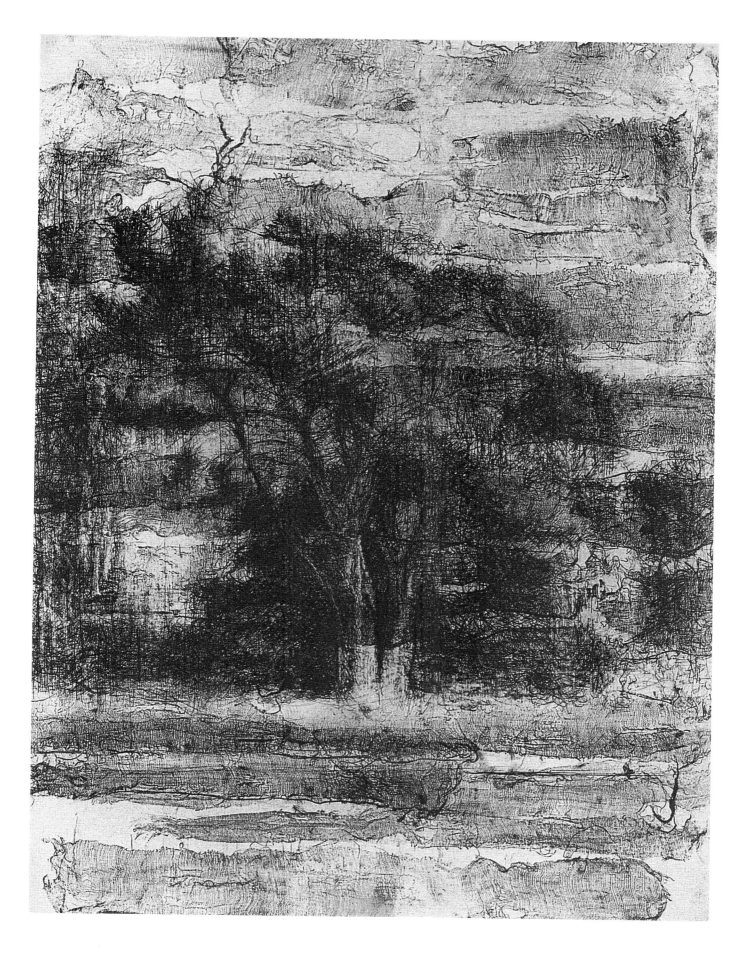

Tree, 1983, Pen and ink on paper, 30¹/² x 24 in. 77.5 x 61 cm
Artist Collection

Abomination of Desolation, 1999, Photo-collage, based on photographs by Igor Palmin and Dmitri Plavinsky
12 x 10 in. 30.5 x 25.3 cm
Artist Collection

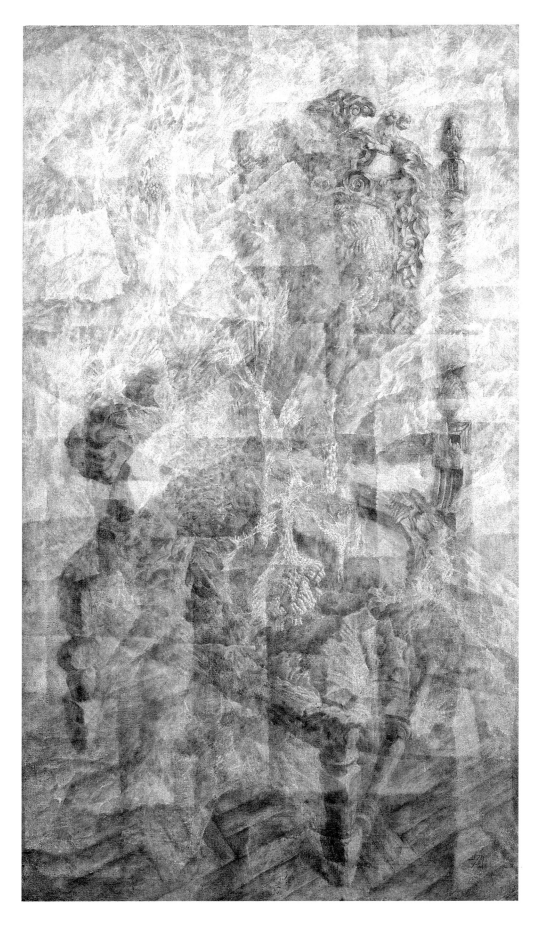

Armchair, 1977-1978, Oil, polyvinylacetate tempera on canvas, 47$^{1/4}$ x 71 in. 180 x 120 cm
Museum of Modern Art, Moscow
Alina Roedel Collection

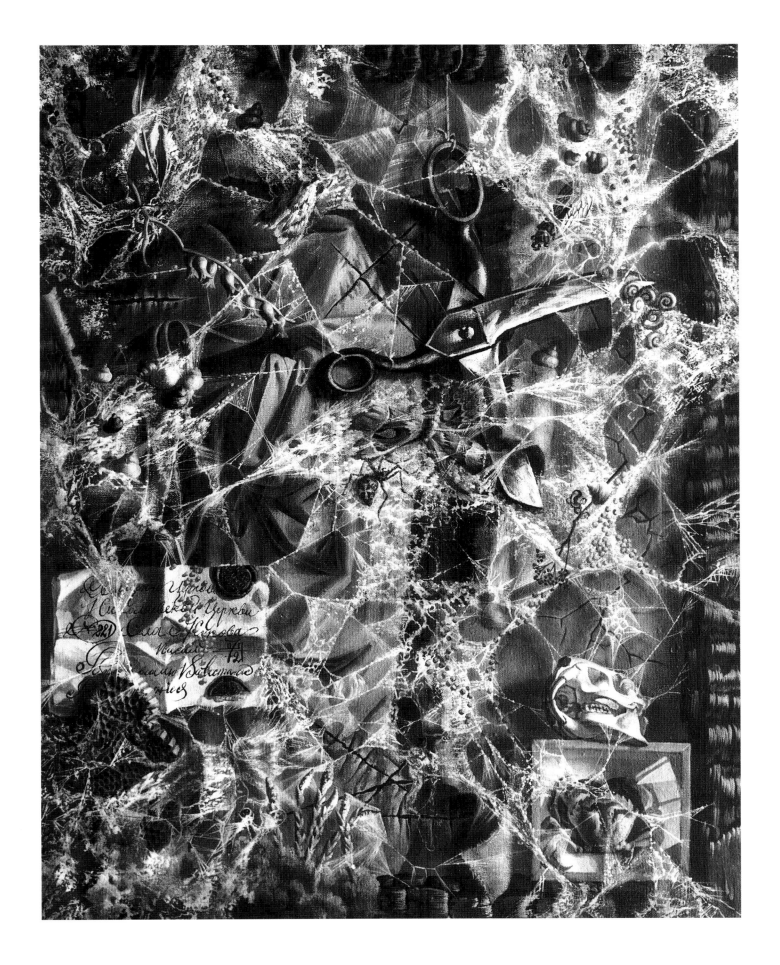

Still Life in a Cobweb, 1972, Oil, polyvinylacetate tempera on canvas, 39³/₈ x 31¹/₂ in. 100 x 80 cm
Franco Miele Collection, Italy

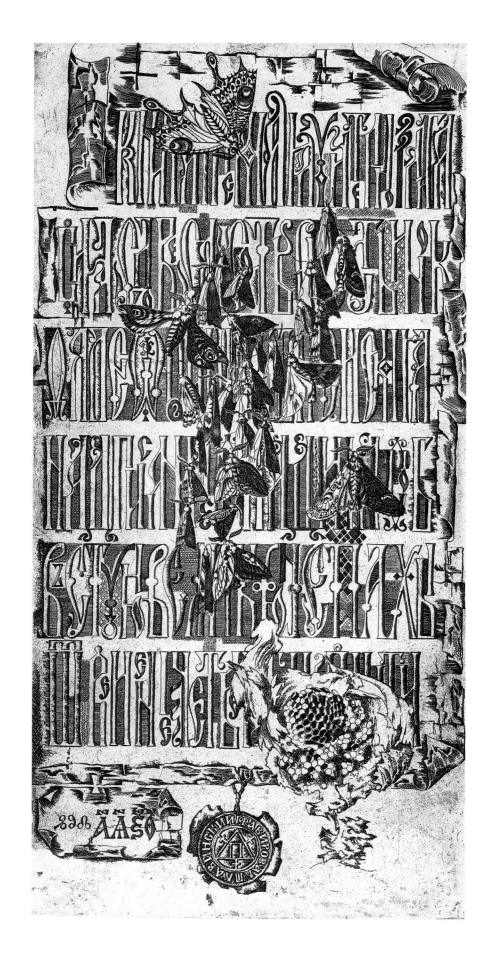

Scroll, 1969, Etching, 25¼ x 12½ in. 64.2 x 31.7 cm
The State Pushkin Fine Arts Museum, Moscow

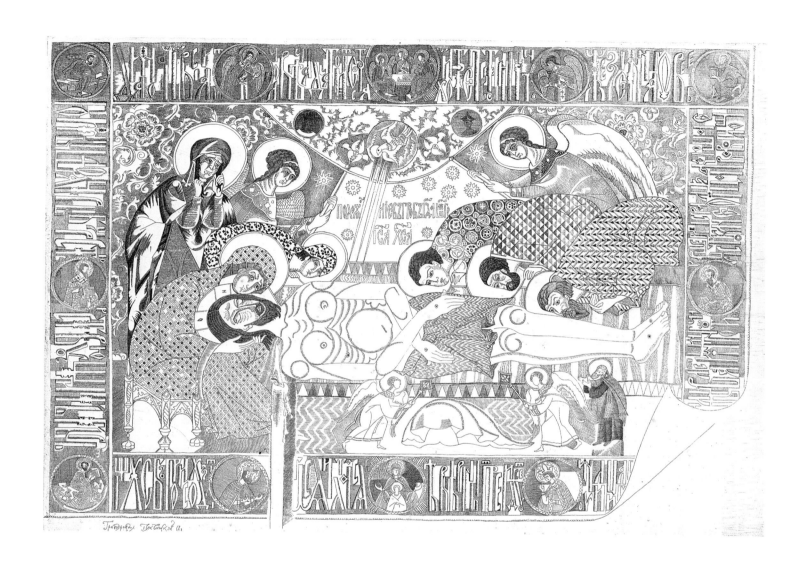

Shroud of Christ, 1968, Etching, 16⁷/₈ x 23⁷/₈ in. 24 x43 cm
Jane Voorhees Zimmerli Art Museum, Rutgers, The State University of New Jersey
The Norton and Nancy Dodge Collection of Nonconformist Art from the Soviet Union

203

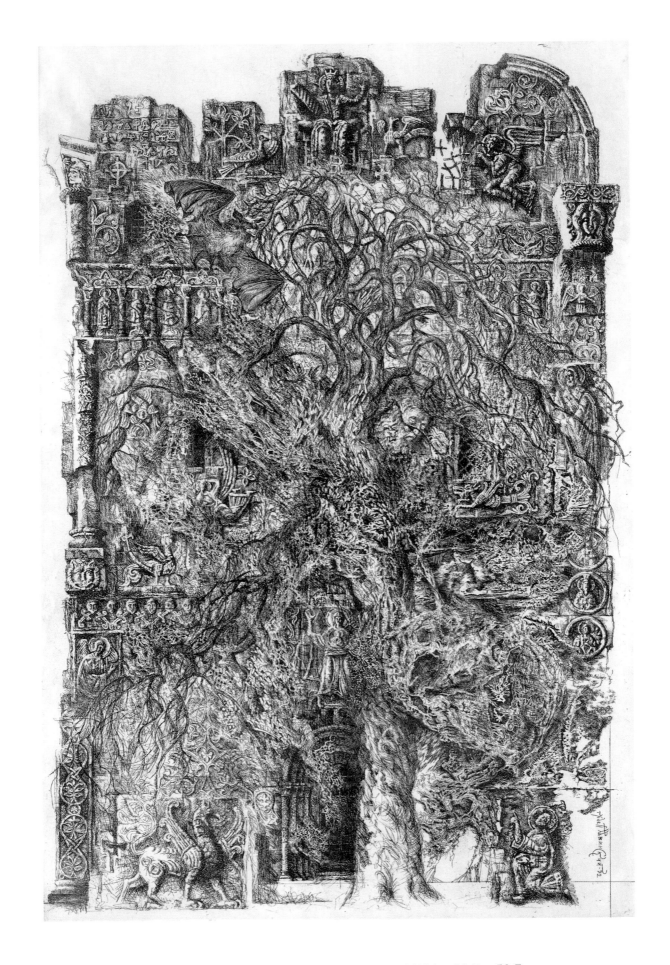

Cathedral with a Bat, 1972, Etching, 34⁷/₈ x 23¹/₈ in. 88.7 x 58.7 cm
The State Tretiakov Gallery, Moscow

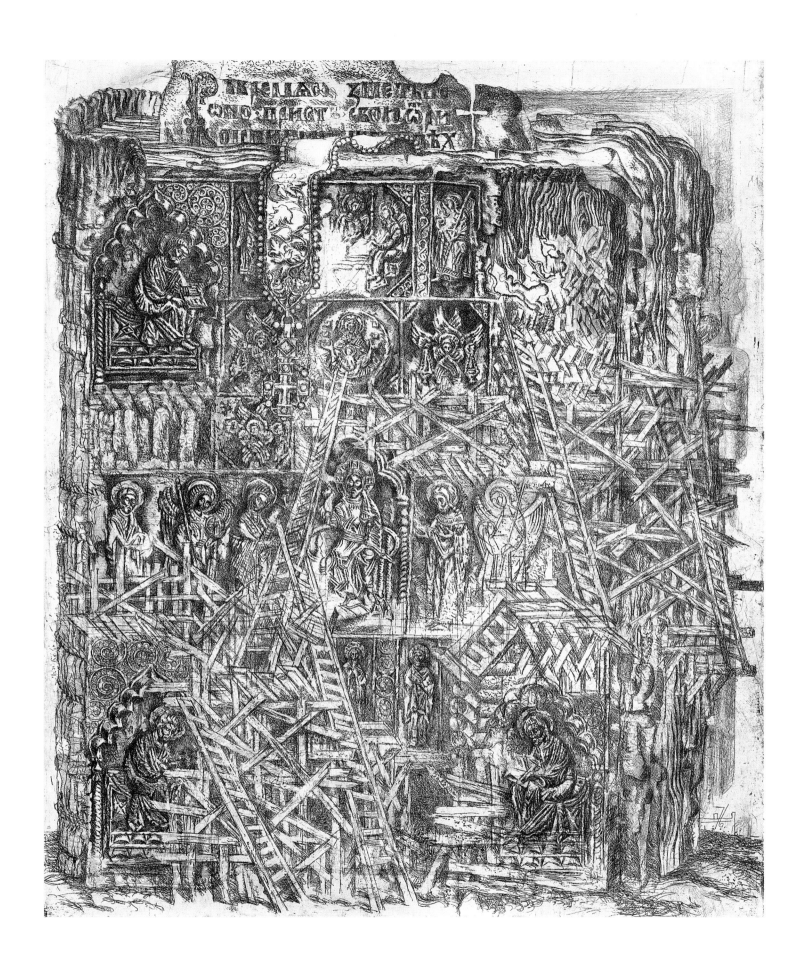

Building of Gospel, 1976, Etching on copper plate, 28¹/⁴ x 22⁷/⁸ in. 71.7 x 58 cm
The State Pushkin Fine Arts Museum, Moscow

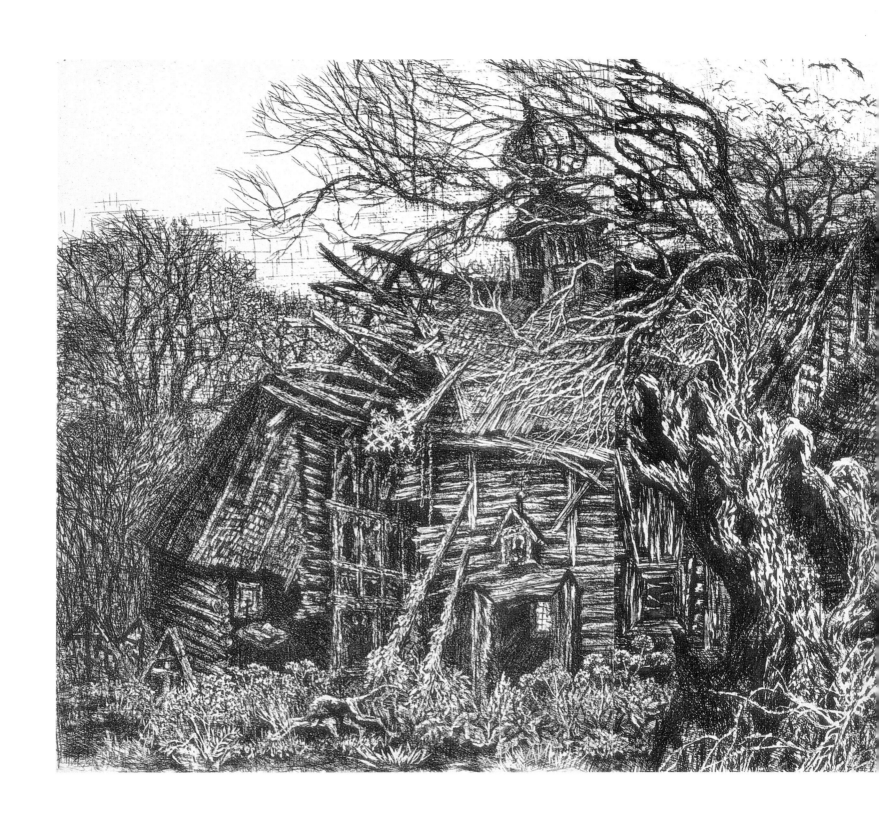

Abandoned Church (3 parts), 1975, Etching, 25$^{1/8}$ x 57$^{1/2}$ in. 64 x 146 cm
The State Pushkin Fine Arts Museum, Moscow

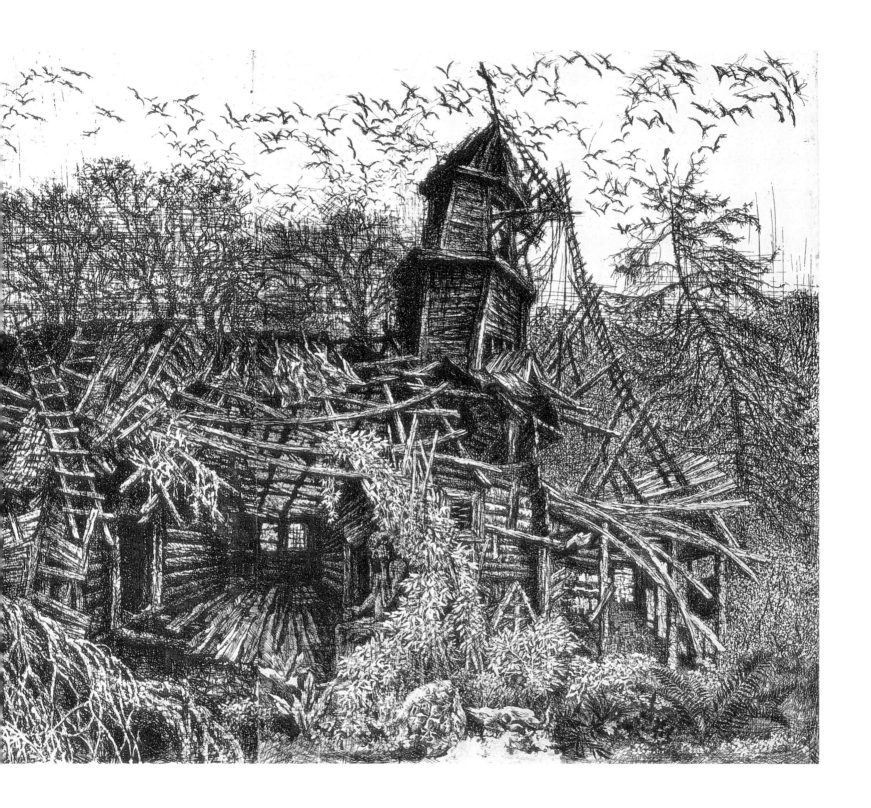

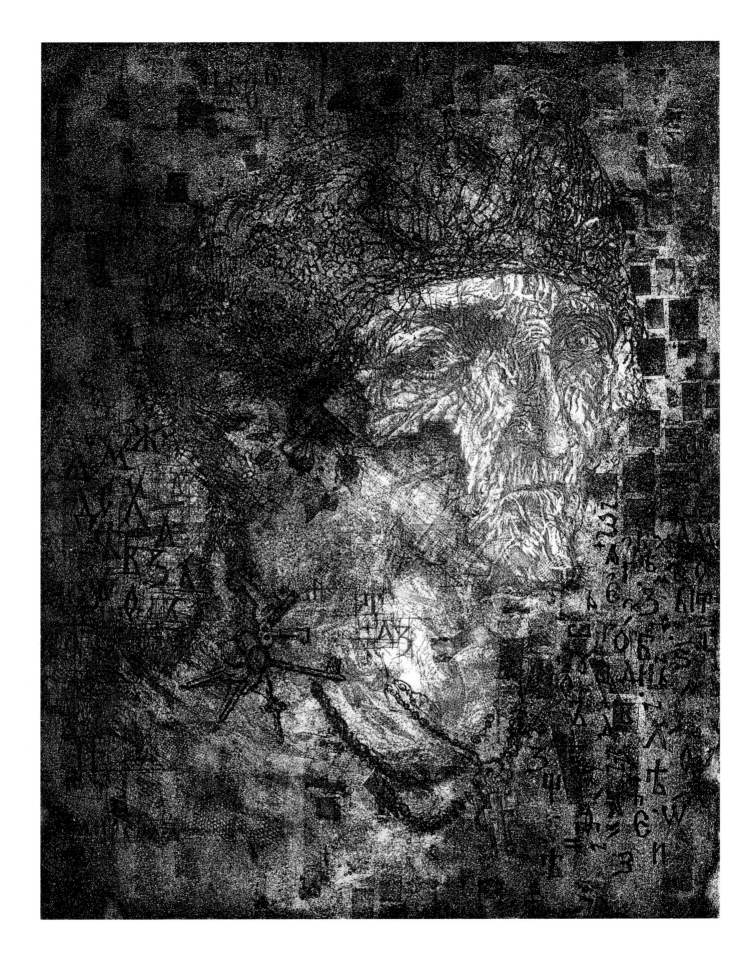

Old Woman, 1972, Etching, aquatint, 25³/₈ x 19 in. 64.5 x 48.4 cm
The State Pushkin Fine Arts Museum, Moscow

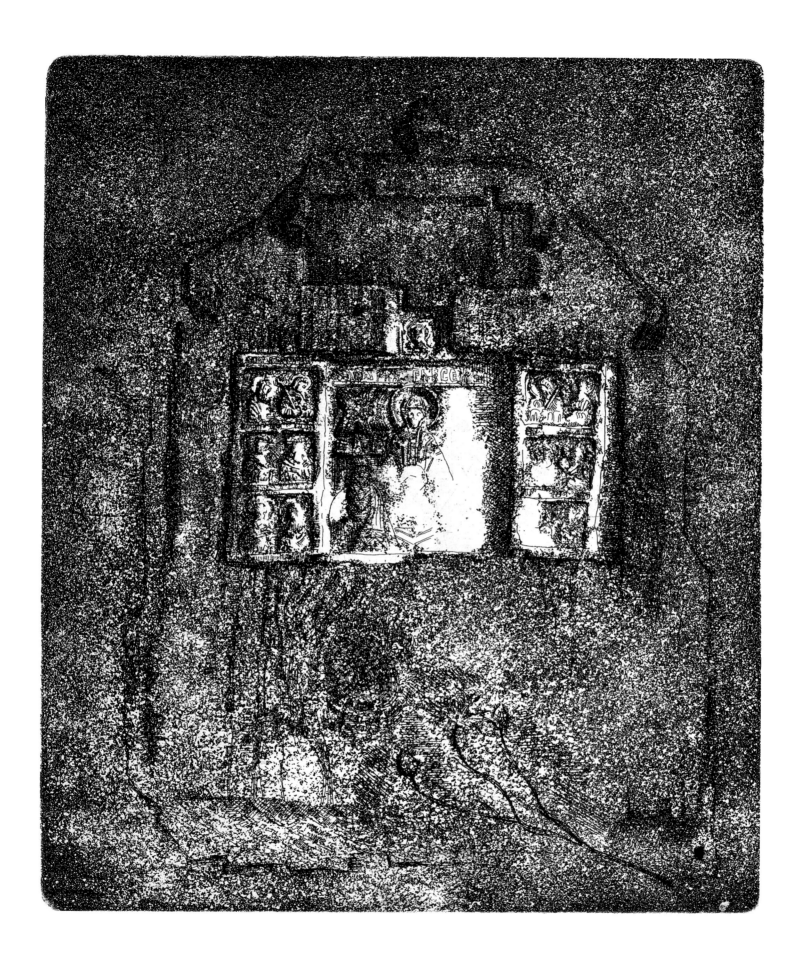

Folding Icon, 1969, Etching, aquatint, 11⁷/₈ x 9¹/₂ in. 30.2 x 24 cm
The State Tretiakov Gallery, Moscow

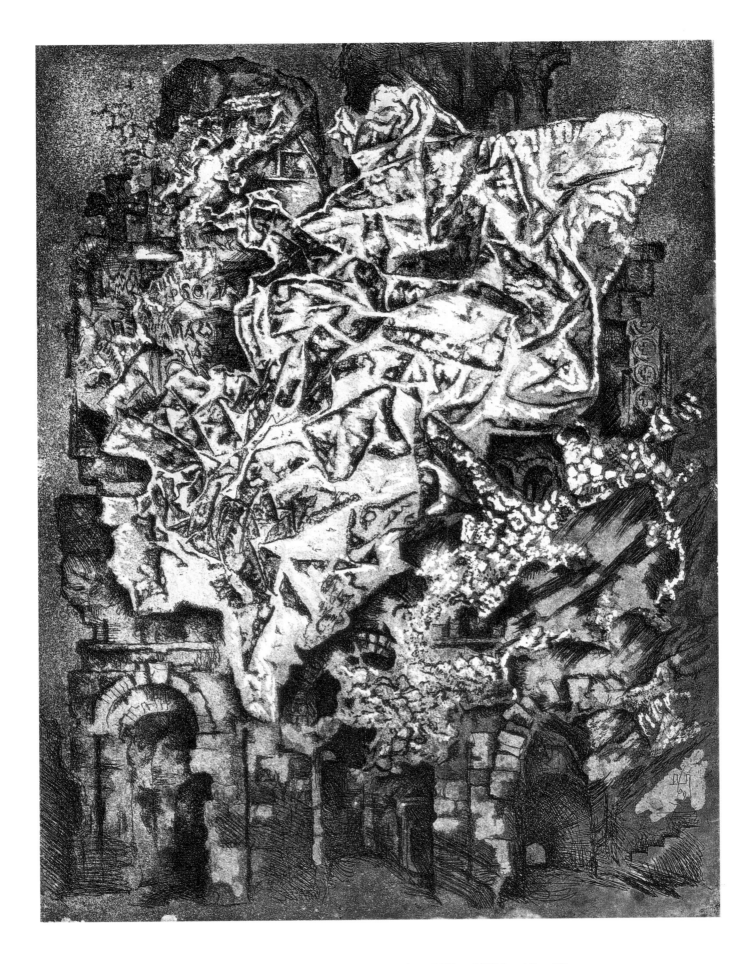

Ruins in the Fire, 1969, Etching, aquatint, 16¹ᐟ² x 12¹ᐟ² in. 42 x 32 cm
The State Tretiakov Gallery, Moscow

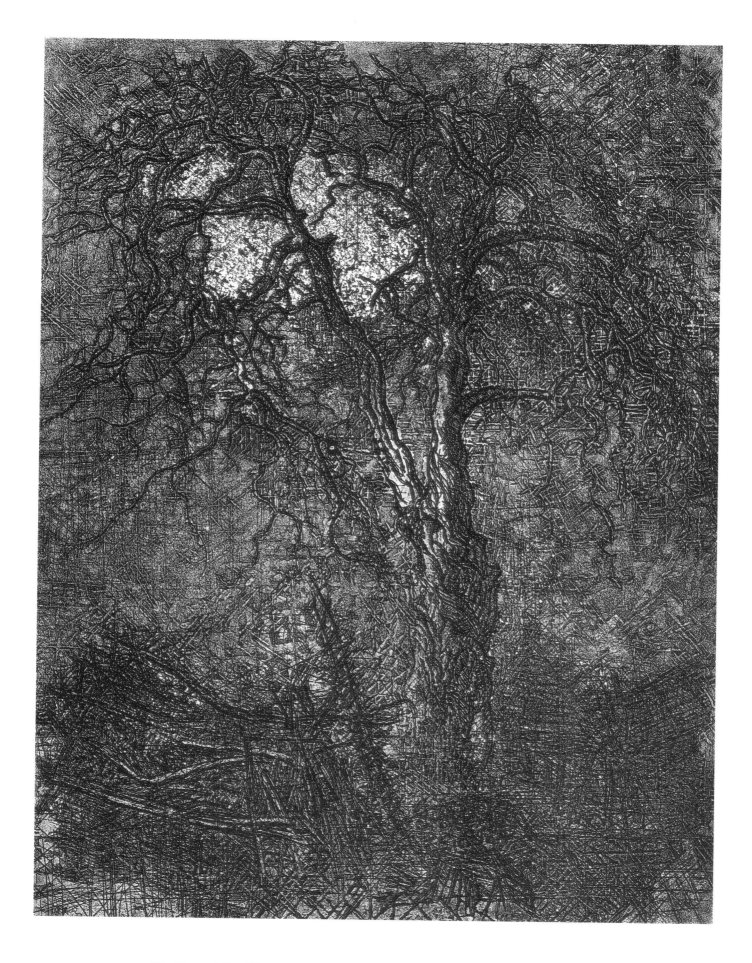

Big Tree with a Moon, 1972, Etching, aquatint, 25¹ᐟ⁴ x 19¹ᐟ⁴ in. 64 x 49 cm
The State Pushkin Fine Arts Museum, Moscow

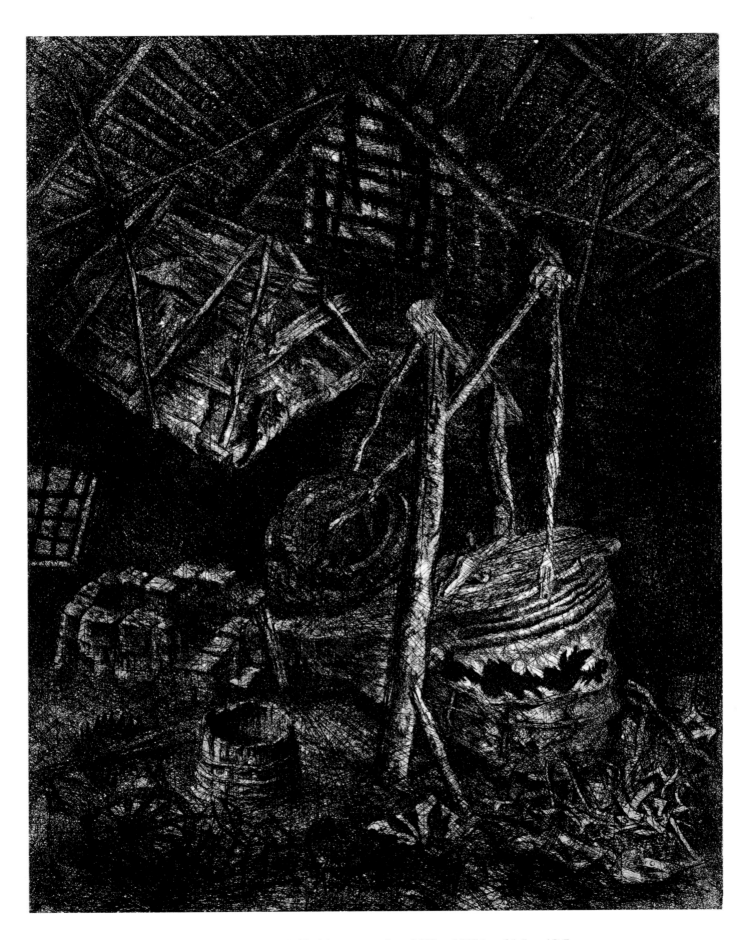

Old Blacksmith, 1975, Etching, aquatint, 25³/₈ x 19¹/₈ in. 64.5 x 48.5 cm
Jane Voorhees Zimmerli Art Museum, Rutgers, The State University of New Jersey
The Norton and Nancy Dodge Collection of Nonconformist Art from the Soviet Union

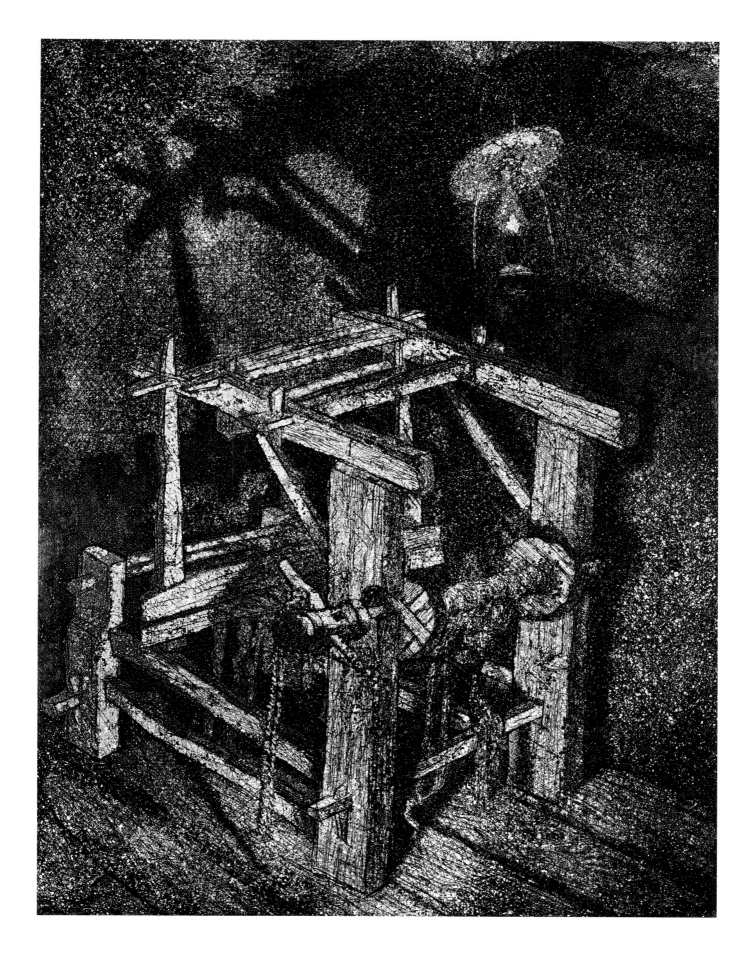

Loom, 1975, Etching, aquatint, 25$^{1/8}$ x 19 in. 64 x 48 cm
The State Pushkin Fine Arts Museum, Moscow

213

Running in the Darkness (3 parts), 1972, Etching, 25^{1/2} x 57^{1/2} in. 64.7 x 146 cm
The State Pushkin Fine Arts Museum, Moscow

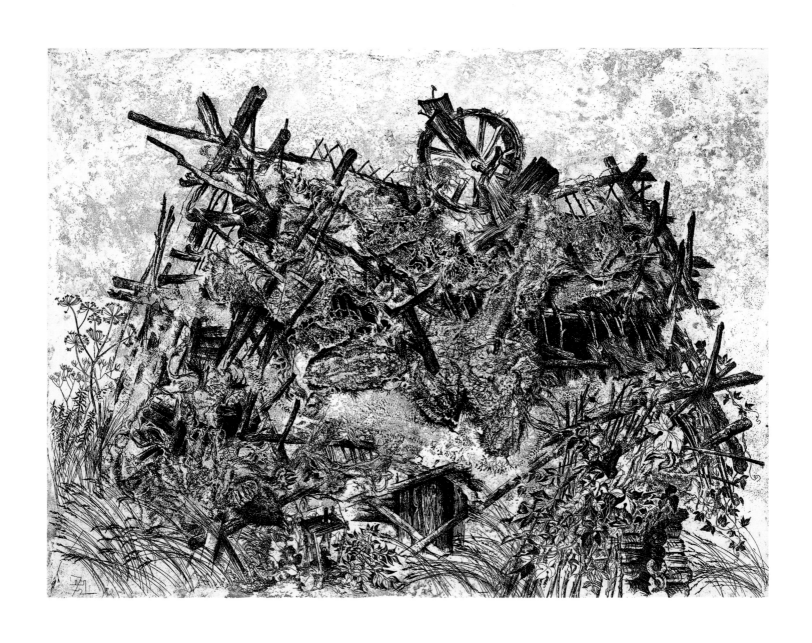

Old Barn, 1972, Etching, 19¹/⁴ x 25¹/⁴ in. 48.8 x 64.8 cm
The State Pushkin Fine Arts Museum, Moscow

216

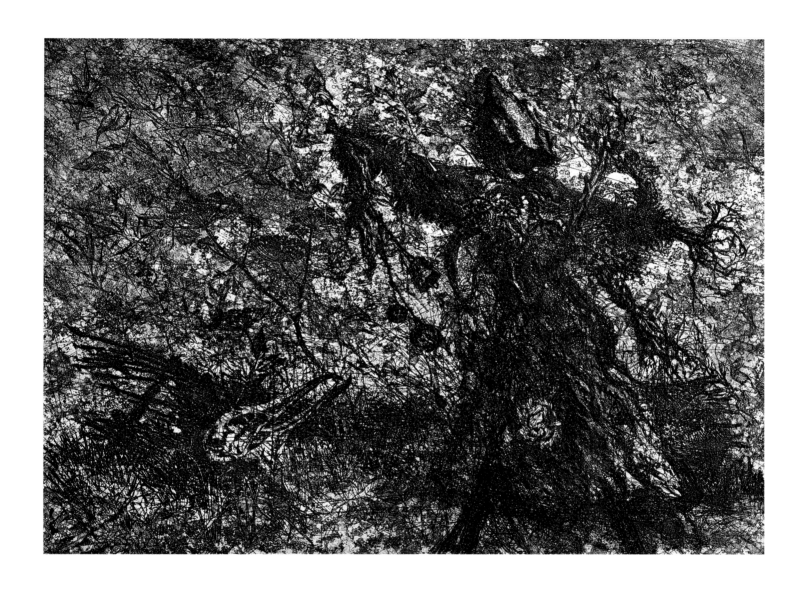

Scarecrow, 1976, Etching, aquatint, 19 x 25³/⁸ in. 48.3 x 64.5 cm
The State Pushkin Fine Arts Museum, Moscow

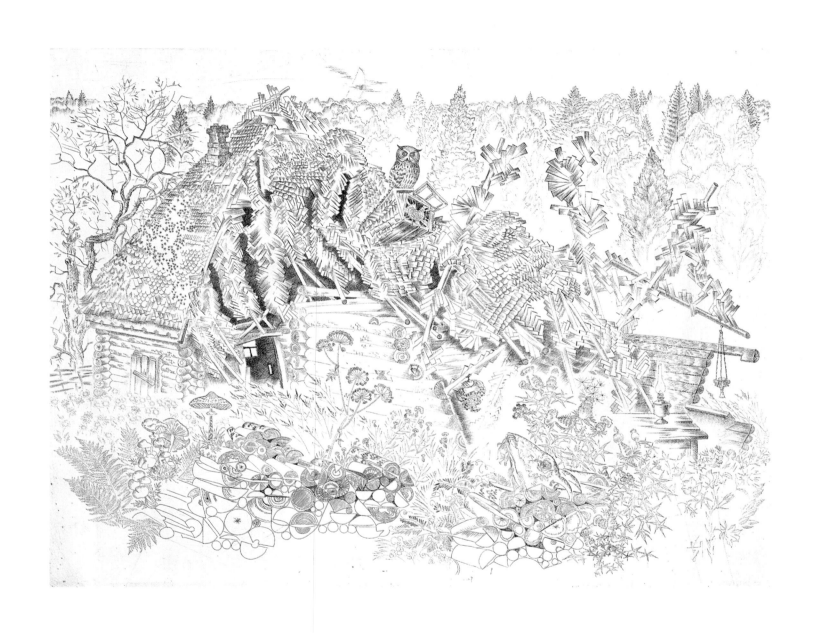

House with an Owl, 1968, Etching, 17⁷/₈ x 23¹/₄ in. 45.5 x 59 cm
The State Pushkin Fine Arts Museum, Moscow

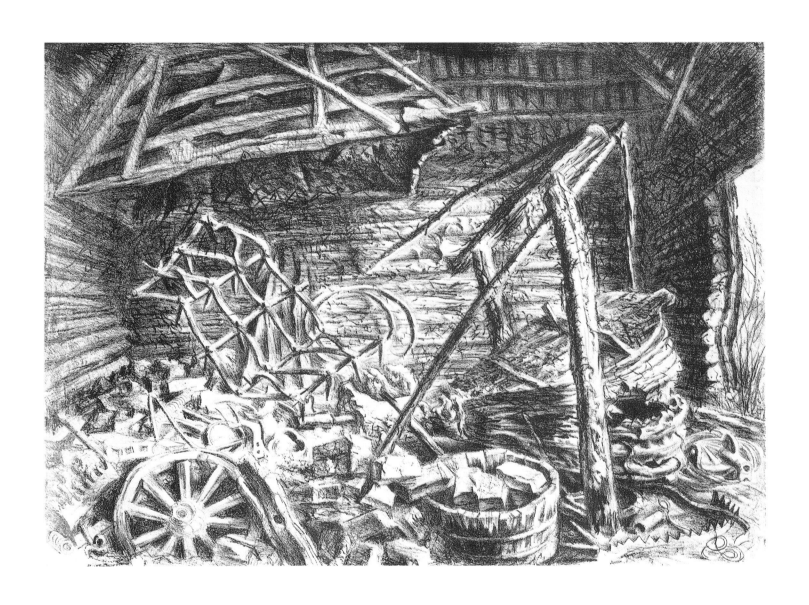

Ruined Blacksmith, 1975, Lithograph on aluminum plate, 12$^{7/8}$ x 19$^{1/8}$ in. 54.3 x 71.8 cm
Jane Voorhees Zimmerli Art Museum, Rutgers, The State University of New Jersey
The Norton and Nancy Dodge Collection of Nonconformist Art from the Soviet Union

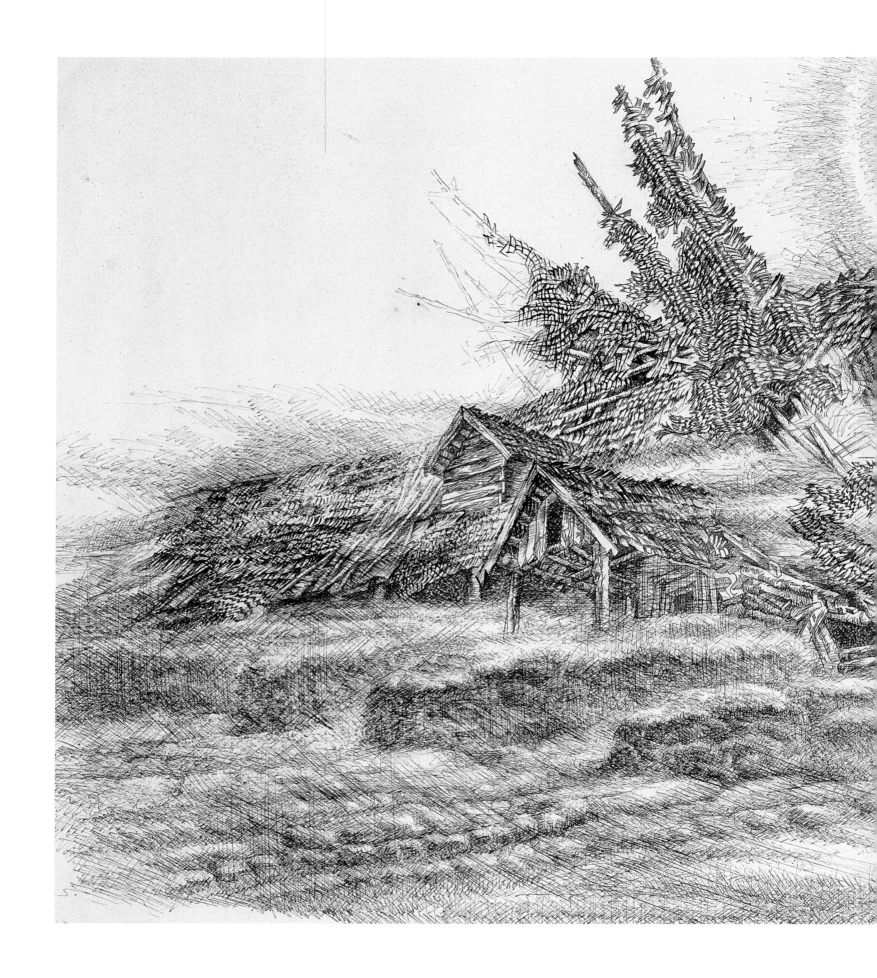

Moonlight, 1980, Pen and ink on paper, 21³/₄ x 39³/₄ in. 55.5 x 101 cm
Artist Collection

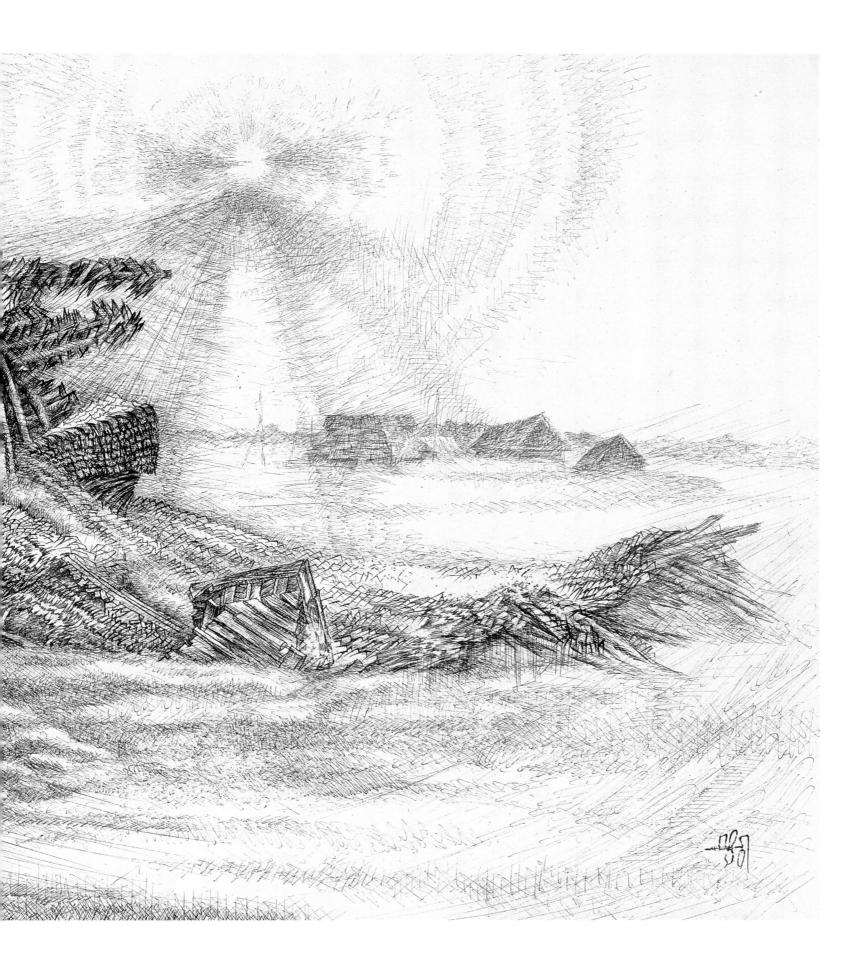

221

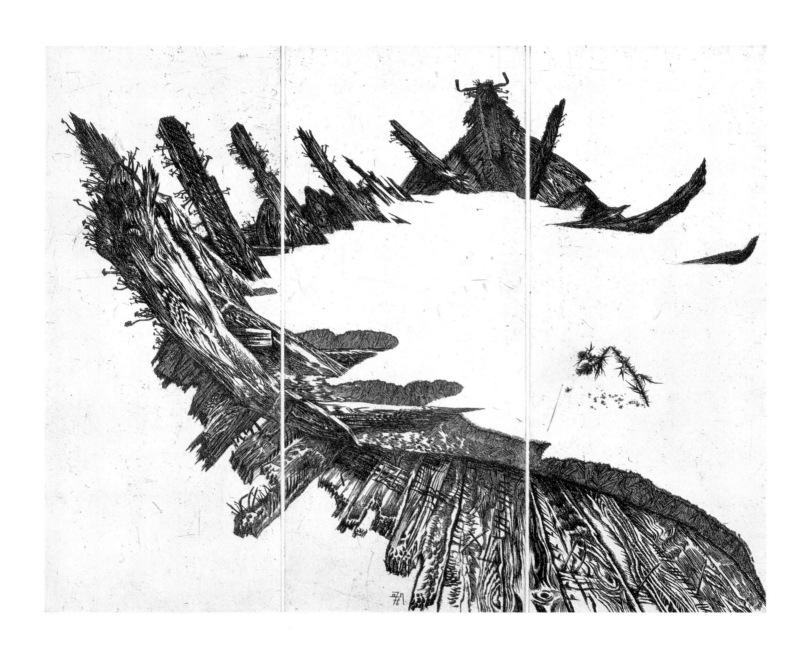

Vikings Boat (3 parts), 1976, Etching on copper plate, 19$^{1/4}$ x 23$^{3/4}$ in. 48.3 x 59.8 cm
Jane Voorhees Zimmerli Art Museum, Rutgers, The State University of New Jersey
The Norton and Nancy Dodge Collection of Nonconformist Art from the Soviet Union

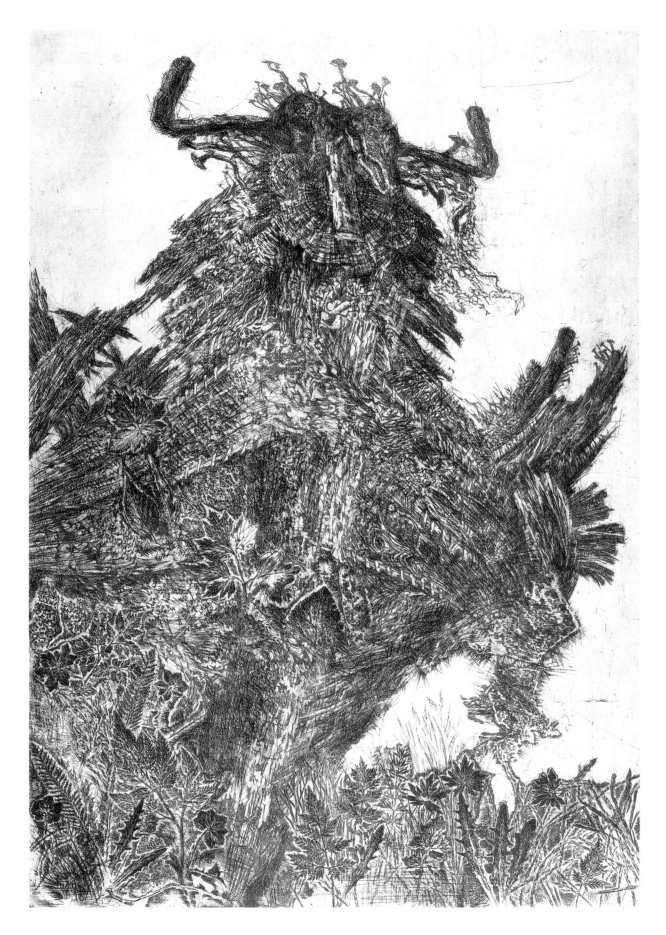

Vikings Ship, 1976. Etching on copper plate, drypoint, 35³/⁴ x 24¹/⁸ in. 91 x 61.5 cm
Jane Voorhees Zimmerli Art Museum, Rutgers, The State University of New Jersey
The Norton and Nancy Dodge Collection of Nonconformist Art from the Soviet Union

I. STRUCTURAL SYMBOLISM

One of the fundamental characteristics of Russian artistic and cultural expression is structural symbolism. In his book *Iconostasis*, Pavel Florenky, Russian philosopher and priest, provided a religious-mystical interpretation of the creative process as a path towards an incarnation of the highest reality for a system of symbols. During the ascent to the celestial realm and crossing from the mundane world to the celestial one, images of the mundane world that we are abandoning as well as the spiritually unsettled elements of our oxistence are being discarded like the attire of the diurnal bustle. Nevertheless, the artist deludes himself when giving into the feeling of inspiration that elevates him - thouse are but images of the ascent, psychologisms and raw materials. Crossing from the reality into the imaginary realm, naturalism creates an illusory image of the reality, a semblance of the everyday life. The artistry of the descent is, conversely, the crystal of time in the imaginary realm, the symbolism that, in real images, incarnates a different experience - the one which was acquired in the mundane world - and creates the highest reality. In this construct, an original image is split by an artist into a series of self-sufficient symbols. The symbols are then arranged into horizontal rows within a structural-temporal space. When they are being read vertically, what emerges is the manifestation of one within the other, as well as superimpositions, influxes, displacements, conditions, and mutual destructions. The splitting and absorption of an image by the space in which it is embedded is, in fact, what makes up structural symbolism.

In structural symbolism, the chronological sequence of time is destroyed, giving way, instead to the laws of the imaginative structural-temporal space. I replace time past, present, and future with time recurrent, given and conjectured. Time given is measured by the life of today's generation. It is what we call modernity. Time conjectured is future time. It is the realm of dreams, guesses, and assumptions. It has neither form nor dimension, and its direction is not defined. The most active time, which shapes man and fills him with internal meaning, is time past or recurrent. While reflecting on time and space, Pavel Florensky maintained that each of the various spatial systems has its own time that flows with its own speed and in its own dimension. Breaking through into the infinite speed, the timecontorts upon itself and acquires the reverse movement of its stream. Crossing from the visible world into the invisible world, from the real space to the imaginary one, the "immediate time" is created, the one that is aimed from the future to the past, being "the time redirected" or "the time recurrent". For man, this time is the only real time. Indeed, it is this sense of reverberating time that created man, juxtaposing him with the surrounding world.

Art is created of art. If we do not filter our reality through this prism, art merely becomes another mass medium. Art's element lies not in the cognition of the world or its reflection but in the creation of unknown spiritual landscapes. It is generally accepted that an artist reveals himself in his works. On the contrary, in painting an artist codes his "self" through a system of hieroglyphs. Not everyone is capable of reading these symbols, and the last of them is beyond reading.

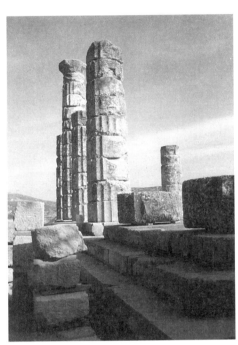

1. Temple of Apollo. Delphi, Greece
(Photo by Dmitri Plavinsky)

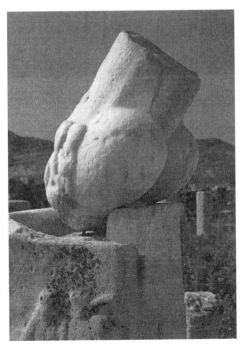

2. Phallic statues at the island Delos, Greece
(Photo by Dmitri Plavinsky)

1. Axis of Dionysus and Apollo

Engrossing into the ancient culture, one cannot help the idea of dual unity of the opposing Apollonian and Dionysian principles that was first recounted by Nietzsche in his book *The Birth of Tragedy from the Spirit of Music*. This idea determined the content of my paintings on ancient subjects, first and foremost, *Sign over Delphi* (1995), *Pythagorean Light* (1995), and *Dionysian Element* (1995).

The divine sphere of Apollo is imbued with the light of world harmony, the measure of things, and the proportion and regulation of the form. Apollo is a god of the illusory nature of dreams and poetic inspiration; he is the ruler and the patron of the Muses (*Apollo and Muses*, 1995). Being a god of the Sun, he possesses a gift of prophecy. Numerous temples are dedicated to him, among them the religious center of Ancient Greece—his temple in Delphi from which the oracle's will influenced the private life of the citizens and the politics of the entire state (Fig. 1). At his time, Apollo gave Hermes a herd of bulls for a cither made from a tortoise shell. On that instrument with a limited sound range, one could play an austere, rhythmic music that was close in spirit to the Doric architecture. Playing the cither, Apollo brought joy to the world, and he was also recognized as a god of music. Representing the personality principle, the divine incarnation of serenity, majesty, and wisdom, he was the god of Greek aristocracy.

The Dionysian element was completely opposite. The wild, ecstatic debauch of the Dionysian feasts swept everything on its way. The symbol of the god Dionysus was the phallus (Fig. 2). Its carving was carried out on a litter at the feast's most solemn moment; it was decorated with garlands of spring flowers and wines of wild grapes. It would appear that the inebriated riotous dances were performed to the music that was closer to rock-n-roll than to divine triads of the cither of Apollo. The Dionysian element of destruction, a passion for the devastating drunken debauch, for the heat of amorous orgies wiped out individuality, bringing the faceless crowd in touch with the primeval forces of nature.

Nevertheless, the Apollonian absolute and the Dionysian chaos are inseparable and analogous. Philosopher Friedrich Schelling maintained that "the Chaos in the Absolute is not just the refusal of the form, but also the formlessness in the highest and absolute form, much like, conversely, the highest absolute form in the formlessness."

Pavel Florensky, approached the phenomenon of dual unity of Apollo and Dionysus from a religious-mystical point of view. Maintaining that the structure of multiple planes of the real world is expressed only by the language of symbols, P. Florensky wrote that God, having created heaven and earth, created the visible world and, as the inverse thereof, the invisible world. The Dionysian element, leaving the earthly visible world, ascends to the celestial world of the invisible, and then descends yet again to the visible world. It brings in itself the symbols of images of the invisible world and, through the material sheath of things, the symbols of their essential ideas begin to emerge. What takes place is a transmutation of the Dionysian elemental world vision into the Apollonian, ergo, the spiritual vision.

2. Symbolism of the Knossos Installation

In my youth, while copyng frescoes by Theophanus the Greek in Novgorod or paintings by El Greco in the State Pushkin Museum of Fine Arts, I vividly visualized the remote island of Crete, the homeland of these geniuses. It was long ago in Moscow, in the house of George Costakis, a Greek by birth, submerged in contemplation of his remarkable collection of paintings, that I eagerly listened to the stories of a recent voyage to Greece told by Costakis and his wife, Zinaida: sun, marble temples, merriment, wine, taverns, Greek dances. How different this was from the oppressive atmosphere of our days. thirty years later, by some miracle I am at last in the house of the Costakis, in Athens. Laughter, wine, and marble temples are real this time, and as my feet step into the labyrinth of the Knossos Palace in Crete, my dream is realized.

The tablets with scripts of the Linear *B* language attest to the spread of clay in the cult of Hermes in Crete. This defines the hermetic symbolism of the *Knossos* installation. On the horizontal plane of the floor, along the central axis, a symbolic range of the Knossos Palace is being lined up (Fig. 3). At the sides of this axis are flanks of the palace's buildings: temples, a throne room, living quarters, basins, and storerooms for grain and wine. In the foreground, the Orphic Egg is set up; it contains an embryo of the Cosmos. It is guarded by a serpent, which is the Fiery Creative Spirit (Fig. 4). Behind the Egg of the World, the labyrinth of the Minotaur begins; it is a symbol of the underground world where the human soul wanders in search of truth. The Minotaur is a transformation of the sacred Egyptian god Apis, who is a symbol of Osiris and, simultaneously, of the Egyptian god Serapis—a creature, half man and half bull, who dwells in the center of the labyrinth. He presides over the judgment of souls that seek a reunion with the Immortal Ones. The labyrinth of the Minotaur progresses under the processional staircase in the mysteries of Hermes (Fig. 5). Behind the staircase, the altar is installed with a pyramid on top of it. The pyramid is an archetype of the Sacred Mountain, which is the domicile of the Sacred Divinity and a symbol of the Flame of World's Life. There is a myth that Hermes, the son of Zeus and Maya, had originally been—rather than a god—a totemic force of the phallic stone pillar, or a pyramid. What stops the horizontal plane of the Knossos Palace is a sacral image of the sacred bull's horns. Their diverging ascent, together with the upwardthrusting staircase, transports the palace's horizontal plane into the vertically develop-

3. D. Plavinsky. Sketch for Minos' Palace, 1993, Pen and ink on paper
8¹/² x 11 in. 22 x 28 cm
Artist Collection

4. The Ancient symbol of the Orphic Mysteries was the serpent-entwined egg, which signified the Cosmos as encircled by the fiery Creative Spirit

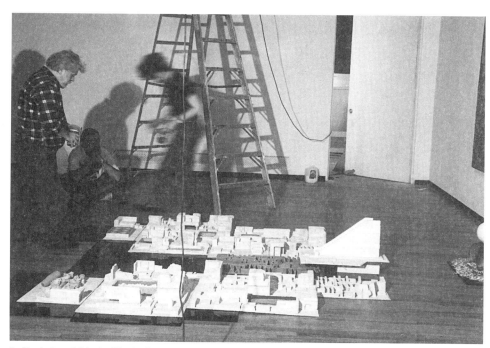

5. Dmitri and Maria Plavinsky mounting Minos' Palace (Installation *Knossos*.)

ing topography of Hades. Its structure is the frame of Charon's boat, and its silhouette is a leaf from the golden branch in the garden of Persephone, which is a pass to the kingdom of the dead. The labyrinth of Hades is crowned by the head of the Minotaur with gilded horns, which was a sacrifice to Minos who, like Osiris, became a king of the netherworld. Above the horns of the Minotaur is a lunar disc of the goddess Isis, Osiris's sister and wife. Upon it is a chiseled sign from the Linear *B* language, which is a symbol of the hand of the Creator of the Universe (Figs. 6, 7).

On one side of the labyrinth is *Hurricane of Time I*, and on the other is *Hurricane of Time II*. Streams of volcanic lava had crashed upon the Knossos Palace, thus bringing this epoch back to us after the millennia in the form of a half-erased and mute image of the Minoan culture, (Fig. 8).

My immediate impressions of Greece did not coincide at all with my preconceptions of the ancient world. Friedrich Nietzshe wrote: "The fact does not exist, just its interpretation." This idea also applies to my works. Having touched upon the cradle of European art, we find ourselves in a dual world of discrepancies-between reality and our notion of reality. In order for me to define my present self, I had to synthesize time recurrent and time given. A dual transparency of superimpositions of time recurrent and time given outlines a cartography of the ancient world in my painting and begets a breakthrough in the myth of that which is yet to come.

6. D. Plavinsky. Sketch for Minotaur's Labyrinth, 1995, Pen and ink on paper. 11 x 8½ in. 28 x 22 cm
Artist Collection

7. D. Plavinsky. Sketch for Knossos, 1995, Pen and ink on paper. 8½ x 11 in. 22 x 28 cm
Artist Collection

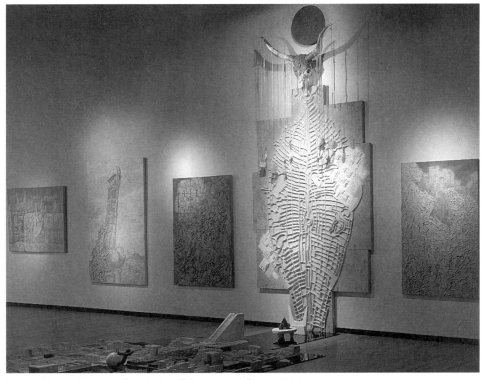

8. Installation *Knossos*. Exhibition *Echo Ancient Ruin*, 1995 (Photo by Arkady Lvov)

Mannahatta

I was asking for something specific and perfect for my city,
Whereupon lo! Upsprang the aboriginal name.

Now I see what there is in a name, a word, liquid, sane, unruly,
musical, self-sufficient,
I see that the word of my city is that word from of old,
Because I see that word nested in nests of water-bays, superb,
Rich, hemm'd thick all around with sailships and steamships, an
Island sixteen miles long, solid-founded...

 Walt Whitman, *Leaves of Grass.*

It was the summer of 1960. Working on a painting, I reached an artistic impasse. In frustration, I tossed my paintbrushes and decided to get some air and visit Sasha Kharitonov, an artist who lived nearby, on Plushchikha Street. He was finishing a magic extravaganza, *Funeral of the Heart*. I liked the painting a lot, and I told the artist so. Chatting about this and that, and leafing through an issue of *Around the World* magazine, I jumped. There was a full-page photograph showing an imprint in stone made by the most ancient fish, the Coelacanth, accompanied by an article about the fish (Fig. 9). "The most famous of all living fossils is undoubtedly the Coelacanth. Coelacanths have a distinctive three-lobed tail and fins with Armtek bases. They range back to the Devonian. It was thought that Coelacanths had become extinct in Cretaceous times. Then, in December 1938, a living one was caught by a fisherman off the South African coast, causing a major stir in scientific circles. More specimens have since been caught, and some have been photographed alive in water 200 to 1,310 ft. (60 to 400 m) deep off the Comoro Islands northeast of the island of Madagascar." In the same article, there was an ad from that period: "Wanted! The first modern Coelacanth was identified in 1938 by Professor J.L.B. Smith, an ichthyologist in South Africa. He offered a reward of £ 100 to anyone who found a second one." (Fig. 10)

10. Newspaper ad offering a reward for the capture of Coelacanth

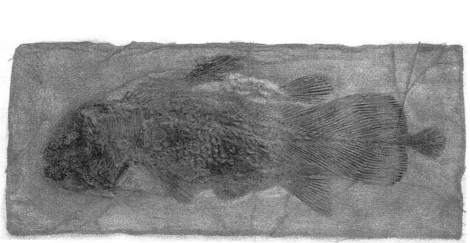

9. Fossil. Coelacanth

I was engulfed by an unexplained sensation of reversed infinite Time. It was as if I had taken a peek into the foggy abyss of my protomemory. There, at its very bottom, was a barely audible, distant whir of the world's creation. In a feverish state, without taking leave of my host, I rushed home. The painting *Screaming Fish* (1960) was completed in two days.

Reflecting upon the origins of ichthyomania and reptilophilia in the very depth of my soul, I am still unable to find a sound and logical answer to the questions Where? When? and How? As a teenager, when I visited my mother in Latvia, I often went to the town of Sigulda, not far from Riga. I remember its superb landscapes—hills covered with beechwoods, medieval castles and caves that contained the coat of arms of knights carved on the walls. But my most vivid recollections are of myself on the sandbars of the wandering and turbulent river Gaua. On the practically white sand, it was easy to notice brown, rusty pieces of shell of alligator gars that belonged, much like the most ancient fish Coelacanth, to the Devonian period and lived 420,000,000 years ago. I would put pieces of shell into a bag and bring them to Moscow, and they were more valuable to me than the Baltic amber.

11. D. Plavinsky. Sketch for Coelacanth, 1965, Pen and ink on paper. Artist Collection (Photo by Alexander Saveliev)

An image of *Screaming Fish* emerged from the depth of my subconscious and became my first depiction of the fish, rapidly rushing through implacable streams of time, screaming with aggression and frustration. This work was structured upon the contrast of different textures. The "orchestration" of textural surfaces was done with the application of various grains and other groceries mixed with glue. Artists and other friends laughed, reminding me that the writers Ilf and Petrov described my forerunner in their *Twelve Chairs*— an artist who used various grains instead of paints. After the fish, I made a painting, *Tortoise*, in the same "grocery" technique. Soon after, polyvinylacetate paints became available in Russia, a surrogate for the American acrylic paints, and I was spared having to resort to semolina, buckwheat, and pasta. For months afterward, my family fared very nicely on the grains that I had stored in large quantities for artistic purposes.

Fish as a symbol that changes its meaning throughout time has often bobbed up to the surface of my canvases, as if independently of my consciousness. It emerged now in a human form (*Man-Fish*, 1964), now as the one that carries a human embryo in itself (*Coelacanth*, 1965)(Fig.11), now as the one that bestows the written language upon mankind (*Birth of Sign*, 1989), now in a series of New York images (*Manhattan Fish*, 1992-97). Coelacanth continued to haunt me even in America.

Panoramic views of New York from the harbor at sunset are an unforgettable, powerful spectacle. Untwisting vertically, the city is growing from nothingness into nowhere. The parallelism of skyscrapers' quartz-like sides, which refract the setting sun, creates the illusion not of a city built by human hands but, rather, of a natural crystalline formation that emerged on a fragment of the earth's crust. It is as if it had been created at the same time as our planet and then, all of a sudden, had revealed itself rising from the depths of the ocean. I experienced a disturbing sense of foreboding that this part of the globe would,

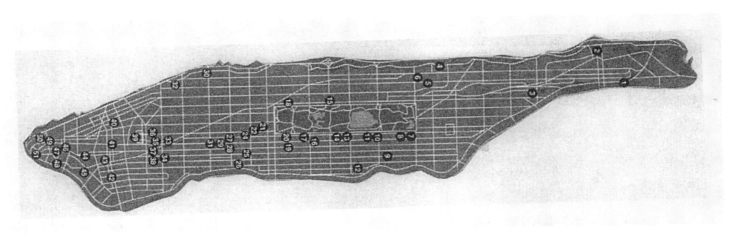

12. Subway map of Manhattan

230

in the future, meet the same fate that had stricken the realm of Montezuma. I could not anticipate that this city was meant to draw a fiery hieroglyph upon my destiny.

Examining the subway map of Manhattan in search of a station that I needed, I was struck by the similarity between the island and the silhouette of Coelacanth (Fig. 12). Old geographic maps of America and New York brought to my mind zoomorphic images of Earth and Ocean and Ptolemaic notions thereof. In a small store in Chinatown, I bought a stone with the imprint of a fish which reminded me of the picturesque granite rocks in Central Park—the bedrock upon which New York City stands.

In the series *Manhattan Fish*, the motley life of New York, which is full of dynamics and tense dramatic situations, reaches its culmination in the scream of the fish, in its spasmodic attempt to break free from the hell of the city's enormous stone bulk. In the layout of buildings and urban blocks, enmeshed in the perpendicular net of streets and avenues, I could not help noticing a similarity between the island's map and computer circuits.

At the same time, to me, a Russian artist, the compositional layout of the island's mass along the drawing's entire horizontal plane brought to mind the horizontal layout of the body of Christ in Russian representations of the Holy Shroud composed in the sixteenth century. The background of the composition, pasted from fragments of New York's map in a mosaic arrangement, looks like Russian rural quilts sewn from wedges of colorful fabric.

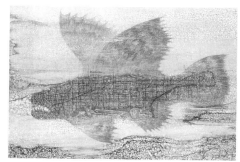

13. D. Plavinsky. *White Manhattan Fish*. 1994. Oil, acrylic, collage on canvas. 42 x 60 in. 107 x 153 cm Private Collection, Moscow (Photo by Arkady Lvov)

Thus, from various impressions, the multilayered compositional image of the *Manhattan Fish* was delineated. The compositional basis is formed by the principle of *compressed* Time. The island's rock is the geological time, which is the time first. The impression of a fish in stone is the ichthyological time, which is the time second. The subway map is the historical time, which is the third time. All three temporal strata are conjoined in the drawing. New York, relegated to the ichthyological stratum of the Devonian period, is therefore located in a time that is yet to come. This is what the city will be like millions of years from now. Having conjoined all the heterotemporal strata, I obtained an X ray of Time Unified. The unity of the heterotemporal matters, the juxtaposition of that which cannot be juxtaposed, the unification of opposing entities—this is, in fact, what constitutes creative thinking. The Arab doctor and philosopher Avicenna (Ibn Sina, 980-1037) said, "Join a terrestrial toad with a celestial eagle: then shall you see in our art a splendid, true mastery." It has a power to conjoin and compress the temporal strata until it becomes devoid of value, mass, or time.

In America, from 1992 to 1998, the theme of *Manhattan Fish* developed and took over more than twenty of my paintings (Fig. 13) and drawings that are two meters in their horizontal dimension. While working with them, I was trying to clarify and specify images of the movement of temporal strata-their superposition, shining through each other, their shifts and disappearances.

Time is a boundless and swift stream that everlastingly changes its direction and carries in its straits myriad symbols in the most unexpected patterns, forming islands, continents, and mountain ranges. In a brief moment, all this acquires the destiny of Atlantis—that is to say, an intangible guess about the past.

IV. SEARCHING FOR THE FUTURE
IN THE DEPTHS OF A DISTANT PAST

14. D. Plavinsky. *Ancient Russian Paleography,*
drawing from notebook, 1966
Pen and ink on paper
10¼ x 7⅞ in. 26 x 20 cm
Artist Collection
(Photo by Alexander Saveliev)

After graduating from the 1905 Institute of Art, I had an acute sense of the deficiencies and gaps in my education. In the early sixties, the State Pushkin Museum of Fine Arts was indeed one of the most democratic cultural centers in Moscow. Students and young artists were able, unhindered, to make copies of Western European paintings and to draw sculptures of antiquity, which is precisely what Professor Tsvetayev had in mind when he founded the museum. Admission and copying were free of charge for students and artists. In those bygone days, the museum looked far more like an artistic studio than it does today, with its slapdash presentations, inadequate lighting, pretentious exhibitions and high admission fees. I used to work at the Pushkin Museum quite a lot: I copied details of the Egyptian frescoes, Faiyum portraits, paintings by El Greco and Cézanne. Together with Anatolii Zverev and other artists, I drew ancient sculptures or visitors who happened to pass by. The museum was our home away from home. I worked there primarily during winter months. As soon as spring came, I would go to the cities of Novgorod or Pskov, Armenia or Central Asia.

As a rule, I tried to make life-size copies of the frescoes in Novgorod, which were amazing in their beauty and powerful in their religious spirit. In the sixties, tourists rarely visited those dilapidated churches. An artist had only to bribe a church custodian with enough money for a bottle of vodka, and he would lock you inside a church with your paints and canvases until the end of the day.

I once worked at the Church of Savior-on-Iln, which is world-famous for its fourteenth-century frescoes painted by Theophanes the Greek. I copied the faces of the prophets in the church's dome, which was located so high up that it could be reached only by a narrow wooden staircase that had no handrails. In its steepness, it could be compared to a ship's gangplank. One weekend, a group of Soviet soldiers, headed by their sergeant, visited this church in lieu of a museum. They were young, rubicund, brave guys. They started their fearless ascent to the church's cupola on the wooden steep gangplank, but the staircase could not withstand the marching rhythm of soldiers' boots. It cracked, disintegrating into splinters. The soldiers, headed by their sergeant, fell from a staggering height onto the stone slabs of the cathedral. The sergeant's fall was broken by a dozing custodian, and both were instantly reduced to the state of a ripe watermelon thrown from the Empire State Building. The rest of the soldiers fell onto the stone slabs any which way, one on top of the other. Bleeding and moaning, those who were still able to move began to crawl outside. The citizens of Novgorod, who had survived the invasion of Hitler's army, fled in horror at the sight of the bloodied soldiers. Terrible scenes from the war came to their minds and, in shock, they imagined that war had returned to Novgorod. When they finally called emergency, it took hours for ambulances, towed by tractors, to make it through the roads, which were bloated by abundant rainfalls. Night came, the bodies were removed, and Novgorod fell into an uneasy sleep.

In the city of Pskov, I copied fourteenth-century frescoes at the Church of Nativity of the Virgin in Miletovo, using a large old canvas that I had found in the Pskov Drama Theater. The church was located in the suburbs, and the bus route at the very edge of the city passed through an area that was surrounded by concentration camps. Early in the morning, from a window of the bus, I observed prisoners being counted at the gate and then led to work under armed escort with dogs. Barking, yelling, and cursing could be heard... and the bus passed on. Obviously, no stops were scheduled on that territory.

Upon my arrival to Miletovo, I would search for a church custodian and, for the usual price of a bottle of vodka, he would lock me inside the cold church and let me out at the end of the day. Immersed in my work, I hardly noticed that a week had gone by. The frescoes were rendered in two or three colors, in a broad and expressive manner. I failed to capture certain details and had to repaint them again and again, to the point of exhaustion. On one of those days, the church lock rattled, and the iron door opened to reveal the custodian, scared out of his wits, with a certain comrade dressed in gray. They approached me, and the "comrade" softly demanded that I show him my documents. I handed him my Moscow passport and a receipt from the hotel where I was staying. He studied them at length and finally yelled, "Stop drawing!" I tried to reason with the KGB representative that the work was not finished, that... but the bozo cut me short: "You are not a child, and you are fully aware in what zone you are working. We are still to find out your intents and purposes for choosing this particular location." There is no use arguing with cretins, especially those who are endowed with absolute power. I was forced to pick up my gear and leave the church.

Whatever God does, however, has its own profound meaning. In Pskov, I discovered an extensive museum library housed in a church whose name I cannot recall. The librarian was a lank, tall old man who was very cultured, though a bit weird. For instance, he maintained that he was privy to the secret location of Ivan the Terrible's library, and that he was the owner of the only extant autograph of that tsar. (Both of these things are still to be discovered.) I understood the full extent of the old man's oddities when he revealed that he had spent twenty-five years in a Vorkuta concentration camp as a political prisoner in accordance with Article 58 of the Criminal Code. Common criminal prisoners tortured him by using an enema tube to inject water into the keyhole of his cell. With temperatures often falling forty degrees below zero, the water would freeze instantly, and he was forced to remain outside until morning.

He adored his books, and maintained the library in commendable order. The museum library was truly priceless. Before long, my notebook was full of copies of handwritten pages from annals, church books from the twelfth to the eighteenth-century, letters from boyars and petitions from commoners, herbals, Novgorod birch-bark charters, and Latin manuscripts on astrology and alchemy. I immersed into the unbeknownst realm of the ancient Russian paleography, half-decayed Gospels, handwritten scrolls, geographic and astronomic maps (Fig. 14).

Time passed, and the precious world that I acquired at the museum library determined for many years the context of my compositions, such as *Word* (1967), *St. John's Gospel* (1967), *Wall of Novgorod Church* (1974; 1978), the installation *The Cross* (1976), and a entire series of paintings and etchings (Fig. 15).

It was a winter in the seventies. In Novgorod, on the shore of Ilmen Lake, I photographed the shells of fishermen's longboats, crashed by storm and by time. On the dazzling white snow, those majestic vestiges of struggle and perdition conjured primal images of Noah's Ark lost in the eternal snow of the Ararat Mountain, along with shells of ships that belonged to the Vikings, those fearless seafarers who reached the coasts of America long before Columbus did. There were many works in which I used the boat as a symbol of conquering infinite spaces, as a connection between continents and islands, a victory over the elements; among these are the 1976 Moscow etchings *Viking's Boat* and *Viking's Ship*, as well as American works on the same subject, *Mirage in Aegean Sea* (1995), *Lost Ship* (1995), the painting *Boat of Remembrances* (1997), and the photo-collage *Paestum Vessel* (1999). On another plane of imagery, my boats are interconnections and interpenetrations of cultures and civilizations that, historically speaking, are worlds apart. Their shells are reminiscent of the skeletons of prehistoric animals. My boats, thrown upon the shore and overgrown with grass, constitute majestic monuments to an uneven and tragic struggle with the elements of time and space.

In my travels to ancient Russian cities, I used every opportunity to expand my knowledge of Russian paleography, and I persistently searched for incunabula in museums, monastery libraries, and abandoned churches.

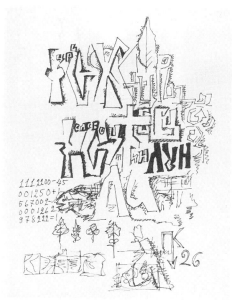

15. D. Plavinsky. *Paleographic Composition*, drawing from notebook, 1966
Pen and ink on paper
10¼ x 7⅞ in. 26 x 20 cm
Artist Collection
(Photo by Alexander Saveliev)

16. D. Plavinsky. *"Hook" Notation*,
drawing from notebook, 1966
Pen and ink on paper
10¼ x 7⅞ in. 26 x 20 cm
Artist Collection
(Photo by Alexander Saveliev)

17. Fludd's Mundane Monochord

In the village of Berezhki, not far from Kineshma, a town on the Volga River, I once did my paintings in a large church of St. Nicholas. The church, which had been closed for a long time, had also been relinquished to the disposal of the Schelykovo Museum. On the altar, among amassed candlesticks, church vestments, and other implements, I discovered a voluminous disarray of books on ecclesiastical chants. They had neither the five lines for notation nor bass or treble clefs, and they looked nothing like the European system of notation in music. It was the "hook" tablature, which is still used by the Old Believers (Fig. 16). An undiscovered territory opened to me; I became engrossed in the history of the development of notation in music in Europe and Russia. I researched this subject in the libraries of Moscow and Leningrad (Figs. 17, 18).

I did not and I still do not know the meaning of a single note, but this only heightened my graphic perception of the score. Often, knowledge replaces truth. At the behest of Stravinsky, the libretto to the opera *Oedipus Rex*, based on the tragedy of Sophocles, was written in Latin by the poet Jean Cocteau. In his book *Stravinsky: An Autobiography* (1936), the composer wrote: "What a joy it is to write music using the language that has not changed for centuries, that functions almost ritualistically and, therefore, it is capable of creating a deep impression by its pure form. One does not submit to power of the phrase or of the word in its literal sense... A composer is able to arrange that text in any order he desires and concentrate all his attention on the primary component, namely, the syllable." (Fig.19) Solomon Volkov wrote in his book *Dialogs with Joseph Brodsky* (Moscow, 1998) that Brodsky reminisced about the English poet Auden, who "...quite often visited Armenian and Russian churches. Auden said that it was awfully pleasant to be in a church and listen to a service without understanding the language because then one does not get distracted from that which is really important. And this is, in fact, an extremely credible justification of the worship in Latin."

Many composers emphasize the impact of the score's graphic pattern on the music they compose, as well as the interconnection between the two. This observation was made by the American conductor Leopold Stokowski in his book *Music for All of Us*. A handwritten score, much like a handwriting sample to a graphologist, could reveal the epoch, style, context of a music piece, and the composer's name. The poet O. Mandelstam accurately compared Bach's notes, which appear to be rushing ahead of themselves, with a bunch of dried mushrooms. A complex, mazelike notation does not necessarily imply a musical genius, however. Scores by Mozart serve as a great example; they are visually transparent and simple to the point of boredom. Conversely, the American composer George Crumb creates with his notes mystical, occult semiotic images: circles, spirals, crosses, peace signs, etc.

There are countless examples of music influencing painting. The artist Mark Rothko strove to elevate his painting to the level of dramatic tension expressed in music and poetry. My work *Bach Fugue* (1987) inadvertently reminds me of Dürer's watercolor landscapes of German and Italian towns, lost and transparent, with superimposed planes of green hills, ochre fields, and azure mountains on the horizon.

Examining the scores of various epochs, styles, and composers ranging from the Gregorian Chants, Bach, Beethoven, Vivaldi, and Mahler to Schoenberg, Stockhausen, Schnitke, and John Cage, I tried to comprehend the mystique and magic in conjunctions of notation signs, the proportion and rhythm of black and white on the pages of numerous scores.

One could tentatively divide the musical instruments in an orchestra into the feminine and the masculine. Wind and percussion instruments represent a masculine origin; string instruments, a feminine origin. The violin is the soul of the feminine element, both in the shape and the sound of the instrument.

In the sixties, I made frequent visits to the museum of the composer Scriabin in Moscow, and his sister showed me voluminous handwritten scores of *Ecstasy Poem* and *Prometheus*. *Prometheus* is striking: its symphony score is accompanied by the *color clavier*. Scriabin claimed that there are composers who possess the *color pitch*. Among the Russian composers who pos-

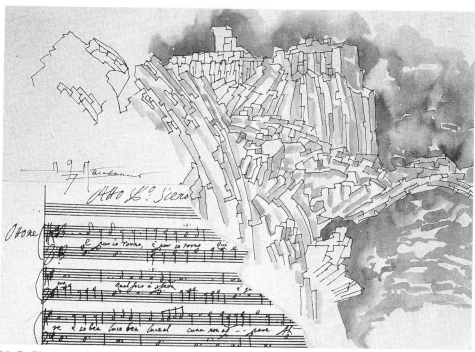

18. D. Plavinsky. *Manuscript Page with the Music of Monteverdi*, 1997
Pen and ink, watercolor, collage on paper
$10^{1/2}$ x 14 in. 26.8 x 35.8 cm
Artist Collection
(Photo by Arkady Lvov)

sess this rare gift, he named only two: Rimsky-Korsakov and himself. A genius who possesses this rare phenomenon is capable of uniting sound and color into one harmonious whole. Scriabin's idea was that the whole world should participate in the recital of *Prometheus*. This is a worldwide extravaganza in which shoemakers of the earth make boots for performers, tailors—the clothes and the musicians of the whole world distribute among themselves the instruments of the orchestra, which is cosmic in scale. The length and pulsation of sound waves should totally correspond to the oscillations and changes of the color wave. The color-sound vibrating substance should fill the atmosphere of the entire earth. The sky, therefore, is the most important participant of the universal mystery. Upon the completion of *Prometheus*, in Scriabin's vision, everybody joins hands in an ecstasy of happiness and love, and the human race unites in the utmost harmony of a renewed world. Scriabin did not live to see the end of World War I and the ensuing catastrophe of 1917, which split the world into two hostile social systems. I do not think that Scriabin's utopia of the world's uniting in happiness and harmony will be realized anytime soon.

The idea of a correlation between notation and color is incorporated in my painting *Color-Sound Vertical* (1987), as well as in a large cycle of my Moscow works from the late eighties, *Measure of the Universe*, which found its continuation in my art of the New York period—the exhibitions *Echo Ancient Ruins* (1995) and *In Search of Italy* (1998).

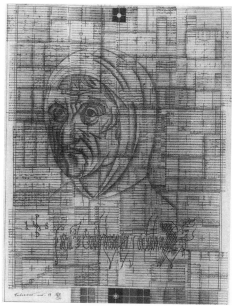

19. D. Plavinsky. *Dreams of Igor Stravinsky*, 1983, Pen and ink, color pencil collage on paper
$43^{1/4}$ x $35^{1/2}$ in. 110 x 90 cm
Private Collection, Moscow.
(Photo by Vladimir Belov)

1. Roads of Asia

No matter how much I begged, my father gave me only enough money for a one-way rail ticket to Tashkent. As to how I would manage when I got there, that was up to me. I had just turned twenty-one and, full of romantic ideas, I departed for the unknown land of Central Asia. It was a postal train and, therefore, it made all the local stops. A trip to Tashkent took five days, quite sufficient time to strike up friendships with passengers. I became especially close with a soldier who had just been discharged from the army after two years of service. He was coming home to a *kishlak* (village) near Tashkent, and he invited me to stay at his house. That is how I got into the house of his father, who owned a *tchaikhana* (tea salon). When the father found out that I was an artist, he asked me to paint his new house with ornaments and murals. I eagerly agreed. The house was surrounded by a gallery, and I coated its ceiling with an azure oil paint, the Uzbeks' favorite color, and covered it with multicolored interlaced ornaments. I painted carved wooden doors with gold and arranged variegated frescoes on the walls. One fresco depicted a roaring lion with burning emerald eyes and a fiery-red tongue sticking out from under crooked ivory fangs. In the background, was the towering silhouette of a volcano bursting with fire and lava. Those murals made me a celebrity in the entire *kishlak*. All the households formed a line and eagerly awaited my murals. While I worked, I had room and board in those houses and even received some money, which gave me the freedom to draw and travel in Asia. *Abai* (the elders) prayed at the local mosque for my health, happiness, and talent. (Fig. 20)

At the very first occasion, I went to the city of my dreams—Samarkand. As soon as I arrived in that magical city of *the Arabian Nights*, I went to Chakhi-Zinda to see the fourteenth-century multitiered complex of mausoleums, the magnificent azure majolica, the fretted ceiling of the mosque, the stalactite structures in the tier of sails carrying a slender vault covered with starry-sky

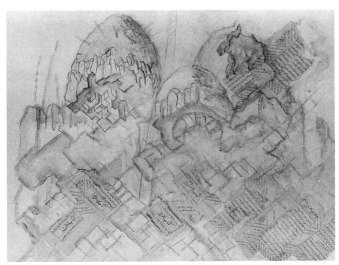

20. D. Plavinsky. *Earthquake in Tashkent*, 1978
Polyvinylacetate tempera, collage on canvas
31$^{1/2}$ x 43$^{1/4}$ in. 80 x 110 cm
(Photo by Vladimir Belov)

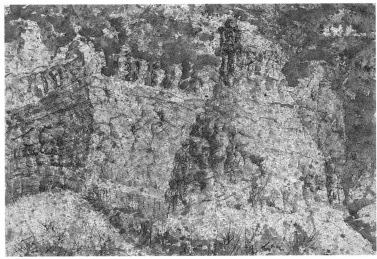

21. D. Plavinsky. *Kirghizian Cemetery*, 1977
Watercolor pen and ink on paper
Igor Palmin Collection, Moscow
(Photo by Igor Palmin)

ornaments, which created an impression of crossed battle swords, and the Cufic scripts of the Koran's suras.

The mausoleums of Chakhi-Zinda were undergoing restoration. The ancient, slightly damaged ceramics, removed from the walls together with crushed stone, had been thrown into the dump. In accordance with a decision of restorers from Tashkent, it was to be replaced by an "everlasting, brighter" plastic surrogate. I sifted through all the construction debris and discovered priceless chips of glazed ceramics from the fourteenth century. Subsequently, I brought it all to Moscow.

I wandered the city's crooked pise streets from mausoleum to mausoleum, mosque to mosque, then to a *medres*, and suddenly I would find myself at an isolated, neglected cemetery among cracked *mazars* covered with dry grass. The cemetery would unexpectedly be succeeded by the Samarkand marketplace filled with guttural cries, gaudy fabrics, jars, hookahs, trays, batten counters cluttered with fruits and vegetables, rows of meat carcasses suspended from hooks, hee-hawing donkeys, and women peering out at the world though a trunklike purdah. (Fig. 21)

A traveler gets relief from swelter and thirst in a cool *tchaikhana*, where green tea and Oriental delight are served. The swift stream of kaleidoscopic impressions consumed practically all of my time, and demanded from me concentrated attention and acute vision.

I went to Asia on numerous occasions, visiting Nukus, Khiva, Kokand, Mahry, Ashkhabad, Merv, and the Old Nisa. Those places were virtually swarming with tortoises. Indeed, the very architecture of those cities—the cupolalike mosques of Bukhara, the cemeteries of Khiva—reflected in its very shape the presence of those mysterious creatures.

I began drawing tortoises in the sixties. Soon tortoises, much like fishes, were taking up more and more space in my paintings. Nevertheless, during those years I did not reflect much on the complex cultural and mystical layers embodied by these objects, and only the magnetic impact of a tortoise shell would bring me, time and again, to this theme. In America, in the nineties, I was captivated by tortoises and, through them, discovered many interesting things that I could not have surmised earlier.

In the third century B.C., Fu Hsi, the legendary first ruler of China, took notice of the tortoise shell. Contemplating its structure, he realized the multitude of ways in which cosmic polarities interact. Fu Hsi saw the opposing principles of *yin* and *yang* in two central octagons (Fig. 22). In patterns surrounding the octagons, he saw eight possible *trigrams*. The diagram of eight trigrams around the central yin-yang symbol is known as the eight diagrams, which, according to Chinese philosophy, represents the ideal form for the transformation of the cosmos into a unified whole. The Chinese used it to help them determine the most harmonious locations and orientations for cities, temples, houses, and graves in relation to the landscape and its earthly energies. In other words, eternity is compressed by the shell into hieroglyph. Or perhaps it is the other way around: The tortoise, as an organism that is totally unknown to us, transmits this information from within—through architecture, paintings, graphics, music, and the structure of its shell.

Why were the significance and the magical properties of the tortoise known to ancient cultures that did not necessarily know about each other? This is an intriguing question, to be sure, but, ultimately, it is not what counts. The important thing is that the tortoise came to us as a message of eternity.

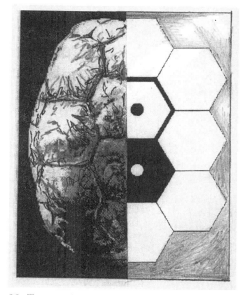

22. Tortoise Shell with a Symbol of yin-yang

2. A Skull and the Koran.

When the sun is overthrown,
And when the stars fall,
And when the hills are moved,
And when the camels big with young are abandoned,
And when the wild beasts are herded together,
And when the seas rise,
And when souls are reunited,

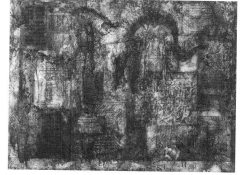

23. D. Plavinsky. *Skull and the Koran*, 1978
Oil, polyvinylacetate tempera,
collage on canvas
31$^{1/2}$ x 43$^{1/4}$ in. 80 x 110 cm
Private Collection, Columbia
(Photo by Vladimir Belov)

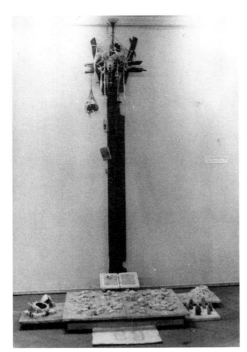

24. D. Plavinsky. *Asia – The Wall of the Koran.* Installation, 1978
Oil, polyvinylacetate tempera, paper, plaster, sand, fine gesso, cardboard, animal sculls, metal, canvas, wood
118$^{1/8}$ x 61$^{1/2}$ x 67 in. 300 x 156 x 170 cm
National Collection of Contemporary Art (in Tsaritsino Museum), Moscow
(Photo by Vladimir Belov)

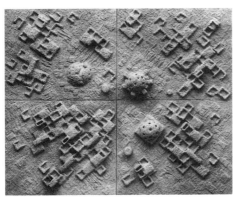

25. D. Plavinsky. *Asia. The Town of the Dead* (detail from the installation *Asia – The Wall of the Koran*), 1978

And when the girl-child that was buried alive is asked
For what sin she was slain,
And when the pages are laid open,
And when the sky is torn away,
And when hell is lighted,
And when the garden is brought nigh,
(Then) every soul will know what it hath made ready.

The Koran, Surah 81, *The Overthrowing.*

I have been relentlessly haunted by an image of death and how to capture it (Fig. 23). I traveled the country a lot, and no matter where I happened to be, I would intuitively come to a city of the dead. Paradoxical as that may be, it is precisely in such a place that the heart of a people beats on. As a rule, temples have been maimed by Soviet atheism, and only the cemetery's relief contains the carved face of a people's soul contemplating eternity.

From a distance, the pise city of the dead, chaotically scattered along the roadway skirting Lake Issyk Kul, looks like the petrified jaw of some prehistoric animal, beaten by wind and cracked beneath sun and rain. (Fig. 24) The vast space of almost indescribable color and relievo monotony is interrupted by a chain of lapis-lazuli crystals. These are the five-thousand-meter-high peaks of the Tien Shan Mountains, their tops covered with the whiteness of an eternal snow, sparkling and blinding to the eyes.

Burial mounds are pockmarked with the holes of scorpions, phalanges, tarantulas, and other such abominations. Only they, of all living creatures, disturb the unshakable eternal peace. The burial mounds are pierced with sticks and, quite often, with crooked branches that have faded pieces of cloth stuck in them, due to the lack of wind. Here and there, one sees black, dry crevices leading into the underworld. All of this is surrounded by thistle and henbane, mighty poisonous entities. The ground is covered with practically colorless patches of moss, but if one takes a closer look, it is possible to distinguish hues, from poisonous yellow and gray-green to purple and drab-blue (Fig. 25). In the cemetery's center, are the tall tombs of rich and respectable people. These are models of medieval fortresses; they have no ingress. Some of them have rectangular and triangular embrasure windows. Their lower horizontal part contains wooden sticks with tin crescents stuck into them. If you take a look inside, you will find the same mound, overgrown with moss. Such are the cemeteries of Kirghizia that I visited in 1977. (Fig. 26)

In my travels in the sixties, I encountered similar warrior edifices in dark and wet ravines. High above them, on the poles, were the tied-up skulls of wild rams decorated with faded ribbons. Below them were tied-up tails of horses. These were the especially revered burial places of the *basmatchi.* The cemeteries of Kunia-Urgench possess a totally different appearance. They are represented by a forest of burial hand barrows stuck into a damp burial mound. They are meant to facilitate the assent of dead souls to heaven. Among the graves are a scattering of trees with thin, leafless green branches. At first, the branches grow up. Then, inclining, they droop all the way to the ground. These are the only interlocutors and companions of the voiceless souls. A human hand should not touch those graveyard trees. In the vicinity of Old Nisa, I discovered a carefully hidden tabernacle that, apparently, was the burial place of some religious devotee. It was empty inside. There was a white cloth on the earthen ground with a hemisphere of polished granite on top. Outside, in the oblique sunlight of early morning, I noticed a faint footprint near a wall of the *mazar.* Its contour was inlaid with small stones, as was the circle beside it, 15 to 20 centimeters in diameter.

The city of Khiva, has, perhaps, the most picturesque multitiered city of death (Fig. 27). Its graves grew into a large clay hill that used to be a fortress wall. Time turned it into a shapeless block corroded by wind. Bellow the hill, grave edifices with decayed walls from various epochs had interlaced in a most preposterous fashion. Interlaced this way, they had invoded shabby dwelling houses. This graphic idea of unity is not, perhaps, altogether bad, when people live among graves and graves grow into their houses. Many edifices with

collapsed walls gape at the world through black holes. Inside, in daytime, it is possible to discern human bones and cats that rest there, enjoying the cool. At night, they return to the houses of living people. Among burial places, there are tall poles. Lanterns and white flags hang form them, and the wind stirs them ever so slightly.

Near the walls of Merv, I wandered into a boundless saline desert. Moss, burned by the sun, crackled under my feet, the surface of dead earth was, here and there, covered with holes, and I could not help feeling that, below, there was a labyrinth of underground hollows. At times, the ground under my feet sagged, as if I were walking on an air cushion. On the way, I encountered soap cakes of the walls of once mighty ancient fortresses with fingers of wind-beaten battlements that rose to the sky as if in prayer. Unawares, I wandered off to a very remote spot. A lowland opened before me with a bizarre cult edifice. One after another, the tires of large trucks had been dug into the ground in the upright position, forming a perfect circle approximately 150 meters in diameter. In the circle's center, the very same tires had been arranged to form the semblance of an altar. One could get inside only through a narrow entrance, marked at the sides by two huge, vertically positioned tires. "Rubber Stonehenge" came to my mind as I beheld that formidable, mystical emblem of the twentieth century. I looked around-there were no signs of life or any human presence. All around were endless hills of dead earth and, above them, the colorless cupola of the empty sky. In the golden rays of the setting son, from the mosque's minarets, the wind carries far the calls of the muezzins who render eternal glory to Allah.

Those were ever-new mysterious impressions that found their incarnation in the painting *Voices of Silence* (1962), which absorbed my Central Asian impressions of a direct encounter with an earth that embodies temporal layers of cultures and civilizations. A painted series, *A Skull and the Koran* (1970's-1980's), as well as, a few works *Oriental Manuscripts with Butterflies* (1989), also reflect this theme. The subject is concluded in a large-scale installation, *Asia. The Koran Wall* (1977).

3. The Mysteries of the Islands in the Sea of Japan

In May of 1973, I traveled to the Far East with a geological expedition from Moscow. The purpose of that expedition was the reconnaissance of gold deposits on the floor of the Sea of Japan. We were to work at the frontier coastline, which spread for a few hundred miles in the direct vicinity of the Soviet-Japanese border. Access to the frontier zone was possible only by a special pass. The picturesque shore of Tinkan Cove, where we made camp, had for many years been closed to human habitation, so we were totally cut off from the outside world. Geological samples of the ocean floor yielded strange results. Under a layer of the granite rock was a layer of wood, and, bellow that, a hollow. This puzzle was subsequently solved. At the turn of the twentieth century, the Chinese had dug deep mines with wooden buttresses and taken all the gold long before our expedition. The depleted mines were blown up and their entrances were blocked with pieces of rock.

After a day of work, our sole entertainment was musical radio programs from the Japanese island Okinawa, which was closest to us in distance, or the program *Voice of America*, which, for some reason, was not blacked out in that area. I spent entire days painting landscapes, drawing, or wandering along the paths of the coastal Ussuri taiga, where I encountered signs with inscriptions like "Secret Path No. 1" or "Secret Turn No. 9." I never met any border guards, however. Apparently, we were under a long-distance surveillance.

Of all the things I did during the expedition, I derived the greatest pleasure from examining and searching the immense coastal dumps, especially when they had been enriched by tempests and typhoons (Fig. 28). Hopping from stone to stone, I choose the tallest one and, feeling as if I were master of all the world's treasures, I survey my kingdom with an imperial eye. Right beside me is a Japanese fishing boat that has been broken into splinters by the tempest. Its bamboo mast, with shreds of the sail, has been thrown to a totally different

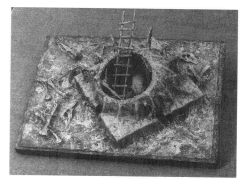

26. D. Plavinsky, object *Ruined Mazar*, (detail from installation *Asia– The Wall of the Koran*), 1978, Oil, sand, polyvinylacetate tempera, cardboard, fabric, animal bones, wood on masonite 11³/₄ x 17³/₄ in. 30 x 45 cm National Collection of Contemporary Art (in Tsaritsino Museum), Moscow

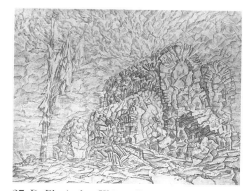

27. D. Plavinsky. *Khiva. Cemetery*, 1977 Polyvinylacetate tempera on canvas 31¹/₂ x 39³/₈ in. 80 x 100 cm (Photo by Vladimir Belov)

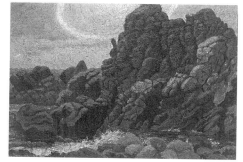

28. D. Plavinsky. *The Eye of the Typhoon*, 1973, Oil, sand on paperboard. 19¹/₂ x 27³/₈ in. 49.5 x 69.5 cm Jane Voorhees Zimmerli Art Museum, Rutgers, The State University of New Jersey, The Norton and Nancy Dodge Collection of Nonconformist Art from the Soviet Union. (Photo by Arkady Lvov)

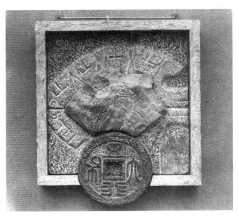

29. D. Plavinsky. *Composition with Chinese Medal*, 1974, Oil, polyvinylacetate tempera, stone, plaster, wood
15$^{1/2}$ x 13$^{1/4}$ x 2 in. 39 x 33.5 x 5 cm
Museum Center, State Russian University for the Humanities, Moscow
Museum "The Other Art,"
(Leonid Talochkin Collection)
(Photo by Vladimir Belov)

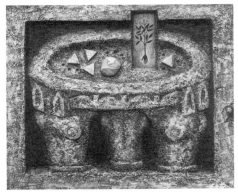

30. D. Plavinsky. *Ritual Table*, 1974
Oil, polyvinylacetate tempera, plaster on wood
15$^{3/4}$ x 19$^{3/4}$ in. 40 x 50 cm
Private Collection, USA
(Photo by Vladimir Belov)

spot, behind the sparkling white skeleton of a swordfish. Next to it, in the surf, a rusty cigar-like torpedo is rolling over. It is overgrown with barnacles and seaweed. A bit farther, there are broken boxes covered with Japanese hieroglyphs stuffed with oranges, swollen with seawater. The previous year after yet another typhoon the headless corpse of a Japanese man was discovered with an absolutely intact and, more to the point, uncorked bottle of whiskey in his pocket. Continuing on my way, I stumble upon a bunch of deep water mines. A wave threw a fishing net with glass, and cork floats over them. I am approaching a forest brook that disgorges into the sea. Its bank is overgrown with tall rushes, already faded from the sun, and coastal grass. I move the rushes apart in order to jump over the brook and stop dead in my tracks. Right in front of me, in the damp sand, is a print of the paw of a Ussuri tiger. A huge butterfly *Machaon* with widely spread azure wings is resting in shade on its jagged edge. The words "A living symbol of the Orient" rush through my mind.

Let's return to the enigmas of the surrounding islands. They have been long deserted. They have their own microclimate, vegetation, and unsolved mysteries. Their silhouettes conjure up images of magical, mythical beasts, one moment and, in the next, a group of people discussing something in the flickering light of the fading day. The island of Petrov is located close to our shore. Geologist-divers told me that they discovered an underwater stone ridge that was not too deep. It was as straight as an arrow and led from the mainland to the island. From the point of view of ocean-floor tectonics, the ridge was not natural in origins, but rather an artificial mound.

I happened to be in Vladivostok on business one day, and I decided to visit the Museum of Local Lore and History to find out something about our island. This is what the museum's curators told me: A very long time ago—no one know exactly when—there was an invasion by the barbarian matriarchal tribe Batkhyz. Under the command of a warrior princess, they conquered a large portion of the Maritime Territory and some areas of mainland China (Fig. 29). The Tinkan Cove was also a part of their dominion. The Batkhyz princess fancied the island of Petrov, and she ordered her warriors to erect a stone mound from the mainland to the island just above sea level. A mound about three kilometers in width, was erected over a strait immediately, and the princess, without so much as dampening the tip of her golden embroidered shoes, set her foot on the island.

I shared this story with the geologists, and the next day we took a motorboat to explore the mysterious island. Not unlike the warriors of the Batkhyz tribe, we descended, victorious, upon the shore. On the island, behind the thorny underbrush, there was a picturesque dark-green grove of yew trees, which had obviously been planted long ago by human hands. The grove skirted the thicket of wild grapevine, where, thorough the foliage, one could discern outlines of the partly overgrown foundation of the palace with a throne hall in the middle and service rooms on the sides. (Fig. 30) Suddenly, as if it were the soul of the princess, a multicolored bird with an aureate crest-crown whirred from beneath our feet.

We did not utter a single word in that solemn silence, which contrived to keep the mysterious past hidden from us forever with a translucent shroud. It was all the more fantastic because it could not be reconciled with the reality of our twentieth-century world. When necessary, according to stories told by navy officers, the top of the island of Petrov, rocks and trees included, automatically slides to one side. From deep shafts, it is said, the conic heads of ballistic missiles rise and stand still, awaiting the next order. In the evening, the motorboat took us back to the camp.

When these pictures of the Sea of Japan, full of the beauty, power, and fury of nature, come back to me in memory, I cannot help asking the question, "What place does the human being occupy in this world, and what does he ultimately wish for himself?" And the answer comes in the words of Dostoyevsky: "The human being wishes the worst for himself."

VI. A HUMAN BEING IN THE REFLECTED WORLD

1. Shadow

The two-dimensional space of shadows, as a projection upon the plane of the three-dimensional world, possesses an isolated inner life and a magic of impact that are quite remote form the actual reality. To some tribes and peoples, the shadow is the realm in which the soul dwells. They cherish the shadow and protect it from all kinds of insidious surprises. For instance, in China, during a funeral, when the lid has been placed on the coffin, those who are present withdraw to a safe distance so that their shadows will not be nailed down inside the coffin. Among the tribes of New Britain, there was a belief that if a husband cast his shadow, even accidentally, upon his mother-in-law, it meant that he was guilty of having engaged in an amorous relationship with his wife's mother, which was a great sin and served as grounds for a divorce. In Romania, among the inhabitants of Transylvania, the land of Dracula, a curious business flourished: trade in shadows. (This brings to mind the book *The Dead Souls* by Nikolai Gogol.) Dealers in this merchandise would sneak unawares upon a person and take measurements of his or her shadow. This measurement, which was considered to be equivalent to the person's shadow itself, would be sold for good money to the architect of any castle or house that was under construction. There it would be buried under the cornerstone of the building, which invested it with durability and longevity.

During my travels in Central Asia, I frequently experienced odd sensations from my own shadow, the shadows of passersby, animals, and intricately crossed tree branches. The world of shadows is submerged in the realm of inaccessibility that is its inner life (Figs. 31, 32). The shadow, like a person's transition into the world of his soul, is a device that is widely used in both modern and folk theater—in the shadow theater of Indonesia for instance; and in the movies, such the film *Ivan the Terrible* by Eisenstein, where the tsar's enormous shadow is seen hunched over a globe, as well as in the films of Orson Welles.

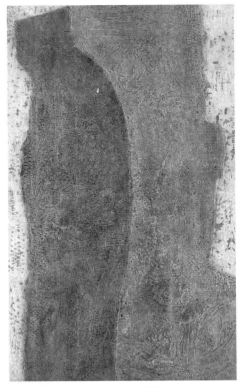

31. D. Plavinsky. *Shadow*, 1963
Oil, fine gesso on board
$40^{1/2}$ x $23^{5/8}$ in. 103 x 60 cm
Jane Voorhees Zimmerli Art Museum,
Rutgers, The State University of New Jersey.
The Norton and Nancy Dodge Collection of
Nonconformist Art from the Soviet Union
(Photo by Arkady lvov)

2. Trace

A person and the trace he leaves... A person is nothing more than a biological substance. He eats, drinks, sleeps, awakens, and his entire existence follows this vicious circle toward the inevitable end: death. A person himself is not as important as the energy realm that radiates from him. A person disappears from the face of the earth, but his energy field—now diminishing, now expanding—continues to interact with the energy fields of both people who are still living and those who are no longer alive. This is a trace that never disappears, because it remains in the cosmos for eternity. Pavel Florensky came up with the idea "of existence in the biosphere or, perhaps, *on* the biosphere of that which could be called the *pneumatosphere*; that is to say, the existence of a special part of the matter which gets involved in the cycle of culture or, to be more precise, in the cycle of spirit." Hand prints in the caves of prehistoric man, prints of the Buddha's hands and feet, those of the feet of Christ and of Muhammad in Jerusalem, a print of the astronauts' boots on the Moon—they have all acquired a cosmic life that is more real to us than the images that form a ghostly appearance in the fog of our protomemory. In the words of Joseph Brodsky, "People are not that interesting. We more or less know what to expect from them.

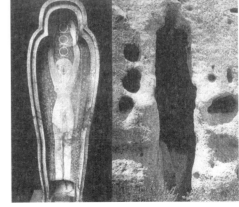

32. The soul, in the guise of the dead man's shadow, leaves the tomb

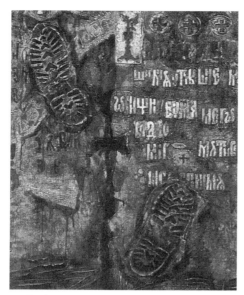

33. D. Plavinsky. *St. John's Gospel*
(detail with imprints of artist's boots), 1967

34. Hollow of a tree trunk in the form of a human foot, New York, 1998
(Photo by Dmitri Plavinsky)

Ultimately, people ... are much more synonymic than the art. That is to say, people have much more in the denominator than they have in the numerator ... whereas the art is the constant change of the denominator." (Solomon Volkov, *Dialogs with Joseph Brodsky: Literary Biographies*, Moscow, 1998.)

In my works, starting with *Voices of Silence* (1962) and *St. John's Gospel* (1967), I returned, again and again, to the symbol of Human Trace (Fig. 33). In *Voices of Silence*, on the structures of temporal strata of the earth, there is a print of my hand in the drawing of the Pythagorean theorem. *St. John's Gospel* is, in fact, the same solid ground that enables a person to make a step and to leave a trace in his own soul. (Fig. 34)

3. Soul and Image

Many a page has been written about the soul being reincarnated in an image. In art, it has been quite an important subject. Consequently, it requires some clarification.

The birth of photography was accompanied by a good deal of fear and misgiving. Many people believed that their soul would be transferred to the photograph. Mexicans were certain that the photographer carried their souls away in the pictures and then devoured them at his leisure. At the very least, they thought, the photographer would take the photographs into his land and, with their help, sell the depicted people into slavery. They called the photo lens "the bad eye of the box." Furthermore, they considered landscape photographs to be harmful to nature. That makes sense, of course, if we take into consideration the global scope of modern photographic advertisement for travel in countries all over the world and the negative impact on nature and people's way of life caused by the omnipresent flood tourism.

Among certain people, there is a belief that, through the portrait of a person, an artist possesses and controls this person's destiny as well as the power to take his or her life. I had a direct encounter with this superstition in 1959, in the cave dwellings of the Kurds in the mountains of Armenia. Not far from their dwellings, a group of women were clearing a field of stones, gathering them in their colorful aprons. They presented quite a picturesque spectacle. I was so absorbed in drawing them that I did not hear their threatening screams, followed by a barrage of stones being thrown in my direction. My companion, a young Kurd who knew Russian, shouted something to them and then translated their answers for me. The women were in an extremely aggressive mood and were dead set against having their portraits made; they believed that if I later tore up the drawing they would die. We had to resort to flight.

4. The Myth of Narcissus and Mirror Symmetry

Certain ancient peoples determined that the dwelling place of the soul was not the shadow or the depicted image but the person's reflection in water or mirrors. A classic example of such an attitude toward one's own reflection is the ancient myth of Narcissus. On a whim of the gods, the nymph Echo and Narcissus were plunged into a mystical realm of symmetry from which there was only one way out: death. Ovid describes Echo as having been exsiccated by her unrequited love for Narcissus. Nothing remained of her "but bones and voice." Then the bones turned into mountains, and only the voice remained. As a result, everyone can hear the nymph, but it is impossible to see her. Narcissus, having rejected Echo and fallen passionately in love with his own reflection in a source, tries to unite with the reflection and dies of the impossibility of doing so. His dying word was addressed to his own image, whose glance reverberated from the mirror-like surface of the water.

"Fare-thee-well!"

"Fare-thee-well!" Echo responded sorrowfully.

"He was looking at himself in the waters of the Styx."

That is how Ovid ends his myth of Narcissus in *Metamorphoses*.

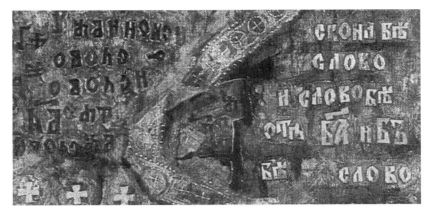

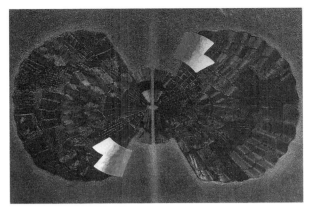

35. D. Plavinsky. *St. John's Gospel*
(detail), 1967

36. D. Plavinsky. *Double Black Seashell*, 1966
Oil, sand, polyvinylacetate tempera, cardboard on canvas
27¹/² x 28³/⁴ in. 70 x 100 cm
Private Collection
(Photo by Vladimir Belov)

Now we have an opportunity to look at this myth from the point of view of geometry, applying laws of symmetry to it. The world of Echo and the words *Fare-the-well, Fare-the-well* are a direct similitude in symmetry. A vivid example of an image being transferred directly, through numerous repetitions, to the picture plane can be seen in the art of Andy Warhol—in the twenty portraits of Marilyn Monroe (*The Twenty Marilyns*, 1962), for instance or in Jasper Johns's, two beer cans (*Painted Bronze*, 1960).

Narcissus, however, was confined to a more complex realm—the world of mirror (or bilateral) symmetry. Possessed of divine beauty, Narcissus was nevertheless an ignoramus where geometry was concerned. Otherwise he would not have tried to superimpose himself on his mirror image. The reflected image is not equal to the object. In a mirror, the concepts of *left* and *right* are mutually opposed; in a mirror reflection, Narcissus' right ear corresponds with his left one, and his left hand would assumes the position of the right one. Perhaps the reason love is often tragic is that the lovers are doomed to be in opposite spatial realms that are impossible to reconcile. Embracing our beloved, we touch her left shoulder with our right one, and our left leg feels her right leg. Our visible surrounding world unfolds before us in the estranged space of bilateral symmetry. Our automatic psychologism constantly makes a 180-degree turn for everything that we behold in order to adapt the external space to our inner perception. Otherwise we would unable to make even a single step in the reality that surrounds us.

The notion of mirror symmetry can probably be illustrated by this example: Among the tombs of medieval Spain, there are gravestones with inscriptions that are engraved in a mirror image. These inscriptions are not addressed to the living visitors of a cemetery but, rather, to the person who lies in the sarcophagus, to the one who can, time and again, enjoy his own name, title, and the epitaph that has been dedicated to him.

In my work St. John's Gospel, the right and left pages of the book are bilaterally juxtaposed (Fig. 35). The lettering СΛОВО, on the right side of the book, is bilaterally reflected on its left side as СΛОВО - ОВОΛС (word-drow).

The Russian futurist poet Velimir Khlebnikov, studying the folklore of pagan Russia, developed entire *palindromic poems* in which the words are the same read from left to right and, in accordance with mirror symmetry, from right to left. The *mirror* principle has also been employed in polyphonic musical compositions. In fact, it was established and developed by Bach in the fugue. The notation of a musical phrase gets reversed in the mirror reflection and reads backward, which, formally, achieves an economy of musical means and imparts integrity to the compositional harmony.

In the art of engraving, the laws of mirror symmetry are strict and irreversible. The metal plate of the engraving subsists in a mirror-like relation to

its imprint. In making etchings, which I have been doing for many years, I have always used a mirror to verify the correctness of an image. Once, however, I got so carried away by my work on the plate that I forgot all about the mirror. The print depicted an old knight, battle-weary yet triumphant, on his way home. His hand, clad in a steel gauntlet, proudly clenched the victorious sword. In my excitement, I made the first print, and the sword turned out to be in the knight's left hand. To this day, nobody has noticed that my knight was a left-hander (which, in fact, could easily be the case in real life), but since then I have never forgotten the mirror.

Finally, we should consider the third law of symmetry: the rotation of a figure around the central axis. We frequently encounter this principle in the world of plants, sea organisms, and microbiology. In ornamentation, this law is used in the structuring of ornaments of ceilings and vaults. In semiotic systems, it is employed to devise cryptograms. The painting *Double Black Seashell* (Fig. 36) and the drawing *Geometry of Iris* (1997) are constructed in accordance with this principle. In the composition *Word* (1967), the first phrase of *St. John's Gospel*, *"In the beginning was the Word, and the Word was with God,"* unfolds from the center to the edges, with a four-part rotation around its axis.

The first and foremost law of symmetry states that each figure is symmetrical if, when it is rotated 360 degrees around its axis, it coincides with itself. In other words, everything that exists, any apparent coincidence—be it a cigarette butt thrown into a mud puddle, a broken bottle, a floating cloud, or the Milky Way—is governed by symmetry.

5. The Reflected Life of Giovanni Giacomo Casanova

In the object *Memory of a Venetian Mirror* (1997), I am passing inside the mirror surface, layer after layer, through the half-effaced dampened amalgam that once reflected and fixed in its memory the twilight life of ghostly persons, the life that vanished without a trace in a bygone carnival (Fig. 37). The space of mirror projection is dissected into three planes. The first one is before the mirror. It is composed of the frame with rubbed-off gold, the silver violin that Giacomo played in his youth, tarot cards, and the magic hexagram. The next plane is the mirror proper. It is composed of small mirrors, each of which is an independent world with a web of cracks, molded amalgam, and its own memory. Such wall-wide mirror panels vaguely reflect the luxurious interiors of the Palazzo Dolfin and the Correr Museum in Venice. And, finally, the last plane is the wonderland through the looking glass, which is coated with the twilight of Casanova's soul and which absorbed the slumbering butterflies, the smoldered manuscripts of the Cabala, and the bats, forever petrified inside the glass, that futilely attempt to free themselves. All three planes of the mirror's space are pierced through by Casanova's sword as a challenge to destiny and a sneer at its omnipotent might.

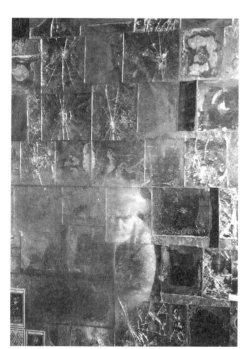

37. D. Plavinsky. *Memory of Venetian Mirror* (detail), 1997

When he was dying, Casanova fastened his pale countenance on the mirror one last time. The reflection before him gave forth an image of Henriette, perhaps the only woman he had ever loved, and of her words, *"Vous oublierez aussi Henriette,"* in French addressed to him, scratched on the glass with a diamond ring. "I thank God, the prime cause of everything, and I rejoice at the realization that life is a blessing. Giovanni Giacomo Casanova, 1798." With these words the memoirs and the life of the great Venetian end.

I turn a leaf of the calendar and put my own name below these notes— D. Plavinsky, 1998.

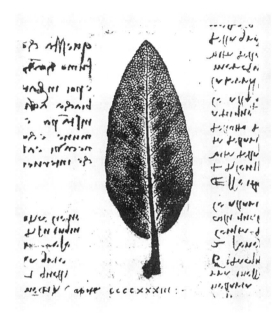

38. Leonardo da Vinci. Nature print

39. D. Plavinsky. *Grass Script* from *Book of Grass* (detail), 1963

During the entire summer of 1963, I worked on the *Book of Grass* at my stepmother's dacha near Moscow. The nature, woods and their life full of flowers, grasses, and butterflies, dissolved into oblivion the clamorous city life and the commotion of Moscow. I would sit on a stump and draw ferns, mushrooms, and dandelions. The drawings were done with the finest of pens and ink, lavishly diluted with water, to the point where the drawing was barely distinguishable from the white background; in order to create this effect I used extra-absorbent watercolor paper. This technique, which did not allow for mistakes, required a great deal of concentration and yielded a silvery soft line for the contours of plants that was almost devoured by the whiteness of the paper. The *Book* is divided into two sections: the drawings of grasses from nature and the monotype nature of leaves.

I often recalled the magic imprint of a leaf in one codex of Leonardo da Vinci (Fig. 38). This is precisely what inspired me to do a direct impress of nature. My work in the *Book of Grass* is a personal experience in meditation. I would walk barefoot in the woods, apprehensive of stepping on a caterpillar, an ant, or a flower. This utter concentration gathered and directed my will so that there were no intermediaries between myself and nature. Drawings in the *Book of Grass* are totally devoid of the artificiality in art. I immersed myself in the world of grasses to such an extent that each leaf seemed to have its own sound and a hieroglyph that expressed that sound. I came very close to creating a written language for the grasses and an alphabet for the leaves of plants (Fig. 39). The most important thing in such an alphabet is to define the different forms of consonants and vowels. The consonants appeared to me as vertical leaves that determined the rhythmic structure of a line. They are akin to the percussion instruments in an orchestra. As for the vowels, they are closer to each other in sound; they easily merge into each other, and their modulation is free and uninterrupted. The delineation of a round leaf or an oval leaf fully

40. The Japanese Zen calligraphic drawing

41. Enneagram

42. Joseph Beuys. Lady's Cloak (detail), 1948

expresses the fluid transformation of the vowels. I dreamed of writing down Velimir Khlebnikov's poem *Word about "L"* in this grass script, but upon my return to Moscow, I become distracted by other affairs, and this idea has remained unfulfilled.

* * *

Three figures—a triangle, a square, and a circle—rest as a divine triad in the foundation of the entire creation, piercing the microcosm of plants with a universal harmonious unity (Fig. 40).

The small in the great and the great in the small—this axis of interrelations imaginatively unfolds in the world of plants. The human mind has always created and will continue to create an infinite sequence of philosophic systems that forge keys to the solution of the mystery of cosmic unity. One of such universal systems is an open nonagon or an enneagram (Fig. 41). Artist Joseph Beuys (Fig. 42) elucidates and asserts the leaf of a plant as a manifestation of the Creator's ingenious will. "Every complete whole, every cosmos, every organism, every plant is an enneagram." Gurjieff. The figure of the enneagram is formed by linking the two "sacred cosmic fundamental laws of the Trinity and the Sevenness."

Floods of cosmic light that flow on earth in waves are concentrated into a sparkling dot in a drop of morning dew on the palm of a leaf. In the moonlight, myriad dewdrops absorb the light vibration of the starry skies, casting a shadow of the Milky Way upon the earth's visage. We have only to scrutinize a leaf of grass, and we are overwhelmed by an illumination of the truth and by the impossibility of capturing this incarnation in the imperfect form of a word. The leaf is an imprint of the hand of the Creator that unfolds toward the ray of light.

Anna Kasparovna Bauman, artist's mother. Riga, Latvia, 1920s.

1937

This was the year I was born. My mother, Anna Kasparovna Bauman, a Latvian on her mother's side and the illegitimate daughter of a German baron, had spent her childhood and youth in Jaundubulty, a summer-residence village on the Baltic coast. In the twenties, she came to Moscow with a group of revolutionary Letts in order to actively participate in the development of socialism. In Moscow, after graduating from the university, she became a history teacher at a local high school. At the university, she met my father, Petr Markovich Plavinsky, who was also a history teacher. In the autumn of 1937, my mother was arrested, after being falsely accused of anti-Soviet activities, and sentenced to seven years in a concentration camp in Kolyma. After serving her sentence,

because of the ongoing Soviet-Japanese War, she was deported to Siberia for another five years.

Women's hard labor camp in Kolyma, Siberia, 1930s.

1939

I was constantly and seriously ill and spent practically all my time in the Filatov Children's Hospital. It was hard for my father to take care of me on his own, so he married Alexandra Vasilievna Fyodorova, who became my stepmother. She was devoted to me with all her heart and soul, and I have always considered her to be my mother. We lived in her nine-square-foot room, in a huge communal apartment in the basement of Building 44 on Sivtsev Vrazhek Street. Through a basement window, I watched people pass by. They had no heads, only legs, and only those, who fell on the pavement, acquire a face.

1941-44

It was the war with Germany. Our family was evacuated from Moscow to Siberia, to the vicinity of Omsk.

1944-45

Our family returned to Moscow after the evacuation. A year later, I was admitted to a primary school.

D. Plavinsky. Moscow, 1939.

Entrance to the artist's apartment building on Sivtsev Vrazhek Street, Moscow. (Photo by Igor Palmin)

Artist with his stepmother, Aleksandra Vasilievna Fyodorova. Moscow, 1945.

1948

An art teacher noticed my drawings and advised my father to have me admitted to an art school. I passed the entrance examinations to the Municipal Secondary Art School on Chudovkaya Street, where artists of the Russian avant-garde of the thirties were the instructors. My schoolwork was noticed by a teacher named Gluskin, who in the past had been a member of the group NOZH (New Society of Painting). At the graduation exhibition of the school's students, he said that, of all my classmates, I was the only one among who had the potential to become an artist.

1951

I was admitted to the 1905 Institute of Art, to the theater design department. Among the professors who had an impact on my art were O. A. Ovesyan, who taught composition; V. A. Shestakov, a teacher of scenography who, in the thirties, was the chief artist of the Vsevolod Meyerhold' Theater, and L. A. Fyodorov, a brilliant connoisseur of the painting technique who held the position of chief executive artist at the State Bolshoy Theater.

1955

The first trip to my mother in Latvia.

I got to know the Riga Academy of Art and the Latvian school of painting. Travels with my mother all over Latvia.

Artist with his mother, Jaundubulti. Latvia, 1955.

1956

Graduation from the 1905 Institute of Art and assignment to the city of Buguruslan as the chief artist of a drama theater.

1957

Return to Moscow at the time of the Sixth International Festival of Youth and Students. I participated in an exhibition in the halls of Art Academy, timed to the festival, and worked at the International Art Workshop at Gorky Park. With fasci-

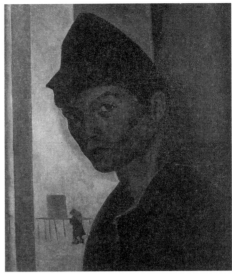

D. Plavinsky. *Self-Portrait with Old Woman*, 1957. Oil on canvas, 23³/⁴ x 19³/⁴ in. 60 x 50 cm
Artist Collection
(Photo by Alexander Saveliev)

nation, I was observing the work of Anatolii Zverev and the American abstract artist Coleman. I struck up friendships with the artists Mikhail Kulakov and Aleksandr Kharitonov. I was earning my living as a photo-retoucher at the publishing house of Great Soviet Encyclopedia. All my free time was dedicated to the search for a style of painting that would be uniquely mine. Among my principal works of that period are *Self-Portrait with Old Woman, Scissors on Broken Glass*, and *Girl by the Window*.

1958

My first trip to Central Asia, which left a deep impression on my perception of the world and on my subsequent work in the realm of painting.

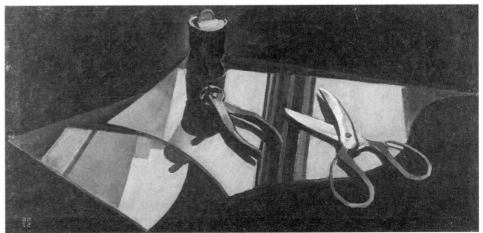

D. Plavinsky. *Scissors on Broken Glass*, 1957. Oil, sand on canvas, 20 x 39³/⁸ in. 50.5 x 100 cm
Museum Center, State Russian University for Humanities, Moscow, Museum *The Other Art*,
Leonid Talochkin Collection (Photo by Alexander Saveliev)

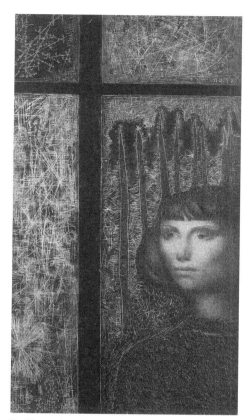

D. Plavinsky. *Girl by the Window*, 1957
Oil, sawdust on canvas
35⁷⁄₈ x 20³⁄₄ in.; 91.2 x 52.5 cm
Jane Voorhees Zimmerli Art Museum, Rutgers.
The State University of New Jersey.
The Norton and Nancy Dodge Collection of
Nonconformist Art from the Soviet Union

My introduction to the work of
French artist Jean Dubuffet. His
works encouraged my quests and my
experiments with the texture of paint-
ed surfaces.

1959

Trip to Armenia—Yerevan, Ashtarak.
Lived in the cave dwellings of the
Curds, in the valley of the Alaghez
Mountain. At that time, I did more
than a hundred pastel drawings.

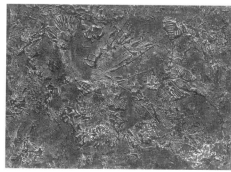

D. Plavinsky. *Cosmos*, 1960
Oil, fine gesso on canvas
Alexander Costakis Collection, Athens

1960

Personal exhibition at the apartment
of the progressive art critic Ilya Tsyrlin.
He introduced my works to the inde-
pendently thinking intelligentsia of
Moscow. George Costakis acquired
my painting *Screaming Fish* from the
exhibition. From that moment on, he
closely observed my artistic develop-
ment. Trip to Novgorod, Pskov,
Izborsk, and Pechory. This was the
beginning of the semiabstract textural
period of my work. Wooden plates
were covered with fine gesso contain-
ing textural pigment extenders, while
the surface of the painting was treat-
ed and glazed with varnish-based oil
paints.

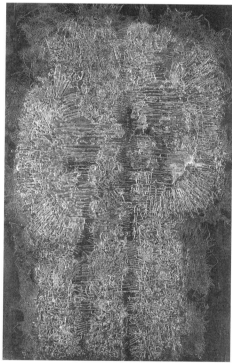

D. Plavinsky. *Bloomy Pomegranate Tree*, 1962
Oil, fabric, fine gesso on board,
45¹⁄₂ x 28 in. 115 x 71 cm
Jane Voorhees Zimmerli Art Museum, Rutgers.
The State University of New Jersey.
The Norton and Nancy Dodge Collection of
Nonconformist Art from the Soviet Union
(Photo by Arkady Lvov)

1961

Trip with artist Boris Sveshnikov to
the town of Tarusa. Encounters with
the poet and artist Arkadii
Shteinberg, the writer Konstantin
Paustovsky and the literary family
the Ottons. Rapprochement with the
Lianozovo Group, whose members

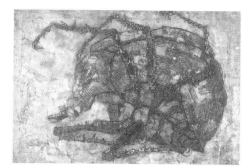

D. Plavinsky. *Beetle*, 1963
Oil, fabric, fine gesso on board,
23³⁄₄ x 33⁷⁄₈ in.; 60.5 x 86 cm
Aliki Costaki Collection, Athens

included the artists Oscar Rabin, the
Kropivnitsky family, Vladimir
Nemukhin, Lydia Masterkova, and
the poets Genrikh Sapgir and Igor
Kholin.

1962

Acquaintance with Nina Stevens.
Following the example of Costakis,
she began collecting my works. She
opened a permanent collection of
nonconformist artists at her house.
Prolonged trip to Central Asia. Upon
my return, I painted the composition
Voices of Silence. This work repre-
sented a compendium of my artistic
ideas and became the subject matter
of my future paintings. Jean-Paul
Sartre commented on it when he vis-
ited my studio.

1963

Trip to Novgorod and Pskov to copy
frescoes in those cities. Worked on
the ancient Russian paleography and
"hook" notation at the book deposi-
tory of Pskov Museum. I bought a
house in Tarusa, where the artists

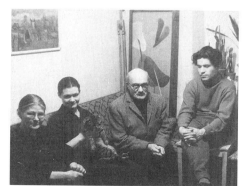

Olga Potapova, Valentina Kropivnitskaia,
Evgenii Kropivnitsy, and D. Plavinsky.
Lianozovo, Moscow Region, 1961
(Photo by Oscar Rabin)

Anatolii Zverev and Aleksandr Kharitonov came to work. That summer I made drawings that became a part of *Book of Grass*.

1964

Trip to Moldavia, where I did watercolors, drawings, and painting *Easter*. I also did a series of gouache works on a large scale, depicting monuments made by primitivist rural sculptors at a Kishinev cemetery.

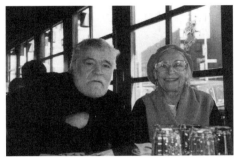

D. Plavinsky and Nina Stevens. New York, 1998. (Photo by Maria Plavinsky)

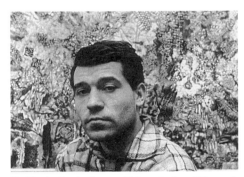

D. Plavinsky in front of his painting *Voices of Silence*. Moscow, 1962. (Paul Sjeklocha and Igor Mead, *Unofficial Art in the Soviet Union*, 1967)

1965

Spent the entire summer in the village of Priluki, where the artists V. Nemukhin, L. Masterkova, O. Rabin and V. Kropivnitskaia lived and worked.

1966-69

In the village of Berezhki, in the Kostroma region, I made a series of etchings, including *Shroud of Christ*, and *House with an Owl*, as well as drawings based on materials of the ancient Russian paleography. One of them, *Paleographic Composition*, was subsequently acquired by the Museum of Modern Art in New York.

1967

The collection of Nina Stevens was included in the exhibition *A Survey of Russian Paintings from Fifteenth Century to the Present* in the New York Gallery of Modern Art, where twenty-two of my works were shown. From that exhibition, the Museum of Modern Art acquired my paintings *Voices of Silence* and *Coelacanth*. The compositions *St. John's Gospel* and *Word* became the summation of many years of my fascination with ancient Russian paleography. Alexander Glezer organized an exhibition of nonconformist artists at the club *Druzhba (Friendship)*. Among those who attended the opening night were diplomats from European and American embassies, the wife of the American ambassador Thompson, and the poets Yevgeni Yevtushenko and Boris Slutsky. Within an hour after the opening, the club was surrounded by KGB operatives. Electricity was shut down in the showing room, and our works were arrested. Couple of days later, a KGB bus took us and our canvases home.

1969-72

Moved to the village of Rodovo, where I worked on the etchings *Cathedral with a Bat*, *Bosporus Tortoise*, *Scroll*, *Running in the Darkness*, and others.

1972-77

Acquired a house in the village of Khotilovo, in the Kalinin region, where I did a series of etchings on rural subjects, the painting *Gospel with Potatoes*, and other works.

1973

Trip with a geological expedition to the Far East, where I did a series of landscape paintings of the coast of the Sea of Japan.

1974

Trip with the photographer Igor Palmin along the Upper Volga River. Visit to the town of Staritsa.

1975

Establishment in Moscow of a paint-

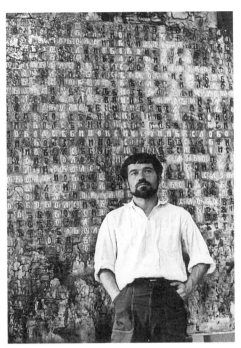

D. Plavinsky in front of his painting *Word*. Moscow, 1967. (Photo by Igor Palmin)

D. Plavinsky, Viacheslav Kalinin, Vasilii Sitnikov, and Albert Rusanov at the exhibition at the club Friendship. Moscow, 1967.

ing section at the Moscow Joint Committee of Graphic Artists on Malaya Grusinskaya Street. From that year forward, that entity began organizing exhibitions of our works on a regular basis. At that point, too, the nonconformist artists acquired the status of union members, which allowed us to avoid persecution under the law "on voluntary unemployment." The administration of the Commitee of Graphic Artists offered us to organize an exhibition at the Exhibition of National Economic Achievement (VDNKh), in the Beekeeping Pavilion. It opened in February of that year and enjoyed colossal success.

1976

I finished the installation *Cross* and

D. Plavinsky. Town Staritsa on the Volga River. Russia, 1974. (Photo by Igor Palmin)

dedicated it to the memory of my friends the artists Yevgenii Rukhin and Aleksei Paustovsky, both of whom had died tragically that year. George Costakis participated in the wake for Rukhin at the studio of V. Nemukhin. *Cross* was included in an exhibition of paintings at the Commitee of Graphic Artists.

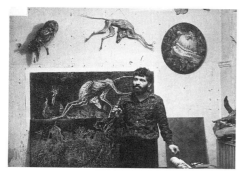

D. Plavinsky in his studio. Moscow, 1975. (Photo by Igor Palmin)

D. Plavinsky, George Costakis, and Vladimir Nemukhin. Moscow, 1975.

1977

The installation *Cross* marked the end of many years of my work in the field of ancient Russian paleography. I made a radical change from textural surfaces to the multilayered glazed surface, in which the structural space with multiple planes dissolves the

image of a material object and itself becomes the object of the painting. The paintings *Old Armchair* and *Flying Fish* were done in this key. Trip to Kirgizia with the artists V. Nemukhin, N. Vechtomov, and

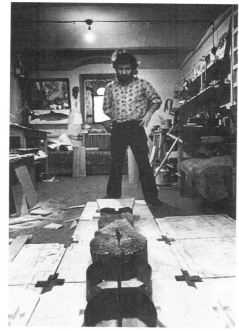

D. Plavinsky creating the installation *Cross* in his studio. Moscow, 1975. (Photo by Igor Palmin)

D. Plavinsky. Ancient Kirghizian cemetery in Przhevalsk. Kirghizia, 1977. (Photo by Nikolai Vechtomov)

Eduard Shteinberg, Ilya Kabakov, Aleksandr Kharitonov, D. Plavinsky, and Otari Kandaurov. Malaya Gruzinskaya Street, Moscow, 1977. (Photo by Igor Palmin)

V. Kalinin. I did a series of watercolors at a cemetery near the town of Przhevalsk. Into the exhibition *Russian and Soviet Painting. An Exhibition from the Museums of the USSR* at the Metropolitan Museum of Art in New York, and at the Fine Arts Museum in San Francisco, the Soviet Ministry of Culture included, for the first time, works by O. Kandaurov, V. Nemukhin, and my work *Old Painting*. Forced emigration of G. Costakis. George invited all of his artist friends to his farewell party.

1983

This is when I began including collages of the musical notations of Bach, Mozart, Beethoven, Stravinsky, and other composers into my compositions.

1985

Personal exhibition at the Cultural Club of the I. V. Kurchatov Institute of Nuclear Energy. This was the most comprehensive exposition of my works in Russia. The institute's party leadership tried to undermine

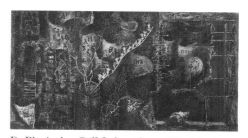

D. Plavinsky. *Still Life with an Old Painting*, 1974. Oil, fabric, polyvinylacetate tempera, plaster on canvas, 27½ x 47¼ in. 70 x 120 cm (Photo by Vladimir Belov)

N. Vechtomov, Lev Kropivnitsky, V. Nemukhin, Vladimir Veisberg, O. Kandaurov, George Costakis, Boris Sveshnikov, Francisco Infante, D. Plavinsky, Aleksandr Rabin, Mikhail Odnoralov, and Vladimir Yakovlev. G. Costakis' farewell party, Moscow, 1977. (Photo by Igor Palmin)

I. Palmin, N. Vechtomov, Anatolii Zverev, V. Nemukhin, and D. Plavinsky. Nemukhin's studio, Moscow, 1976. (Photo by I. Palmin)

the exhibition, however. From the visitors' book, they tore out the pages that contained ideologically incorrect texts.

D. Krasnopevtsev, L. Kropivnitsky, D. Plavinsky, and A. Kharitonov. Malaya Gruzinskaya exhibition hall. Moscow, early 1980s. (Photo by Igor Palmin)

1986

Last encounters with Zverev, who died that winter. Natalia Shmel'kova collected money for Zverev's monument, and donations were made by everyone who knew him, in whatever amounts each of them could afford, except for two art collectors, who possessed and traded hundreds of Zverev's works, but didn't give a single kopeck. Still and all, let God be the judge of them. I did the design of the cross for Zverev's grave.

1988

Sotheby's auction took place in Moscow. For the first time, paintings by contemporary Russian artists were entered in the international market.

D. Plavinsky and his daughter, Elizaveta Plavinskaya. Moscow, 1983. (Photo by Igor Palmin)

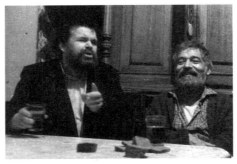

A. Zverev and D. Plavinsky. Moscow, 1986.

1990

Departure from Moscow to New York on the eve of 1991. We celebrated that holiday twice: on the plane and at the apartment of the artist Vitalii Dlugi.

1991-93

Concluded the contract for a personal exhibition with the New York Alex-Edmund Galleries. At my first exhibition in America, I decided to unfold before the public all my capabilities: thematic, formal, and technical. The visual theme of the exhibit was deliberately devoid of unity. I exhibited works from my new series *Manhattan Fish* and the painting *Music of Ancient Ruins*, which determined the theme of my next exhibition in New York. The opening night was a big success. Among the exhibition's visi-

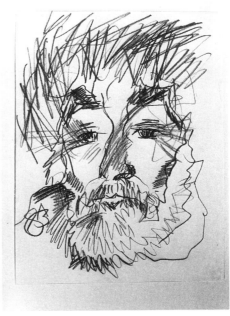

A. Zverev. *Portrait of D. Plavinsky.* 1983. Pencil on paper.

tors was William H. Luers, my old friend from the sixties and seventies, and a diplomat at the American Embassy in Moscow, who later became president of the Metropolitan Museum of Art in New York; he was accompanied by his wife. From this exhibition, the Metropolitan Museum acquired the drawing *Manhattan Fish.*

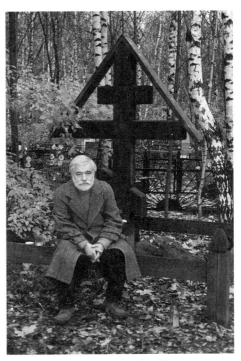

D. Plavinsky at the tomb of A. Zverev. (Memorial cross designed by D. Plavinsky.) Moscow Region, 1995. (Photo by Maria Plavinsky)

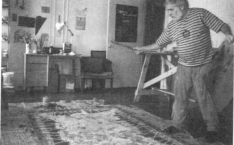
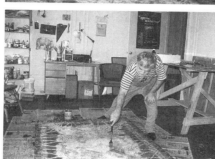

D. Plavinsky at work on *Bull Skin*. New York, 1991. (Photo by Maria Plavinsky)

Gallery. As a continuation of my idea of the interrelation of cultures, I planned my journey to Italy.

D. Plavinsky in front of his painting *Dionysian Element*. Mimi Ferzt Gallery, New York, 1995. (Photo by Arkady Lvov)

1993

Collaboration with a new gallery—Mimi Ferzt. Preparation for the next exhibition on the subject of ancient Greece, *Echo Ancient Ruins*.
At the invitation of Aliki, the daughter of George Costakis, my wife, Masha (Maria), and I went to Greece. We saw museums and ancient architectur-

a trip to the island of Crete, where, at the museum in the town of Herakleion, I studied clay tablets with the Linear *B* script, Cretan ceramics, and frescoes from the Palace of Minos at Knossos. I scrutinized the ruins of the Knossos Palace. That material became the basis for the installation *Knossos*.

1995

Travels in America, to the states of Utah, Arizona, Colorado, and New Mexico.
Opening night of the exhibition *Echo Ancient Ruins* at the Mimi Ferzt

D. Plavinsky. Arizona, 1995. (Photo by Vladimir Bron)

Mihail Chemiakin, Norton Dodge, Renee Baigell, D. Plavinsky, and Matthew Baigell. Mimi Ferzt Gallery, New York, 1993. (Photo by Arkady Lvov)

al monuments in Athens; went to the Temple of Poseidon on Cape Sounion; and in Delphi visited the ancient complex surrounding the Temple of Apollo and the Museum of Archaic Sculpture. For about a week we lived on the island of Aegina, where I drew the two-tiered Temple of Aphaia.

1994

I visited Greece once again and made

D. Plavinsky. Delphi, Greece, 1993. (Photo by Maria Plavinsky)

Virginia Kinzey and D. Plavinsky. Mimi Ferzt Gallery, New York, 1998. (Photo by Maria Plavinsky)

D. Plavinsky. Venice, Italy, 1996. (Photo by Maria Plavinsky

D. Plavinsky at the tomb of Igor Stravinsky. San Michele, Venice, Italy, 1996. (Photo by Maria Plavinsky)

1996

At the invitation of Alberto Sandretti, Masha and I visited Venice and stayed at his house. In Venice, I made several watercolors. During the prolonged trip over the entire Apennine Peninsula, we visited Turin, in the northern part of the country, and, via Milan, Florence, and Rome, reached the ancient Paestum in the southernmost part of the peninsula. In fact, it is Paestum

D. Plavinsky. Pompeii, Italy, 1996. (Photo by Maria Plavinsky)

that constitutes the link between Ancient Greece and Ancient Italy.

1998

During the course of three years of work on the paintings for a new exhibition, I managed to create a show, that was polyphonic in subject and form. It was held by the axis of two installations, *Memory of a Venetian Mirror* and *Cathedral*, which were diametrically opposed in placement. In November, the opening night of the exhibition, *In Search of Italy* took place at Mimi Ferzt Gallery.

William H. Luers, D. Plavinsky, and Maria Plavinsky. D. Plavinsky's personal exhibition. Mimi Ferzt Gallery, New York, 1998. (Photo by Petro Grishuk)

1999

In the month of May, I made a trip to Israel. In an automobile, I crossed the entire country from the north to the Dead Sea coast, the Qumran Caves, and the Masada ruins. In December, Masha and I repeated that trip, restricting ourselves to Jerusalem and the vicinity. My friends and I managed to visit the Negev desert in the country's southern part, on the Egyptian border. We found ourselves at the edge of the colossal annular canyon, formed by the fall of Beelzebub whom God cast

down from Heaven. The pope proclaimed that location as holy.

2000

We welcomed the New Year in Jerusalem with our friends. On January 9, we left for New York, where I continued preparatory work for the exhibition *The Holy Land*. The exposition's center will be Jerusalem, the city of Torah, Gospel and Koran. this is a spot on the globe that represents the crossroads of the world's major religions that nowadays sway destinies of the mankind.

D. Plavinsky. Jerusalem, Israel, 2000. (Photo by Maria Plavinsky)

Paola Gribaudo and D. Plavinsky in his studio. New York, 2000. (Photo by Maria Plavinsky)

Dmitri and Maria Plavinsky with Ezio Gribaudo and his daughter Paola in their studio in Turin, 2000. (Photo by Maddalena Zolino)

SELECTED EXHIBITIONS
by Natalia Kolodzei

SOLO EXHIBITIONS

1960-61
Moscow, Apartment of Ilya Tsyrlin.

1970
USSR, Dubna, Scientists' Club of the Nuclear Physics.

1985
Moscow, Cultural Club, I.V. Kurchatov's Institute of Nuclear Energy.

1990
Moscow, Today Gallery. *Dmitri Plavinsky*.

1993
New York, Alex-Edmund Galleries. *Dmitri Plavinsky*. Catalogue.

Moscow, Reception House, Ministry of Foreign Affairs of the Russian Federation. *Dmitri Plavinsky*.

1995
Moscow, Dom Nashchokina Gallery. *Dmitri Plavinsky*. Catalogue.

New York, Mimi Ferzt Gallery. *Dmitri Plavinsky: Echo Ancient Ruins*. Catalogue.

1997
Moscow, Capital Bank. *Dmitri Plavinsky*.

1998
Moscow, Kino Gallery and Moscow Auction House. *Dmitri Plavinsky*.

New York, Mimi Ferzt Gallery. *Dmitri Plavinsky: In Search of Italy*. Catalogue.

2000
New York, Mimi Ferzt Gallery. *Dmitri Plavinsky: The Images of the World*.

New York, Mimi Ferzt Gallery. *Dmitri Plavinsky: Holy Land*.

GROUP EXHIBITIONS

1957
Moscow, The House of Artists. *The Third Exhibition of Young Moscow Artists*. Catalogue.

Moscow, Academy of Fine Arts. *Exhibition of Young Soviet Artists*. Sixth World Festival of Youth and Students. Catalogue

Moscow, Gorky Park. International artists' workshops. Sixth World Festival of Youth and Students.

1958
Moscow, The Moscow State University. *Plavinsky, Kharitonov, Kulakov*.

Moscow, The House of Artists. *The Fourth Exhibition of Young Moscow Artists*. Catalogue.

1959
Moscow, The House of Artists. *The Fifth Exhibition of Young Moscow Artists*. Catalogue.

1960
Moscow, Apartment of George Costakis.

1961
Moscow, Central House for Art Professionals. *Review Exhibition for Graduates of Moscow Art School of the Memory of 1905*.

1962-67
Moscow, House of Edmund and Nina Stevens.

1964
London, Grosvenor Gallery. *Aspects of Contemporary Soviet Art*. Catalogue.

1965
San Francisco, Arleigh Gallery. *The Fielding Collection of Russian Art*.

1966
Poland, Sopot-Poznan. XIX Festival of Fine Arts. *Sixteen Moscow Artists*. Catalogue.

1967
Moscow, Friendship (*Druzhba*) Club on Shosse Entuziastov. *Exhibition of Twelve Artists*.

USSR, Georgia, Tbilisi, Georgian Section of Artists' Union. *Painting and Graphic from the Collection of Alexander Glezer*.

New York, Gallery of Modern Art. *A Survey of Russian Painting from the Fifteenth Century to the Present*. From the Nina Stevens Collection of Twentieth-Century Russian Paintings. Catalogue.

Rome, Galleria il Segno. *Quindici Giovani Pittori Moscoviti*. Catalogue.

France, Saint-Restitut, Drome, Galerie ABC Decor, Maison de la Tour. *Peinture Nouvelle d'URSS*.

1968
Moscow, Moscow Union of Artists Exhibition Hall on Begovaia Street. *Fall Exhibition of Muscovite Artists*.

1969
Moscow, Institute of World Economics and International Relationship.

Stuttgart, Galerie Behr. *Neue Schule von Moscau*. Traveled to Frankfurt, Galerie Interior; Florence, Galleria Pananti. Catalogue.

1970
Moscow, House of Edmund Stevens. *Open-Air Exhibition*.

Lugano, Museo di Belle Arti. *Nuove correnti a Mosca. 58 artisti della giovane avanguardia a villa ciani*. Catalogue.

Cologne, Galerie Gmurzynska. *Russische Avantgarde in Moskau Heute*.

Geneva. Versoix. L'Atelier du Soleil. *Panorama de la jeune peinture slave*.

1970-71
Zurich, Kunstgalerie Villa Egli-Keller. *Alexei Smirnov und Russische Avantgarde von Moskau*.

1971
Copenhagen, Komune Kulturfond i Samarbejde med Billedkunstnernes Forbund Nicolai. *10 Kunstnere fra Moska (Ten Painters from Moscow)*. Catalogue.

1974
West Germany, Bochum, Bochum Museum. *Progressive Strömungen in Moskau, 1957-1970*. Catalogue.

Grenoble, Musée de Peinture et de la Sculpture. *Huit peinteres de Moscou*. Catalogue.

1975
Moscow, VDNKh, Beekeeping Pavilion. *Twenty Muscovite Artists*. Handmade catalogue by Igor Palmin.

Austria, Vienna, Künstlerhaus. *Der Russische Februar '75 in Wien. Glezer Collection*. Catalogue.

1975-76
West Germany, Braunschweig, Kunstverein. *Russian Nonconformist Artists (Glezer Collection)*. Catalogue. Traveled to Freiburg, Kunstverein; West Berlin, Kunstamt Charlottenburg; Konstanz, Kunstverein; Zalgau, Städtische galerie Die Fähre.

1976
Moscow. MOKKHG (The Moscow Joint Committee of Graphic Artists) on Malaya Gruzinskaia Street. *Seven Artists*.

France, Montgeron, Musée Russe en Exil. Inaugural exhibition.

France. *La deuxième biennale Européenne de la gravure de Mulhouse*. (D. Plavinsky, V. Kropivnitskaya, V. Kalinin, O. Kudryashov, V. Yankilevsky). Catalogue.

USA, St. Louis. *New Art from the Soviet Union from the Norton Dodge Collection*. Catalogue. Accompanied exhibition at annual convention of American Association for the Advancement of Slavic Studies.

West Germany, Esslingen, Kunstverein. *Alternatives* (Glezer Collection). Catalogue.

London, Parkway Focus Gallery. *Image of Modern Russia* (Glezer Collection).

Paris, Palais des Congrès. *La peinture russe contemporaine. Collection du Musée Russe en Exil de Montgeron*. Catalogue.

1977
New York, Metropolitan Museum of Art; and San Francisco, Fine Arts Museum. *Russian and Soviet Painting*. An exhibition from the museums of the USSR. Catalogue.

London. Institute of Contemporary Art. *Unofficial Art from the Soviet Union*. In collaboration with the Musée Russe en Exile.

Moscow, MOKKHG (The Moscow Joint Committee of Graphic Artists) on Malaya Gruzinskaia Street. *Painting*.

Venice, La Biennale di Venezia. Palazzetto dello sport all'Arsenale. *La Nuova Arte Sovietica: Una Prospettiva Non Ufficiale*.

Paris, Orangerie du Luxembourg. *Arts et Matiere*. Avec la participation des artistes russe contemporains.

France, Saint-Maur, Maison de le culture. *Les peinture non-officiels de l'Union Sovietique*.

1977-78
USA, Itaka, Herbert F. Johnson Museum of Art, Cornell University. *New Art from the Soviet Union from the Norton Dodge Collection*. Traveled to Washington D.C., The Arts Club of Washington; Kiplinger Editors Building.

1978
Milan. *Libera arte sovietica*.

Italy, Lodi, Museo Civico di Lodi. *Aspetti e Documentazione degli Artisti Non Conformisti dell'Unione Sovietica*.

Turin, La Biennale di Turin. Palazzo Reale. *La nuova arte sovietica*. In collaboration with the Musée Russe en Exile (Montgeron).

Switzerland, Bellinzona. *La Nuova arte Sovietica non ufficiale*.

France, Laval, Musée du Viex Château de Laval. *L'Art russe non officiel*. Catalogue. Traveled to Musée des Beaux-Arts de Tour; Musée des Beaux-Arts de Chartres.

Tokyo, Municipal Museum. *Contemporary Unofficial Soviet Art*. In collaboration with the Musée Russe en Exile (Montgeron).

1979
Moscow, MOKKHG (The Moscow Joint Committee of Graphic Artists) on Malaya Gruzinskaia Street. *Exhibition of Works on Paper*.

Moscow. MOKKHG (The Moscow Joint Committee of Graphic Artists) on Malaya Gruzinskaia Street. *Color, Shape, Space*. Catalogue.

Bochum, Museum Bochum, Kunstsammlung. *20 Jahre unabhangige Kunst aus der Sowjet-Union*. Catalogue.

1980
Paris, Galerie Moscou-Petersburg. *15 de Moscou*.

Moscow. MOKKHG (The Moscow Joint Committee of Graphic Artists) on Malaya Gruzinskaia Street. *Nineteen Muscovite Artists*. Catalogue.

Moscow, The State Pushkin Museum of Fine Arts. *Exhibition of Recent Acquisitions 1970-1980*. Catalogue.

France, Vesinet, Centre des arts et loisirs de Vesinet. *Premier biennale des peintres russes*.

(USA), Jersey City, Museum of Soviet Unofficial Art in Exile. (C.A.S.E.) Inaugura exhibition

Switzerland, Aubonne, Galerie Chantepierre. *L'art russe à Paris à 75 ans*.

Paris, Galerie Moscou-Petersburg. *Biennale de l'Art Graphique-80*.

Canada, Vancouver. *Nonconformist Russian Art*.

Italy, Rimini, Salon Fieristico. *Exhibition of Unofficial Russian Art*.

1981-1982
(USA), Jersey City, Museum of Soviet Unofficial Art in Exile. (C.A.S.E.). *25 Years of Soviet Unofficial Art: 1956-1981*.

1982
Moscow, MOKKHG (The Moscow Joint Committee of Graphic Artists) on Malaya Gruzinskaia Street. *Drobitskii, Zverev, Kalinin, Krasnopevtsev, Nemukhin, Plavinsky, Kharitonov, Shteinberg, Yakovlev, Yankilevskii*. Catalogue.

Moscow, Central House of Artist. *50th Anniversary of Moscow Section of the Artists' Union (MOSKH)*.

1983
Moscow, MOKKHG (The Moscow Joint Committee of Graphic Artists) on Malaya Gruzinskaia Street. *Watercolor, Drawing, Etching*. Catalogue.

Moscow, House of Artists. *Object*.

Washington, D.C., Cannon Rotunda and Russel Rotunda, Capitol Hill. *Unofficial Art from the Soviet Union*. In collaboration with the Museum of Soviet Unofficial Art in Exile (C.A.S.E.).

Costa Rica, University of San Jose. *Exhibition of the Works of Moscow Artists*.

1984
Moscow, MOKKhG (The Moscow Joint Committee of Graphic Artists) on Malaya Gruzinskaia Street. *Painting*.

Germany, Meersbuch, Meerbuscher Kultursomer. *Unofficial Russian Art*.

1985
Moscow, MOKKHG (The Moscow Joint Committee of Graphic Artists) on Malaya Gruzinskaia Street. *Painting*.

1986
Moscow, Central House of Artist. *NTR (Scientific and Technological Revolution) and Art*.

Moscow, MOKKhG (The Moscow Joint Committee of Graphic Artists) on Malaya Gruzinskaia Street. *Painting*.

1987
Moscow, Hermitage Association. *A Retrospective Exhibition of the Works of Moscow Artists: 1957-1987*.

1988
Bern, Kunstmuseum. *Ich lebe-Ich sehe. Künstler der achtziger Jahre in Moskau.* Catalogue.

Moscow, The State Tretiakov Gallery. *Exhibition of Works of Art from the Sixteenth Century to the Twentieth Century, from the Garig Basmadjian Collection.* Catalogue. Traveled to St. Petersburg, The State Hermitage Museum.

Moscow, Sovincentr. Sotheby's. *Russian Avant-Garde and Soviet Contemporary Art.* Catalogue.

Bochum, Museum Bochum. *Exhibition of Moscow Artists.*

Copenhagen. Galleri Balderskilde. *Soviet Contemporary Art.*

1989
Moscow, Glinka Museum of Musical Culture. *Festival of Avant-Garde Art. Alternative.*

London, Phillips Auction. *Russian 20th Century & Avant-Garde Art.*

Moscow, Exhibition hall on Solianka Street. *Sacred Art.* In collaboration with the Patriarchite of Moscow.

Uzbekistan, Tashkent, The State Museum of Fine Arts. *100 Artists from the Collection of Tatiana and Natasha Kolodzei.*

Switzerland, Luzern, Kunstmuseum. *Von der Revolution zur Perestrojka. Sowjetische Kunst aus der Sammlung Ludwig.*

Moscow, Central House of Artist. *Graphic of Moscow Artists.*

1990
Moscow, Central House of Artist. *Art Mif One (Moscow International Art Fair), Ideal Project for a Soviet Art Market.* Catalogue.

Moscow, Kashirskoye shosse Exhibition Hall. The Tsaritsino National Museum Collection of Contemporary Art. *Towards an Object.* Traveled to Amsterdam, Stedelijk Museum of Modern Art, *To the Object.*

Moscow, The State Pushkin Museum of Fine Arts. *Exhibition of Recent Acquisitions 1980-1990.*

Moscow, Central Exhibition Hall Manezh. Anniversary Exhibition for MOKKHG (The Moscow Joint Committee of Graphic Artists) on Malaya Gruzinskaia Street.

1990-1991
Moscow, The State Tretiakov Gallery. *The Other Art. Moscow 1956-1976.* Book. Traveled to St. Petersburg, The State Russian Museum.

1991
Tokyo, Setagaya Art Museum. *Soviet Contemporary Art. From Thaw to Perestroika.* From the collection of the Tsaritsino National Museum. Catalogue.

Hong Kong, La Rotunda of Exchange Square. *Modern Art from Russia – Contemporary Artists.* Tang Collection.

Czechoslovakia, Bratislava, Dom Kultury. The Tsaritsino National Museum Collection of Contemporary Art. *In the Rooms/Vizbah.*

Washington, D.C., Gregory Gallery. *Russian Art Now: The Moscow Avant-Garde.*

1992
(USA), New Brunswick, Jane Voorhees Zimmerli Art Museum, Rutgers University. *New Directions.* Inauguration opening of permanent installation of the George Riabov Collection of Russian Art.

Moscow, Central House of Artist. *Moscow Romanticism from the Collection of the Firm "Carat".* Catalogue.

1993
Moscow, The State Tretiakov Gallery. *National Traditions and Postmodernism.* Catalogue.

(USA), Madison, N.J., Schering-Plough Corporation. *Struggle for the Spirit: Religious Expression in Soviet Nonconformist Art.* Exhibition organized by the Jane Voorhees Zimmerli Art Museum. Traveled to Dixon Gallery and Gardens, Memphis, Tenn. Catalogue.

1994
Moscow, Central House of Artist. *Artist Instead of an Art Work or Jump into the Void.* Catalogue.

Moscow, House 100. *20th Anniversary of Bulldozer Exhibition.*

Cetin, Montenegro. Cetinjski Bienale II.

Warsaw, Krolikarnia. *The Nonconformists from Collections of the State Russian Museum and P. Nowicky.*

1995
Moscow, Sotheby's. *Contemporary Russian Painting and Graphic.* In collaboration with Art MIF. July 1. Catalogue.

USA, New Brunswick, Jane Voorhees Zimmerli Art Museum. *From Gulag to Glasnost, Nonconformist Art from the Soviet Union.* Permanent Installation of the Norton and Nancy Dodge Collection of Nonconformist Art from the Soviet Union, 1956-1986. Book.

Ludwigshafen am Rhein, Wilhelm-Hack-Museum. *Nonconformisten Russland 1957-1995. Sammlung des Staatlichen Zarizino-Museums, Moskau.* Book. Traveled to Kassel, Documenta-Halle; Altenburg, Staatliches Lindenau-Museum; Moscow, Central Exhibition Hall Manezh.

Moscow, Gogolevskii bul'var 10. *20th Anniversary of Bulldozer Exhibition.*

1996
Moscow, The Tsaritsino National Museum Collection of Contemporary Art. Kashirka Exhibition Hall. *Aesthetic of Thaw.*

St. Petersburg, The State Russian Museum. *Non-Conformist: The Second Russian Avant-Garde 1955-1988. From the collection of Bar-Gera.* Catalogue. Traveled to Moscow, The State Tretiakov Gallery; Germany, Frankfurt on Main, State Art Institute and State Gallery; Leverkusen, Exhibition Hall, Bayer A.G. and Museum Schloss Morsbroich; Bottrop, Josef Albers Quadrat Museum; Samara Art Museum; Italy, Verona, Galleria d'Arte Moderna e Contemporanea Palazzo Forti.

St. Petersburg. Manezh. *Contemporary Art of Russia and the Netherlands. From the collection of Stolichny Bank and the ING Group.* Catalogue.

Moscow, Spaso House. *The Silk Nets of Art.* The Moscow Studio. Catalogue. Traveled to Kaluzhskii Regional Art Museum, Riazanskii Regional Art Museum.

Moscow. Gallery Kino. *Oriental Motifs.*

Moscow. Gallery Kino. *Summer.*

New York, Hudson. The Tabakman Collection Museum. Permanent exhibition.

1997
New York, Mimi Ferzt Gallery. *Celebrating the Still-Life.*

Moscow, Central House of Artist, Gallery Moscow Palette. International Art Fair– Art Moscow

Budapest, Mucharnok. *Russian Art in 15 Destinies.* From the collection of The Tsaritsino National Museum Collection of Contemporary Art.

Feodosia, Alexander Grin's House-Museum, *Contemporary Russian Graphic.* Collection of Alexander Glezer. Catalogue. Traveled to Maksmilian Voloshin's House-Museum.

Moscow, The Tsaritsino National Museum Collection of Contemporary Art. *The History in Faces, 1956-1996.* Catalogue. Traveled to the State

Museums of Fine Arts in Nijni Novgorod, Samara Regional Museum of Fine Arts, Perm' Regional Museum of Fine Arts, Novosibirsk Museum of Fine Arts, and Ekaterinburg Museum of Fine Arts. Poland, District Museum in Torun. *Exhibition of Recent Acquisitions.*

Cheboksary, Chuva State Museum of Fine Arts. World of these eyes—2. Aiga and his artistic environment. Catalogue.

Moscow, The State Pushkin Museum of Fine Arts, Museum of Private Collections. *Exhibition from Evgenii Nutovich Collection.*

Moscow, Academy of Fine Arts of the Russian Federation. *Association Magnum Ars.*

1998
Moscow, Novij Manezh Exhibition Hall. *International Art-fair ART-MOSKVA.* Catalogue.

Moscow, Dom Nashchokina Gallery. *The Second Avant-garde. Graphic Art.* Catalogue.

New York, Tabakman Gallery. *Russian Still-Life.*

1998-1999
California, Pasadena, Art Center College of Design Alyce de Roulet Williamson Gallery. *Forbidden Art: The Postwar Russian Avant-Garde.* Catalogue. Traveled to St. Petersburg, The State Russian Museum; Moscow, The State Tretiakov Gallery; Ohio, Oxford, Miami University Art Museum.

1999
Moscow, Central House of Artist. *Museum of Contemporary Art: Russian Art End of 1950s Beginning of 1980s (from Abstract art to Conceptual art).*

Moscow, Central House of Artist. *In Memory of Alexander Vasiliev.*

St. Petersburg, The state Russian Museum. *Exhibition of Recent Acquisitions*

Washington, D.C., Kennan Institute for Advanced Russian Studies, Woodrow Wilson International Center for Scholars. *A Twenty-Five-Year Retrospective on Nonconformist Russian Art. Selections from the Kolodzei Collection.*

Moscow, Museum of Modern Art. Inauguration opening of permanent installation.

2000
Moscow, Museum Center, State Russian University for the Humanities, Museum "The Other Art." Inauguration opening of permanent installation of the Leonid Talochkin Collection.

Italy, SanRemo, Municipal Hall. *Turn of the Century, Close of the Millenium. Selections from the Kolodzei Collection.*

PUBLIC COLLECTIONS

The Metropolitan Museum of Art, New York

The Museum of Modern Art, New York

New York Public Library, New York

Jane Voorhees Zimmerli Art Museum, Rutgers University, New Brunswick, NJ
The Norton and Nancy Dodge Collection of Nonconformist Art from the Soviet Union

Jane Voorhees Zimmerli Art Museum, Rutgers University, New Brunswick, NJ
The George Riabov Collection of Russian Art, donated in memory of Basil and Emilia Riabov

Duke University Museum of Art, Durham, NC

Ludwig Stiftung für Kunst und Internationale Verständigung, Cologne

The State Tretiakov Gallery, Moscow

The State Pushkin Fine Arts Museum, Moscow

National Collection of Contemporary Art (in Tsaritsino Museum), Moscow

Museum of Modern Art, Moscow Alina Roedel Collection

Museum Center, State Russian University for the Humanities, Moscow
Museum "The Other Art," (Leonid Talochkin Collection)

The State Russian Museum, St. Petersburg

District Museum in Torun, Poland

SELECTED BIBLIOGRAPHY

by Natalia Kolodzei

Akvarel', risunok, estamp. Catalogue. Moscow: Moskovskiĭ Gorodskoĭ Komitet Profsouza Rabotnikov Kul'tury, Ob'edinennyĭ Komitet Profsouza Khudozhnikov-Grafikov, 1987. (In Russian)

Alternatives (Glezer Collection). Catalogue. West Germany, Esslingen: Kunstverein, 1976.

Art Miami '92. Miami International Art Expositions. Miami: International Art Exposition, 1992.

L'Art russe non officiel. Catalogue. France: Musée des Beaux-Arts de Tour, Musée des Beaux-Arts de Chartres, Musée du Viex Château de Laval.

Aspects of Contemporary Soviet Art. Catalogue. London: Grosvenor Gallery, 1964.

Der Aufstand der Bilder Moskauer Maler 1974 - 1994. Hamburg: Hallescher Kunstverein E.V., 1995.

Baigell, Renee, and Matthew Baigell. *Soviet Dissident Artists: Interviews after Perestroika.* New Brunswick, N.J.: Rutgers University Press, 1995.

Costakis, George. *Moĭ Avangard. Vospominaniia kollektsionera.* Moscow: Modus Grafiti, 1983. (In Russian)

La deuxième biennale Européenne de la gravure de Mulhouse. (D. Plavinsky, V. Kropivnitskaya, V. Kalinin, O. Kudryashov, V. Yankilevsky). Catalogue. France: 1976.

Deviatnadtsat' moskovskikh khudozhnikov. Catalogue. Moscow: Moskovskiĭ Gorodskoĭ Komitet Profsouza Rabotnikov Kul'tury, Ob'edinennyĭ Komitet Profsouza Khudozhnikov--Grafikov, 1982.

Dodge, Norton T., and Alison Hilton. *New Art from the Soviet Union: The Known and the Unknown.* Washington, D.C.: Acropolis Books, 1977. (Catalogue for an exhibition at the Arts Club, Washington, D.C., and Herbert F. Johnson Museum of Art, Cornell University, Ithaca, N.Y.)

Drobitskii, Zverev, Kalinin, Krasnopevtsev, Nemukhin, Plavinsky, Kharitonov, Shteinberg, Yakovlev,

Yankilevsky. Katalog vystavki. Catalogue. Moscow: Moskovskiĭ Gorodskoĭ Komitet Profsouza Rabotnikov Kul'tury, Ob'edinennyĭ Profsouznyĭ Komitet Khudozhnikov-Grafikov, 1985. (In Russian)

Dyogot, Ekaterina. *Contemporary Painting in Russia.* Australia: Craftsman House, G+B Arts International, 1995.

El'shevskaia, Galina. *Novyĭ al'bom grafiki.* Moscow: Sovetskiĭ khudozhnik, 1991. (In Russian)

Encyclopedia of Contemporary Art. Moscow: Creative Fund of Russia, 1996. (In Russian and English)

Erofeev, Andrei, and Jean-Hubert Martin, eds. *Kunst im Verborgenen: Nonkonformisten Russland 1957-1995.* Munich, New York: Prestel, 1995.

Erofeev, Andrei. *Non-Official Art: Soviet Artists of the 1960s.* Australia: Craftsman House, G+B Arts International, 1995.

The Fine Art Index. North American Edition, 1992.

Forbidden Art: The Postwar Russian Avant-Garde. Los Angeles: Curatorial Assistance, Inc., in association with Distributed Art Publishers, New York, 1998.

The George Riabov Collection of Russian Art. New Brunswick: Jane Voorhees Zimmerli Art Museum, Rutgers, State University of New Jersey, 1994.

Glezer, Alexander. *Sovremennoe Russkoe iskusstvo / L'art russe contemporain / Contemporary Russian Art.* Paris, New York, and Moscow: Third Wave Publishers, 1993. (In Russian)

Golomoshtok, Igor, and Alexander Glezer. *Soviet Art in Exile.* New York: Random House, 1977. Also published as *Unofficial Art from the Soviet Union.* London: Secker and Warburg, 1977.

Heartney, Eleanor. "Russian and Soviet Art: Assimilation and Alienation." *Art in America* (February 1996), 51-54.

Huit peinteres de Moscou. Catalogue. Grenoble: Musée de Peinture et de la Sculpture, 1974.

Ich Lebe – Ich sehe. Kunstler der achtziger Jahre in Moscau. Bern: Kunstmuseum Bern, 1988.

In the USSR and Beyond. (Erofeev, Andrei. *To the Object.*) Amsterdam: Stedelijk Museum, 1990.

Istoria v litsakh, 1956-1996. Moscow: Institut Otkrytoe Obshchestvo moskovskoie predstavitel'stvo, Gosudarstvennyĭ muzeĭ-zapovednik "Tsaritsino," kollektsiia sovremennogo iskusstva, 1997. (Catalogue for the exhibitions at the Nizhniy Novgorod State Art Museum, Samara Regional Art Museum, Perm State Art Gallery, Novosibirsk Art Gallery and Ekaterinburg Museum of Fine Arts.) (In Russian)

20 Jahre unabhangige Kunst aus der Sowjet-Union. Bochum: Druckhaus Schurmann & Klagges, 1979.

Kashuk, Larisa. *Khudozhnik o khudozhnike.* Moscow: Zverevskiĭ tsentr sovremennogo iskusstva, 1999. (In Russian)

Khudozhnik vmesto proizvedeniia. Mezhdunarodnaia khudozhestvennaia vystavka v Moskve. Moscow: 1994.

Kozlova, Natalya. "Glimmering Reflections of Something Forever Lost… Artist Dmitri Plavinsky." *The Russian* (November 1995): 70-77.

La Peinture Russe Contemporaine. Palais des Congrès. Paris: Arts Grafique de Paris, 1976.

Lee, Gretchen. "Glastnost and the Arts – Alex-Edmund Galleries Forces New Ties." *Artexpo Preview* (January-February 1992): 32, 34, 36.

Meiland, Wiliam. "Zapovednik." *Nashe Nasledie n° 49, 1999:* 125-131. (In Russian)

Mikhailov, Petr, and Aleksandr Shchuplov. "Ah, Vernisazh! Ah, Vernisazh," *Stolitsa n° 8,* (February 19, 1995): 6-7. (In Russian)

Mir etikh glaz. Aigi i ego khudozhestvennoie okruzhenie. Catalogue. Cheboksary: Chuvashia Republican Regional Studies Museum, 1997. (In Russian)

Modern Art from Russia – Contemporary Masters. Hong Kong: Hongkong Land

Property, Ltd., 1991.

Modern Art from Russia and Netherlands. Catalogue. Amsterdam: Stichting Onderneming & Kunst, 1996.

Moscow Romanticism from the Collection of the Firm "Carat." Catalogue. Moscow: Bonfi, 1992. (In Russian and English)

Natsional'nye traditsii i postmodernism. Moscow: Gosudarstvennaia Tretiakovskaia Galereia, 1993. (In Russian)

Nenarokomov, Maksim. "Master Chistoï Meditatsii." *Stas* (2, 1995): 120-122. (In Russian)

Nonkonformista Muveszet a Szovjetuniobol, Mucharnok (Kunsthalle), Budapest. Hungary: 1997.

Pann, Lilia. "Venetsiia v prostranstve i vremeni Dmitriia Plavinskogo." *Kul'tura,* 24, 1999 (July 8-14). (In Russian)

Peschler, A. Eric. *Künstler in Moscau: Die Neue Avantgarde.* Schaffhaussen, Zurich, Frankfurt, Düsseldorf: Edition Stemmle Verlag Photographic AG, 1988.

Pisateli-Khudozhniki. Khudozhniki-Pisateli. Moscow: Third Wave, 1997. (In Russian)

Plavinsky, Dmitri. "Golosa Molchaniia." *Strelets n° 1* (68), 1992. Moscow, Paris, New York: Third Wave, 1993. (In Russian)

Plavinsky, Dmitri. "Zapiski o proshlom." *Nashe Nasledie n° 5,* (1991): 119-132. (In Russian)

Dmitri Plavinskii. Moscow: Dom Nashchokina Gallery, 1995. (In Russian)

Dmitri Plavinsky. New York: Alex-Edmund Galleries, 1993.

Dmitri Plavinsky: Echo Ancient Ruins. New York: Mimi Ferzt Gallery, 1995.

Dmitri Plavinsky: In Search of Italy. New York: Mimi Ferzt Gallery, 1998.

Progressive Strömungen in Moskau, 1957-1970. Catalogue. Bochum: Bochum Museum, 1974.

Quindici Giovani Pittori Moscoviti. Catalogue. Roma: Galleria il Segno, 1967.

Rieze, Hans-Peter, ed. *Non-Conformisten. Non-konformisty Vtoroï Russkiï Avangard 1955-1988.* Collection of Bar-Gera. Germany: Wienand, 1996. (In Russian and German)

Rieze, Hans-Peter, ed. *L'Arte vietata in U.R.S.S. Non-conformisti dalla Collezione Bar-gera 1955-1988.*

Italy: Electa, 2000. (In Italian and English).

Rosenfeld, Alla, and Norton T. Dodge, eds. *From Gulag to Glasnost: Nonconformist Art from the Soviet Union.* New York: Thames and Hudson, 1995.

Rosenfeld, Alla, and Jeffrey Wechsler. *Struggle for the Spirit: Religious Expression in Soviet Nonconformist Art.* New Brunswick, N.J.: Jane Voorhees Zimmerli Art Museum, 1993.

Russian 20th Century and Avant-Garde Art, Monday 27 November 1989. London: Phillips, 1989.

Russian and Soviet Painting. New York: Metropolitan Museum of Art. Trade edition distributed by Rizzoli International Publications, 1977.

Russian Avant-Garde and Soviet Contemporary Art. Moscow, Thursday, July 7th, 1988. Geneve: Sotheby's, 1988.

Russian Collection – The Close of the XX Century. Moscow: Fine Arts Enterprise M'ARS Art Gallery Museum Publishing, 1994. (In Russian and English)

Der Russische Februar '75 in Wien (Glezer Collection), Künstlerhaus. Catalogue. Austria, Vienna: 1975.

Riurikova, Natalia, and Marina Kaminarskaia. "Dmitri Plavinsky: Ia nikuda ne speshu." *Stolitsa 5* (January 29, 1995): 64-67. (In Russian)

Ovazione. Collezione Aprile di Cimia. Italy: Electa, 1999.

A Survey of Russian Painting from the Fifteenth Century to the Present. Preface by George Riabov. New York: Gallery of Modern Art, 1967.

"Selected Recent Acquisitions." DUMA, Duke University of Art (Fall 1996-Summer 1997): 33.

Sjeklocha, Paul, and Igor Mead. *Unofficial Art in the Soviet Union.* Berkeley and Los Angeles: University of California Press, 1967.

Shaw, Alexander. "Oprea and Levin Fine Art, Inc. Manhattan's New Russian Art Gallery." *Manhattan Arts* (January-February 1993): 12.

Soviet Contemporary Art. From Thaw to Perestroika. Tokyo: Setagaya Art Museum, 1991.

Sovremennaia Russkaia Grafika iz kollektsii Aleksandra Glezera. Catalogue. Moscow: Third Wave, 1997. (In Russian)

Sovremennoe iskusstvo Moskvy 1995. Moscow: BOOQ Design, 1996. (In Russian)

Stevens, Elisabeth. "Outsider Art inside Russia." *Art in America* (September-October, 1968): 76-79.

Sviridova, Alexandra. *Svitok.* Museum of Art, Duke University, 1997. (In Russian).

Talochkin, Leonid, and Irina Alpatova, eds. *Drugoe iskusstvo. Moskva 1956--1976. K khronike khudozhestvennoï zhizni. Katalog vystavki.* Volumes 1 and 2. Moscow: Interbuk, 1991. (In Russian)

Tsvet, forma, prostranstvo. Catalogue. Moscow: Moskovskii Ob'edinennyï Komitet Khudozhnikov-Grafikov Profsouza Rabotnikov Kul'tury, 1979. (In Russian)

Thorez, Paul. *Sixteen Moscow Artists.* XIX Festiwal Sztuk Plastycznych. Catalogue. Poland, Sopot-Poznan:1966. (In Polish)

Uralskii, Mark. *Nemukhinskie monologi (portret khudozhnika v interiere).* Moscow: Bonfi, 1999. (In Russian)

Videti vo mraku. Guide of II Biennale in Cetinje, Montenegro. Montenegro: 1994.

Vtoroï Avangard. Grafika. Moscow: Dom Nashchokina Gallery, 1998. (In Russian)

III Vystavka molodykh Moskovskikh khudozhnikov. Catalogue. Moscow: Sovetskiï khudozhnik, 1957. (In Russian)

IV Vystavka molodykh Moskovskikh khudozhnikov. Catalogue. Moscow: Sovetskiï khudozhnik, 1958. (In Russian)

V Vystavka molodykh Moskovskikh khudozhnikov. Catalogue. Moscow: Sovetskiï khudozhnik, 1959. (In Russian)

Vystavka Zhivopisi. Catalogue. Moscow: Moskovskiï Ob'edinennyï Profsouznyï Komitet Khudozhnikov-Grafikov Profsouza Rabotnikov Kul'tury, 1982. (In Russian)

Vystavka kollektsii Aleksandra Glezera. Catalogue. State Pushkin Museum of Fine Arts, Museum of Private Collections. Moscow, Paris, New York: Third Wave, 1995.

Vystavka novykh postuplenii 1970-1980. Gosudarstvenyï muzei izobrazitel'nykh iskusstv imeni A. S. Pushkina (The State Pushkin Fine Arts Museum). Moscow: Iskusstvo, 1982. (In Russian)

Vystavka proizvedenii molodykh khudozhnikov Sovetskogo Souza k VI Vsemirnomu Festivalu Molodezhi i Studentov. Moscow: Sovetskiï khudozhnik, 1957. (In Russian)

1947-1950	Caucasus, Crimea
1951	Latvia (Riga)
1954	Pereslavl-Zalessky, Alexandrov
1956	Buguruslan
1958	Middle Asia (Tashkent, Samarkand, Bukhara)
	Vladimir, Suzdal
1959	Armenia (Yerevan, Ashtarak, Alages)
1960	Novgorod, Pskov, Isborsk, Pechory
1961-1963	Tarusa, Serpukhov
1962	Middle Asia (Tashkent, Samarkand, Bukhara, Shakhresjabs)
1963	Jaroslavl
	Novgorod, Pskov
1964	Moldavia (Bendery, Tiraspol, Kishinev)
1965	Jurjev-Polskoij, Vladimir
	Crimea (Koktebel, Sudak, Stary Crim)
1966-1974	Kostroma regoin (Kineshma, Schelykovo, Bereshki, Rodovo)
1968	Vologda, Belosersk, Ferapontov
1970	Kalinin region (Khotilovo)
1972	Middle Asia (Kokand, Fergana, Margeland)
1973	Far East (Nakhodka, Vladivostok)
	Lithuania (Vilnuis), Estonia (Tallinn)
1974	Upper Volga (Staritsa)
	North Ural (Ukhta)
	Crimea (Sevastopol, Khersonese)
1975	Novgorod, Pskov, Isborsk, Pechory
1976	Poland (Warshaw, Czentochowa, Krakov, Lodz, Torun, Danzig)
	Middle asia (Nukus, Urgench, Chiva, Ashkhabad)
1977	Kirgizia (Frunse, Osh, Fergana, Prgevalsk)
	Latvia (Riga), estonia (Tallinn)
1980	Dagestan (Makhachkala, Derbent, Kubachi, grozny)
1982	West Ukraina (Kosovo, Lvov, Uzhgorod)
	Georgia (Tbilisi, Telavi)
1983	Latvia (Riga, Enguri)
1984	Georgia Tbilisi, Telavi)
1987	Crimea (Koktebel, Feodosia, Sudak)
	Armenia (Goris, Yerevan)
1990	USA (New York, Washington)
1993	Greece (Athens, Aegina Island, Delphi, Sonion)
1994	Greece (Athens, Crete)
1995	Russia (Moscow)
	USA (Arizona, Utah, Colorado, New Mexico)
	Italy (Turin, Milan, Venice, Ravenna, Florence, Rome, Naples, Capri, Paestum)
1998	Russia (Moscow)
1999	Israel (Tel Avivi, Jerusalem, Nazareth, Galilee, Dead Sea, Masada, Sea of Galilee)
1999-2000	Israel (Jerusalem, Bethlem, Desert in Judea)

CHECKLIST

I. CANYON'S CIRCLES

Pag. 35 *Coelacanth*, 1965, Oil and synthetic
polymer paint on canvas with small
pieces of cardboard and wood shavings
beneath paint,
39³/₈ x 59¹/₈ in. 99.7 x 150.1 cm

Pag. 37 *Voices of Silence*, 1962, Oil on canvas,
55¹/₄ x 67 in. 139.8 x 200.5 cm

Pag. 38 *The Town of the Dead* (4-parts detail
from installation *Asia – The Wall of the
Koran*), 1978, Oil, sand, polyvinylaceta-
te tempera, cardboard on canvas,
39³/₈ x 47¹/₄ x 5 in. 100 x 120 x 12.5 cm

Pag. 39 *Man-Fish*, 1964, Oil, polyvinylacetate
tempera, fabric on canvas,
39 x 58³/₄ in. 99 x 149 cm

Pag. 40 *Asian Cemetery*, 1977, Oil, polyvinyla-
cetate tempera, matchboxes, matches,
fabric, dried plants on canvas
27¹/₂ x 35¹/₂ x 4 in. 70 x 90 x 10 cm

Pag. 41 *Tortoise*, 1967, Oil, polyvinylacetate
tempera, cardboard on canvas,
39¹/₂ x 59¹/₄ in. 100.5 x 150.5 cm

Pag. 42 *Golden Turtle*, 1991, Oil, sand, acrylic
on canvas, 68 x 50 in. 173 x 127 cm

Pag. 43 *Sea Shell with Barnacle*, 1978, Oil,
polyvinylacetate tempera on canvas,
31¹/₂ x 43¹/₄ in. 80 x 110 cm

Pag. 44 *Manhattan Fish*, 1992,
Oil, acrylic, collage on canvas,
50 x 121 in. 127 x 307 cm

Pag. 46 *Eastern Manuscripts with Butterflies*,
1989, Oil, polyvinylacetate tempera,
collage on canvas
39¹/₂ x 19³/₄ in. 100 x 50 cm

Pag. 47 *Deserted Town Machu Picchu*, 1991,
Oil, acrylic on canvas,
50 x 40 in. 127 x 102 cm

Pag. 48 *Manhattan-Ghost*, 1993,
Oil, acrylic, collage on canvas,
42 x 60 in. 107 x 153 cm

Pag. 49 *Moscow-Tortoise*, 1996,
Oil, acrylic, collage on canvas,
62 x 48 in. 158 x 122 cm

Pag. 50 *Skate*, 1981, Oil, polyvinylacetate
tempera on canvas,
59 x 39³/₈in. 150 x 100 cm

Pag. 51 *Flying Fish*, 1978, Oil, polyvinylacetate
tempera on canvas,
39¹/₂ x 59 in. 100 x 150 cm

Pag. 52 *Agate Turtle Shell*, 1992,
Oil, sand, acrylic on canvas,
48 x 36 in. 122 x 91.5 cm

Pag. 53 *Sea Shell with Barnacles*, 1977, Oil,
polyvinylacetate tempera on canvas,
31¹/₂ x 43¹/₄ in. 80 x 110 cm

Pag. 55 *Manhattan Shark*, 1997,
Oil, acrylic, collage on canvas,
80 x 50 in. 203 x 127 cm

II. WORD

Pag. 59 *Word*, 1967, Oil, plaster, polyvinylace-
te tempera, cardboard on canvas,
79 x 59 in. 200 x 150 cm

Pag. 60 *Jerusalem*, 1999, Oil, collage, acrylic on
board, 48 in. diameter - 122 cm diameter

Pag. 61 *Tower of Torah*, 1989, Oil, polyvinyla-
cetate tempera, collage on canvas,
56¹/₄ x 38³/₄ in. 143 x 98.5 cm

Pag. 62 *Crosses of Armenia*, 1987,
Colored pencil on paper,
39¹/₈ x 28³/₄ in. 100 x 73 cm

Pag. 63 *In the Beginning was the Word...*, 1988,
Colored pencil, pen and ink on paper,
17⁵/₈ x 17⁵/₈ in. 44.8 x 44.8 cm

Pag. 64 *... And the Dusk Descended Upon the
Gardens of Gethsemane*, 1999,
Oil, acrylic, collage on canvas
42¹/₂ x 64¹/₄ in. 108 x 163 cm

Pag. 65 *Wanderer's Vision*, 1992,
Oil, acrylic, collage on canvas,
72 x 50 in. 183 x 127 cm

Pag. 67 *St. John's Gospel*, 1967, Oil, polyvinyla-
cetate tempera, plaster, collage on can-
vas, 70³/₄ x 47¹/₄ in. 180 x 120 cm

Pag. 68 *Letter "C"* (2 parts), 1966, Oil, poly-
vinylacetate tempera, plaster, canvas on
board, 47 x 72 in. 119 x 183 cm

Pag. 70 *Church Wall*, 1965, Oil, curved wood,
engraving on plaster on wood,
29¹/₂ x 20 x 3/4 in. 75 x 50.5 x 2 cm

Pag. 71 *Cross*, 1976, Oil, polyvinylacetate
tempera, carving on plaster, nails,
wood, metal on wood
118 x 71 x 13³/₄ in. 300 x 180 x 35 cm

Pag. 72 *Wall of Novgorod Church* (3 parts),
1974; 1978, Oil, sand,
polyvinylacetate tempera, plaster on
cardboard 41¹/₂ x 100¹/₂ in. 105 x 255 cm

Pag. 74 *Gospel with Potatoes*, 1974, Oil, plaster,
polyvinylacetate tempera on canvas,
43¹/₄ x 31¹/₂ in. 110 x 80 cm

Pag. 75 *Easter*, 1964, Oil on canvas,
46¹/₂ x 34³/₄ in. 118 x 78 cm

Pag. 76 *Dog*, 1965, Oil, sand, plaster,
polyvinylacetate tempera on canvas
47¹/₄ x 71 in. 120 x 180 cm

III. MEASURE OF UNIVERSE

Pag. 81 *The World of Music (Cosmogony)*, 1993,
Oil, acrylic, collage on canvas,
60 in. diameter, 153 cm diameter

Pag. 82 *Cliffs' Voices*, 1995, Oil, acrylic, collage
on canvas, 40 x 59 in. 102 x 150 cm

Pag. 83 *Color-Sound Vertical* (3 parts), 1987,
Oil, polyvinylacetate tempera,
collage on canvas,
98³/₄ x 21⁵/₈ in. 250 x 55 cm

Pag. 84 *Silver Disc*, 1991,
Oil, acrylic, collage on canvas,
42 in. diameter, 107 cm diameter

Pag. 85 *Beethoven's Archipelago*, 1988,
Oil, polyvinylacetate tempera, collage
on wood, 45¹/₄ x 19³/₄ in. 115 x 50 cm

Pag. 86 *Black Mirror*, 1989, Oil, polyvinylace-
te tempera, collage on canvas,
55 x 35¹/₂ in. 140 x 90 cm

Pag. 87 *Bach's Fugue*, 1987, Oil, polyvinylace-
te tempera, collage on canvas,
55 x 35¹/₂ in. 140 x 90 cm

Pag. 89 *Black Landscape*, 1988, Oil, polyvinyla-
cetate tempera, collage on canvas,
55 x 35¹/₂ in. 140 x 90 cm

Pag. 90 *Mozart and Saljeri*, 1987, Oil, sand,
polyvinylacetate tempera, collage on
canvas, 39³/₈ x 56³/₄ in. 100 x 144 cm

Pag. 91 *Sunset*, 1989, Oil, polyvinylacetate
tempera, collage on canvas,
47³/₈ x 31¹/₂ in. 122 x 80 cm

IV. MUSIC OF MYTH

Pag. 95 *Columns of Aegina*, 1995,
Oil, acrylic, collage on canvas,
60 x 30 in. 153 x 76 cm

Pag. 96 *Butterfly of Crete*, 1995,
Oil, acrylic, collage on canvas,
26 x 40 in. 66 x 101 cm

Pag. 97 *Vanishing Point*, 1995,
Oil, acrylic, collage on canvas,
42 in. diameter, 107 cm diameter

Pag. 98 *Music of Ancient Ruins*, 1993,
Oil, acrylic, collage on canvas,
36 x 60 in. 92 x 153 cm

Pag. 99 *Columns*, 1993, Watercolor, pen and
ink on paper, 35¹/₂ x 24¹/₂ in. 90 x 62 cm

Pag. 100 *Columns of Aegina*, 1993,
Colored pencil, pen and ink on paper,
28¹/₂ x 21 in. 73 x 53 cm

Pag. 101 *Mycenae*, 1995, Watercolor, pen and ink,
acrylic, collage, monotype on paper,
31 x 41¹/₄ in. 79 x 115 cm

Pag. 102 *Echo Ancient Ruins*, 1995,
Oil, acrylic, collage on canvas,
42 x 64 in. 107 x 163 cm

Pag. 103 *Sign over Delphi*, 1995,
Oil, acrylic, collage on canvas,
42 x 62 in. 107 x 163 cm

Pag. 104 *Ruins*, 1994, Colored pencil on paper,
19 x 24 in. 48 x 61 cm

Pag. 105 *Demethra. Ancient Relief*, 1994,
Colored pencil on paper,
28¹/₂ x 21 in. 73 x 53 cm

Pag. 106 *Aegina of My Dream*, 1994,
Oil, acrylic, collage on canvas,
30 x 50 in. 76 x 127 cm

Pag. 107 *Pythagorean Light*, 1995,
Oil, sand, acrylic, collage on canvas,
60 x 44 in. 153 x 112 cm

Pag. 109 *Apollo and Muses*, 1995,
Oil, acrylic, collage on canvas,
42 x 64 in. 107 x 163 cm

Pag. 110 *Sanctuary of Knossos' Palace*, 1994,
Oil, acrylic on canvas,
42 x 60 in. 107 x 153 cm

Pag. 111 *Dionysian Element*, 1995,
Oil, sand, acrylic, collage on canvas,
74 x 50 in. 188 x 127 cm

Pag. 113 *Golden Mask of Mycenae*, 1995,
Oil, sand, acrylic, synthetics, collage on
canvas, 60 x 80 in. 153 x 203 cm

Pag. 114 *Knossos. Installation*, 1995,
Part I on the floor: *Knossos Palace*,
Part II on the wall: *Minotaur's Labyrinth*,
Oil, colored sand, acrylic, metal,
synthetics, masonite on plastic and
linen with ready-made objects,
162 x 100 x 110 in. 411 x 254 x 280 cm

PHOTO CREDITS